# OPEN CONCEPT HOUSES

# OPEN CONCEPT HOUSES

Francesc Zamora Mola

HARPER
DESIGN
An Imprint of HarperCollins Publishers

First published in 2018 by:
Harper Design
*An Imprint* of HarperCollins*Publishers*
195 Broadway
New York, NY 10007
Tel.: (212) 207-7000
Fax: (855) 746-6023
harperdesign@harpercollins.com
www.hc.com

Distributed throughout the world by:
HarperCollins*Publishers*
195 Broadway
New York, NY 10007

Editorial coordinator: Claudia Martínez Alonso
Art director: Mireia Casanovas Soley
Editor and texts: Francesc Zamora Mola
Layout: Cristina Simó Perales

ISBN 978-0-06-269414-0

Library of Congress Control Number: 2017936297

Printed in China
First printing, 2018

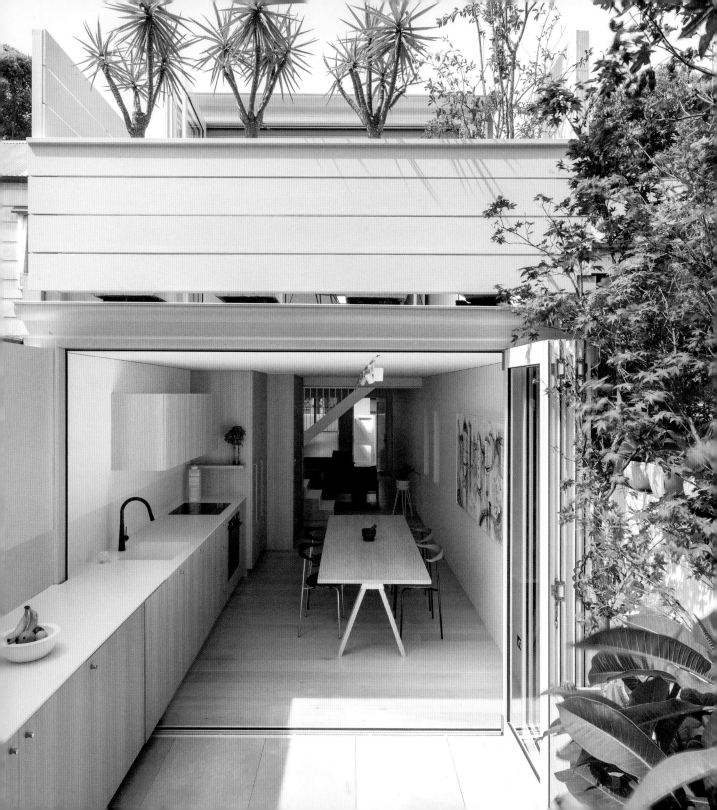

## Introduction

Many are the reasons for renovating a home—for instance, the need for improving functionality and comfort, increasing the floor area, or investing to add value to a property. Opening up cramped living spaces can do wonders by freeing up space, allowing more natural light in, and promoting interaction among family members. Open plan houses are homes made for entertaining.

What first comes to mind when we think of open plan homes is the kitchen. The kitchen has gone from being tucked into a separate room in a traditional house layout to being the heart of a household, where the cook can interact with others in other parts of the living area. Based on these premises, opening up the kitchen to other parts of the house is in most cases a project so much more complex than the mere upgrade of cabinetry and appliances. Still, the appeal is too tantalizing to let the opportunity pass.

The wall-free configuration as we see it now is reminiscent of the post-and-beam house that started to appear in the 1950s but didn't become popular until well into the 1960s and even the 1970s. Their unobstructed common spaces, progressing from entry, living, dining, kitchen, and patio areas, reflected a cultural and social change. These much-sought-after homes appeal to contemporary generations in search of a lifestyle change. Looking to downsize from overbuilt single-family dwellings or to avoid overcompartmentalized houses, these generations favor simple and efficient homes connected with the great outdoors. At a time when clean, open, warmer-than-minimalist spaces appeal to homebuyers of different generations, architects and designers are trying to find ways to incorporate mid-century elements into their designs.

This book features a collection of compelling house-remodel projects. The homeowners had a common request: open rooms to each other and to the outdoors. Beginning with an overview of the existing conditions, the architects and designers involved in these projects share their experiences to point out the challenges they faced, including code issues, communication, structural upgrading, and integration of old and new, among many others. They also express their and their clients' satisfaction over the work achieved, which most certainly meant a significant increase in property value.

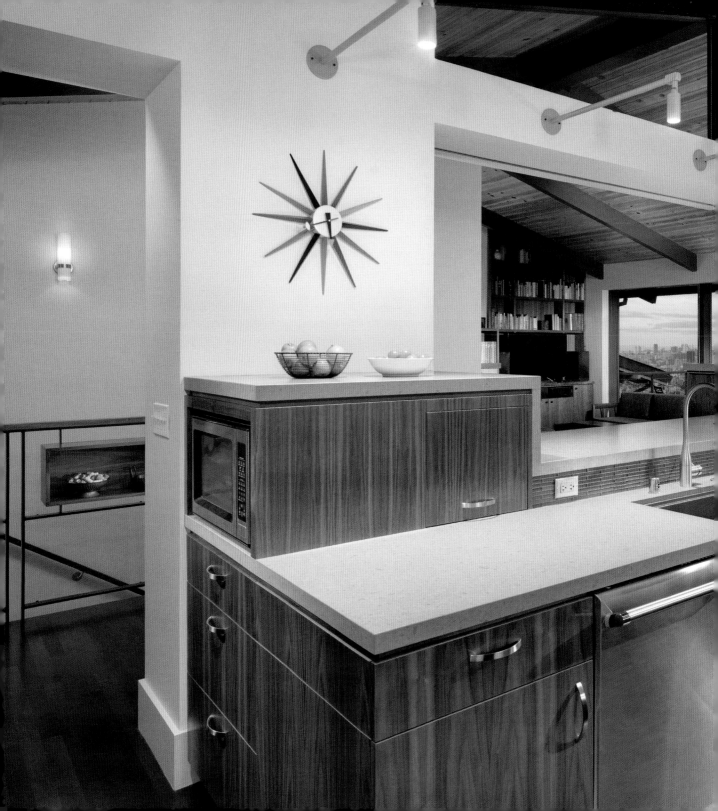

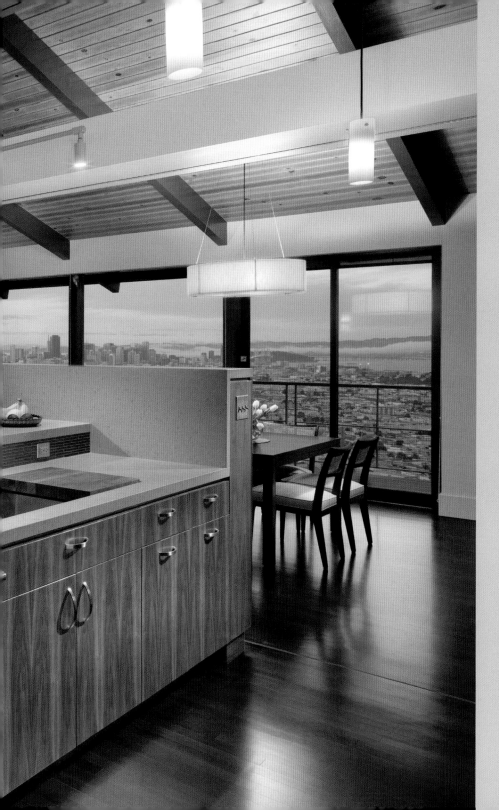

# DIGBY STREET RESIDENCE

## 2,505 sq. ft.

San Francisco, California, United States

———

**ROSSINGTON ARCHITECTURE**

Photos © Rien van Rijthoven, Phil Rossington

Project team: Phil Rossington, Principal
Jackie McKay Detamore

www.rossingtonarchitecture.com

> OPEN UP THE KITCHEN TO THE LIVING AND
  DINING ROOMS, BUT ALSO OFFER THE
  POSSIBILITY TO CLOSE IT OFF FOR MORE
  FORMAL GATHERINGS

> RELOCATE A LARGE CLOSET THAT BLOCKED
  VIEWS

> MODERNIZE A STYLISTICALLY OUTDATED
  MID-CENTURY HOME

WITH A SWEEPING VIEW OF THE SAN FRANCISCO SKYLINE, THIS HOUSE STARTED OUT WITH AN UPPER HAND. THE ORIGINAL HOUSE WAS BUILT BY THE CLIENT'S FATHER—IT WAS STRUCTURALLY SOUND BUT WAS OUTDATED AND NEEDED SOME SERIOUS LAYOUT HELP.

"We tend to follow trends as designers, and this lemminglike mentality is banal and not conducive to creating good design. To understand the wants and needs of a client who can't necessarily articulate them is the challenge that all of us must contend with. In this case, the clients vocalized that they wanted an old-fashioned closed-off kitchen, but at the same time, they really liked leaving the doors open and getting peeks of the view to downtown San Francisco.

To allow the kitchen to be open to the public portions of the house yet be able to close it off at times was the crux of this particular problem. The way most of us live these days, when we have guests over, we tend to be less formal and visitors congregate in and around the kitchen, hanging out with drinks or helping out with preparation. It's wonderful when the occasion permits, but when a more formal event is desired, this format can be much too casual for some.

Our solution consisted in flipping the floor plan, allowing the kitchen to open up to the hallway, visually expanding the space, and creating bar-height seating for larger gatherings. The kitchen is open to the hall and dining room, but can be closed off via pocket doors that hide away into the walls. Part of the project was relocating a large closet at the end of the stair that blocked views from the hallway. This move and removing the barrier between the kitchen and the dining room gives the entire floor full access to the expansive views.

The overall resolution makes a gesture toward the house's DNA while allowing the owners to use it in a way that is flexible and functional and truly takes advantage of its spectacular site."

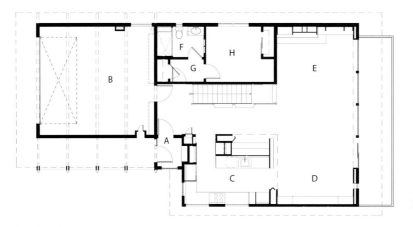

New floor plan

A. Entry      E. Living area
B. Garage      F. Bathroom
C. Kitchen      G. Closet
D. Dining area      H. Guest bedroom

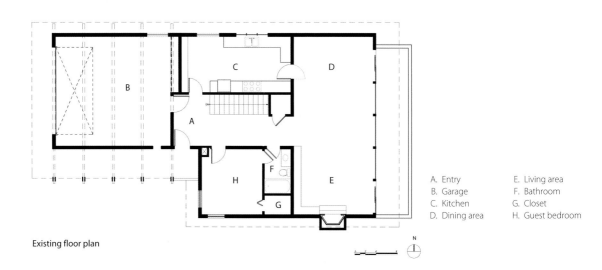

Existing floor plan

A. Entry      E. Living area
B. Garage      F. Bathroom
C. Kitchen      G. Closet
D. Dining area      H. Guest bedroom

N

The kitchen was closed off from the rest of the house and the view—it was large and included an eat-in area, but it was not efficient in its layout. The owners wanted it to be more conducive to both of them working in the space without wasting square footage, which the original one was guilty of.

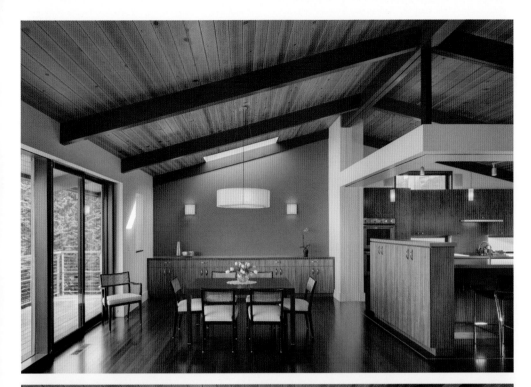

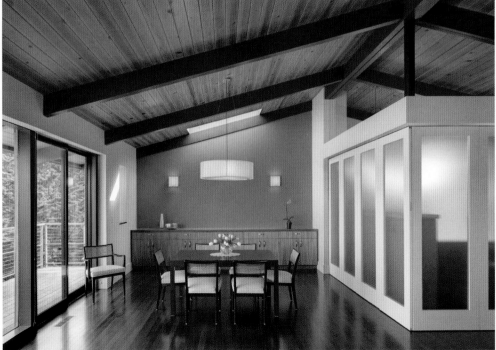

The sliding doors glide along a track hung from the ceiling, allowing the corner to disappear and the views to be unobstructed. The counter drifts like a ribbon, flowing up and over the various cabinets and splitting where necessary, only to come together again at the end.

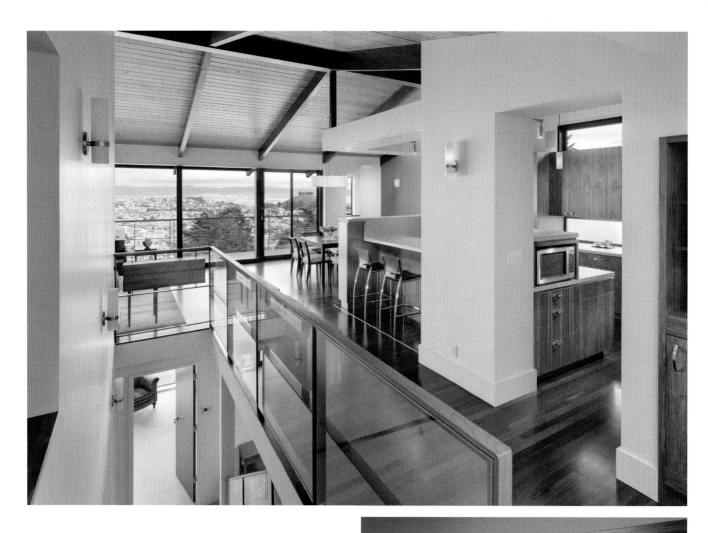

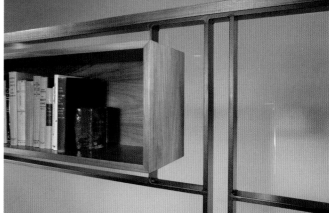

Materials are purposefully warm and welcoming, with a nod to midcentury sensibilities—not overly hard edged, but comfortable.

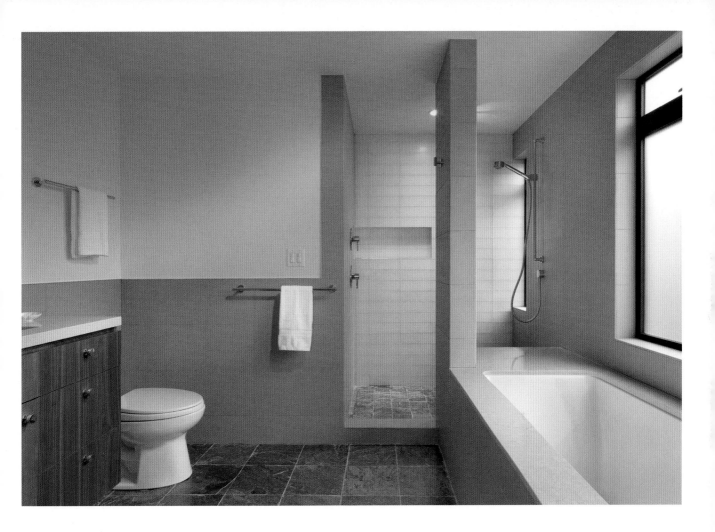

## Credits

**Architect: Rossington Architecture**
www.rossingtonarchitecture.com

**Color consultant: Gale Melton Design**
www.galemelton.com

**General contractor:**
**Bradford Construction**
www.bradford-construction.com

**Structural engineer:**
**SEMCO Engineering**

## Appliances and Materials

**Appliances:** Bosch dishwasher, Thermador microwave, oven, and range,Faber range hood
**Bathroom plumbing fittings:** Lacava, Hansgrohe, Toto, Grohe, MTI, Geberit, Americh
**Cabinets:** Cabinet Craftsmen
**Countertops:** Caesarstone and Cambria
**Fireplace:** Majestic

**Flooring:** Stained ipe
**Kitchen plumbing fittings:** Hansgrohe, Franke
**Paints and stains:** Benjamin Moore, "Aura"
**Sliding patio doors:** Fleetwood
**Skylights:** Velux
**Windows:** Ventana

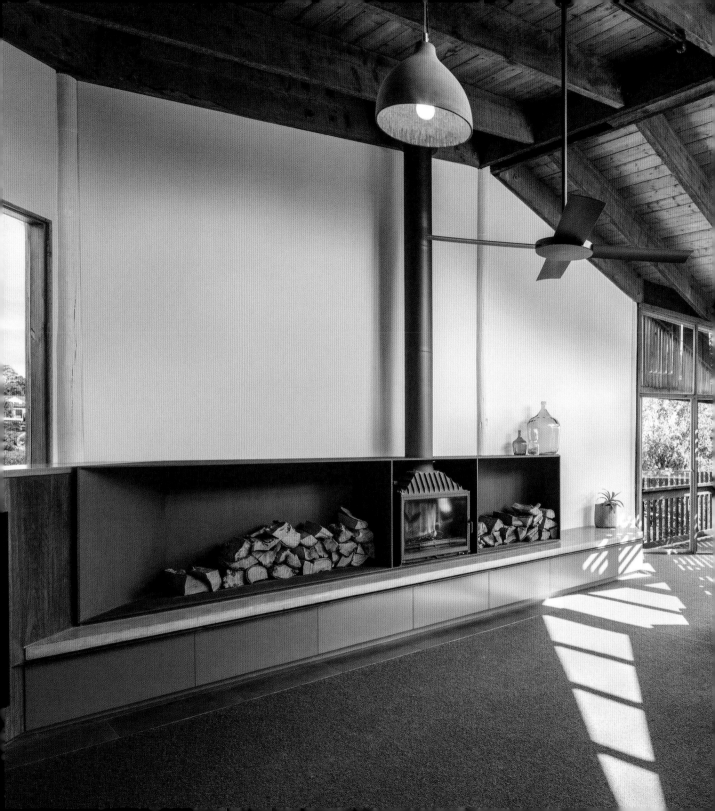

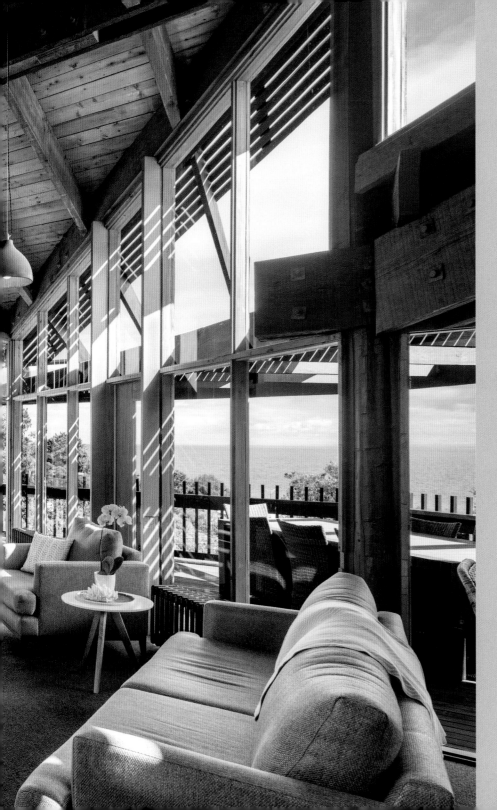

# CHAMFER HOUSE

## 2,906 sq. ft.

Mornington Peninsula, Victoria, Australia

---

**MIHALY SLOCOMBE ARCHITECTS**

Photos © Andrew Latreille

Project team: Warwick Mihaly, Erica Slocombe, Jake Taylor

www.mihalyslocombe.com.au

> RECONFIGURE THE LIVING AND SLEEPING AREAS TO BETTER CONNECT THEM WITH THE GARDEN

> TURN THE EXISTING HOUSE INTO A RELAXED FAMILY HOME SUITABLE FOR ENTERTAINING FAMILY AND FRIENDS, WITH ZONED AREAS FOR LIVING AND WORKING

> MODERNIZE THE INTERNAL FIT-OUT OF THE HOUSE TO SHARPEN UP THE OVERALL FEEL, WHILE PRESERVING ALL ORIGINAL STRUCTURAL FEATURES

## CHAMFER HOUSE REVISITS A POST-AND-BEAM DWELLING ORIGINALLY DESIGNED IN 1977 BY KEVIN BORLAND.

---

"Our clients—a couple with two high-school-age daughters—purchased the house in early 2011. They loved its unique character and wanted to preserve it as much as possible, but also recognized the need to renovate it to suit their family and lifestyle.

The house was typical of Borland's late residential style, often referred to as romantic rationalism: post-and-beam construction, timber linings, a strict 5 meters × 5 meters grid—or approximately 16 feet × 16 feet—and loose triangular geometry.

Shortly after moving in, the owners approached us. They wanted to update the house, but they also wanted to protect the timber ceilings, the exposed Oregon timber, and the finger-jointed window frames they loved.

From a design point of view, coming to understand Borland's approach to architecture, and then adapting our own design process to his philosophy was an exciting challenge that appeared at the beginning of the project.

The builders of Basis Builders would say, however, that renovating a house so carefully was the biggest challenge. They constantly had to interact their perfectly straight and true work with warped timbers and angled walls! We collaborated substantially with them during construction to devise details that would overcome each of these issues whenever we encountered them. Our intervention assumed a strategy of sensitive infiltration. We touched every room, some more heavily than others, yet retained the house's core personality. We unkinked the plan, pulled back a touch on the 1970s psychedelics.

Revisiting the house since our clients moved back in has revealed to us how well the home now merges with their lifestyle. It was immensely rewarding to see how well the house supported their daily activities."

---

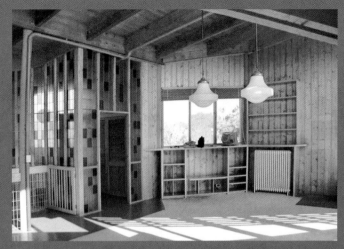
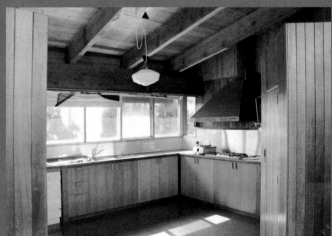
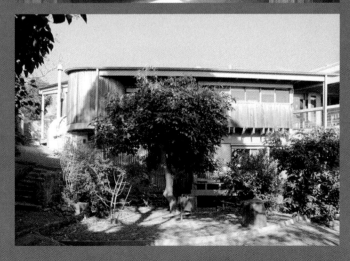

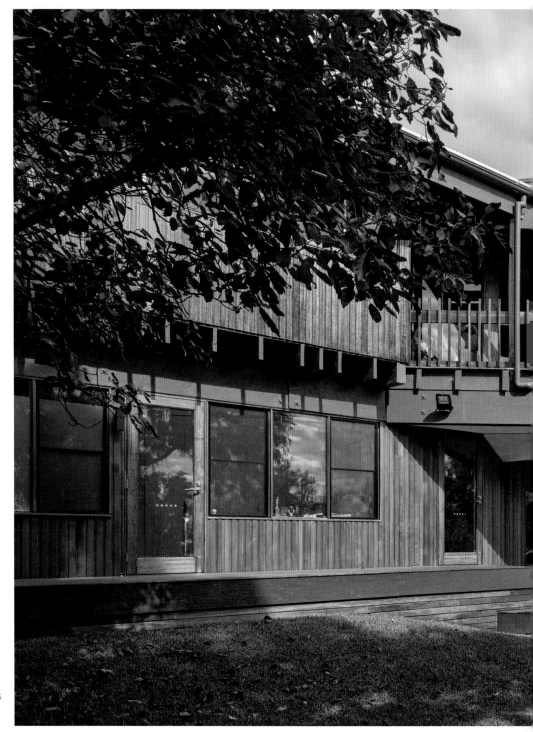

The scale and the modular grid are an extension of the deep humanity of Borland's work: the plan is aligned to the view, the sun, and the garden; rooms are sized to suit the dimensions of living, while triangular pockets provide looseness and intimacy.

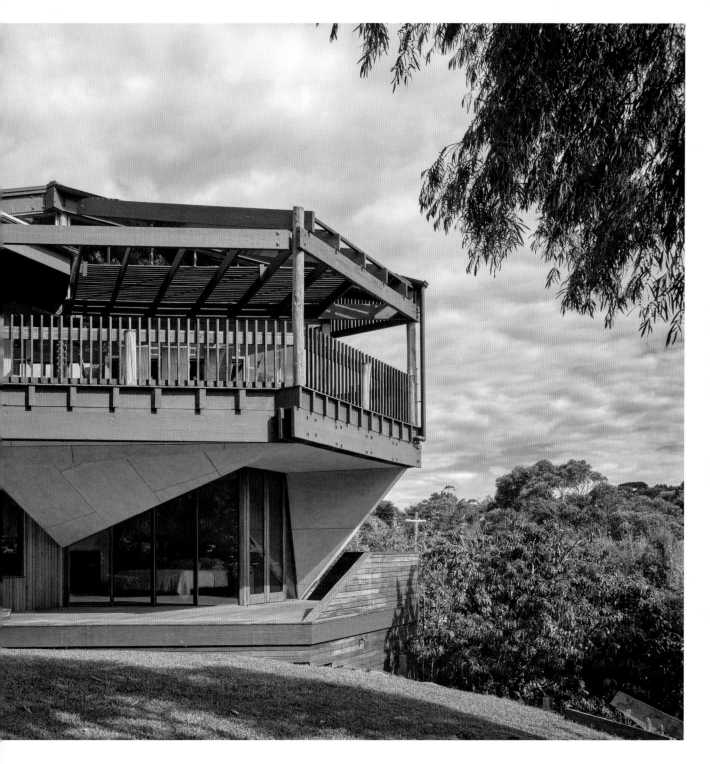

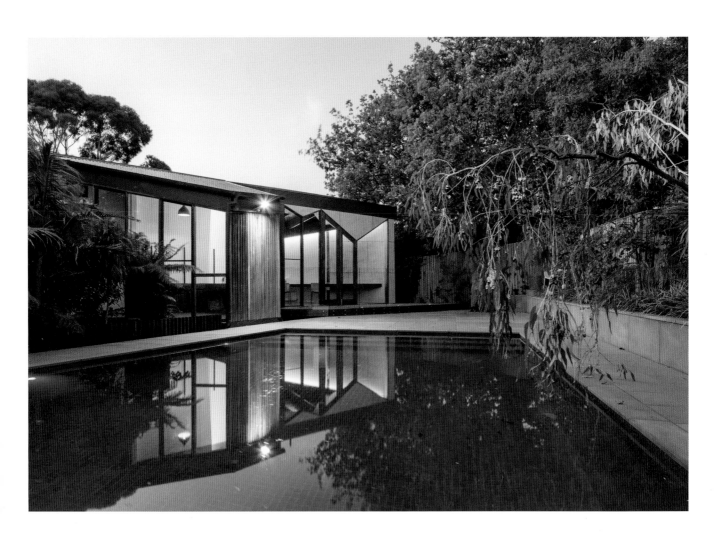

A key strategy was to ensure that each living space and bedroom had direct access to an outdoor area—the main living room spills out onto the balcony, the kids' living room opens into the pool enclosure, and the bedrooms all have doors onto the back garden.

Kevin Borland
1977

Mihaly Slocombe
2015

Diagrams of chamfer interpretation

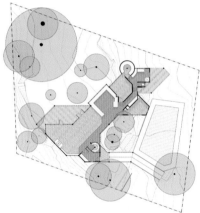

Existing second floor plan

New second floor plan

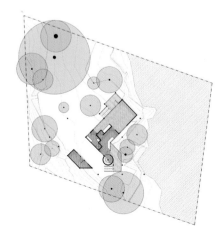

Existing ground floor plan

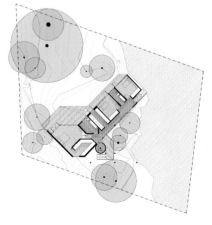

New ground floor plan

The architects created a rational spatial sequence with an exploded interpretation of the chamfer, which is a device used regularly by Borland. However, the original house showed this design gesture only in plan. They developed it into a three-dimensional form that operates from the macro scale to the micro scale.

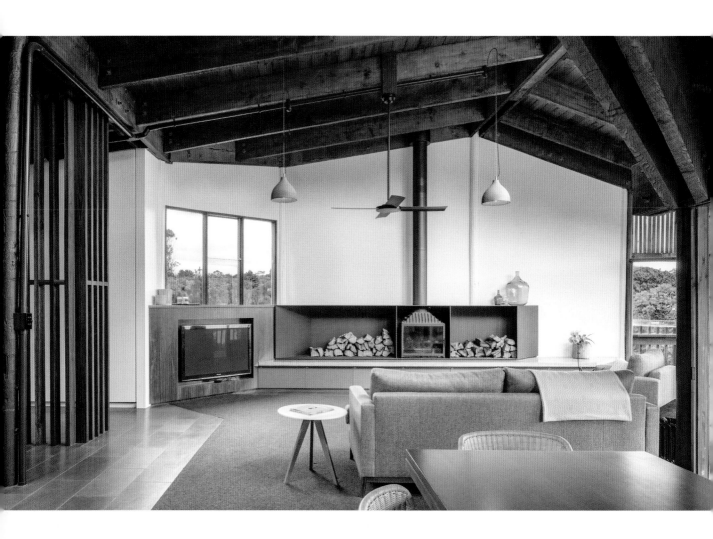

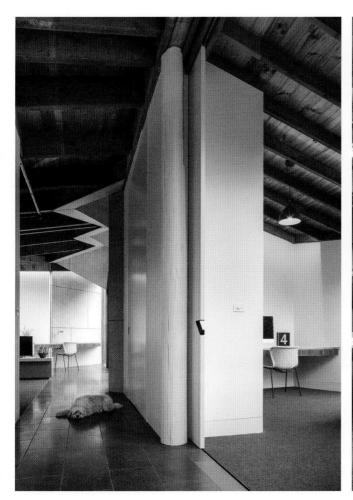
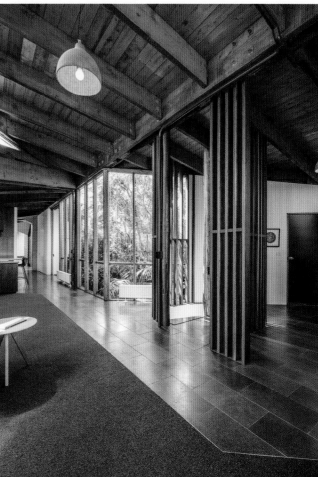

The original exposed Oregon timber ceiling emphasizes the open character of the house interior, providing it with a sense of continuity.

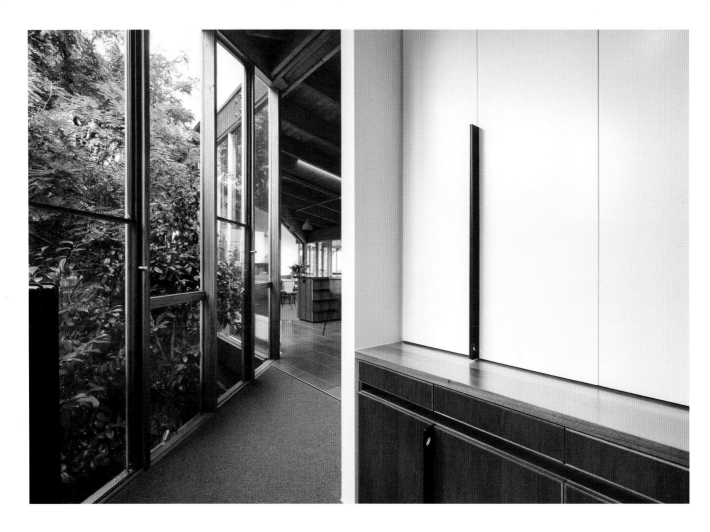

Chamfer House adheres strictly to
the original grid. The trimming and
extending of corners deliberately
interrupt the grid, splitting circulation
paths, and creating visual tension
through a sequence of narrowing
and widening sight lines.

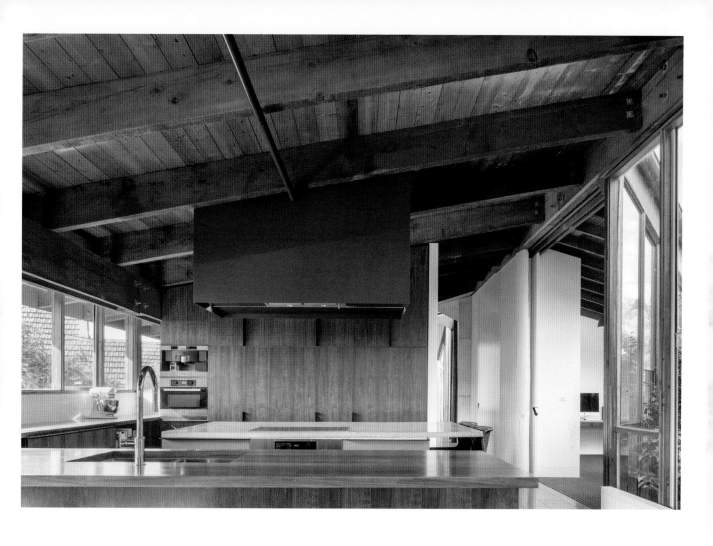

Family life radiates from the kitchen, which straddles a full grid segment at the heart of the house, between the two living rooms.

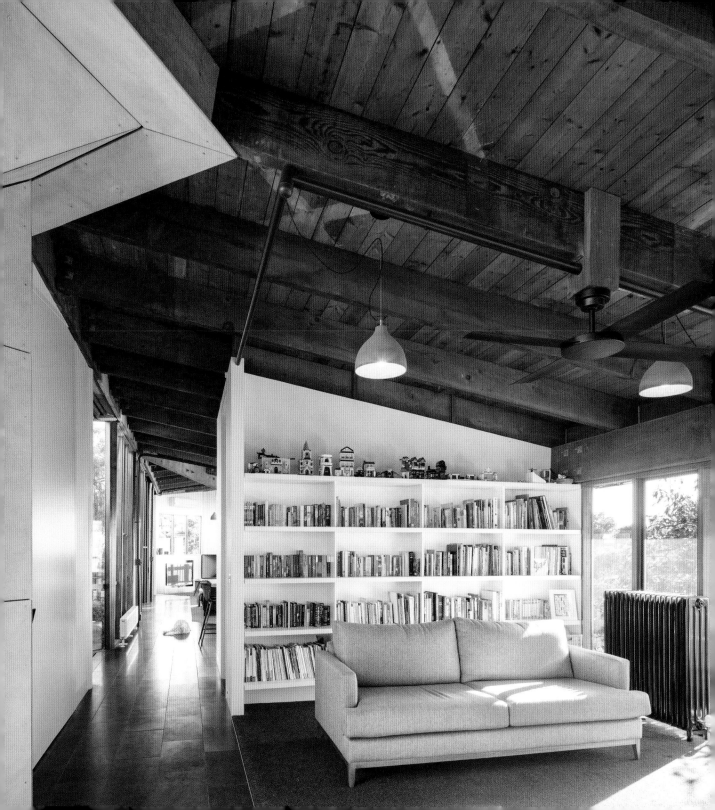

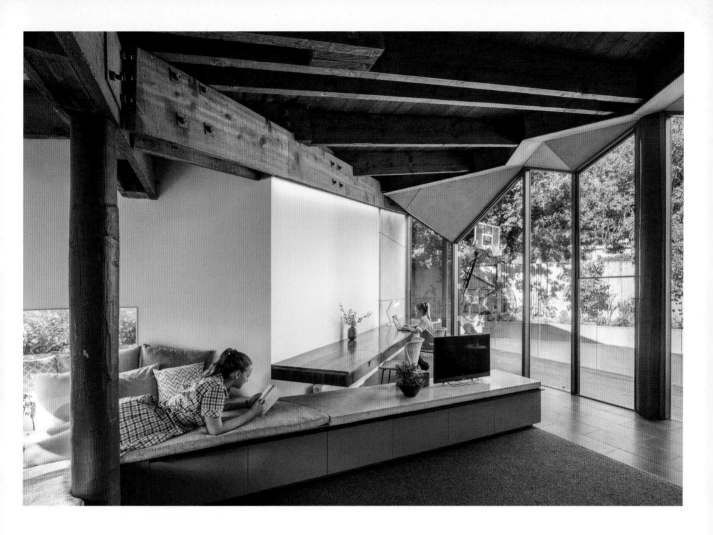

A key part of Mihaly Slocombe's planning strategy was to locate both the adults' and kids' living rooms upstairs. This enabled the two living areas to flow into one another when needed, or be shut off with a big pivoting wall panel otherwise. It also assisted in climatic zoning of the house, with the warmer living rooms and the cooler bedrooms each grouped together.

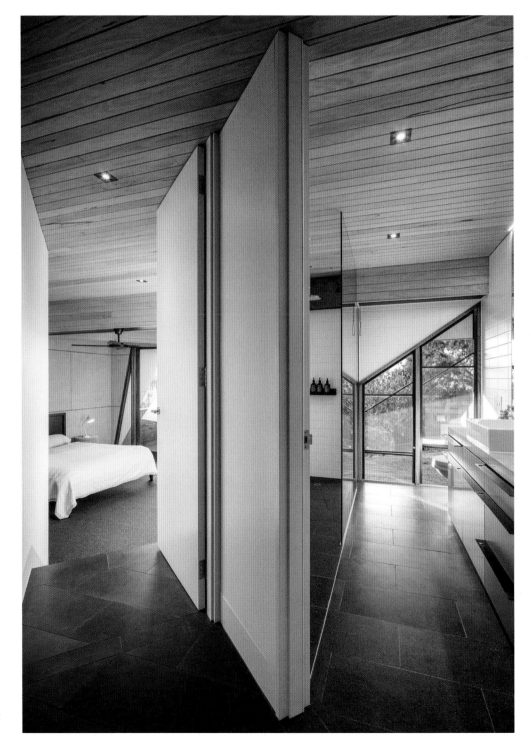

The floor-to-ceiling windows and glass doors allow for the interior spaces to be as much part of the exterior as the landscape to be part of the interior.

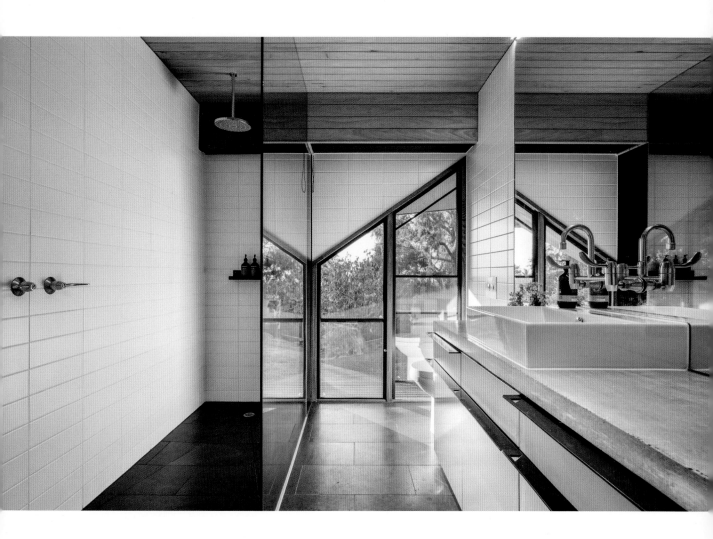

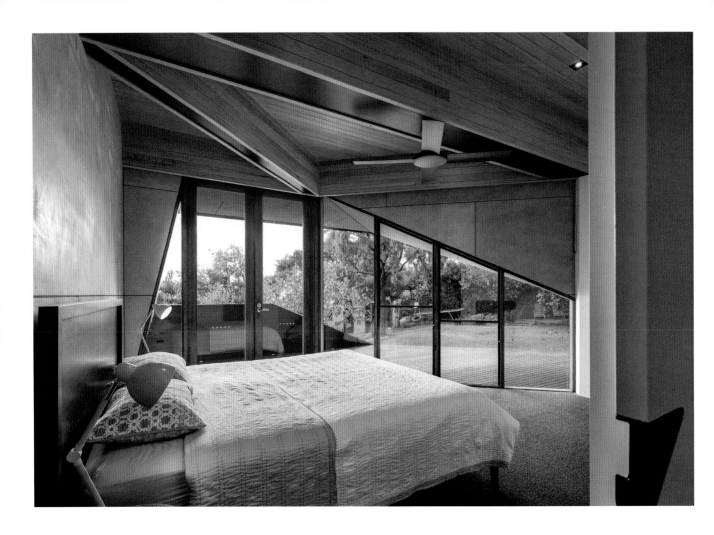

The faceted balcony soffit framing
the view from the master bedroom
is one example of the diamond
and star geometries, the angling
and chamfering of spaces that
characterized Borland's architecture.

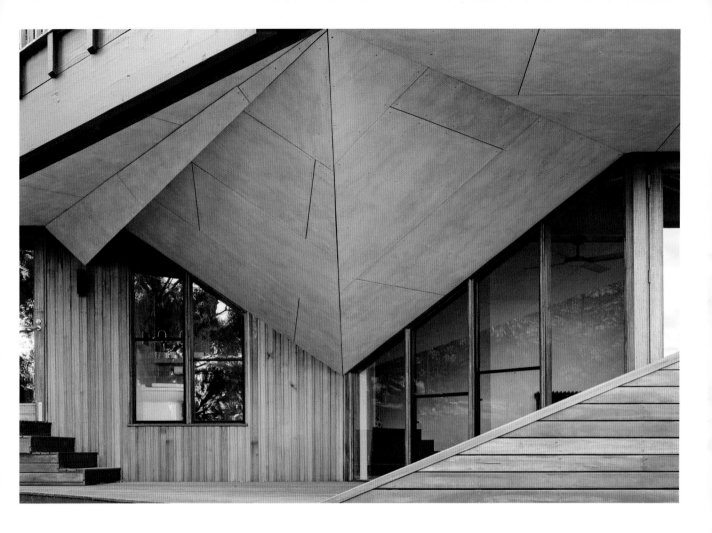

## Credits

**Architect:**
Mihaly Slocombe Architects
www.mihalyslocombe.com.au

**General contractor: Basis Builders**
www.basisbuilders.com.au

**Land surveyor: Dickson Hearn**
www.dicksonhearn.com.au

**Quantity surveyor:**
Jonnar Consulting Services
www.truelocal.com.au

**Structural Engineer: ZS Consulting**
www.zsconsulting.com.au

## Appliances and Materials

**Appliances:** Miele electric ovens, Miele induction cooktop, Miele integrated range hood, Miele dishwasher, Fisher & Paykel inverted refrigerator
**Ceilings:** Silvertop ash shiplapped timber
**Flooring:** Honed bluestone tile, Hycraft Carramar 4 mm carpet, spotted-gum timber decking
**Joinery:** Burnished-concrete benchtops, blackwood timber benchtops, spotted-gum timber veneer, two pack paint, mild steel fireplace, and range hood canopy
**Walls:** Cedar shiplapped timber, plasterboard, pressed edge tiles, Barestone compressed cellulose-reinforced sheet
**Windows:** Victorian ash timber frames, Thermotech double glazing with EnergyTech low-e film
**Screens:** Spotted-gum timber battens

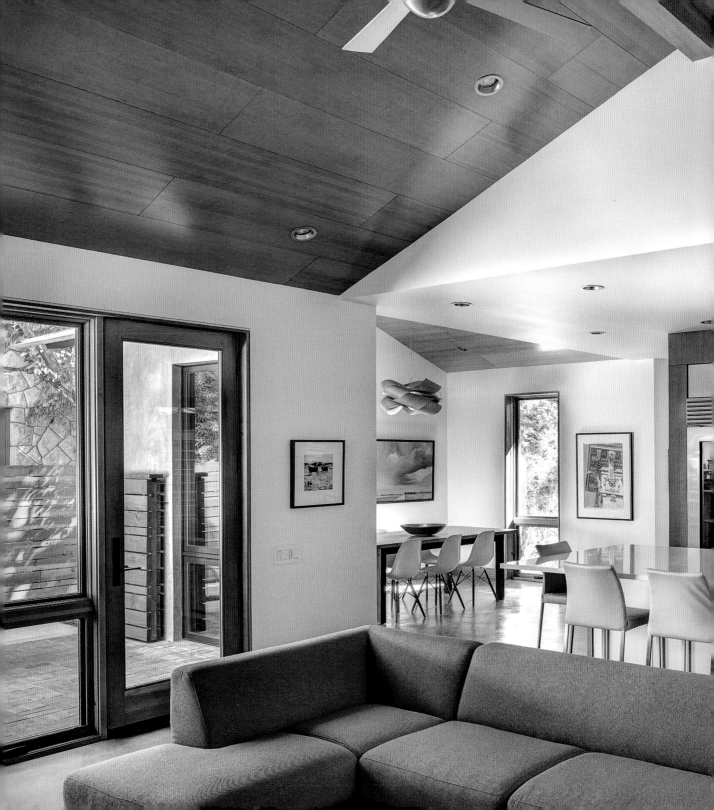

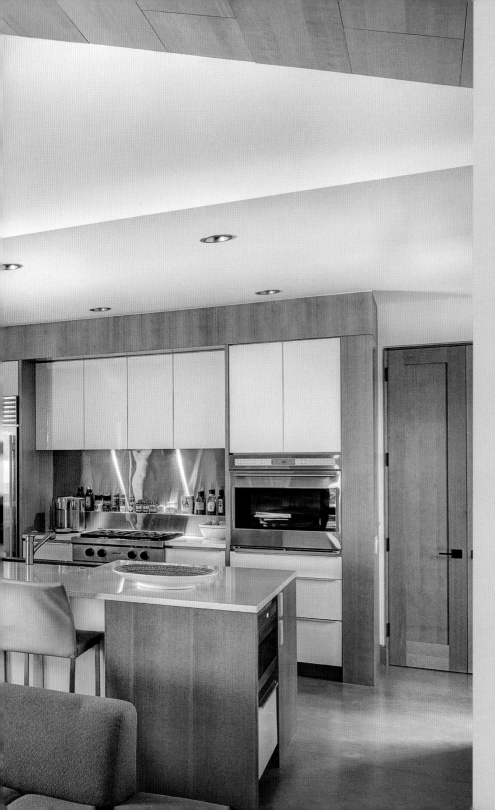

# CASTANO RESIDENCE

## 2,200 sq. ft.

Alamo Heights, Texas, United States

---

**CRAIG McMAHON ARCHITECTS**

Photos © Craig McMahon AIA, Dror Baldinger,
Mark Menjivar

Project team: Craig McMahon, AIA

www.cmarchtx.com

> CREATE COMPACT OPEN HOME WITH
INTERCONNECTED OUTDOOR LIVING SPACES

> GIVE OUTSIDE SPACES AS MUCH DESIGN
ATTENTION AS INDOOR SPACES

> STAY AWAY FROM THE OVERBUILDING
DESIGN PROTOTYPE

A NONDESCRIPT 1950s CONCRETE HOUSE ON A QUIET TREE-LINED STREET OFFERED THE RIGHT PROPORTIONS AND QUALITIES FOR CONTEMPORARY COMPACT LIVING. AN ARCHITECT TRANSFORMED THE TWO-BEDROOM STRUCTURE INTO A MODERN HOME FOR HIS FAMILY.

"We purchased this property mainly for a downsizing experiment as older children were off at school. But also we wanted to look at it as a design/build opportunity to explore a different way of living on the smaller 50-foot-wide lots found in the area. We were kind of frustrated with overbuilt newer homes on similar properties, so the design goal was to create a compact open home with interconnected outdoor living spaces to show how a family can comfortably live on a tight site without sacrificing space or comfort.

The existing two-bedroom, one-bathroom, single-story home sat on a highly sought-after street in an upscale neighborhood and included mature oak trees and impressive 20-foot-tall bamboo trees. We had recently sold our larger home in the same neighborhood, and we were set out to research what potential this home held for this new living paradigm.

We wanted to see what could happen if we built an open, single-story home similar to the nearby Texas ranch retreats, where the outside living areas were equally as important as the interior. We also wanted to stay away from the typical overbuilding prototype that had invaded the neighborhood, where out-of-scale homes were being built for resale on smaller lots."

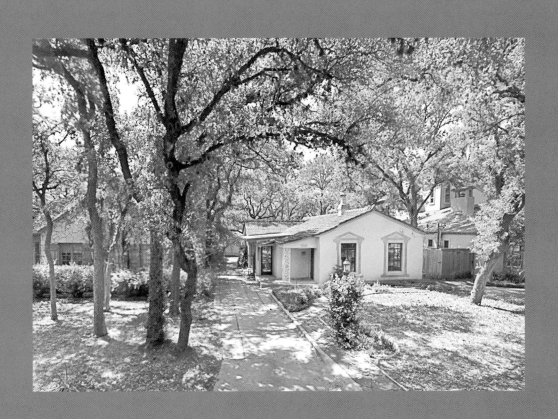

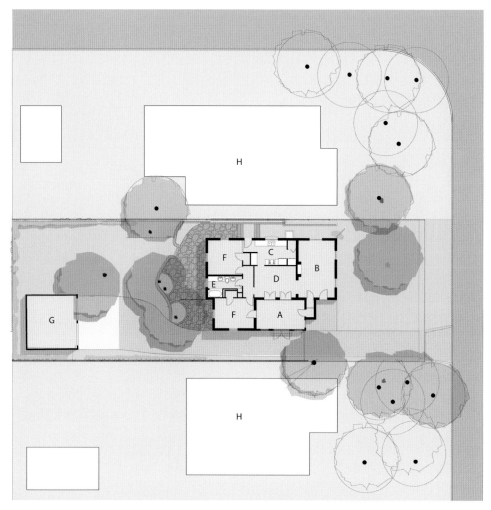

**Existing floor plan**

A. Family room
B. Living room
C. Kitchen
D. Dining room
E. Bathroom
F. Bedroom
G. Garage
H. Adjacent residence

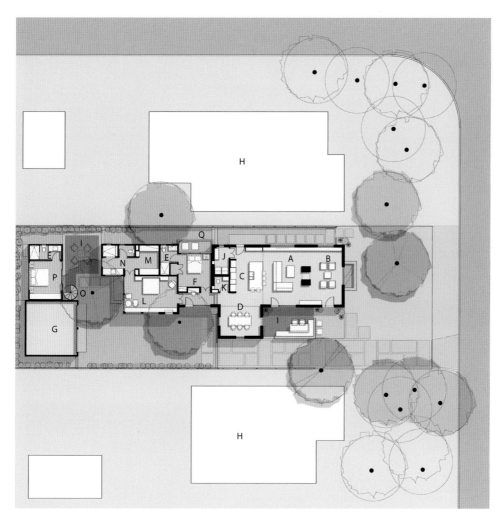

**New floor plan**

A. Family room
B. Living area
C. Kitchen
D. dining area
E. Bathroom
F. Bedroom
G. Garage
H. Adjacent residence
I. Patio

J. Laundry room
K. Powder room
L. Master bedroom
M. Master closet
N. Master bathroom
O. Staircase to roof-deck
P. Studio
Q. Dog run

Setback restrictions on the compact
50 foot x 150 foot lot called for a rear
detached garage, framing the backyard.
This constraint was turned into an
advantage by incorporating several
uses into the separate structure.

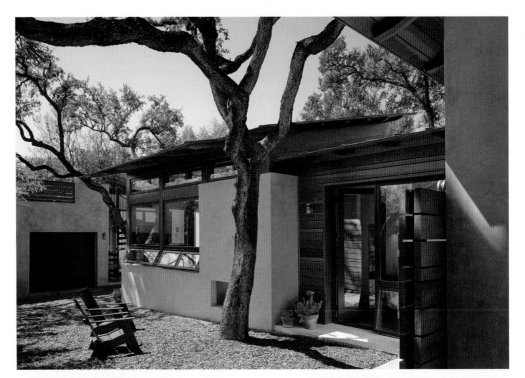

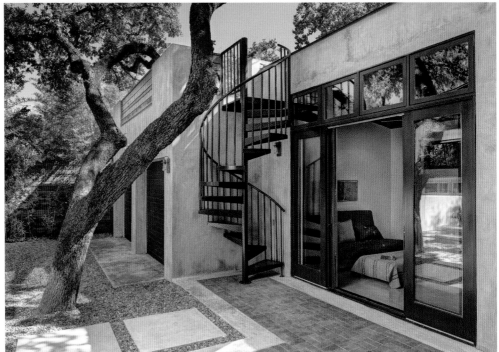

The studio can be fully opened to the backyard. With the 20-foot-tall surrounding bamboo trees and appropriately located and sized overhangs, window shades are unnecessary for all living spaces. A rooftop dining space above the garage provides additional outdoor living to take advantage of San Antonio's temperate climate.

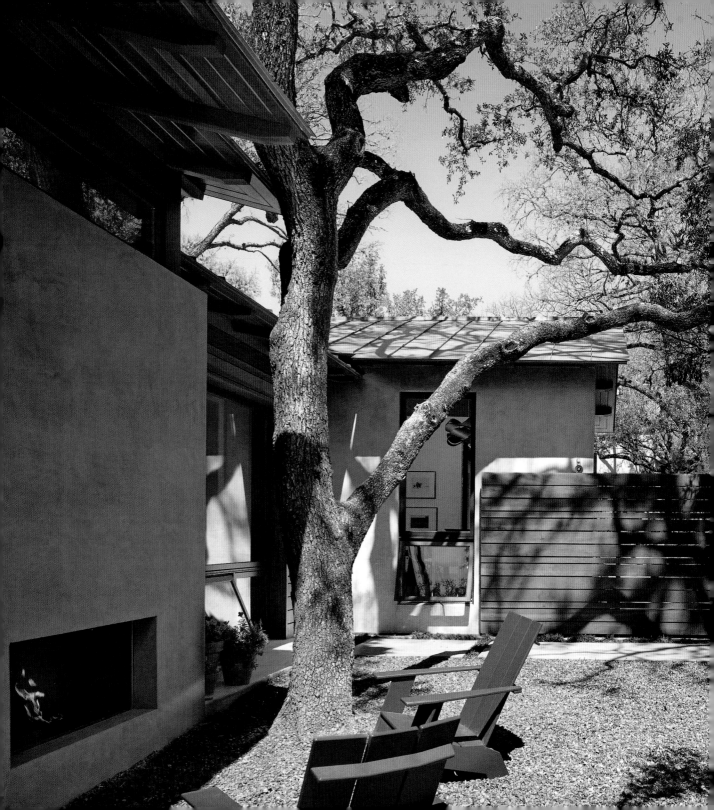

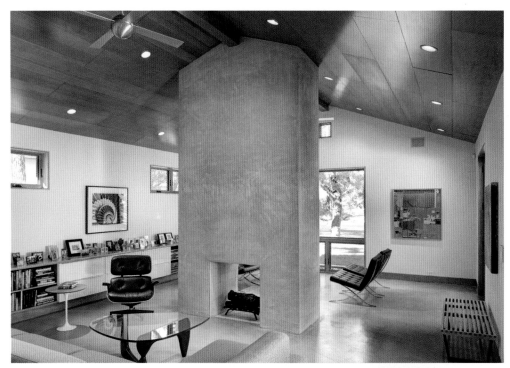

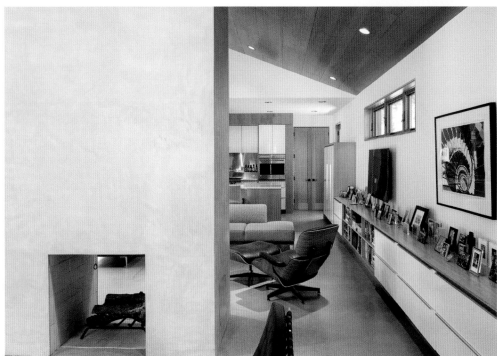

The owners had most interior walls of the original home removed to generate an open living space that easily morphs from one function to another. Numerous windows are located based on the best solar orientation. The thoughtful fenestration provides a light counterpoint to thick concrete walls and deep natural wood.

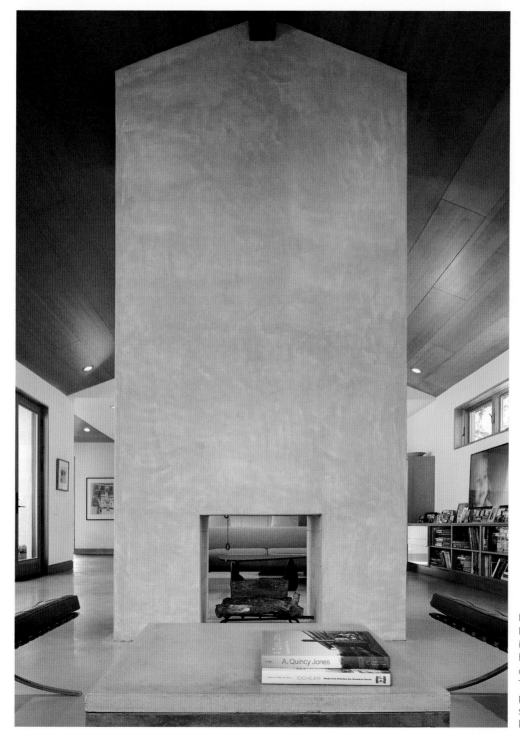

For consistency and added warmth, Douglas-fir plywood was used as interior ceiling panels throughout the house. That same rich wood served as custom built-ins for efficient storage. To maximize as much open space as possible, all rooms include built-in storage, thus minimizing the need for large closets.

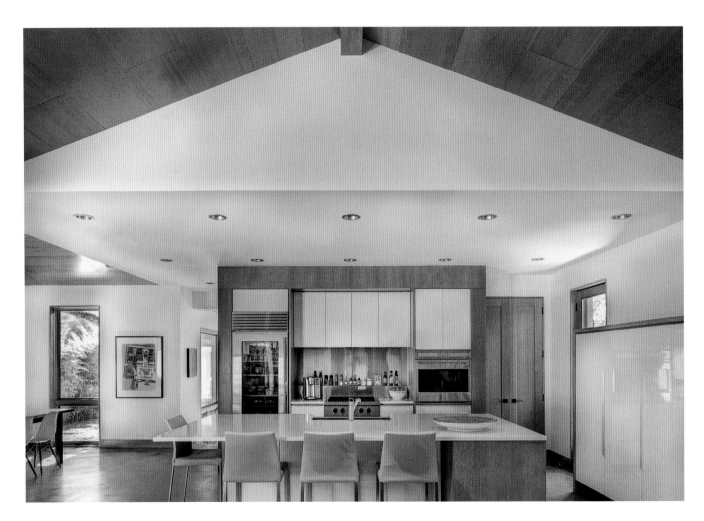

Minimal trim, vaulted ceilings, large operable windows, and polished concrete floors all help the compact, single-story house live large. McMahon and his wife—an interior designer—fill their sleek yet cozy house with iconic mid-century furniture.

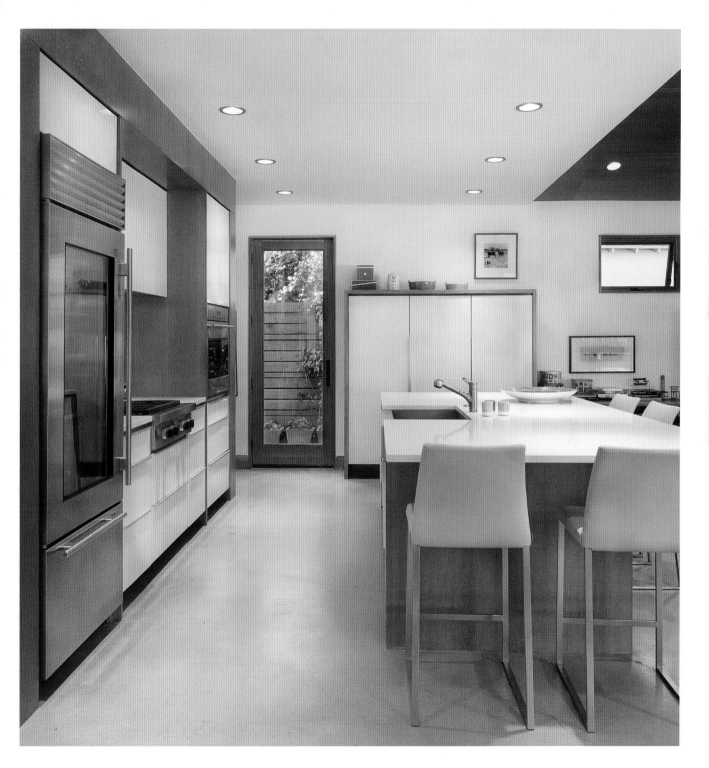

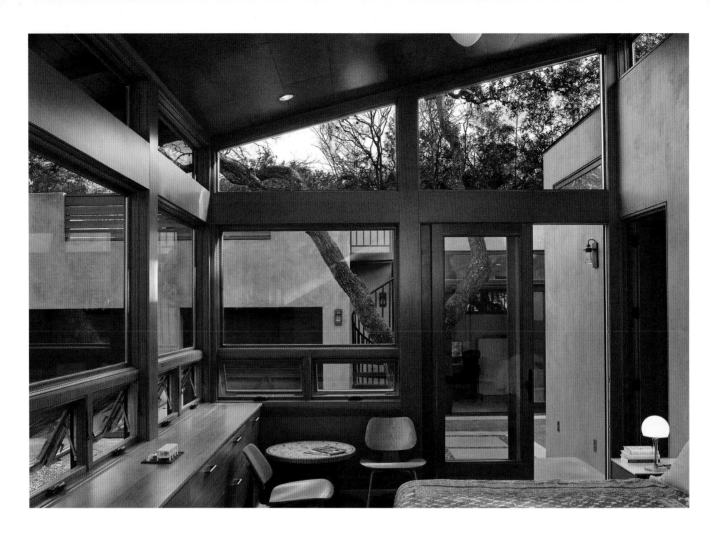

The glassy master suite was built around an existing oak tree that was preserved along with other old growth on the property. Large expanses of fixed glass flood the room with light while lower operable windows pull in cool southeast breeze.

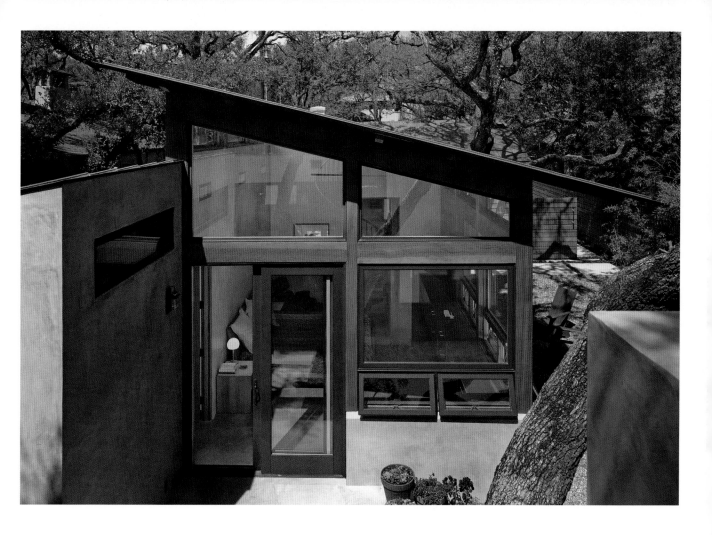

**Credits**

Architect: Craig McMahon Architects
www.cmarchtx.com

Project team: Beth Reader, FAIA
Chuck Swartz, FAIA

**www.readerswartz.com**

> CREATE NEW ENTRY TO THE HOUSE

> IMPROVE CIRCULATION FLOW

> MAINTAIN LAYOUT AS MUCH AS POSSIBLE
ON THE GROUND FLOOR

> DEVISE A NEW ADDITION FOR A NEW LIVING
ROOM

## A HUMBLE EARLY 1920s BUNGALOW IS TRANSFORMED INTO A SLICK TWENTY-FIRST-CENTURY HOME.

"This small bungalow was built in 1923. It's located in a neighborhood of similarly scaled Sears-style kit houses. For several decades, the bungalow had been two apartments on different floors. As a result, the rear of the house was a collection of small, enclosed, former back porches. The low-pitched rear roofline shut the house down to the large backyard. Because there were two front doors to the apartments, the remodel involved the creation of a new entry into the house.

Original walls on the first floors were modified as little as possible; the former porch enclosures were removed, while the original walls upstairs were retained. The street-side façade of the addition sits back from the original house, and its fenestration and massing are restrained.

Circulation now flows from the new entry foyer, through the linearly arranged and axial parlor, dining room, kitchen, and elevated outdoor living area."

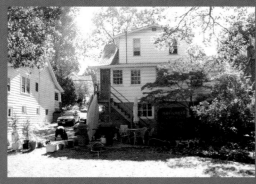
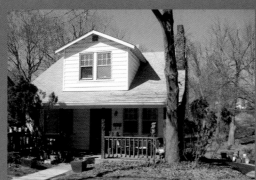
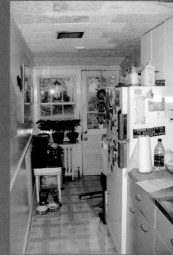

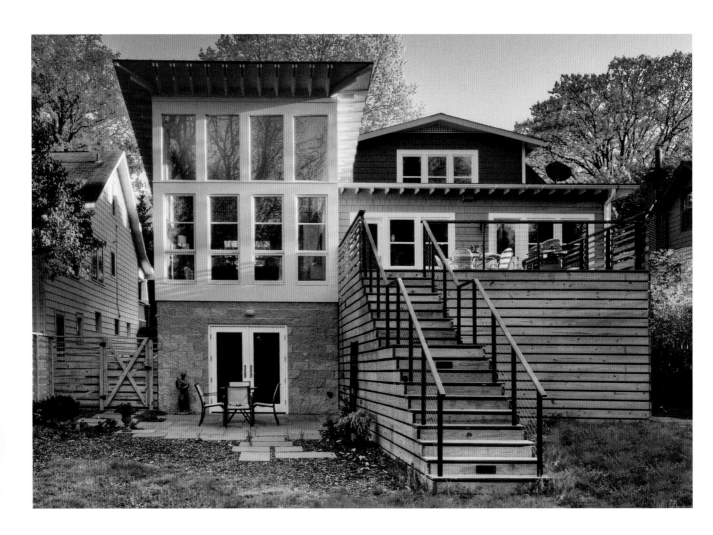

The butterfly roof of the addition
opens up dramatically to the
backyard, with abundant glazed
surfaces, and a band of tall transoms
opening up to the sky.

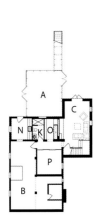

Existing ground
floor plan

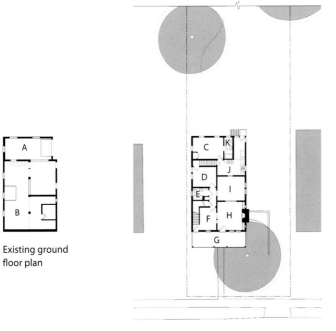

Existing second floor plan

Existing third
floor plan

A. Garage
B. Mechanical and
   storage room
C. TV room
D. Bedroom
E. Powder room
F. Entry
G. Porch
H. Parlor
I. Dining room
J. Kitchen
K. Bathroom
L. Office
M. Walk-in closet

New ground floor plan

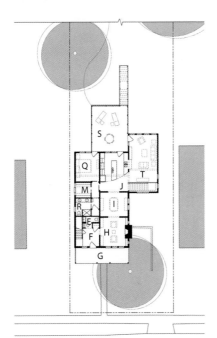

New second floor plan

New third floor plan

A. Outdoor storage
B. Mechanical and
   storage room
C. Media room
D. Bedroom
E. Powder room
F. Entry
G. Porch
H. Parlor
I. Dining area
J. Kitchen
K. Bathroom
L. Office
M. Walk-in closet
N. Potting area
O. Kitchenette
P. Exercise room
Q. Master bedroom
R. Master bathroom
S. Outdoor living area
T. Living area

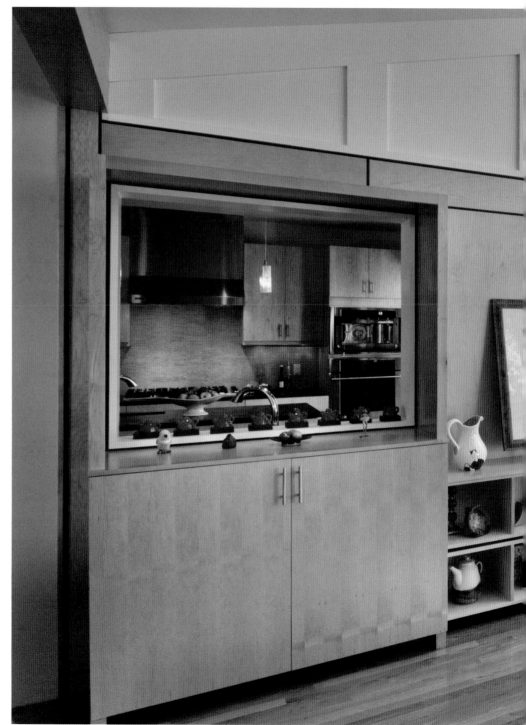

Now the kitchen, living room, and the new first floor master suite all face a large, elevated outdoor living area and newly landscaped backyard.

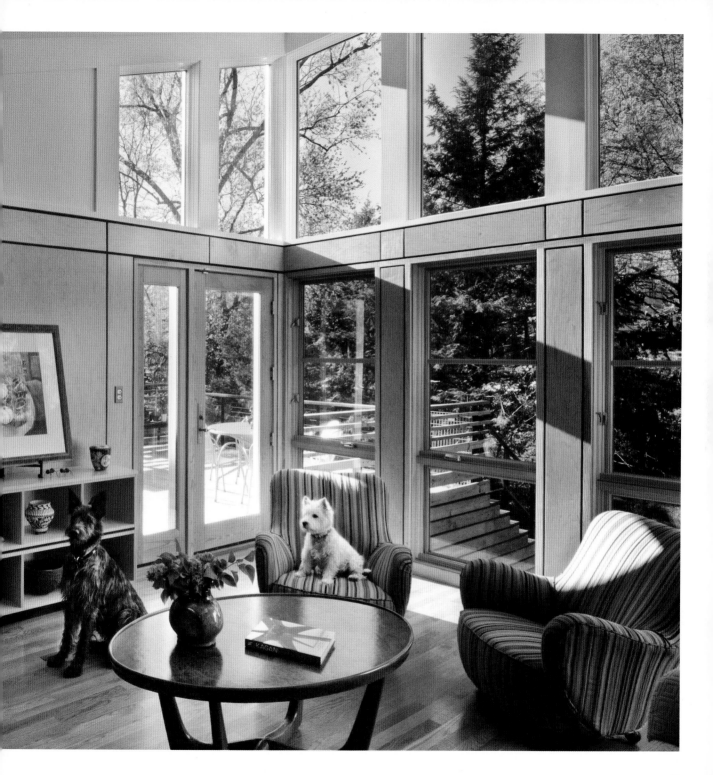

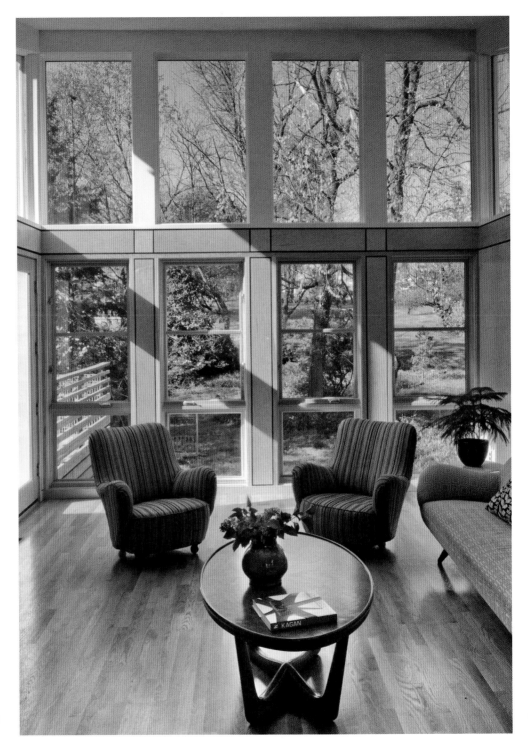

A new addition to the side of the house connects the existing dining room and reconfigured kitchen to a new living room.

## Credits

**Architect: Reader & Swartz Architects**
www.readerswartz.com

**Civil engineer: Painter-Lewis**
www.painterlewis.com

**General contractor:**
**The Old House Company**
www.oldhousecompany.com

**Structural engineer:**
**Allen Associates**

## Appliances and Materials

**Appliances:** Viking range and hood
**Countertops:** Alberene soapstone by Marblex Design
**Flooring:** Refinished hardwood (old house) and matched hardwood (addition)
**Kitchen and bathroom cabinets:** Custom by Dovetail Millwork

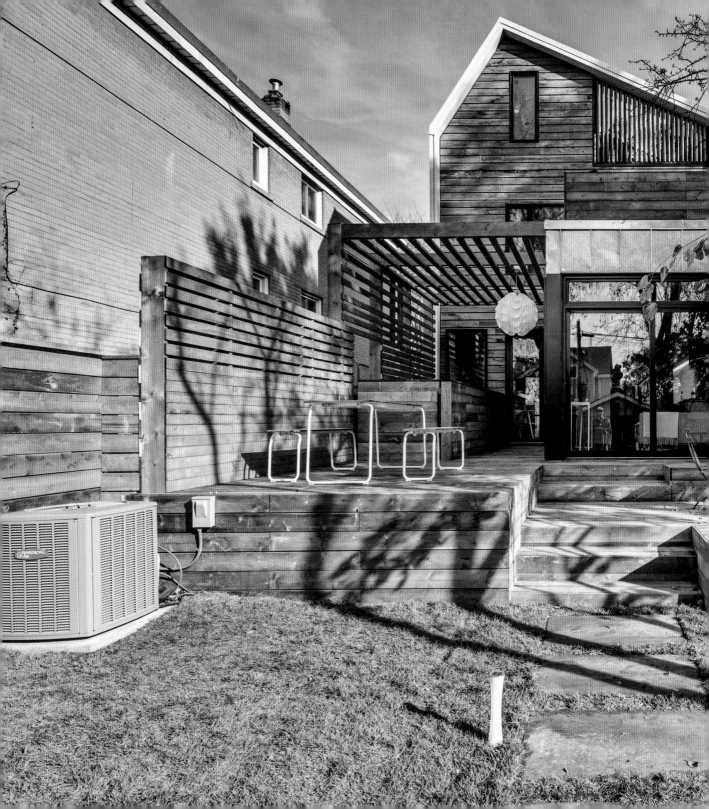

# 46H

## 2,880 sq. ft.

Toronto, Ontario, Canada

———

**BAUKULTUR/CA**

Photos © Alex Lukey, Silverhouse

Project team: Felix Leicher, Lead Architect

**www.baukultur.ca**

> REINVENT THE EXISTING HOUSE AND TURN
IT INTO A BRIGHT, MODERN, SUSTAINABLE
HOME WITH THREE BEDROOMS ON THE
SECOND FLOOR, A MASTER RETREAT ON THE
THIRD FLOOR, AND AN OPEN MAIN FLOOR
WITH A STRONG CONNECTION TO THE WEST-
FACING BACK YARD

THE EXISTING STRUCTURE WAS A TWO-STORY THREE-BEDROOM,
ONE-BATHROOM HOUSE BUILT IN 1905 THAT HADN'T SEEN MUCH
MAINTENANCE SINCE.

---

"From the first time I visited the site, I realized the potential of the property,
and within a short time span the first design concepts evolved. Instead of
building out into the backyard, I decided to go with the more challenging
option to stay within the footprint of the existing building and build up-
wards to create a compact house. The addition allowed for a more cohesive
organization of the rooms, but most importantly we maintained the propor-
tions of the large backyard, minimally encroached upon by a trellis mediat-
ing between interior and exterior spaces.

The building forms found in the vicinity served as a starting point for the
design development. The project had to fit in with the surrounding houses.
Yet, it was conceived to display a more contemporary architectural lan-
guage. The front of the house offers a modern interpretation of the existing
bay windows and porch configurations found in many of the neighboring
houses. It gives the front façade a distinctive look, but is still perfectly in line
with the architectural context. In contrast, the back of the house surprises
with a copper-clad addition on the ground floor opening onto the backyard.

The design of the roof was certainly not an easy task and was a hard nut to
crack for the engineering team. While the new plan maintains some of the
first floor layout, new foundations had to be provided, the existing structure
had to be reinforced, and two steel frames had to be integrated to support
the unique roof."

---

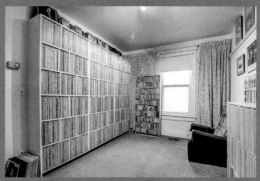
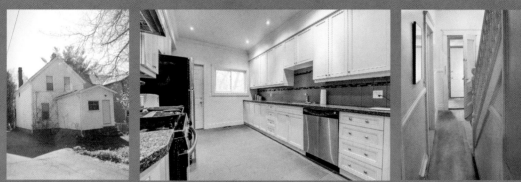
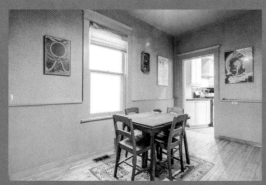
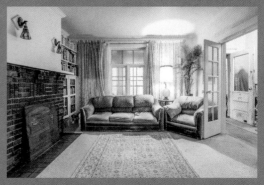

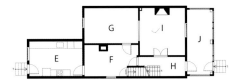

Existing ground floor plan

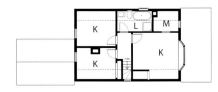

Existing second floor plan

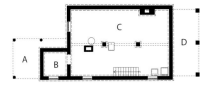

Existing basement floor plan

A. Existing addition partly
   excavated
B. Storage partly finished
C. Utility room and storage
   unfinished
D. Porch unexcavated
E. Kitchen
F. Dining room

G. Family room
H. Entry
I. Living room
J. Enclosed porch enclosed
K. Bedroom
L. Bathroom
M. Walk-in closet

Existing north elevation

Existing east elevation

Existing south elevation

Existing west elevation

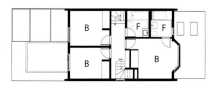

New second floor plan

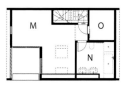

New third-floor-addition floor plan

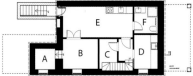

New basement floor plan

New ground floor plan

A. Walk-in closet
B. Bedroom
C. Mechanical room
D. laundry room
E. Living / dining / kichenette
F. Bathroom
G. Family room
H. Kitchen
I. Living area
J. Powder room
K. Entry
L. Dining area
M. Master bedroom
N. Master bathroom
O. Master closet

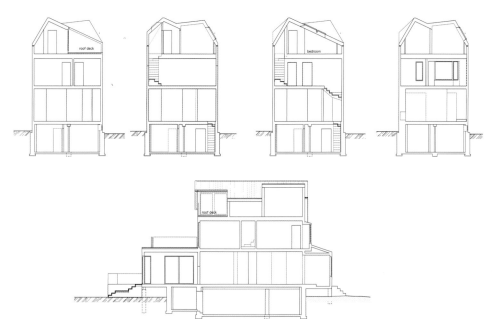

New building sections

The design started with simple sketches to explore dimensions, volume, and proportions. It then evolved to include blanketing the sidewalls in metal and draping an asymmetrical roof over the house's wood-clad structure.

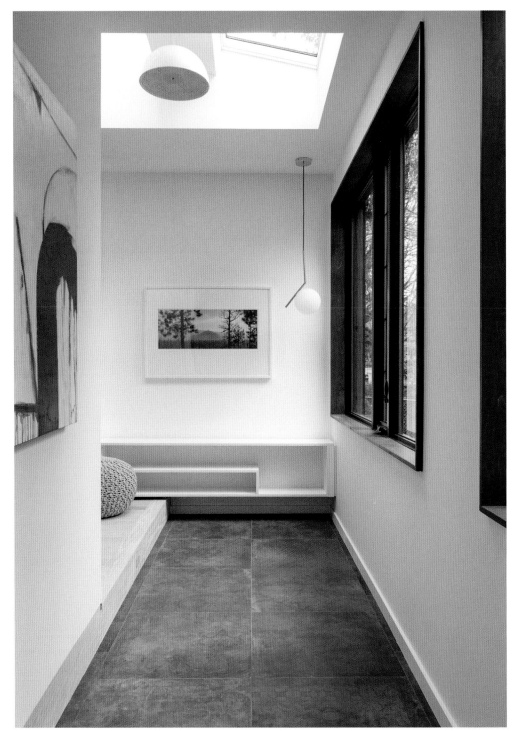

The main floor flows effortlessly from one end of the house to the other, yet this continuous flow doesn't interfere with the specific function of each of the areas.

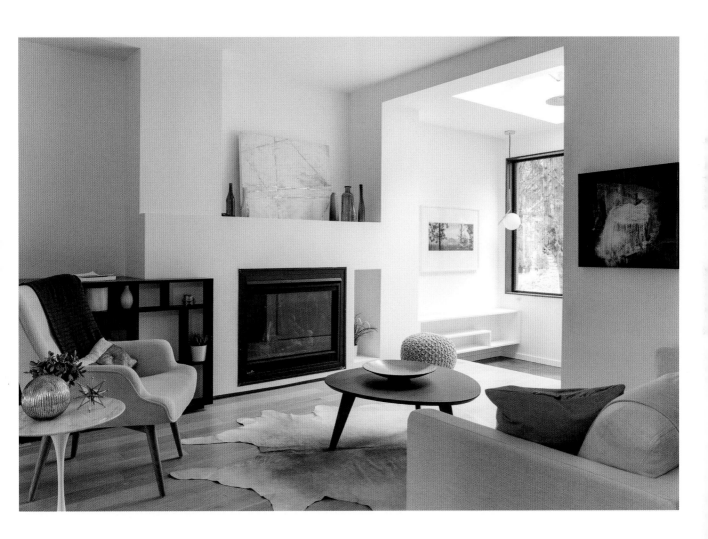

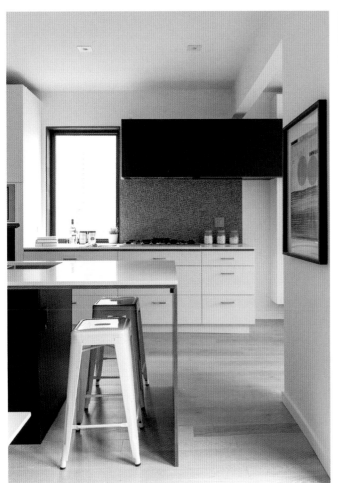
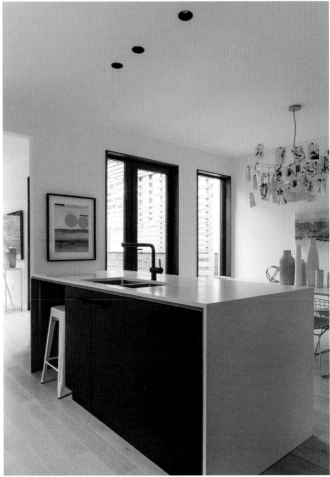

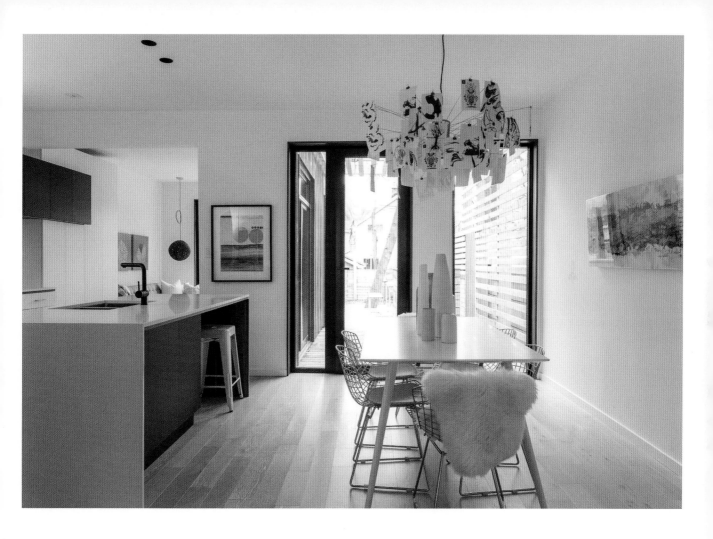

The layout organizes all the daytime
areas into one single open space,
where each function is connected
yet has its own place and identity.

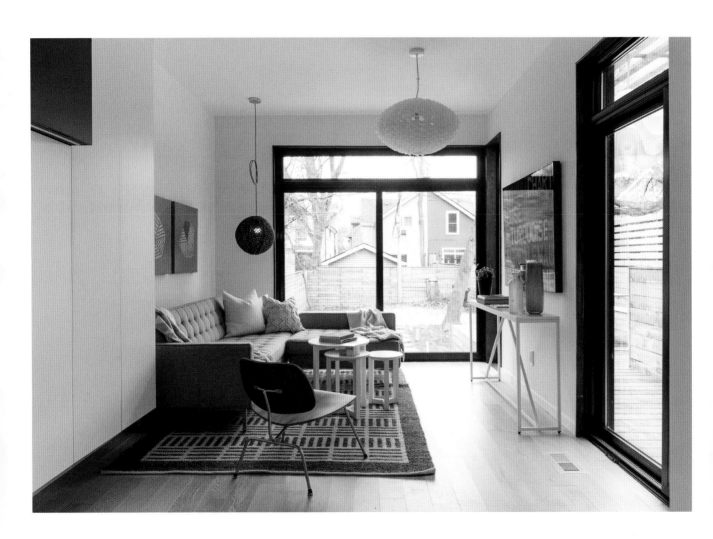

Toward the rear of the building, the
indoors and outdoors fuse, with
the inside living spaces extending
outward to the vast exterior deck and
west-facing garden.

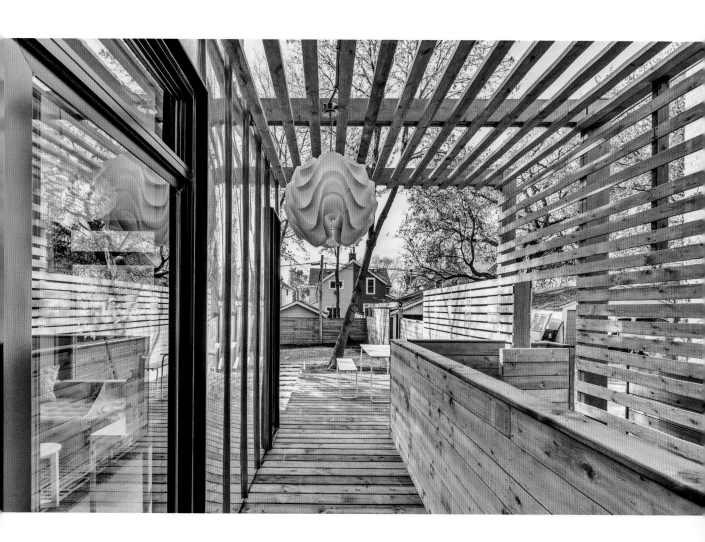

Windows, doors, and skylights
encourage the connection between
interior spaces and the exterior, while
the interior finishes take in and reflect
natural light to create a bright and
clean living environment.

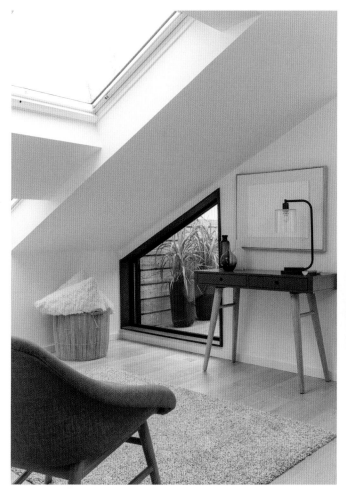

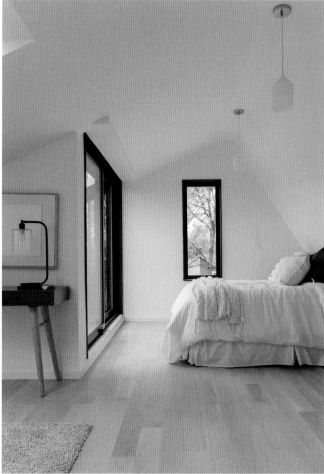

## Credits

**Architect:** Baukultur / ca
www.baukultur.ca

**Civil engineer:** Engineering Link
www.engineeringlink.ca

**General contractor:**
Sasha Lerkhbaum / TIPEQ
www.tipeq.ca

**HVAC design:** BEC Consulting

**Kitchen manufacturer:**
Mooza Wood Arts
www.moozawa.houzz.com

**Staging:** Modern Staging
Modern Spaces

## Appliances and Materials

**Doors:** Solid-white doors with black hinges and hardware
**Faucets and taps:** Hansgrohe
**Flooring:** White-washed and brushed solid-white oak planks
**Front and rear:** Wood siding with thermally modified larch wood
**Front porch:** Exterior MDF and detailing in black-stained rhombus façade

**Kitchen cabinets:** Super matte white and black with walnut and copper detailing
**Kitchen countertop:** White quartz
**Rear addition:** Standing-seam copper cladding
**Sidewalls:** White metal siding
**Tiles:** Céragrès Canada
**Windows:** Black fiberglass windows and patio doors, double-pane glazing

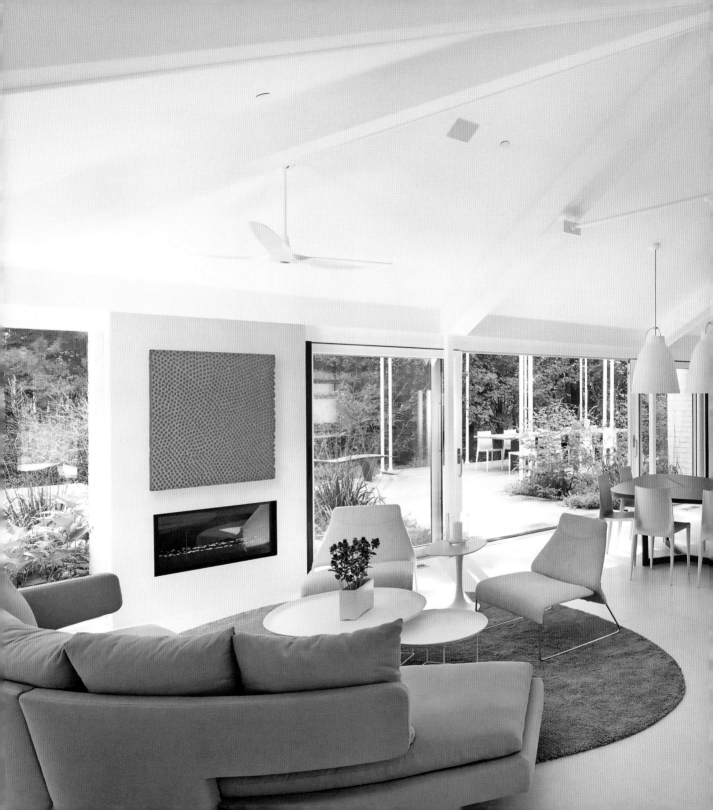

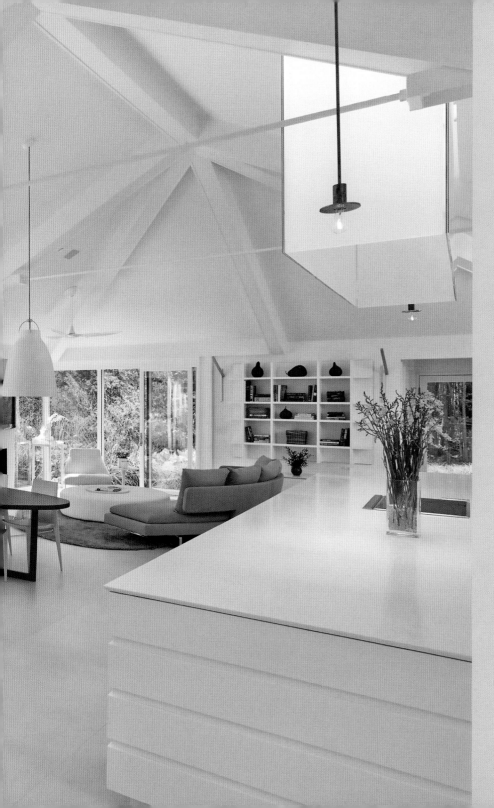

# WOODS RESIDENCE

## 3,000 sq. ft.

Easton, Maryland, United States

**SHINBERG LEVINAS ARCHITECTS**

Photos © Alan Karchmer

Project team: Salo Levinas, Principal
Maria Gorodetskaya, Project Architect

www.shinberglevinas.com

> COMPLETE INTERIOR RENOVATION,
  INCLUDING NEW CUSTOM KITCHEN, LIVING
  SPACES, BEDROOMS, AND EXTERIOR

> CREATE HARMONY BETWEEN THE INDOORS
  AND THE OUTDOORS

> INCREASE NATURAL LIGHTING

> REMOVE INTERIOR WALLS TO CREATE A
  LARGE, OPEN GATHERING SPACE

> OPEN UP KITCHEN TO DINING ROOM AND TO
  OUTDOOR SPACE

## A NEWLY REMODELED HOUSE TAKES IN THE IDYLLIC SETTING WHERE IT STANDS.

"The existing home was dark, fully enclosed, and broken up into a series of small rooms with limited connection to one another. Also, the interior had little connection with its natural surroundings.

By removing interior partitions, a large, open space was created, acting as the core of the home, while a strategic connection between indoor and outdoor spaces was achieved by demolishing portions of the exterior wall, bringing the landscape into the home.

The scope of the project included a complete interior renovation, including a new custom kitchen, living spaces, bedrooms, exterior deck, and pergola. Through the design, the landscape penetrates inside the house. It establishes a dialogue between the interior living space and the outdoor environment."

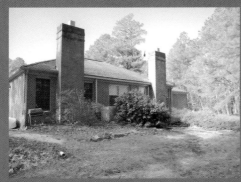
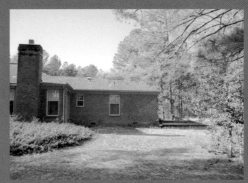
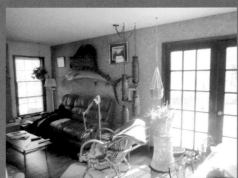
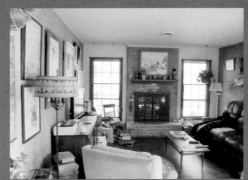

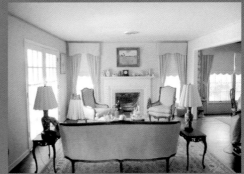

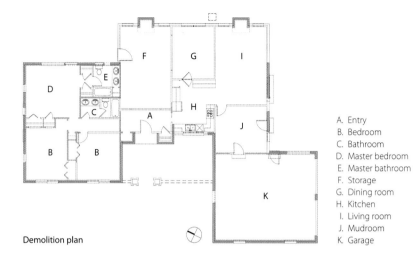

Demolition plan

A. Entry
B. Bedroom
C. Bathroom
D. Master bedroom
E. Master bathroom
F. Storage
G. Dining room
H. Kitchen
I. Living room
J. Mudroom
K. Garage

BEFORE

AFTER

Indoor-outdoor connection diagrams

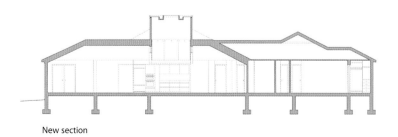

New section

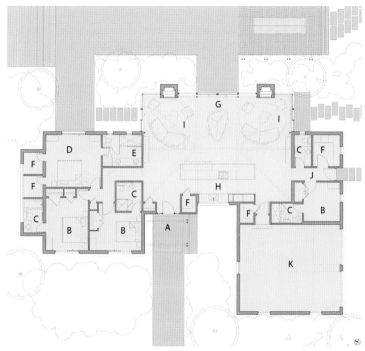

**New floor plan**

A. Main entry
B. Bedroom
C. Bathroom
D. Master bedroom
E. Master bathroom
F. Closet
G. Dining area
H. Kitchen
I. Living area
J. Side entry
K. Garage

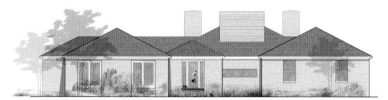

**New front elevation**

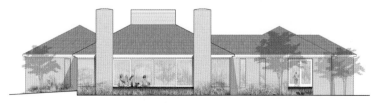

**New rear elevation**

A number of original interior walls were removed, resulting in a large, open gathering space with two fireplaces at the center of the house.

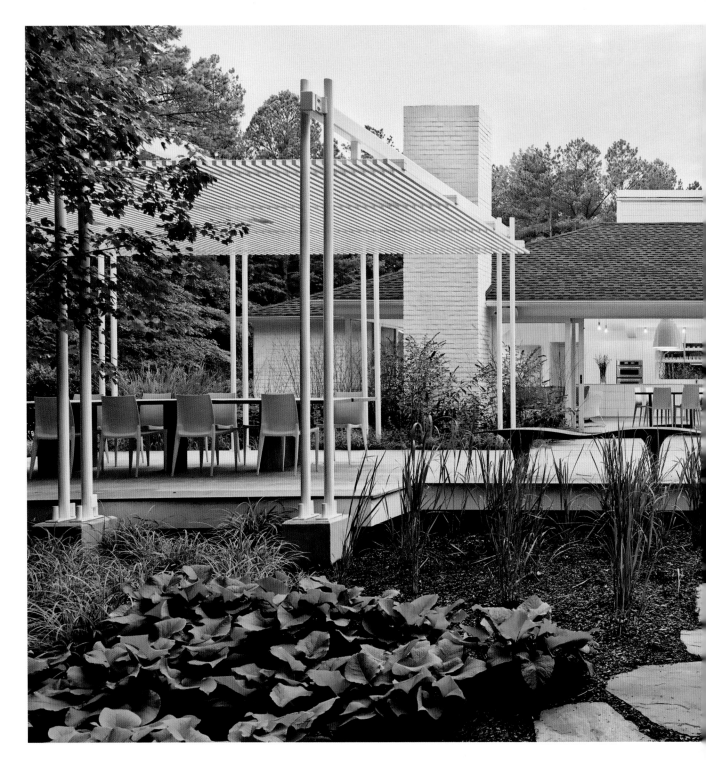

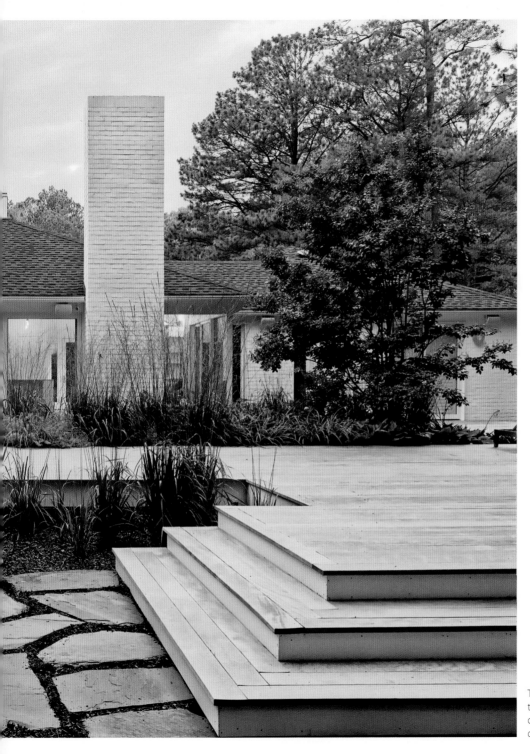

The exterior brick was painted white to refresh the building and better correspond to the contemporary design of the interior renovation.

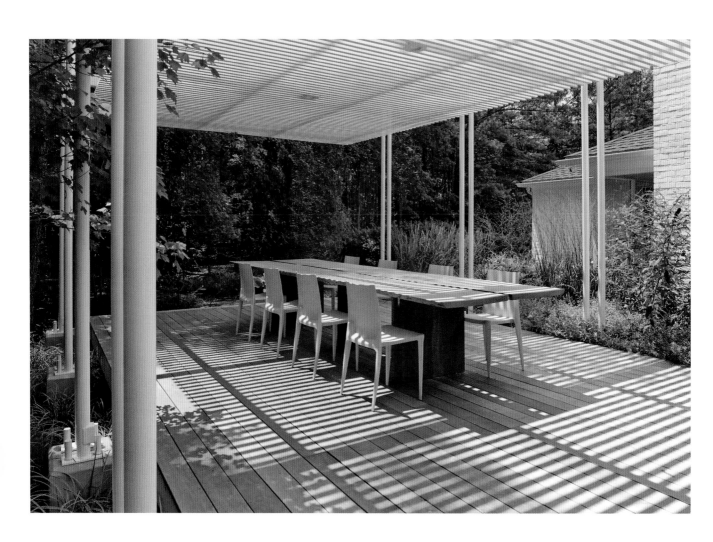

The outdoor space features gray
wood decking, custom-design
pergola and wood table, and a
beautiful landscape design.

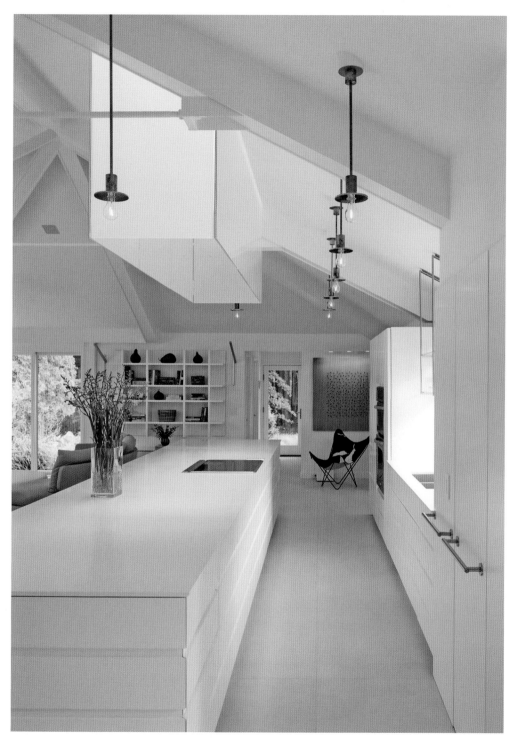

The custom fabricated kitchen includes a 19-foot island, a window, and view to the main house entrance and the boardwalk with pond. A skylight over the kitchen island allows additional light into the large communal space, which is the heart of the home.

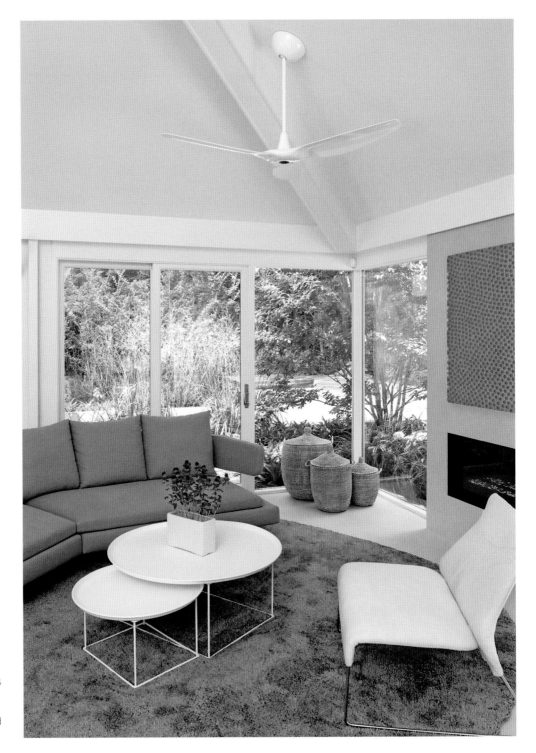

Throughout the house, emphasis is placed on the outside, with visual and physical connections to the surrounding garden landscape and the forest beyond.

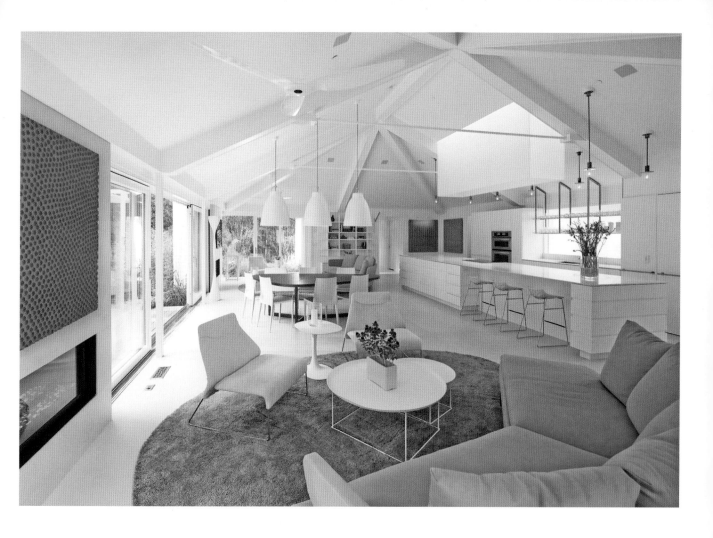

## Credits

Architect: Shinberg Levinas Architects
www.shinberglevinas.com

Furniture: B&B Italia
www.bebitalia.com

Landscape architect:
Eric Groft / Oehme van Sweeden
Landscape Architecture
www.ovsla.com

Lighting: One Lux Studio
www.oneluxstudio.com

Tiles: Lea Ceramiche
www.ceramichelea.it

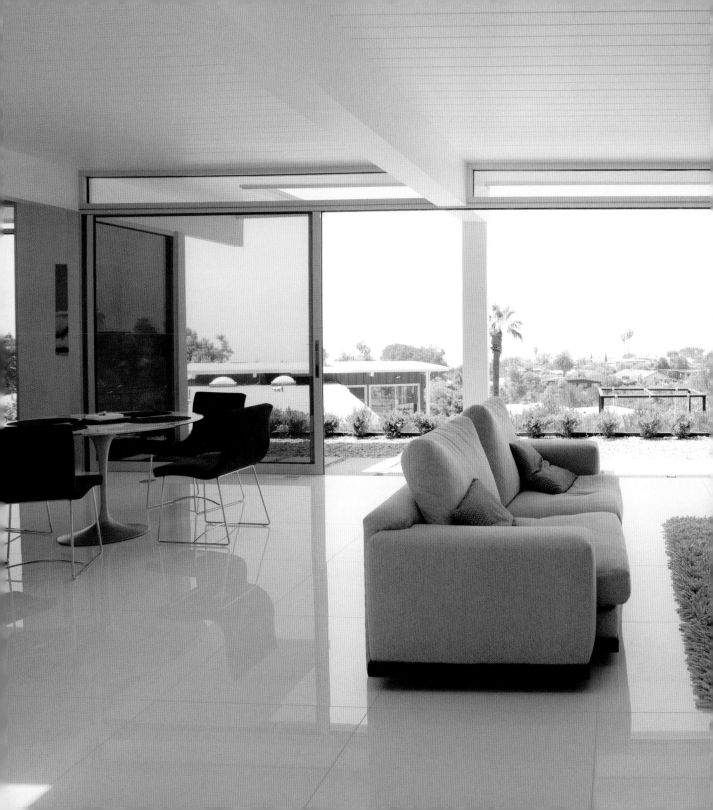

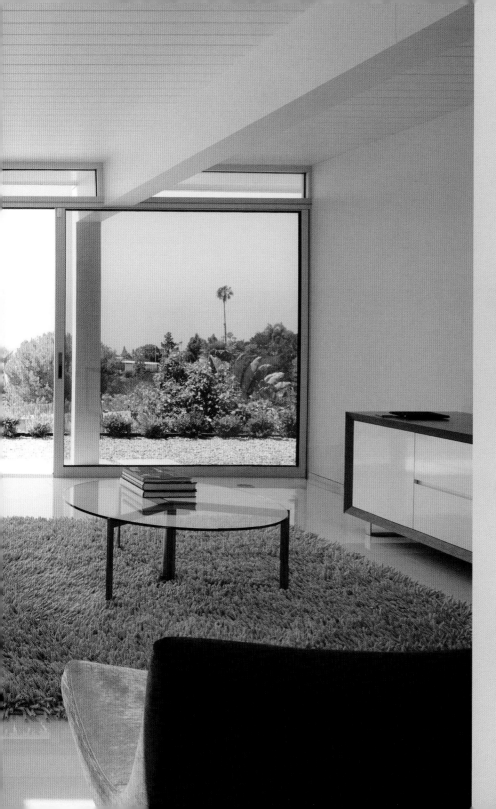

## GREWAL RESIDENCE

### 3,300 sq. ft.

**Pacific Palisades, California, United States**

—

**DESIGN21**

Photos © TJ Grewal

Project team: Roger Kurath, Assoc. AIA/SIA

**www.goDesign21.com**

> KEEP THE OPEN FEEL OF A POST-AND-BEAM HOUSE

> KEEP THE DESIGN CLEAN AND SIMPLE—LESS IS MORE

> MAINTAIN THE EXISTING ROOFLINE AND WORK WITH EXISTING FOOTPRINT

> USE ENVIRONMENTALLY FRIENDLY PRODUCTS FOR THE REMODEL

> MAINTAIN OCEAN VIEW

THE REMODEL OF A MID-CENTURY POST-AND-BEAM RESIDENCE ORIGINALLY BUILT IN 1962 MAINTAINS THE BEAUTY AND SIMPLICITY OF THE ORIGINAL DESIGN.

"The post-and-beam house, with its open floor plan, spaces filled with abundant natural light, and interior seamlessly spilling onto outdoor decks, seem to steadily grow in popularity. These much sought after homes appear to fit well with a diversity of contemporary generation looking at downsizing from the overbuilt single-family dwellings or at staying away from over-compartmentalized houses in favor of simple and efficient homes, where their interiors spill onto patios or pool decks. At a time when clean, yet warmer than minimalist open spaces appeal to homebuyers of different generations, architects and designers are trying to find ways to incorporate mid-century elements into their designs. Based on these premises, we were totally invested in helping our clients with their new home.

After extensive research about the residence, we were able to relocate the original plans. The existing conditions of the house were sound. As a requirement by contemporary city guidelines, the additional cover square footage was limited to 500 square feet. Also, the roofline could not be changed or raised. We remodeled the entire house, but maintained its overall room organization."

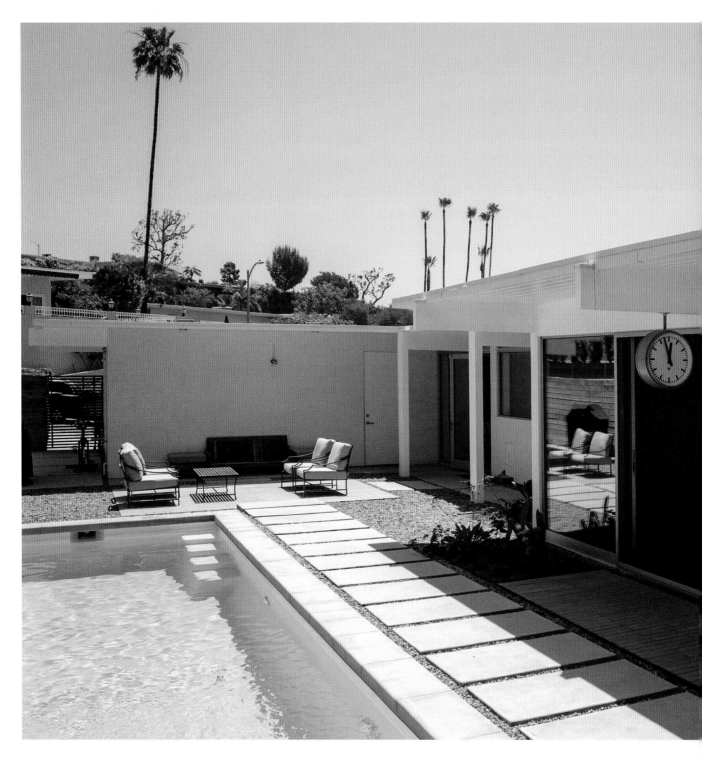

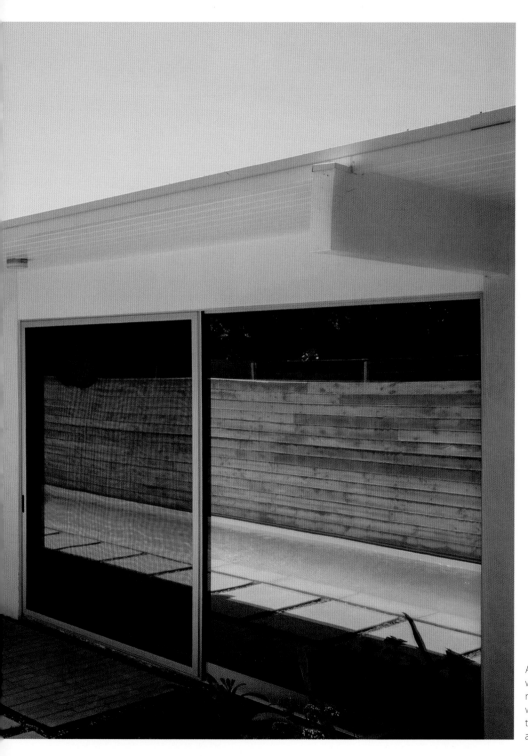

As originally planned in 1961, a pool was added to the backyard. The material selection for the remodel was kept to a minimum to emphasize the quality and beauty of the post-and-beam design.

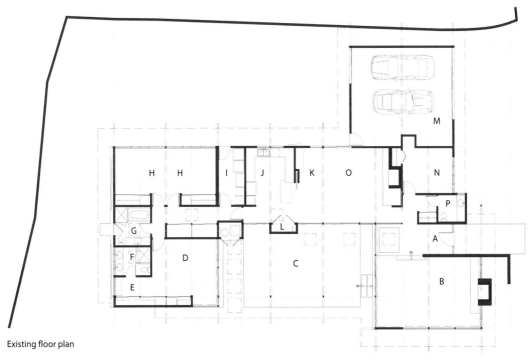

**Existing floor plan**

A. Entry       I. Utility room
B. Living room       J. Kitchen
C. Covered patio       K. Family room
D. Master bedroom       L. Pantry
E. Dressing room       M. Two-car garage
F. Master bathroom       N. Study
G. Bathroom       O. Hall
H. Bedroom       P. Powder room

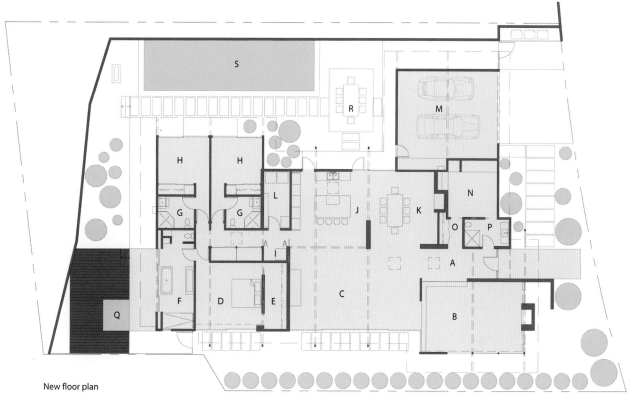

**New floor plan**

A. Entry
B. Formal living room
C. Living area
D. Master bedroom
E. Master closet
F. Master bathroom
G. Kid's bathroom
H. Kid's bedroom
I. Utility room
J. Kitchen
K. Dining area
L. Pantry, washer/dryer
M. Two-car garage
N. Guest bedroom
O. Closet
P. Guest bathroom
Q. Hot tub
R. Outdoor dining area
S. Pool

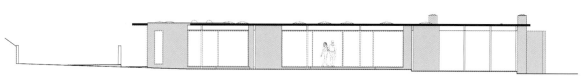

**Southwest elevation**

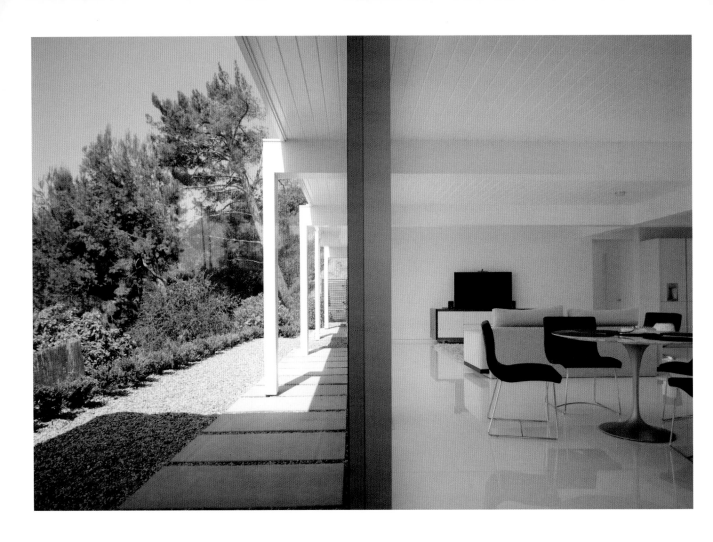

Deep eaves protect the glass façade
and interior against overheating, while
allowing plenty of natural lighting.

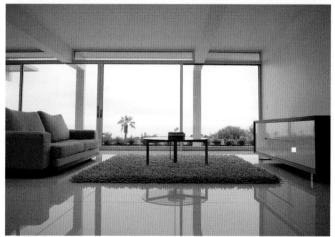

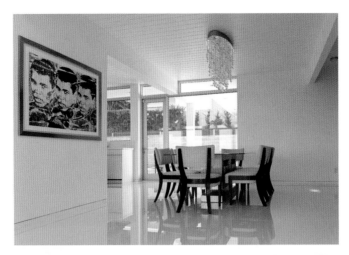

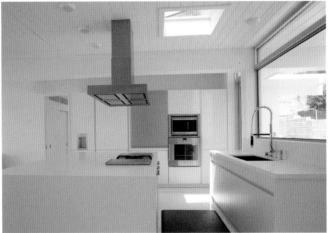

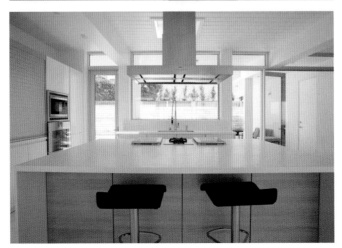

The kitchen was opened up so it could have direct view over the ocean as well as direct access to the backyard. A skylight was added to bring direct sunlight to the cooking area.

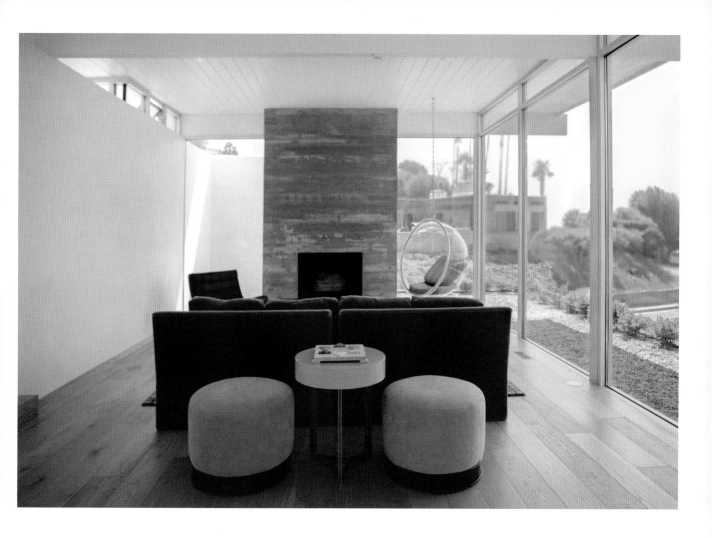

The formal living room has oak flooring anchoring the room to the site, in contrast with the living area, kitchen, dining area, and entrance, which have a pristine white-tile floor that reflects light and creates an airy atmosphere in keeping with the open concept of the house.

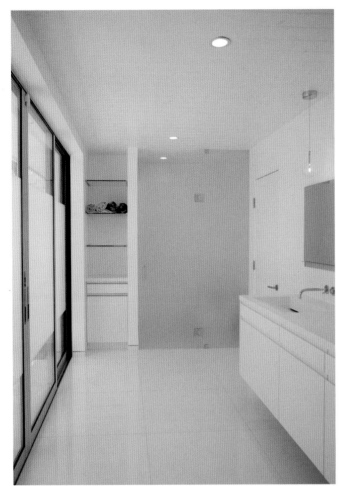

The master bathroom is located in the southwest corner of the house and has an oversized shower with a floor-to-ceiling glass wall and large sliding doors that open up to an outside deck with a hot tub.

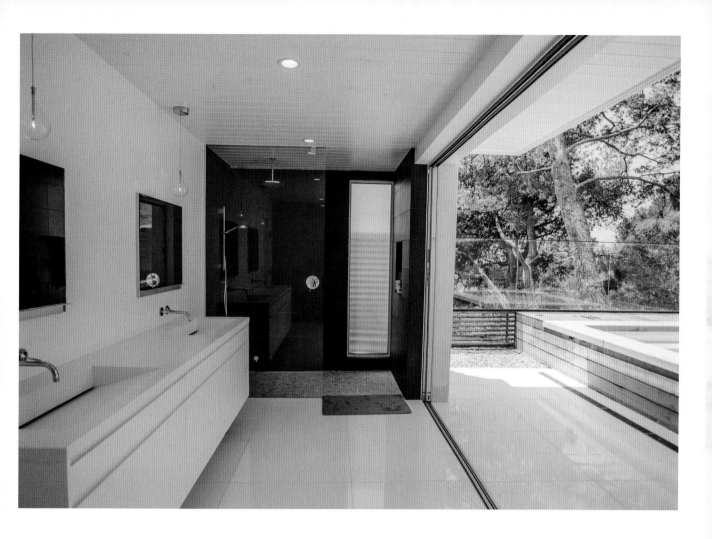

**Credits**

Architect: (Design and concept):
design21
www.goDesign21.com

Bathroom and kitchen cabinets:
Leicht
www.leicht.com

Countertop: Caesarstone (quartz)
www.caesarstoneus.com

Tiles: Porcelanosa
www.porcelanosa.com

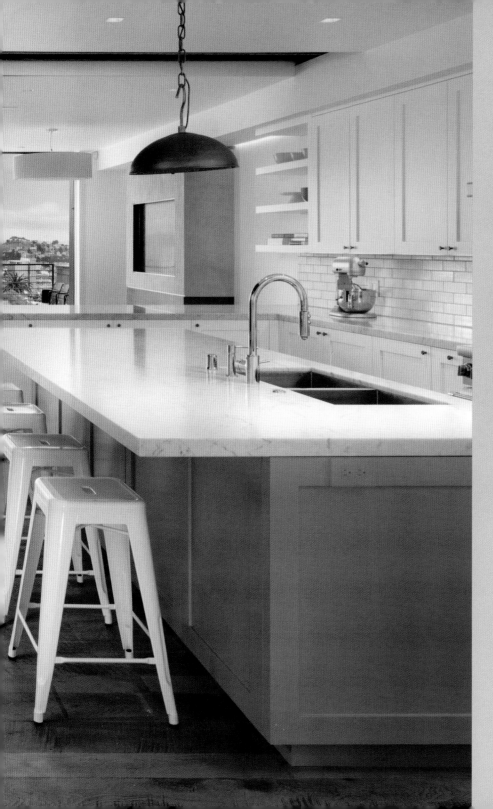

# NOE VALLEY 2

## 4,780 sq. ft.

San Francisco, California, United States

**FELDMAN ARCHITECTURE**

Photos © Paul Dyer

Project team: Jonathan Feldman
Christopher Kurrle

www.feldmanarchitecture.com

> CREATE AN OPEN PLAN WITH A SMALL
  LIVING ROOM, LARGE FAMILY ROOM
  ADJACENT TO THE KITCHEN, AND SEPARATE
  MULTIPURPOSE ROOM ON LOWER LEVEL
  CONNECTED TO OUTDOOR SPACE

> DEVISE A PATIO AREA AT GARDEN LEVEL
  WITH ADDITIONAL SEATING THAT COULD BE
  UTILIZED FOR OUTDOOR ENTERTAINING AND
  A BBQ AREA

> ENSURE THAT EACH LEVEL HAS A
  CONNECTION TO AN OUTDOOR SPACE

> MAXIMIZE NATURAL LIGHTING AND VIEWS
  THROUGH THE BACK OF THE HOUSE

> ACHIEVE LEED PLATINUM CERTIFICATION

THIS URBAN REMODEL FEATURES A CLIENT-DRIVEN DESIGN THAT PAIRS EXPANSIVE OUTDOOR LIVING AREAS WITH PRIVATE AND PERSONALIZED INTERIOR MOMENTS.

"Noe Valley 2 stands on an elongated lot that is the largest on the block. However, the original house failed to take advantage of the spacious yard and, dwarfed by the neighboring houses, felt cramped and confined. It was essential to bring light into the house.

The remodel opened the public spaces on the main floor and created a more fluid connection between floors through the use of natural light. At the front of the house, the street façade was restored in the original character of the house with wood shingle and ornament, and stained glass. Through the careful selection of building materials, the implementation of an efficient heat-driven, radiant floor system, and prudent water-management strategies, including rainwater collection and a gray water system, Noe Valley 2 achieved LEED Platinum certification."

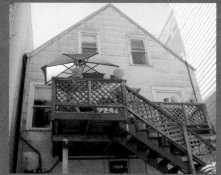
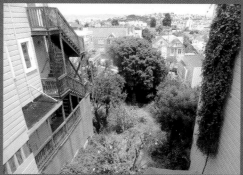

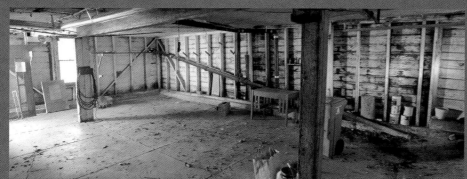

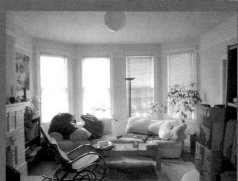

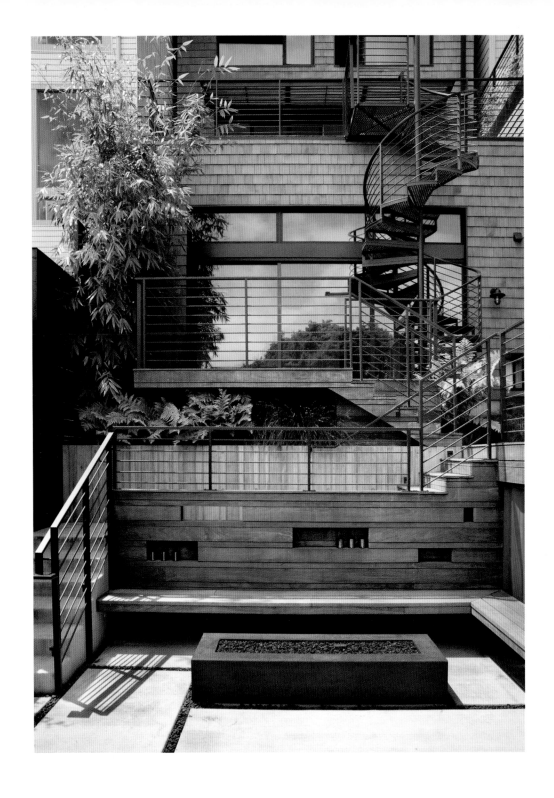

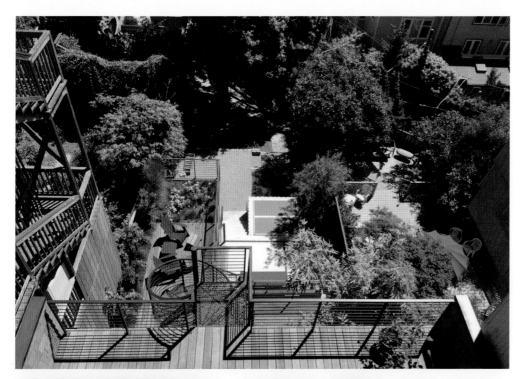

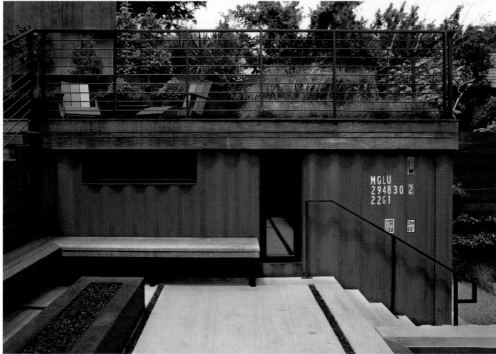

A series of decks cascading into the yard offers outdoor living at each level and easy access to the patio and garden below.

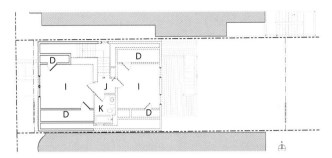

Existing third floor plan

Existing ground floor plan

A. Garage        G. Dining room
B. Entry         H. Deck
C. Living room   I. Bedroom
D. Closet        J. Hall
E. Powder room   K. Bathroom
F. Kitchen

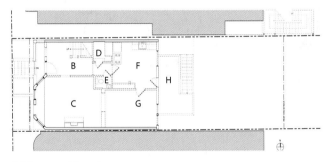

Existing second floor plan

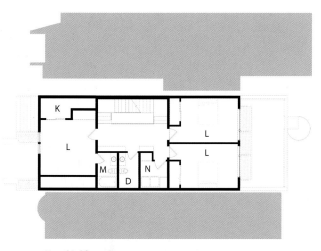

New third floor plan

New fourth floor plan

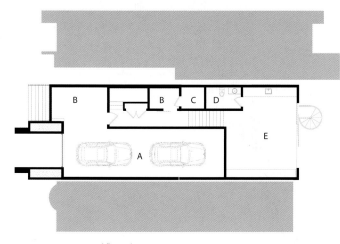

New ground floor plan

New second floor plan

A. Garage
B. Storage
C. Mechanical room
D. Powder room
E. Multipurpose room
F. Lounge
G. Kitchen
H. Dining area
I. Living area
J. Deck
K. Closet
L. Bedroom
M. Bathroom
N. Laundry room
O. Office
P. Dressing room
Q. Master bedroom
R. Master bathroom

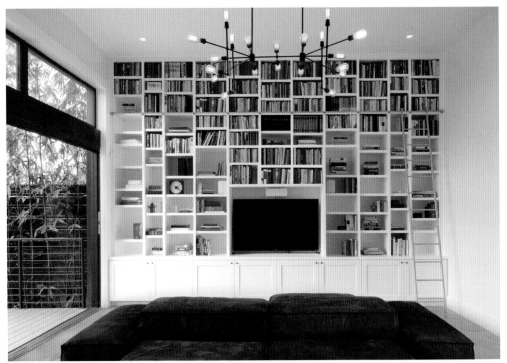

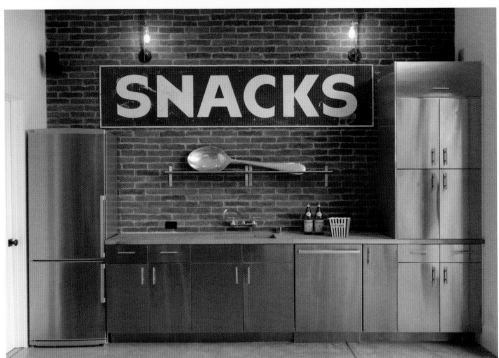

The comfortable living area in the finished basement is exposed to an abundance of light through the home's rear façade.

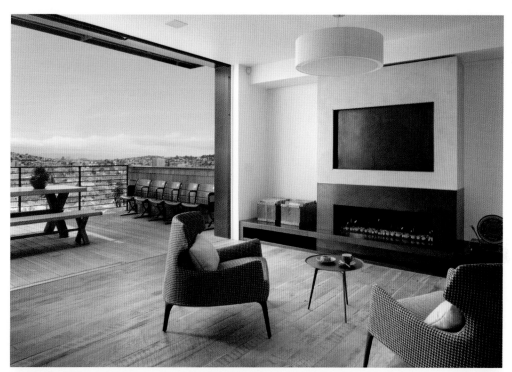

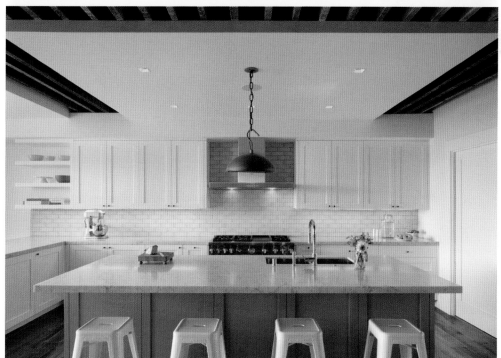

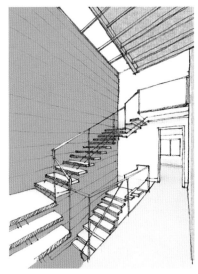

View of kitchen island and staircase

View of staircase from third floor

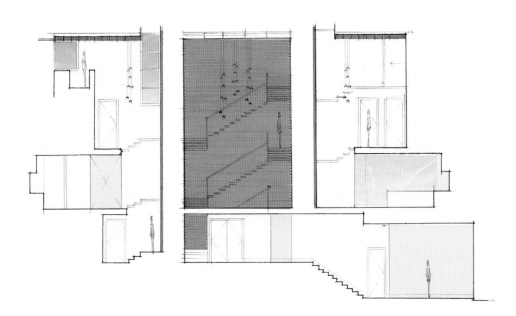

Building sections

The stairwell wrapped in cyprus siding links all levels, and allows sunlight to wash through the core of the home. An 18-foot skylight and a 12-foot vertical window meet above the stairs to form a stunning waterfall skylight, complemented by a thicket of repurposed glass pendants, creating a light well that illuminates the entire home at night.

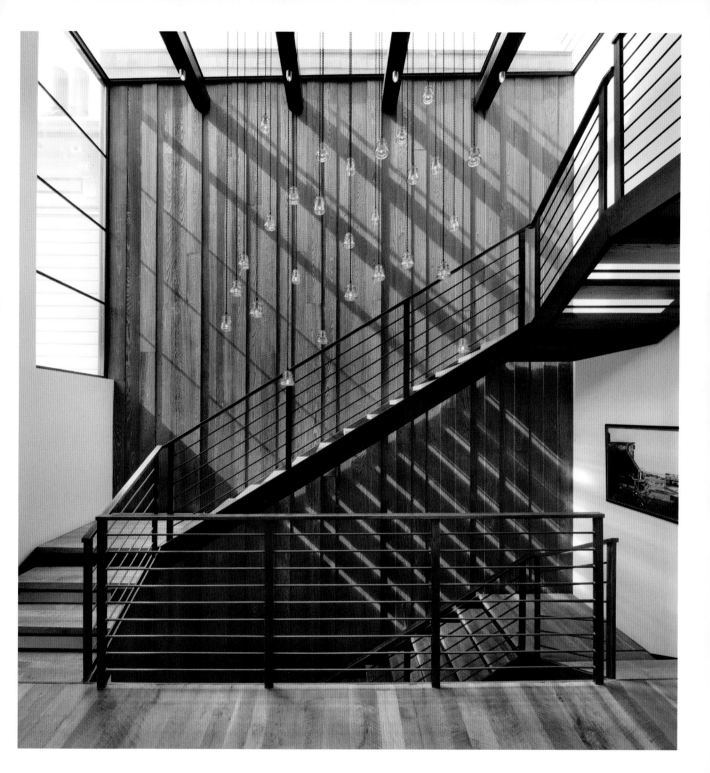

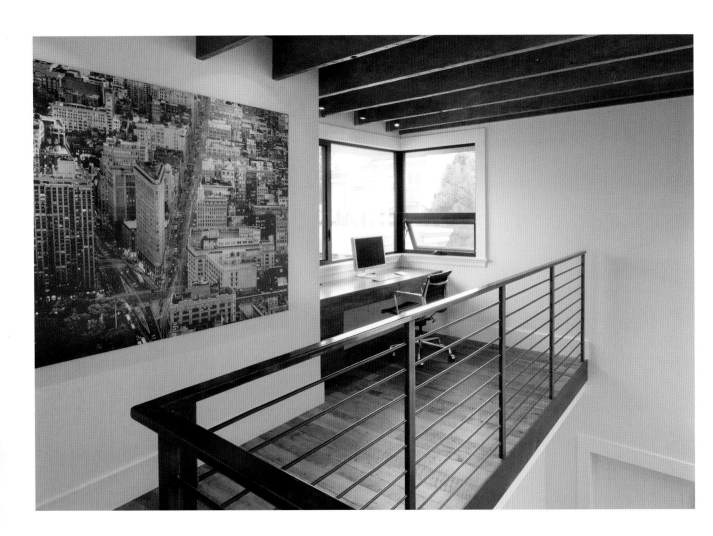

On the fourth floor, a small office space just outside the master bedroom provides unique southern view of the city. It also visually connects to the children's bedrooms on the floor below through the stair atrium.

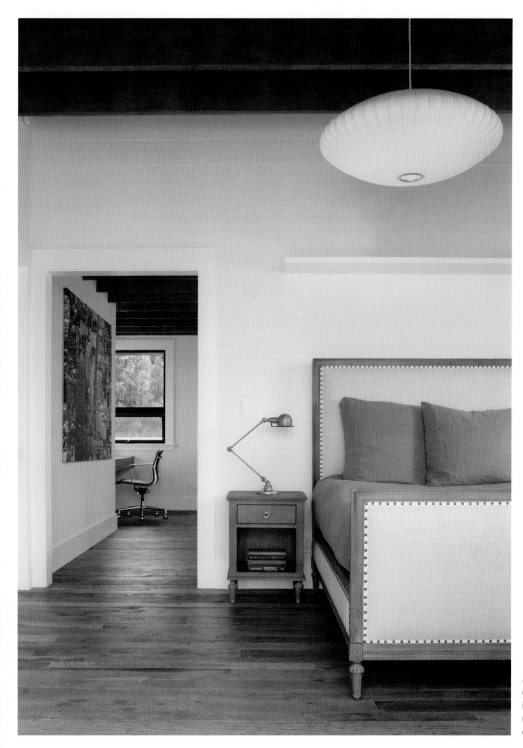

Although the fourth floor is a new construction, its ceiling's framing is exposed to echo the original redwood structure of the kitchen's ceiling on the main level.

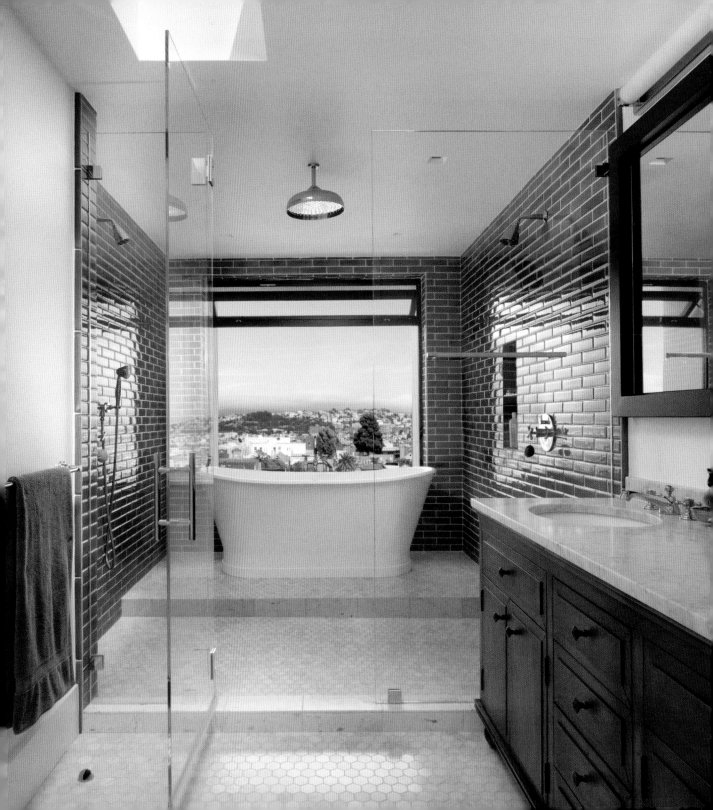

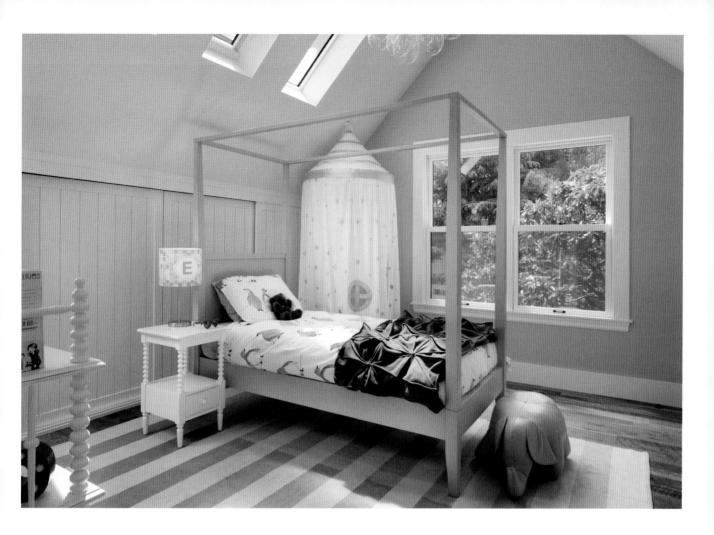

## Credits

**Architect:** Feldman Architecture
www.feldmanarchitecture.com

**Landscape architect:**
Arterra Landscape Architects
www.arterrasf.com

**General contractor:**
Art of Construction
www.artofconstructioninc.com

**Structural engineer:**
Double-D Engineering
www.doubledengineering.com

## Appliances and Materials

**Decorative stair wall:** Delta Millwork
cypress tiger-burned vertical boards
**Flooring:** Wellborn + Wright reclaimed, circle-sawed oak flooring
**Specialty door:** Three-panel sliding
door in living area by Weiland Doors.
**Kitchen and bathroom tile:**
Fireclay Tile

**Waterfall skylight:** Skylight/window
above main staircase by Euroline Steel
Windows & Doors
**Windows and doors:** Aluminum
doors and window at rear façade by
Fleetwood

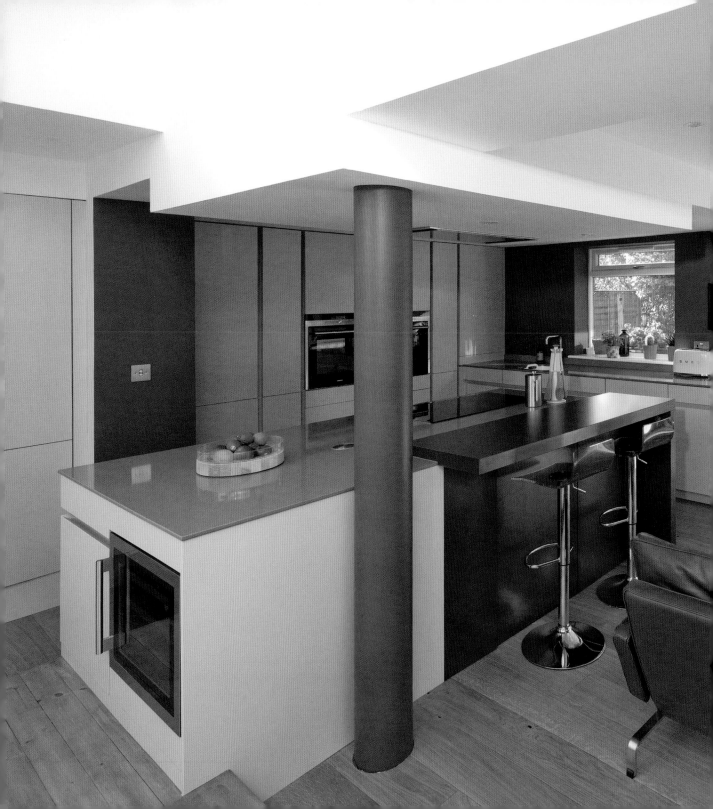

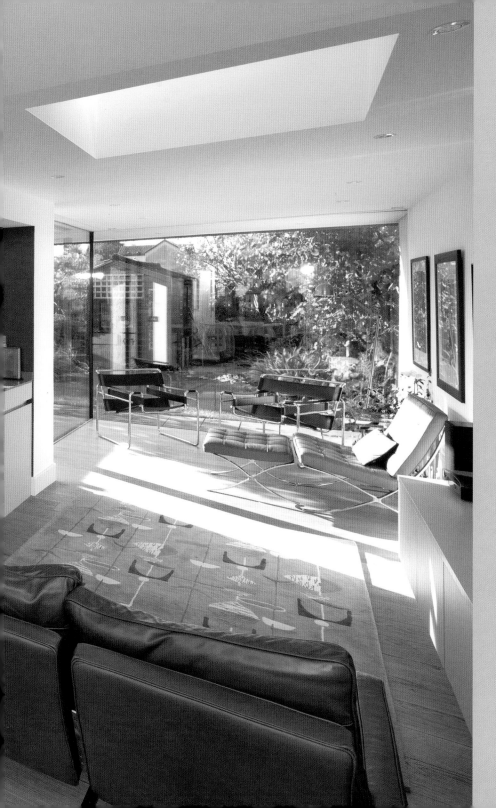

# EXTENSION TO AN ARTS & CRAFTS HOUSE

## 1,755 sq. ft.

Glasgow, Scotland, United Kingdom

---

**EWAN CAMERON ARCHITECTS**

Photos © David Barbour

Project team: Ewan Cameron, Director
Helen McCrorie, Director

www.ewancameronarchitects.com

> BLEND EARLY TWENTIETH CENTURY AND
  EARLY TWENTY-FIRST-CENTURY DESIGN
  SENSIBILITIES SEAMLESSLY

> OPEN UP KITCHEN, DINING, AND LIVING
  SPACES

> CONNECT HOUSE INTERIOR WITH BACKYARD

> CREATE AN OUTDOOR DINING AREA
  PROTECTED FROM THE RAIN

> KEEP COSTS DOWN

HOW TO UPGRADE WITHOUT LOSING ORIGINAL CHARACTER? CAROL AND DREW GRIEVE OWN A TRADITIONAL EDWARDIAN TERRACE IN GLASGOW. AFTER HAVING LIVED IN IT FOR 20 YEARS, THEY DECIDED TO MAKE IT MORE SUITABLE TO THEIR NEEDS.

"The house was relatively untouched when we bought it, and as far as we could see, it hadn't had any major makeovers. As with many houses of that period, the main floor was made of a succession of small rooms with almost no connection with the backyard. Various remodel options were considered, including one that meant cutting through from the dining room to the lounge.

It wasn't until they came across some arts-and-crafts houses in Holland while visiting relatives that the owners realized they might have found the solution. They felt that those houses looked bright and airy despite their heavy construction style. Being open to their rear gardens made them look that way. The couple also remembered a glass pavilion with deep eaves in Kent that they liked. At that point one thought led to another, sparking a series of questions: Was removing the rear wall the answer to their problem? How far could they build into the garden and still comply with building regulations? The answer was thirteen feet. With that in mind, they thought of the possibilities that opening the garden-facing wall had to offer: they essentially wanted an open plan kitchen, dining, and living area, but they liked it even better if their main space was open to the garden.

They also sold their fairly new kitchen equipment, which allowed them to increase their remodel budget. The couple moved out for the duration of the remodel. It lasted fourteen weeks.

The new layout has changed the way they live. 'We use the lounge a lot more now, as the back opening brightens up the whole house. Even with the connecting doors closed, you can see out to the garden wherever you are on the ground floor. It is a great social space now.'"

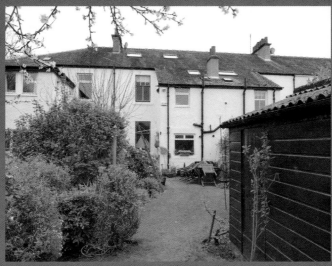

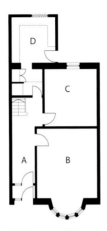

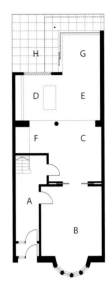

**Existing ground floor plan**

Existing second floor plan

**New ground floor plan**

A. Hall
B. Lounge
C. Dining room
D. Kitchen
E. Study

F. Master bedroom
G. Bedroom
H. Shower room
I. Bathroom

A. Hall
B. Lounge
C. Dining area
D. Kitchen

E. Living area
F. Storage
G. Breakfast nook
H. Terrace

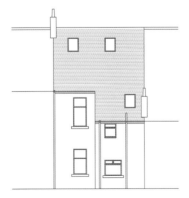
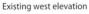

Existing west elevation

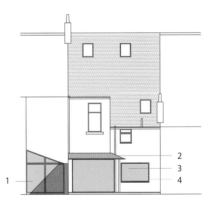

New west elevation

1. Neighboring extension
2. Charcoal gray cement fiber panels
3. Frameless double glazed units
4. Charcoal gray aluminum clad timber triple glazed window

The design solution is a seamless transition from the original period style of the living area at the front of the house, through a mid-century kitchen and dining area, to a contemporary glass pavilion projecting into the garden.

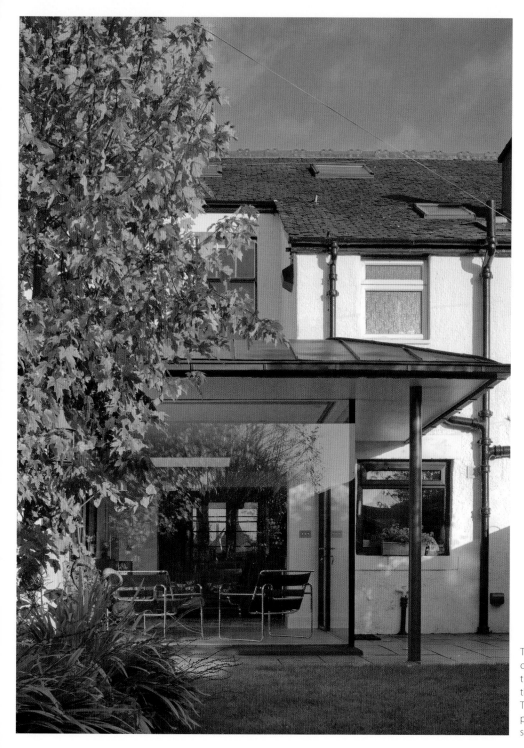

The major work had to do with opening the rear wall, which required three steel beams to support it. Then the glass pavilion was put into place. The deep overhangs provide some protection from sun and rain, while solar glass prevents heat gain.

A set of sliding doors separates the original arts-and-crafts lounge from the open plan kitchen, dining, and living extension at the rear of the house, facing the backyard.

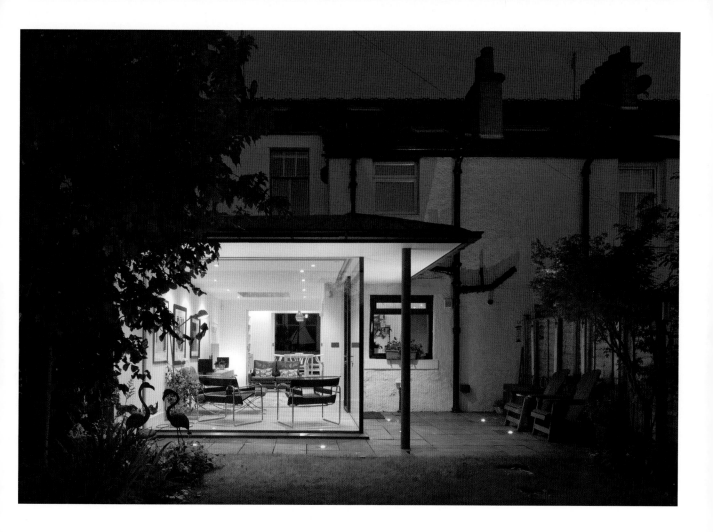

**Credits**

Architect:
Ewan Cameron Architects
www.ewancameronarchitects.com

Frameless glazing: Gray & Dick
www.gdltd.net

General contractor: GMB

Structural engineer:
David Narro Associates
www.davidnarro.co.uk

Zinc roofing: VMZINC
www.vmzinc.com

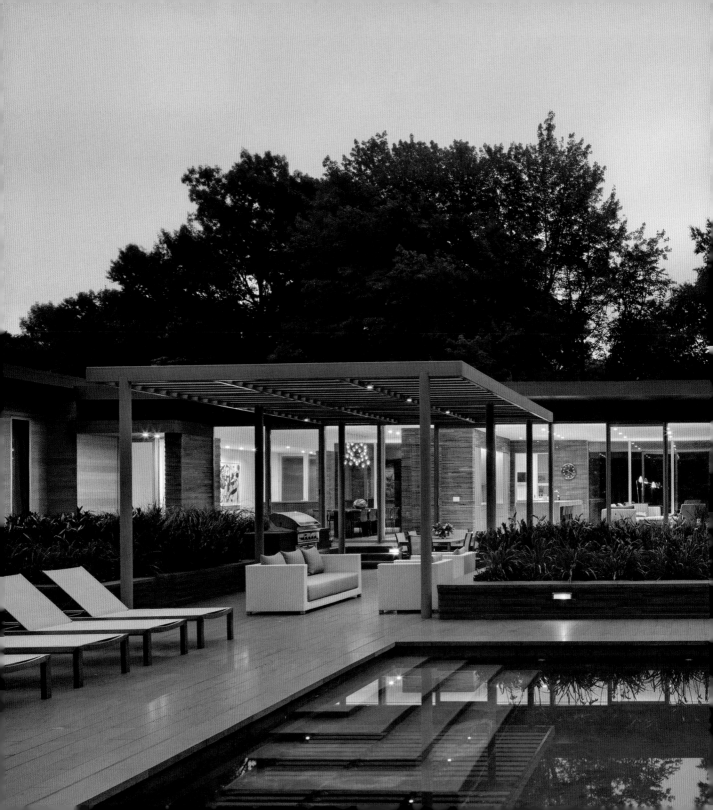

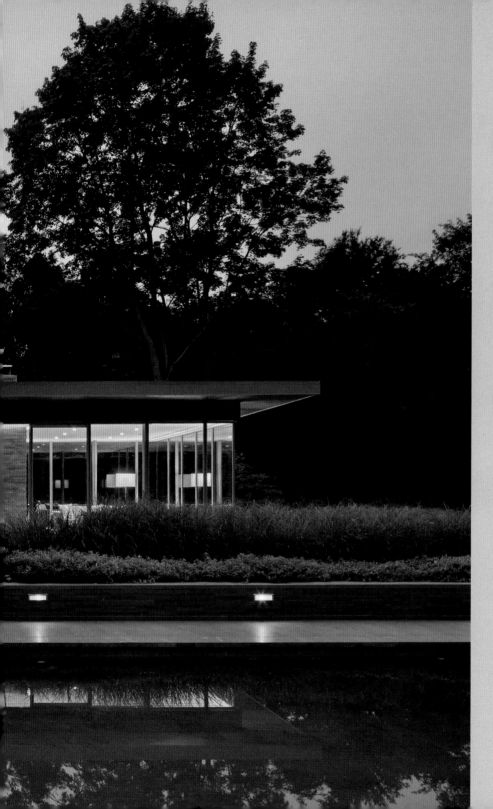

# SANDS POINT RESIDENCE

## 4,940 sq. ft.

Sands Point, New York, United States

---

**MARK DuBOIS ARCHITECTURE**

Photos © Chris Cooper

Project team: Mark DuBois, Principal

**www.boishaus.com**

> TRANSFORM A DARK 1950s RANCH HOUSE
AND GIVE IT THE OPENNESS OF THE 1950s
CASE STUDY HOUSES, WITH WALLS OF GLASS
AND A STRONG CONNECTION BETWEEN THE
HOUSE AND THE LANDSCAPE.

THOUGH THIS SMALL 1950s HOUSE WAS OUTDATED AND POORLY INTEGRATED WITH THE PROPERTY, THE OWNERS SAW THE POTENTIAL TO CREATE GENEROUS SPACES FOR COOKING, LIVING AND ENTERTAINING BY EXPANDING THEIR HOME OUT INTO THE LANDSCAPE.

---

"Small 1950s houses are usually torn down and replaced with oversized McMansions that have no connection to the landscape or the site. While the original house itself was very outdated, it was well sited on a beautiful one-acre property, with a large open lawn hidden in the back, and the owners saw an exciting opportunity to create a house that expands out into the landscape.

The owners' goal was to have comfortable, open, light-filled spaces for both small and large family gatherings, along with generous outdoor living areas suitable for cooking, dining, entertaining, and daily living. The design strategy to accomplish this was to create a house with two distinct parts. The original house was completely reorganized to accommodate the "private" spaces—bedrooms, bathrooms, study, and office. A new glass pavilion was added for the more "public" areas—entry, dining, kitchen, family room, and living area. The glass walls on three sides make it feel like you're outside even in the winter. New outdoor cooking, living and dining areas further extend the house out into the property.

The aesthetic challenge was how to join a pristine glass pavilion onto a dated and non-descript suburban house. The solution was to transform the exterior of the original house with refined horizontal cedar siding and sleek, flush aluminum windows and doors that complement the new glass addition. Together the renovation and addition capture the owner's desires for simplicity, elegance, openness and a strong connection to nature."

---

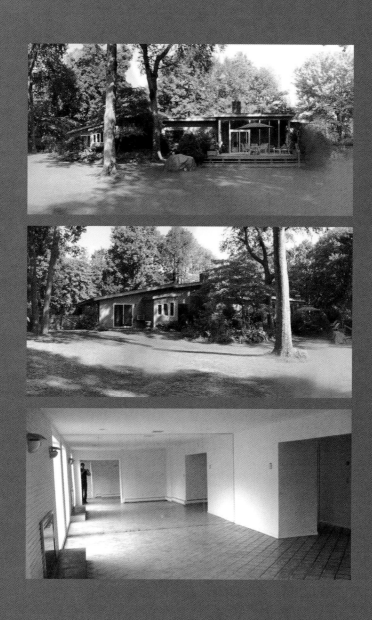

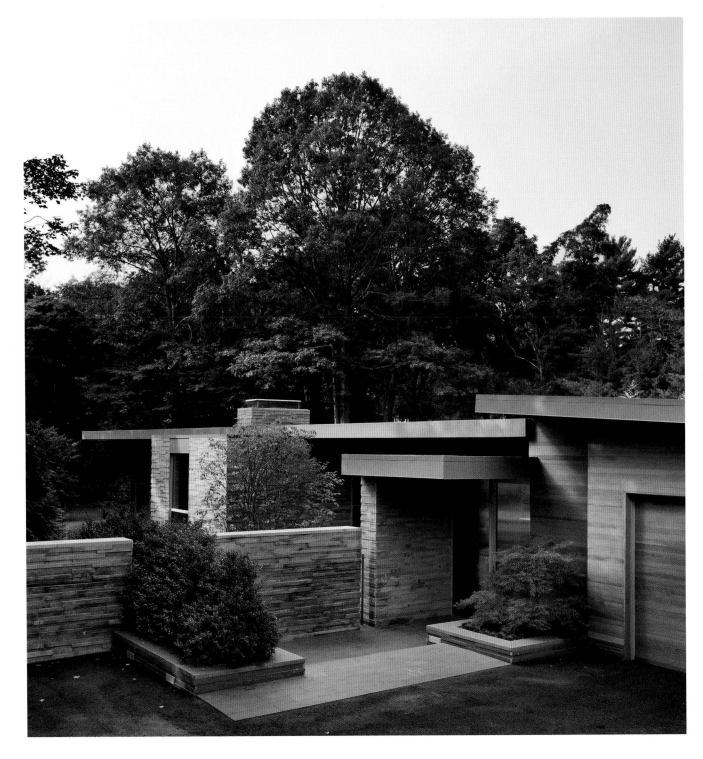

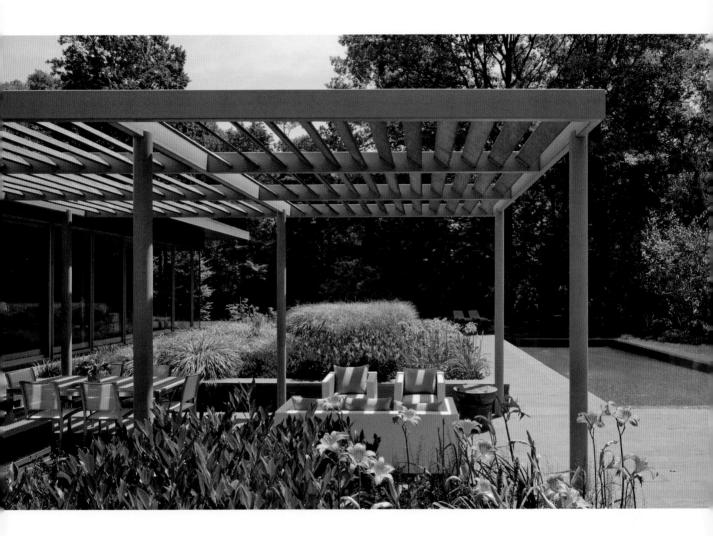

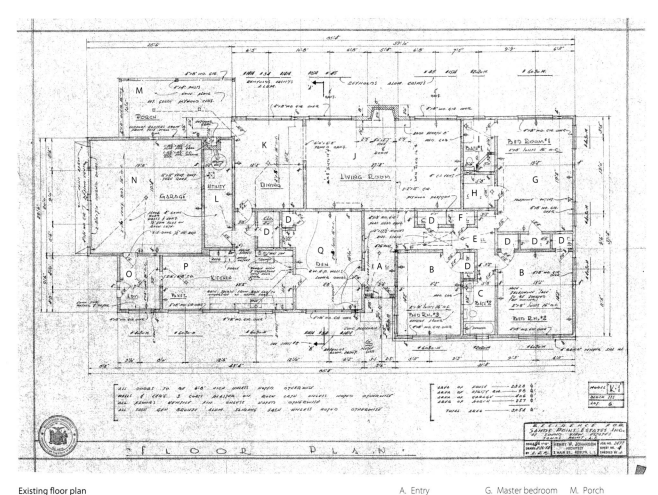

Existing floor plan

A. Entry G. Master bedroom M. Porch
B. Bedroom H. Master closet N. Garage
C. Bathroom I. Master bathroom O. Laundry room
D. Closet J. Living room P. Kitchen
E. Hall K. Dining room Q. Den
F. Linen closet L. Utility room

While the original house had become
very outdated, the layout worked very
well for the new uses. The interior was
stripped down to the wood frame
walls and roof and all new wiring,
plumbing and heating were installed.

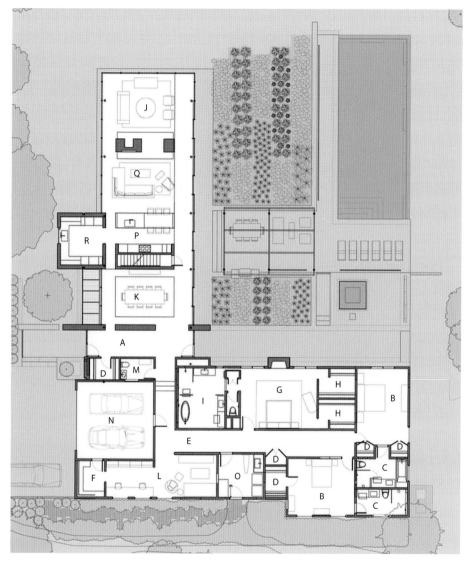

**New floor plan**

A. Entry
B. Bedroom
C. Bathroom
D. Closet
E. Hall
F. Mudroom
G. Master bedroom

H. Master closet
I. Master bathroom
J. Living area
K. Dining area
L. Study
M. Powder room
N. Garage

O. Laundry room
P. Kitchen
Q. Family room
R. Pantry

The spaces were reconfigured so the original living and dining areas became the master suite, the two smaller bedrooms became two guest bedrooms with en suite bathrooms, and the kitchen became the study.

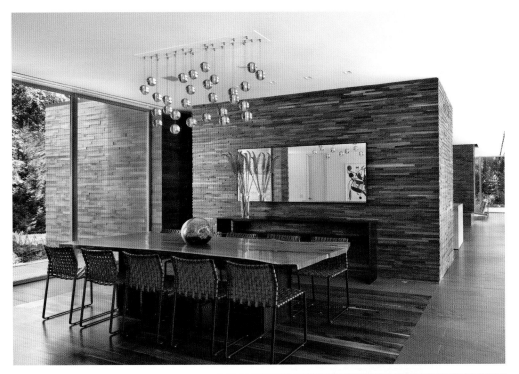

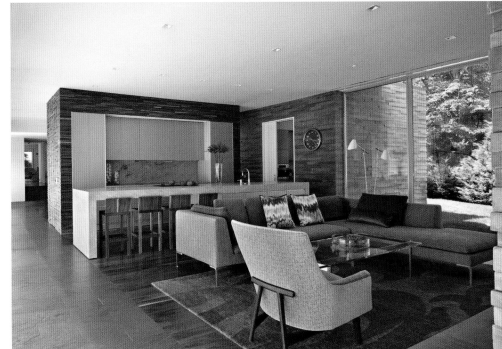

The dining and family room areas are defined by a wood volume that separates the two while maintaining the sense of light and openness. The original, small interior kitchen was replaced with a new one in two parts: a more private preparation space that can be closed off, and a generous public space with an inviting and expansive island for cooking, entertaining and eating.

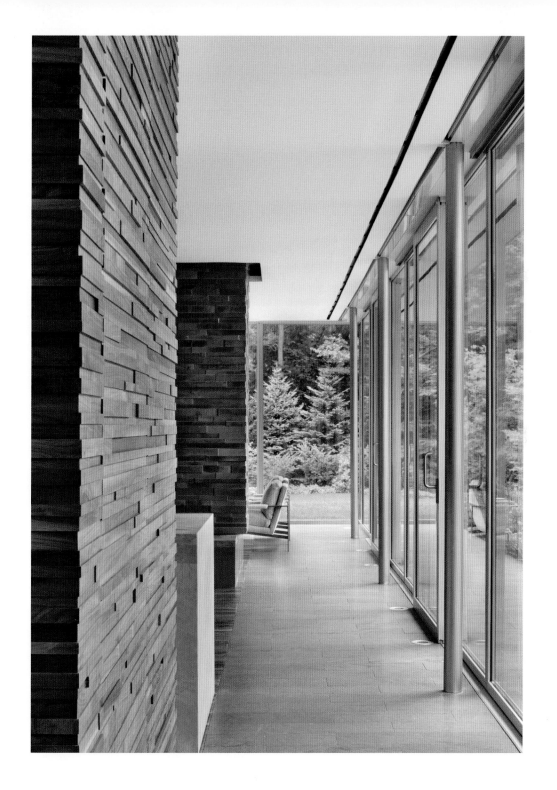

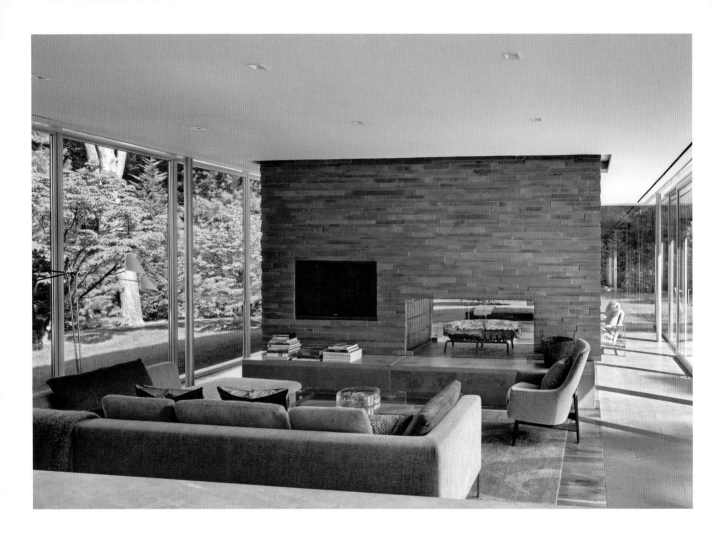

To create the openness that is
not possible in the original 1950s
ranch-style home, a 2,000-square-
foot pavilion projects out into the
landscape with glass on all sides to
connect the house with nature.

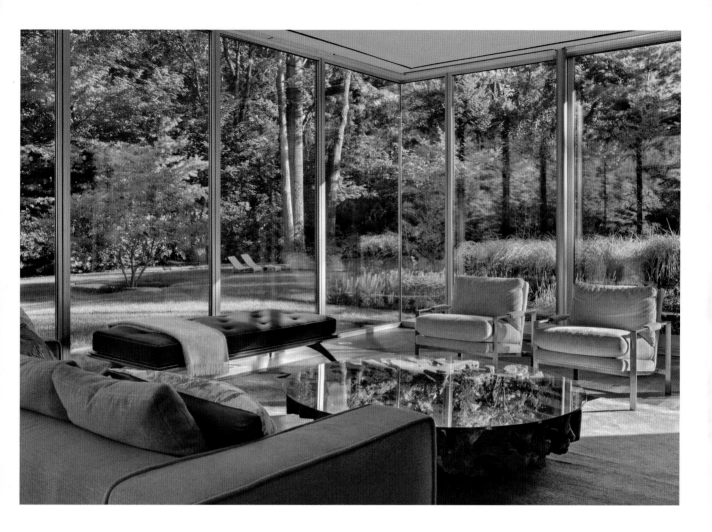

## Credits

**Architect:** Mark DuBois Architecture
www.boishaus.com

**General contractor:**
Ira Parr / Jescorp Construction

**Landscape architect:**
Steven Tupu / terrain
www.terrain-nyc.net

**Lighting designer:**
Carrie Hawley / Horton Lees Brogden
Lighting Design
www.hlblighting.com

**Structural engineer:** Nat Oppenhei-
mer / Robert Silman Associates
www.silman.com

## Appliances and Materials

**Appliances:** Wolf cooktop, Sub-
Zero refrigerator, Miele ovens and
dishwasher
**Bathroom cabinets:** Custom
**Ceramic tile:** Bizazza and Ann Sacks
**Countertops:** "Bleu de Savoie" limestone
**Exterior decking:** Ipe
**Full height glazing and glass doors:**
Arcadia and Centurion by Windorsky
**Kitchen cabinets:** Valcucine

**Paint:** Benjamin Moore
**Stone flooring (interior and exterior):**
Basalt
**Stacked stone:** "Grigio di Tunisi"
limestone
**Windows:** Panorama
**Wood flooring:** American walnut
**Wood walls:** American walnut

# BUCKS COUNTY, NEW HOPE CONDOMINIUM

## 1,700 sq. ft.

New Hope, Pennsylvania, United States

---

**YZDA | YOSHIDA + ZANON DESIGN ATRIUM**

Photos © Peter Rymwid Photography

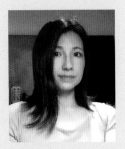

Project team: Satomi Yoshida-Katz

**www.yzdesignatrium.com**

> OPEN UP LIVING AREA

> ADAPT THE NEW DESIGN TO THE OWNERS'
  LIFESTYLE AND PERSONALITY

A ONCE AWKWARDLY PLANNED CONDOMINIUM IS TRANSFORMED
INTO AN OPEN HAVEN OF RELAXED SOPHISTICATION.

"Our challenge was to transform an outdated 1980s condominium into a
modern and comfortable home. The main floor was congested with an en-
closed living room and required a full renovation in order to create an airy
and bright living room and open custom kitchen.

Inspired by the client's cosmopolitan, yet understated lifestyle, we wanted to
create a contemporary, urban, Northern European home style in the design
of this suburban riverside living space. Once we had the most basic aspects
of the design established, everything else fell into place."

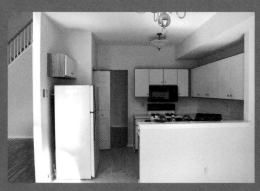
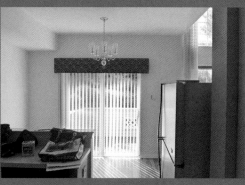
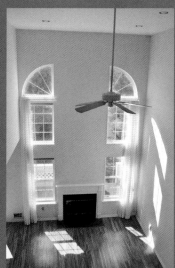
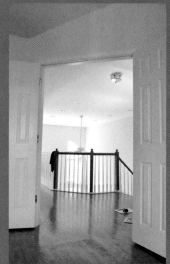

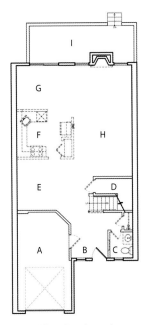

I

G

F

H

E

D

A    B    C

Ground floor demolition plan

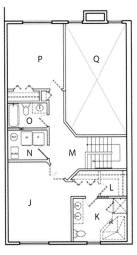

P    Q

O

N    M

L

J    K

Upper floor demolition plan

A. Garage
B. Entry hall
C. Powder room
D. Storage
E. Dining room
F. Kitchen
G. Eat-in area
H. Living room
I. Deck

J. Master bedroom
K. Master bathroom
L. Walk-in closet
M. Hallway
N. Laundry room
O. Bathroom
P. Bedroom
Q. Open to below

**Demolition symbols legend**

——————— Existing wall to remain

------------------- Existing wall to be removed

Existing door to remain

Existing door to be removed

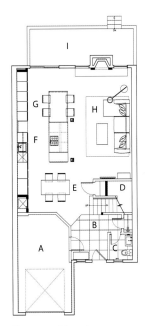

I

G

F

H

E    D

B    C

A

New ground floor plan

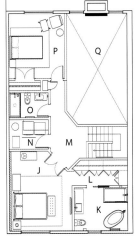

P    Q

O

N    M

J    L

K

New second floor plan

A. Garage
B. Entry hall
C. Powder room
D. Storage
E. Wine room
F. Kitchen
G. dining area
H. Living area
I. Deck

J. Master bedroom
K. Master bathroom
L. Walk-in closet
M. Hallway
N. Laundry room
O. Guest bathroom
P. Guest bedroom
Q. Open to below

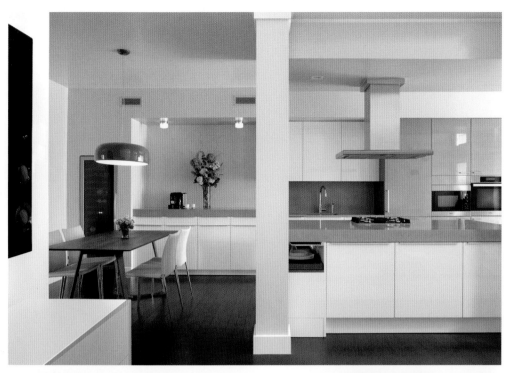

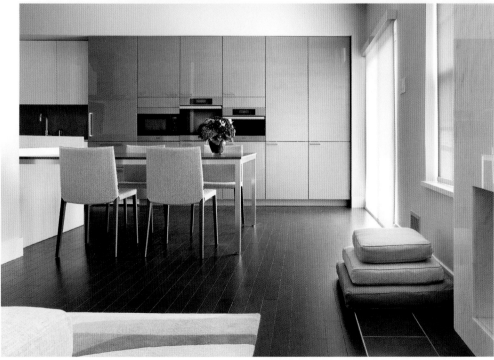

The configuration of the main common spaces focuses on efficiency, better using the available space and rationalizing the circulation.

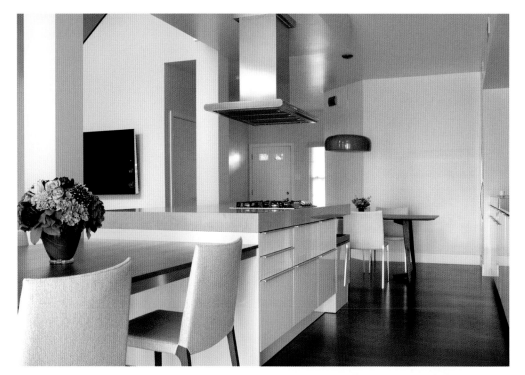

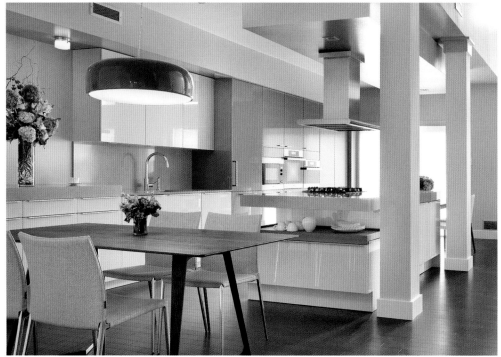

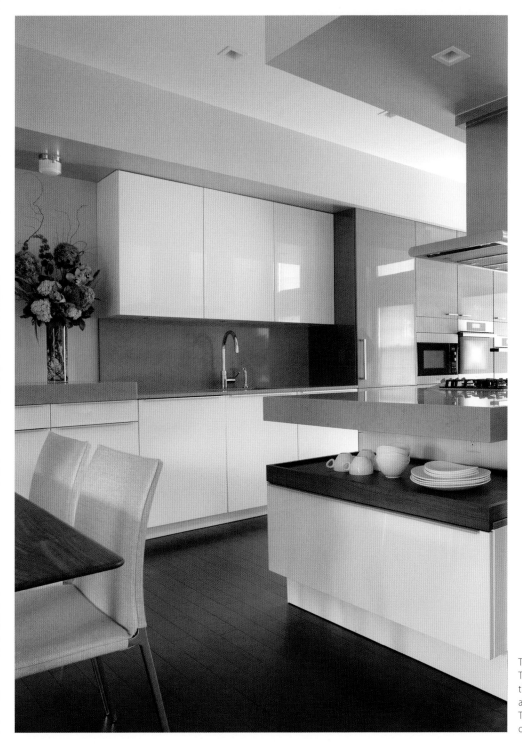

The design stands out for its clean lines. The light color scheme contrasts with the dark flooring, while matte surfaces are juxtaposed to specular finishes. Together, they contribute to the creation of an airy and relaxed atmosphere.

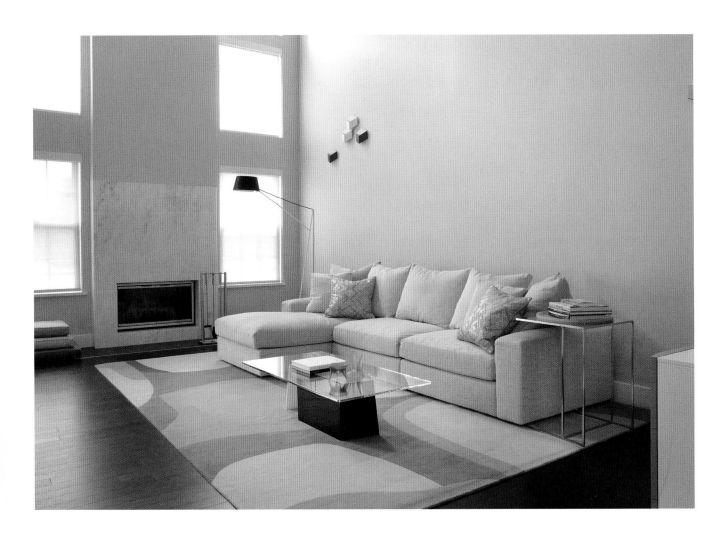

Simple yet elegant furniture is
arranged based on a full range of
earthy tones. These colors are then
set off by the dark flooring materials.

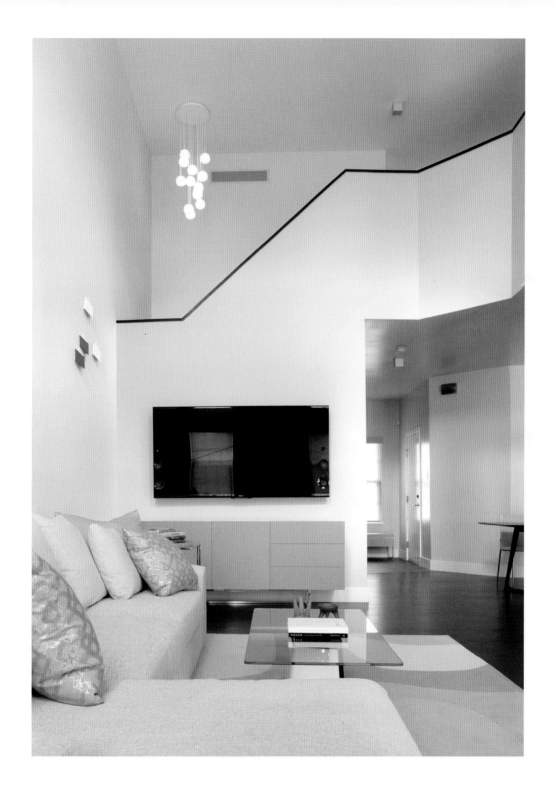

A floating vanity enhances the airy
atmosphere of the bathroom, in
keeping with the desire to create an
open and soothing environment.

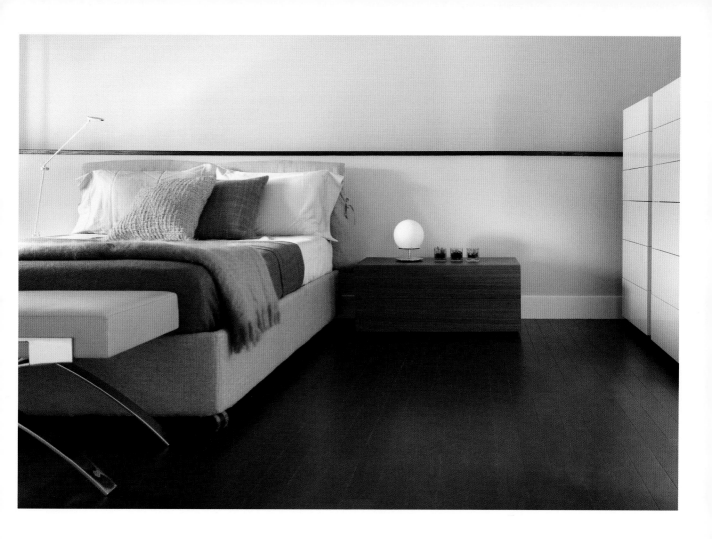

**Credits**

**Architect: Yoshida + Zanon**
**Design Atrium**
**www.yzdesignatrium.com**

**Appliances and Materials**

**Appliances:** Miele and Sub-Zero
**Kitchen cabinetry:** Poggenpohl

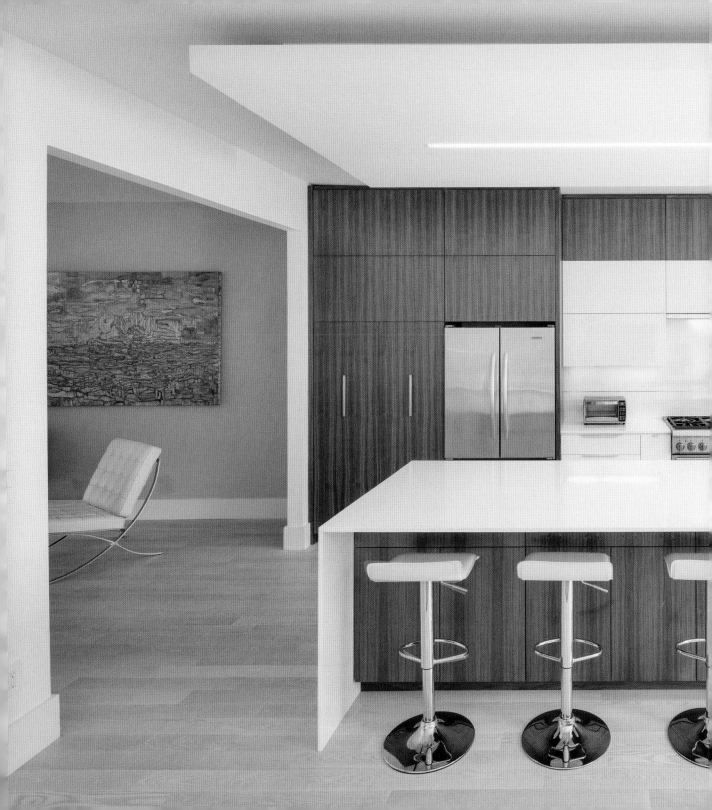

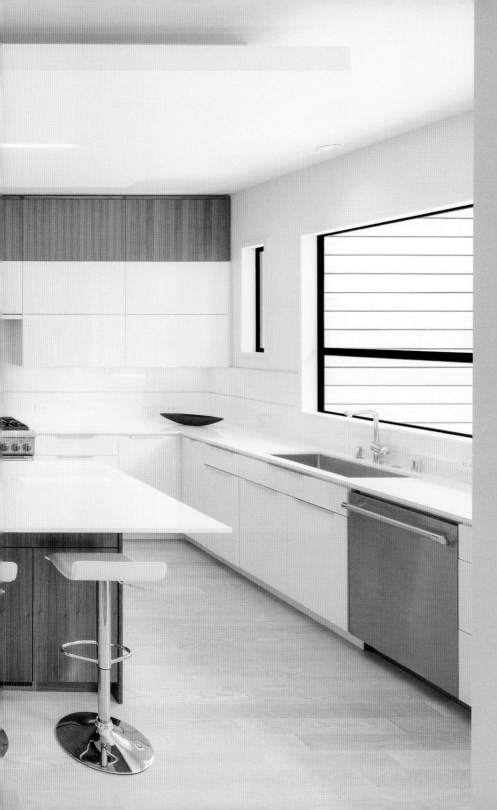

# 30TH STREET RESIDENCE

## 2,995 sq. ft.

San Francisco, California, United States

ROSSINGTON ARCHITECTURE

Photos © Tyler Chartier,
Open Homes Photography, Phil Rossington

Project team: Phil Rossington, Principal
Mason St.Peter

www.rossingtonarchitecture.com

> OPEN UP FLOOR PLAN

> ADD AN EXTRA BEDROOM AND BATHROOM

> IMPROVE ACCESS TO REAR YARD

> CREATE AN OFFICE THAT WOULD BE
  CONDUCIVE TO A PLEASANT WORK
  ENVIRONMENT

THE OWNERS NEEDED AT LEAST ONE EXTRA BEDROOM AND BATH, WANTED BETTER ACCESS TO THE REAR YARD, A MORE OPEN FLOOR PLAN, AND AN OFFICE THAT WOULD BE CONDUCIVE TO A HAPPY, HEALTHY WORK ENVIRONMENT.

"The house sits on a typical lot of a dense neighborhood, and the possibilities for extending the house were limited. Still, we were able to add to the rear of the house by digging the ground floor out. This allowed for a spacious living area, and an extra bedroom and bathroom upstairs. The reconfiguration of the basement required more attention in order to make it more space efficient and to better integrate it into the aboveground living spaces.

The back of the basement, behind the garage, had previously been turned into an office, with a toilet pushed into a corner—a temporary solution that, nonetheless, had been used for years. The program included an extra bedroom as well as a media room in addition to the office that already existed. Digging into the hillside to create these rooms and still allow ample light and air was a big challenge. How can these spaces feel like part of the house and not like a basement? Opening the basement to the rear yard was key and required significant earthwork.

As a result, the original two-bedroom, two-bathroom house was enlarged to four bedrooms and three and a half bathrooms. With an improved connection with the exterior, the rooms at the rear of the house, including the basement, can spill onto a spacious backyard on two levels, making the most of outdoor living."

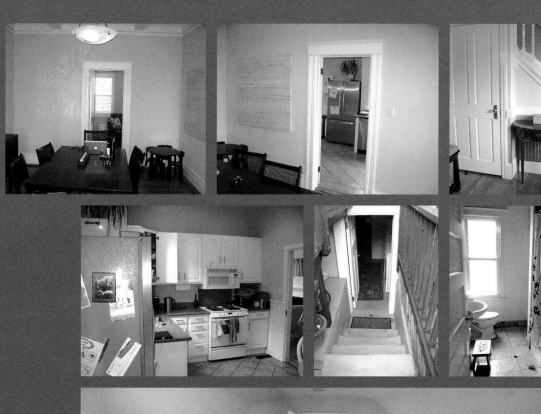
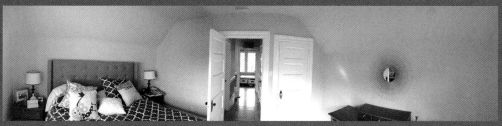

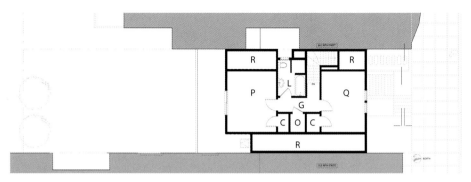

Existing third floor plan

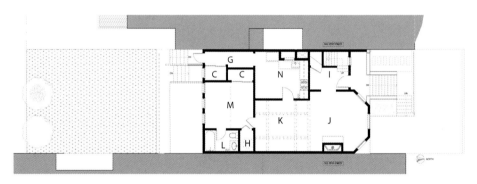

Existing second floor plan

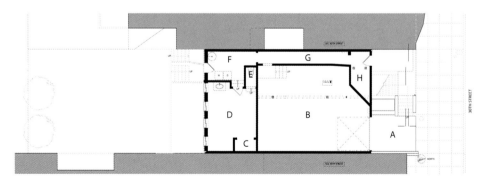

Existing garage floor plan

| | | |
|---|---|---|
| A. Driveway | G. Hall | M. Den |
| B. Garage | H. Storage | N. Kitchen |
| C. Closet | I. Entry | O. Linen |
| D. Office | J. Living area | P. Master bedroom |
| E. Toilet room | K. Dining area | Q. Bedroom |
| F. Laundry room | L. Bathroom | R. Attic |

The original two-bedroom and two-bath house was pretty typical of the period. Small, disconnected rooms were cut off from the rear yard by an ad hoc addition.

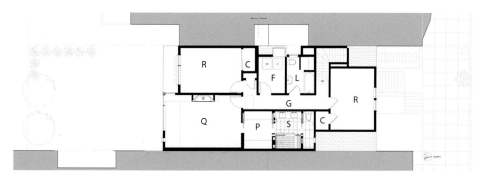

New third floor plan

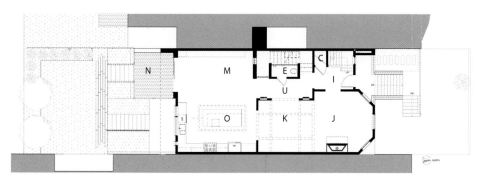

New second floor plan

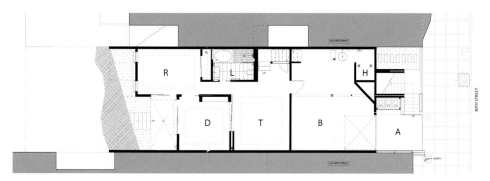

New garage floor plan

A. Driveway
B. Garage
C. Closet
D. Office
E. Powder room
F. Laundry room
G. Hall

H. Storage
I. Entry
J. Living area
K. Dining area
L. Bathroom
M. Lounge
N. Deck

O. Kitchen
P. Master closet
Q. Master bedroom
R. Bedroom
S. Master bathroom
T. Media Room
U. Foyer

The main level was blown out, and
the public spaces of the house
now flow freely into one another,
reflecting the way the owners live.

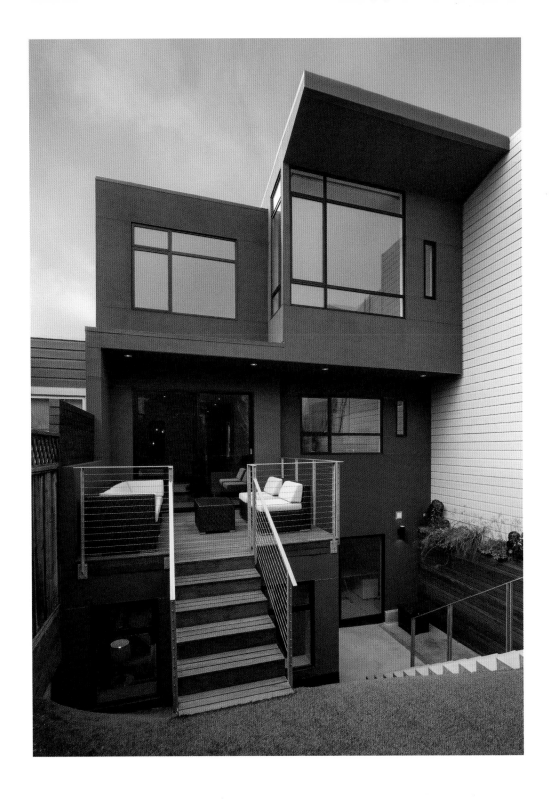

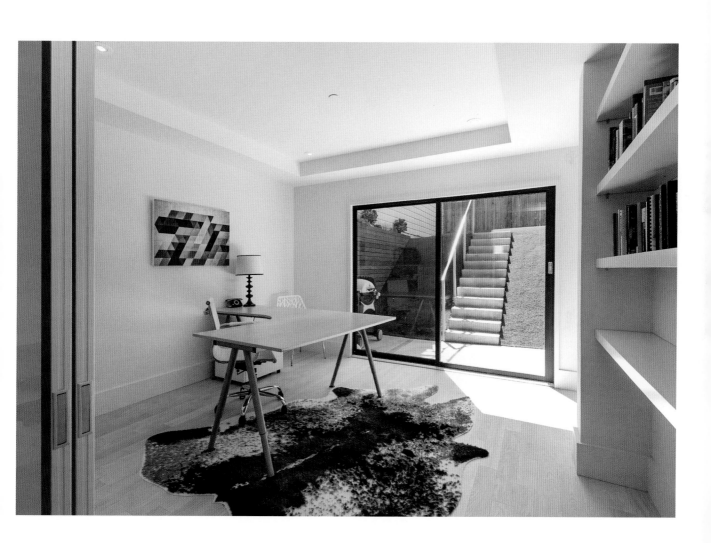

The ground was dug out, and a
sloping hillside with stair connects the
lower level to the rear yard and allows
a gracious visual link to the exterior.

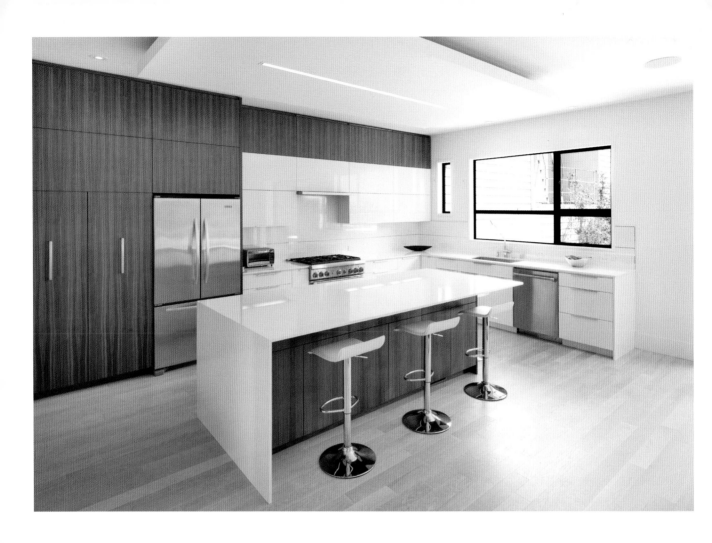

A waterfall counter grounds the island
while a lowered ceiling helps define
the overall kitchen.

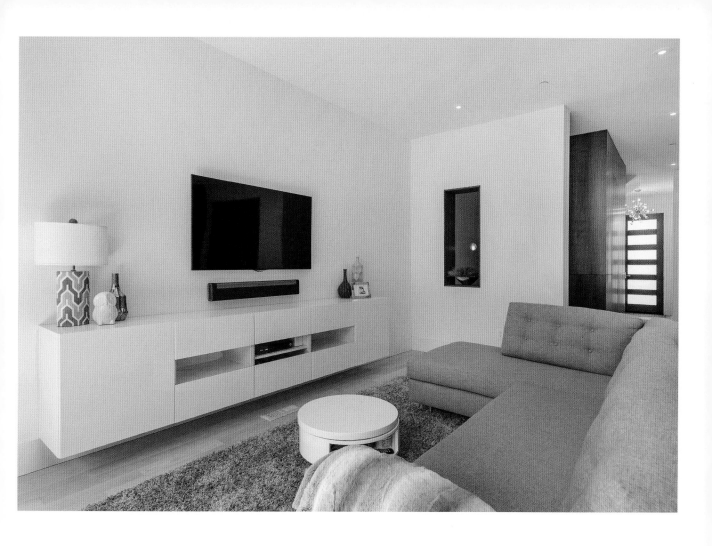

A play of stained rift-cut walnut and painted white cabinets creates a juxtaposition throughout the house, lightens things up, and reduces the scale of the cabinet work.

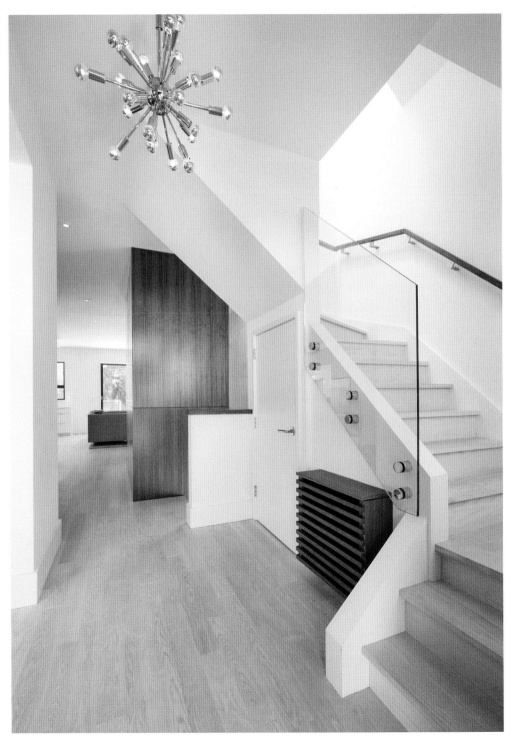

A new glass rail opens up the stair and a custom walnut-slatted box hides the return air grill.

A walnut-clad water closet forms the connector between the main level and basement level, as the stair winds around it and links the two levels.

Windows add visual interest to both
the interior and the exterior, while
corner windows in particular capture
light from various angles.

## Credits

**Architect: Rossington Architecture**
www.rossingtonarchitecture.com

**Color consultant: Gale Melton Design**
www.galemelton.com

**General contractor:**
Amber-Tru Construction
www.ambertruconstruction.com

**Structural engineer:**
SEMCO Engineering

## Appliances and Materials

**Appliances:** Bosch dishwasher, Sharp microwave, Thermador range
**Bathroom plumbing fittings:** Toto, Hansgrohe, Delta, Americh
**Cabinets:** Custom by New Century Custom Cabinets
**Countertops:** Cambria
**Flooring:** Coswick
**Hardware:** Inox, Baldwin, Amerock, Hafele

**Kitchen plumbing fittings:** Kraus, Grohe
**Lighting fixtures:** Elco, Wac, Moooi, Lithonia, Kina by David Trubridge, Modern Bathroom
**Paints and stains:** Benjamin Moore "Aura"
**Skylights:** Velux
**Sliding patio doors:** Fleetwood
**Windows:** Ventana

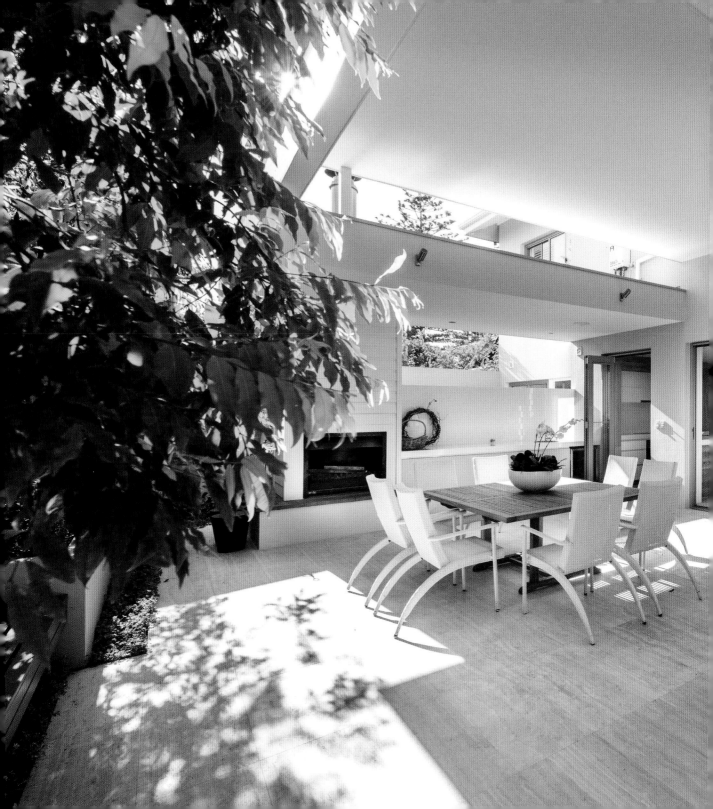

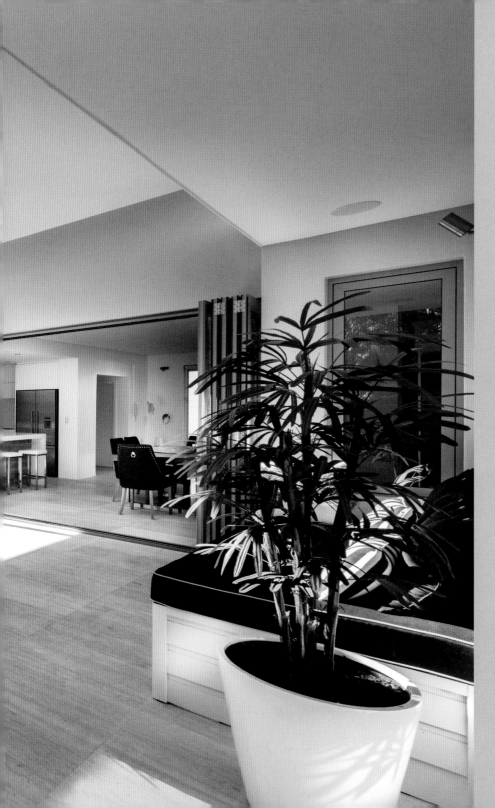

## OZONE

### 1,615 sq. ft.

**Cottesloe, Western Australia, Australia**

---

**SWELL HOMES**

Photos © Joel Barbitta

Project team: Anthony Pillinger, Ben Lamond, Helen Oo, Andrew Annandale, Steve Dickie, Matty Readhead, Jimmy Baker, Nick Ling

www.swellhomes.com.au

> ENSURE THAT THE RENOVATION FITS WELL WITHIN THE ARCHITECTURAL CHARACTER OF THE NEIGHBORHOOD

> ENSURE THAT THE HOME FLOWS SEAMLESSLY FROM OLD TO NEW AND FROM INTERIOR TO EXTERIOR

> CONCEAL THE NONDESCRIPT STYLE OF THE ORIGINAL BUILDING BEHIND THE NEW WORK

> KEEP COSTS DOWN

OUTSTANDING CRAFTSMANSHIP AND FINE DESIGN FLAIR COME TOGETHER FOR A TIMELESS AND MODERN RENOVATION AND EXTENSION OF A 1970S TWO-STORY HOUSE.

---

"Interior and landscape designer Liz Prater approached us to carry out the transformation work of her 1970s two-story house into a modern home. The new house had to fit well within her requirements as well as within the scale and architectural character of the neighborhood. The project was in fact a collaboration that made the most of Liz's flair for design and our ability to tackle complex extension and renovation work.

We maintained the structure to take advantage of the original planning decisions. Had we demolished the building to build a new one, we would never got the same tight setbacks. Keeping the existing house also had economical benefits, as it kept down the costs associated with the repair of the adjacent property's roof and walls.

Because the house has an addition, the challenge was to ensure that the home would flow seamlessly from old to new. The fabric of the building was substantially altered and walls were removed to make this happen, but the goal was achieved successfully and the transition was made unnoticeable. For instance, the living area is new, but the kitchen is existing. The original, nondescript style of the building was completely hidden behind the new work. Except for a few details, one can hardly tell that the house is actually the remodel of an existing building.

While the house isn't particularly large, its striking charm projects a strong sense of spaciousness."

---

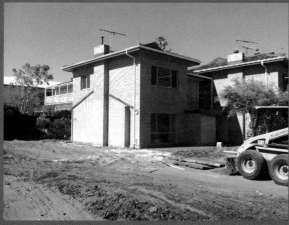

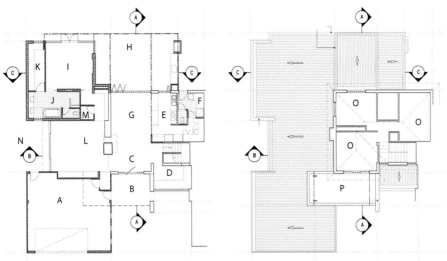

New ground floor plan

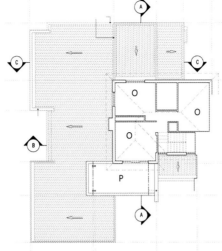

New second floor plan

A. Garage
B. Porch
C. Entry
D. Study
E. Kitchen
F. Laundry room
G. Dining area
H. Outdoor dining area

I. Bedroom
J. Bathroom
K. Walk-in closet
L. Family room
M. Storage
N. Courtyard
O. Existing
P. Balcony

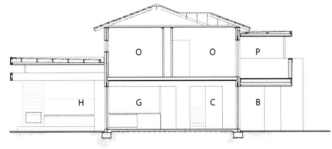

Section A

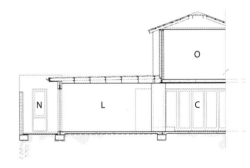

Section B

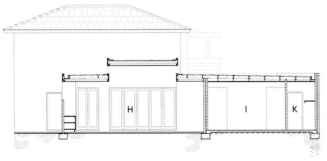

Section C

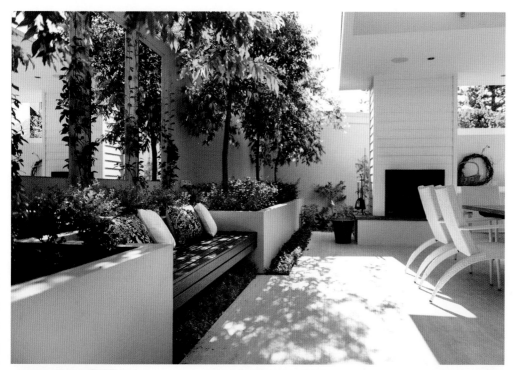

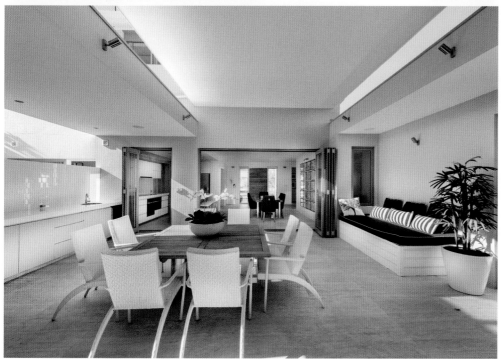

The living room, which opens up to an alfresco dining area with an outdoor kitchen, a wall-mounted fireplace, and built-in benches designed by Liz Prater, is suited for entertaining year round.

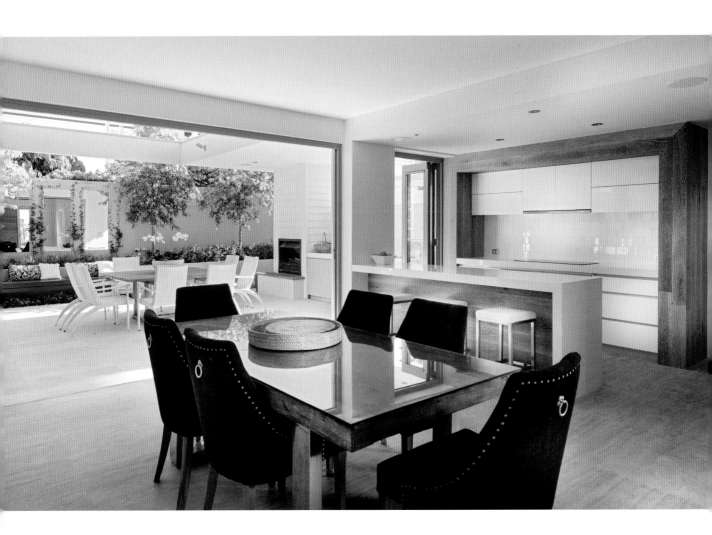

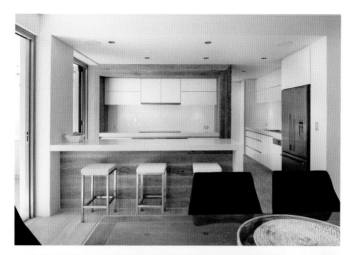

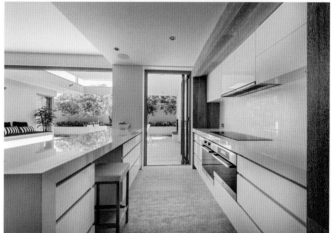

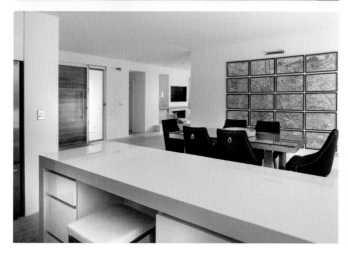

Travertine was used throughout the house, both in exterior and interior spaces, to create a feeling of continuity. The oak cabinets in the living area, kitchen, and bathroom contribute to this feeling, too, and help to unify the whole design.

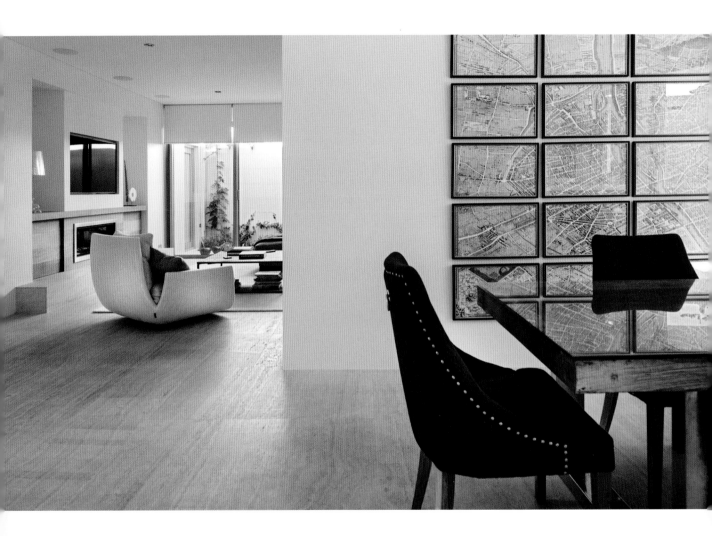

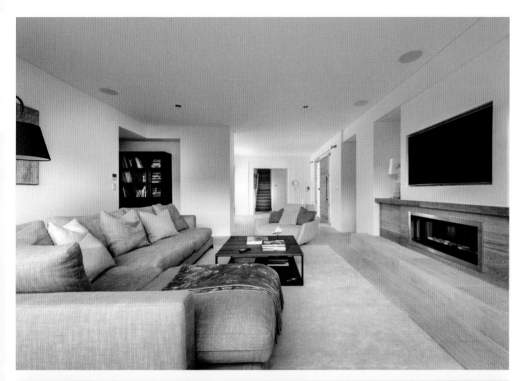

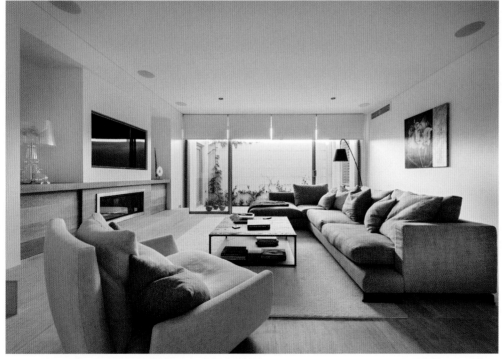

Areas are clearly demarcated, mainly by the arrangement of furniture. Walls act more like planes that guide circulation rather than as building components to enclose rooms.

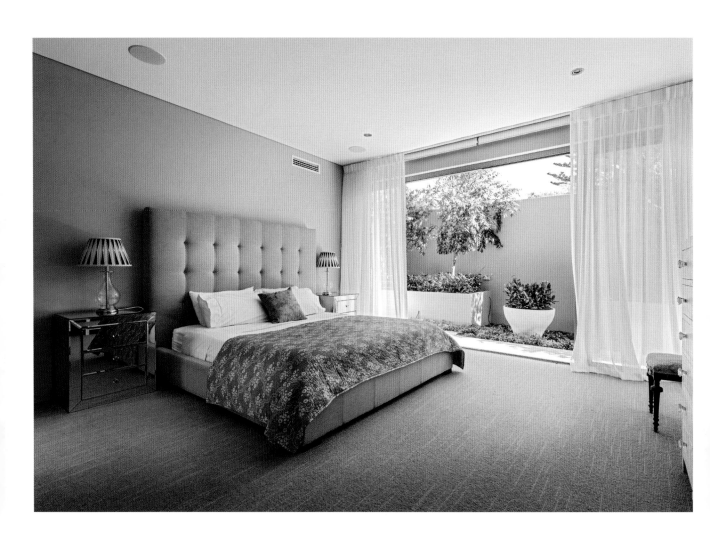

The master bedroom has a private
courtyard that offers privacy and
harmonizes with the light color scheme.

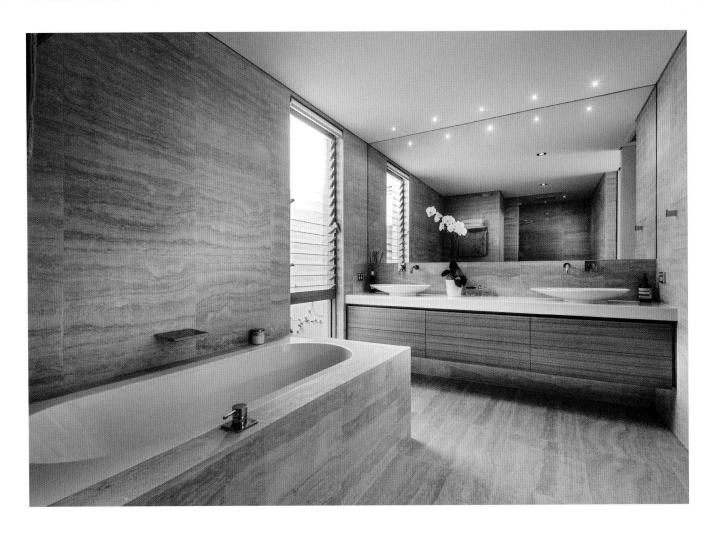

The floating vanities in the bathrooms
increase the sense of space, as do
the sleek materials, wall-to-wall
mirrors, and large windows that let in
abundant natural light.

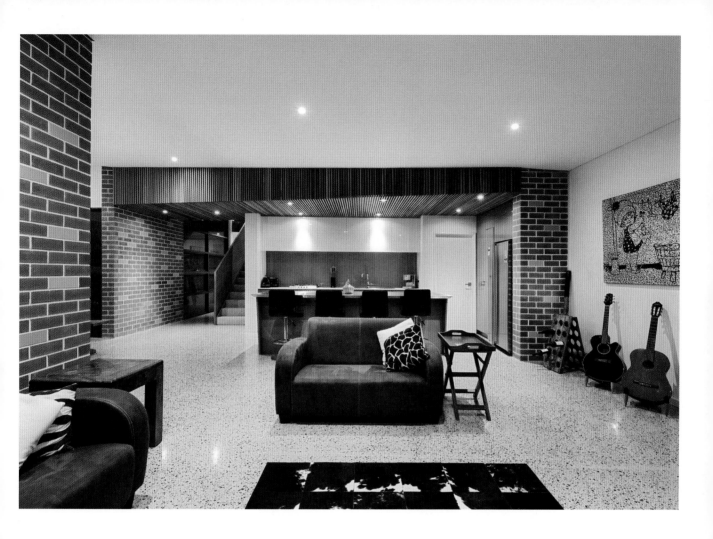

## Credits

**General contractor: Swell Homes**
www.swellhomes.com.au

**Building designer:**
**Karl Spargo Building Designs**

**Interior designer:**
**Liz Prater Design Home**

## Appliances and Materials

**Appliances:** Miele
**Ceilings:** WA White paint
**Kitchen countertops:** Silestone
"Yukon"
**Outdoor fireplace insert:** Subiaco
Restoration
**Selected furniture:** Camerich, Osborne
Park
**Walls:** Dulux, "Antique white" paint

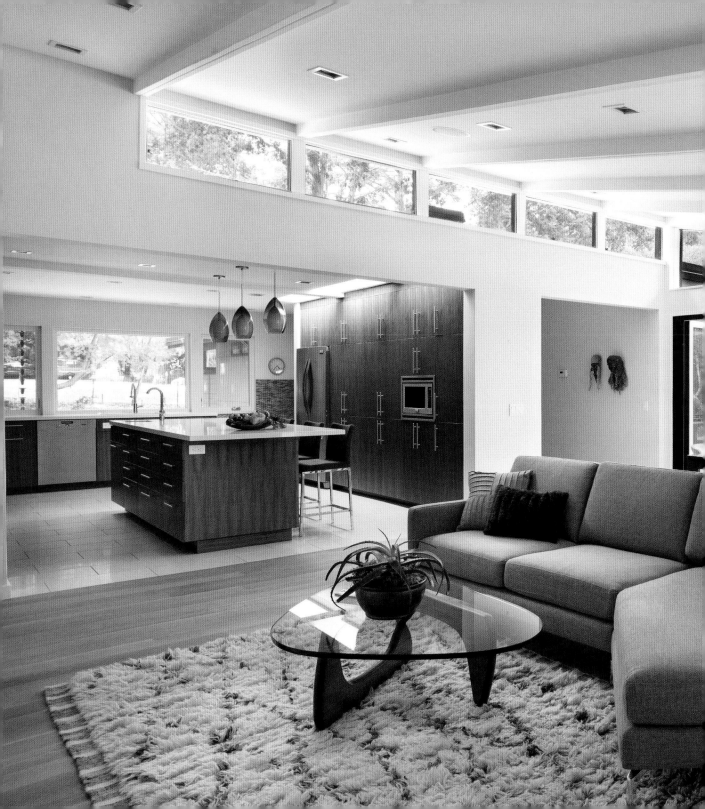

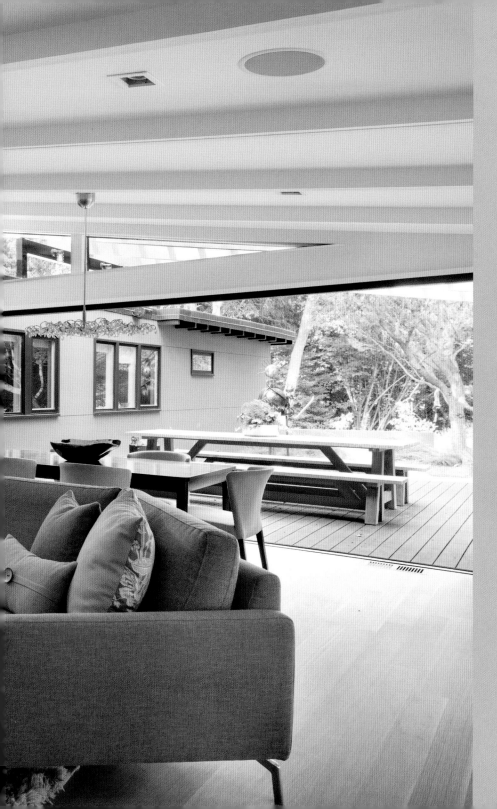

# LAFAYETTE MCM REMODEL

## 3,363 sq. ft.

Lafayette, California, United States

———

**KLOPF ARCHITECTURE**

Photos © Mariko Reed

Project team: John Klopf, Jackie Detamore, Jeffrey Prose, and Angela Todorova

**www.klopfarchitecture.com**

> CREATE A SOPHISTICATED, COMFORTABLE, UP-TO-DATE HOUSE, OPEN TO THE OUTDOORS

> REMODEL AND OPEN THE KITCHEN TO THE MAIN SPACE

> CONVERT CARPORT AT THE FRONT OF THE HOUSE INTO A TWO-CAR GARAGE

> GIVE AWAY SOME SPACE FROM THE OVERLY LARGE MASTER BEDROOM TO CREATE A LAUNDRY ROOM, FAMILY ROOM, HOME OFFICE, WALK-IN CLOSET, AND MASTER BATHROOM

> PROVIDE LOW-MAINTENANCE EXTERIOR MATERIALS, WELL-INSULATED SURFACES, AND WALLS BUILT WITH "RAIN SCREEN" CONSTRUCTION

THE OWNERS OF THIS PROPERTY HAD BEEN AWAY FROM THE BAY AREA FOR MANY YEARS AND LOOKED FORWARD TO RETURNING TO A SOPHISTICATED MODERN HOME FOR THEIR FAMILY OF FIVE.

"The property is a wooded flag lot away from traffic and noise, with a small creek running through the back. One drives down a shared driveway from the main road and ends up at a small parking area embraced by an L-shaped house and an open carport. Also on the property is a small annex structure that might have been used as an office. The house was a mid-century modern home that had its kitchen remodeled, and a haphazard bedroom/family room added from another renovation. It was otherwise disjointed and for the most part run down. The siding was redwood, which is the only reason the house was still salvageable since redwood is rot resistant, but on the other hand, the roof was an old, leaky tar-and-gravel.

The owners wanted a house with an open plan that was open to the outdoors. The only space the client wanted to have closed was the carport, as it was the first thing one sees when driving up to the house and they did not like the incomplete look the carport had."

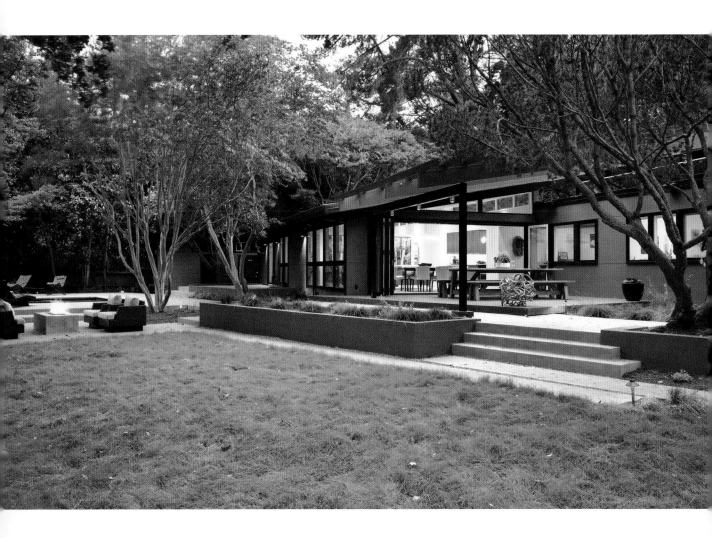

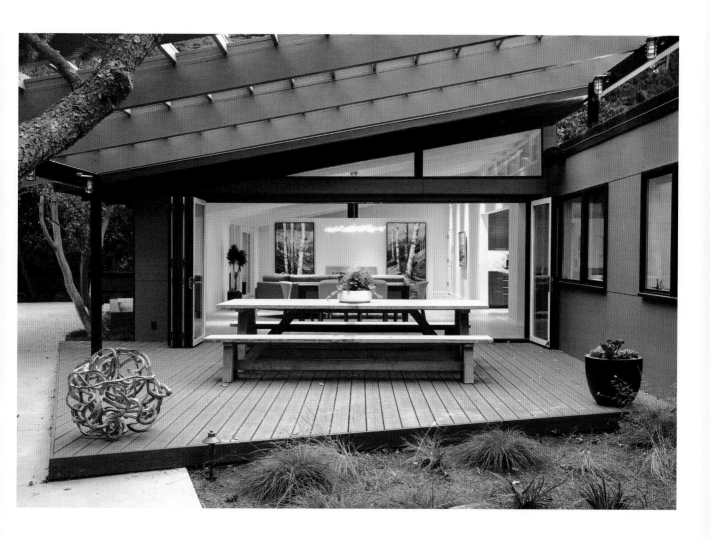

A dark, solid roof structure over the patio was replaced with an open trellis that allows natural light to brighten up the new deck and the interior of the house.

A. Garage                  J. Laundry room
B. Powder room             K. Bathroom
C. Dining area             L. Master bathroom
D. Family room             M. Master bedroom
E. Kitchen                 N. Office
F. Bedroom                 O. Dressing room
G. Closet                  P. Walk-in closet
H. Water heater room       Q. Living area
I. Mechanical room         R. Mudroom

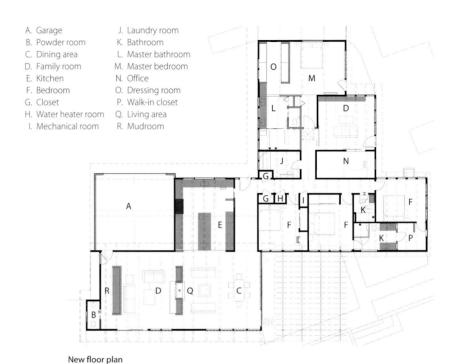

**New floor plan**

A. Carport                 H. Water heater room
B. Powder room             I. Mechanical room
C. Dining room             J. Laundry room
D. Family room             K. Bathroom
E. Kitchen                 L. Master bathroom
F. Bedroom                 M. Master bedroom
G. Closet                  N. Den

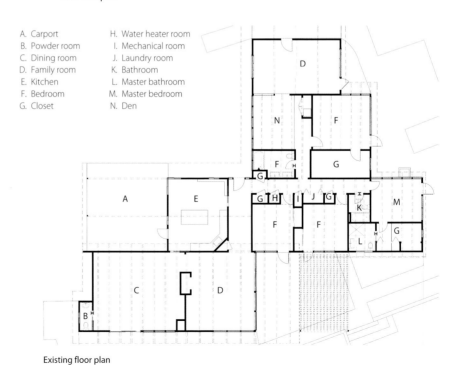

Compared to the original house, the
new layout flows from the kitchen
to the living and dining room and to
the deck seamlessly, making the main
entertainment space feel unified
and complete, and at the same time,
open and limitless.

**Existing floor plan**

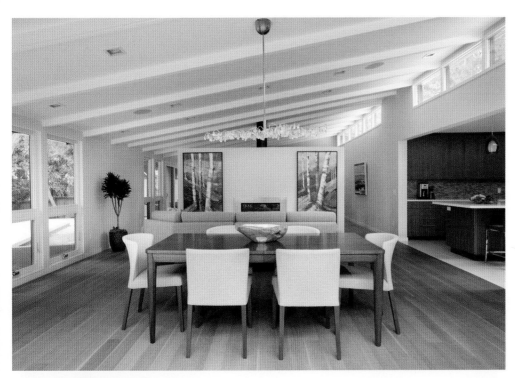

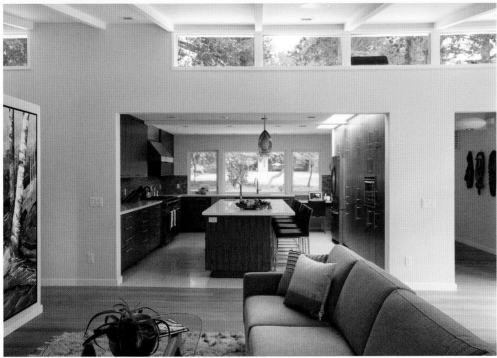

The formerly disjointed kitchen with seven-foot-high ceilings was opened up to the living room, reoriented, and finished with skylights, bringing light into the new spacious cooking area.

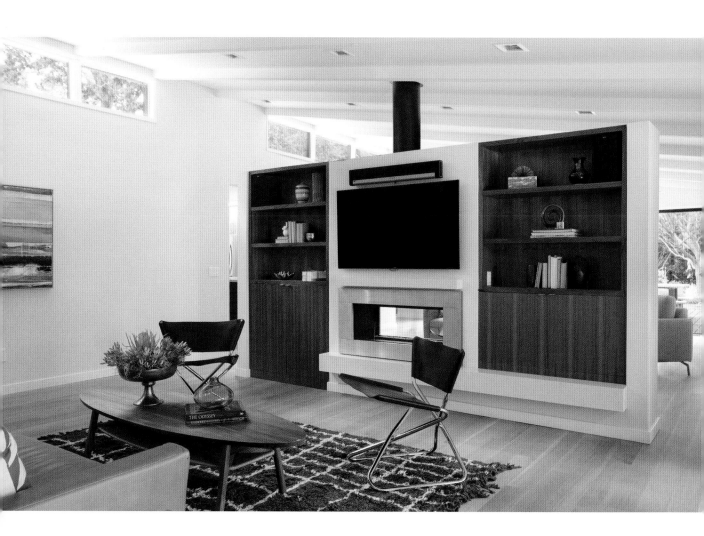

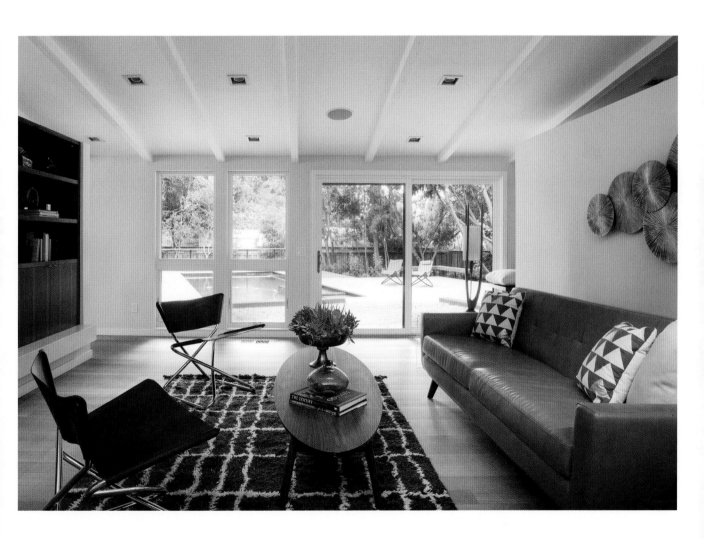

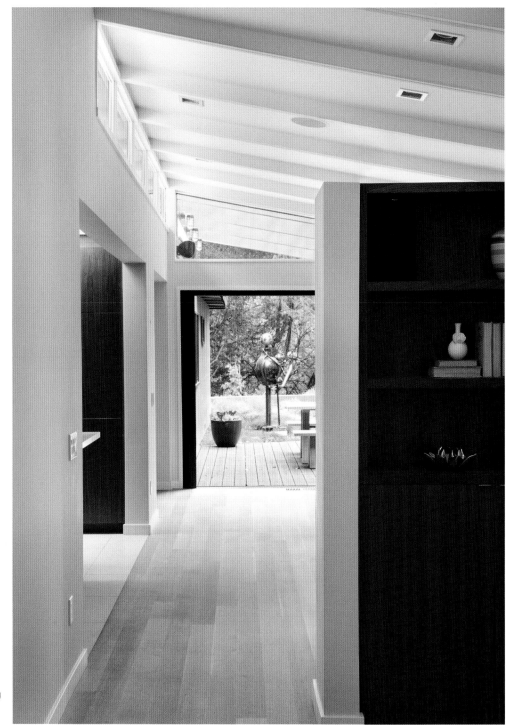

Adjacent to the kitchen, the living room wall was replaced with a folding door system, connecting the interior living space to a new wood deck. The use of similar wood flooring material inside and outside enhances the feeling of continuity.

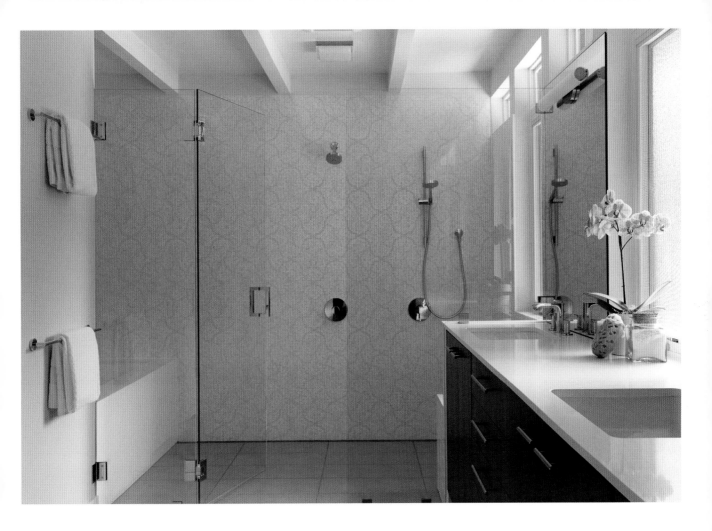

## Credits

**Architect: Klopf Architecture**
www.klopfarchitecture.com

**General contractor:**
**Kasten Builders**
www.kastenbuilders.com

**Landscape designer:**
**Envision Landscape Studio**
www.envisionlandscapestudio.com

**Structural engineer:**
**Brian Dotson Consulting Engineers**
www.bdcengineer.com

## Appliances and Materials

**Bathroom tile:** Neostile
**Countertops:** Caesarstone "Frosty Carrera"
**Flooring:** Maple

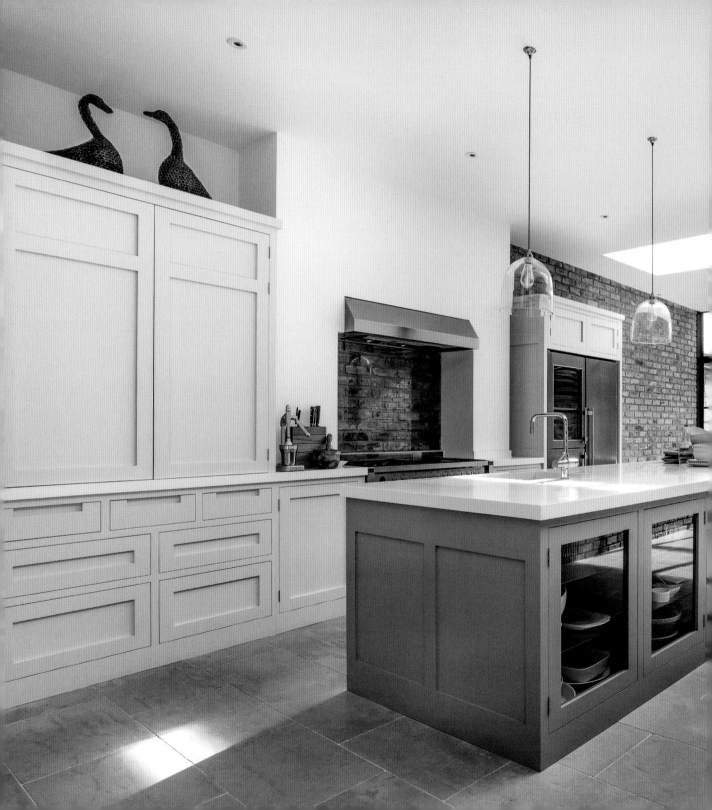

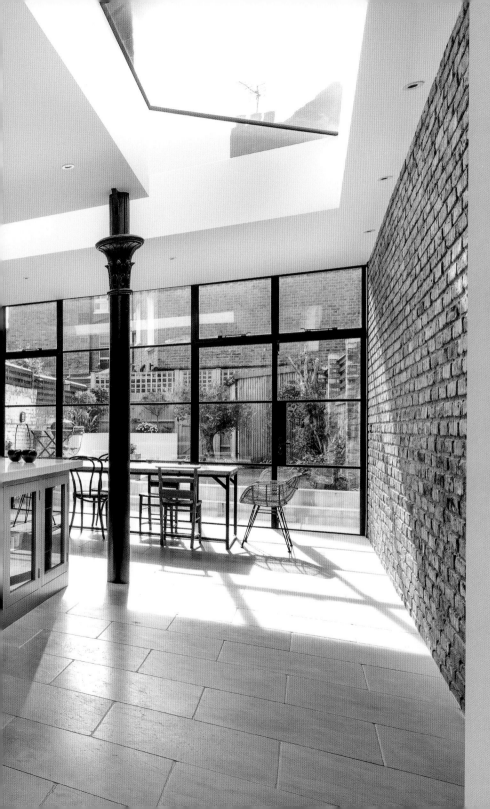

# WANDSWORTH COMMON WESTSIDE

## 2,400 sq. ft.

Wandsworth, England, United Kingdom

---

**GRANIT ARCHITECTS**

Photos © Andrew Beasley

Project team: **James Munro**, Architectural director
**Ben Hawkins**, Associate architect

**www.granit.co.uk**

> OPEN UP THE HOUSE O THE REAR TO CREATE
AN OPEN PLAN AND WELL LIT KITCHEN AND
DINING SPACE WITH STRONG DESIGN STYLE

> CREATE A CONNECTION BETWEEN THE FRONT
AND REAR OF THE HOUSE, ALLOWING FOR
A SEAMLESS FLOW FROM SITTING ROOM TO
KITCHEN AND TO GARDEN

> RENOVATE THE HOUSE THROUGHOUT WITH
PARTICULAR FOCUS ON THE GROUND FLOOR

> ACHIEVE A STANDOUT DESIGN USING
A MIXTURE OF CONTEMPORARY AND
TRADITIONAL MATERIALS

## JULIA AND BERI LIVED IN THEIR PROPERTY THROUGHOUT THE DURATION OF THE REMODEL. WITHOUT A DOUBT, THAT WAS THE BIGGEST CHALLENGE THEY HAD TO FACE.

"The clients, Julia and Beri, decided to refurbish their Victorian terraced house in London to create a modern family home.

We met with the couple to discuss their ideas and to develop a design brief. They were both creative professionals and understood the value of a clearly defined brief to achieve the result they wanted.

The eventual plan was to open the ground floor up to create a large space in the kitchen and dining room. To do this, we decided to extend the space into the garden and to the side of the kitchen. We also agreed on lowering the floor to provide a level threshold with the garden, while we were fully aware that some complications might come up because we were working around the existing foundations.

All the goals were achieved with spectacular results, and Beri had nothing but praising words for the work achieved: 'At no time do we ever walk into our extension and feel anything other than in love with what had been created. The changing light throughout the year makes the work feel new and fresh every time you look at it. And we hadn't had friends or family walk in and say anything other than "wow!" when they see it. The space that's been created is life changing for us.'"

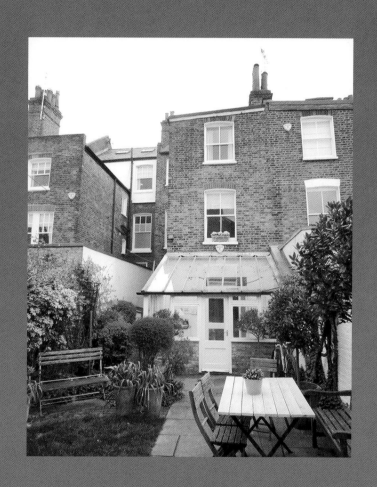

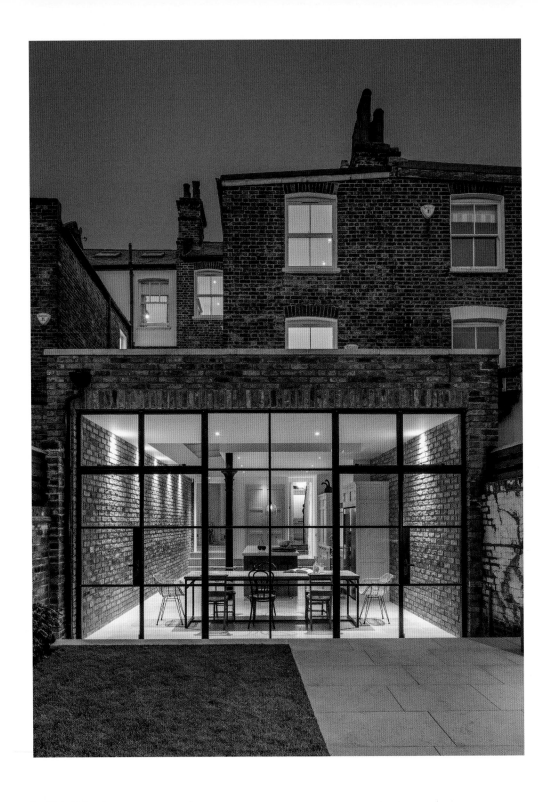

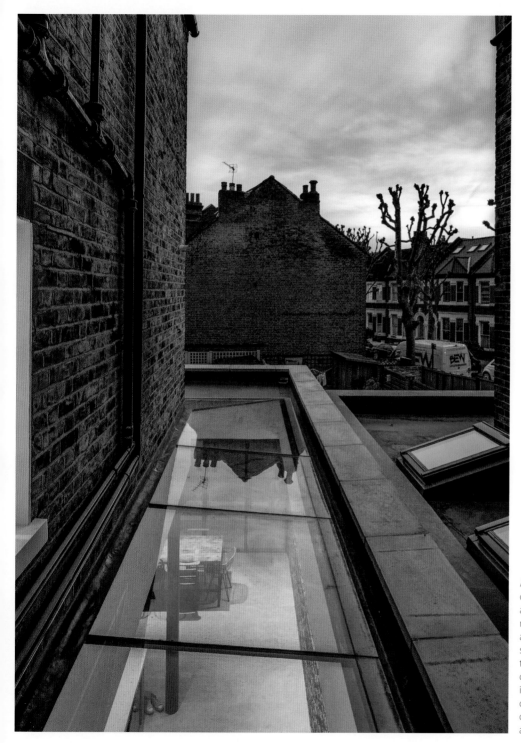

A large L-shaped skylight was designed to sit above the kitchen and dining space, and a column rather than a steel beam was used across the back of the house to support the upper floor and to enable the skylight's dramatic change of direction. Achieving a seamless join in the glazing where the two pieces of the L shape met was a significant challenge in its design, manufacture, and installation.

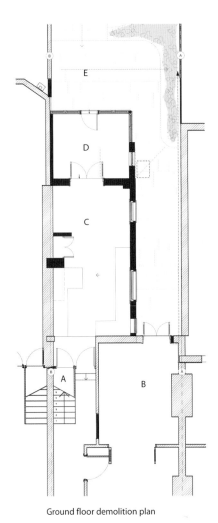

Ground floor demolition plan

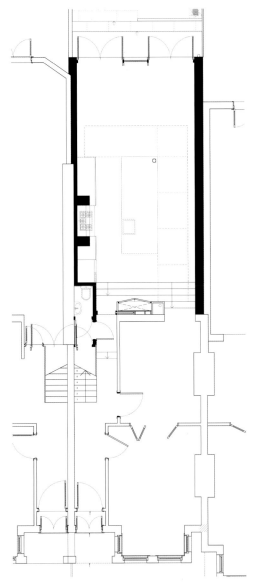

New ground floor plan

A. Hallway
B. Living room
C. Kitchen
D. Conservatory
E. Garden

Most of the work was concentrated on the ground floor, where a conservatory was removed in its entirety, and the kitchen's rear and side wall were demolished.

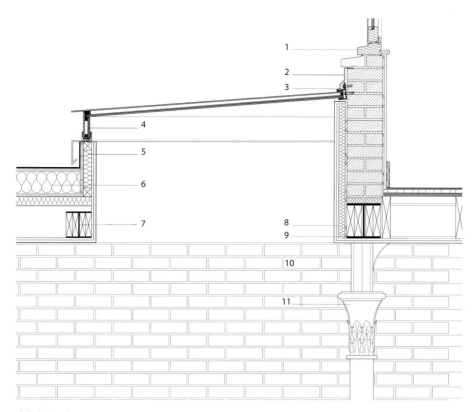

## Skylight detail

1. Existing white painted timber sash window retained and refurbished
2. L shaped skylight flashed into existing brickwork and under existing stone sill
3. L shaped skylight frame fixed to existing wall
4. L shaped skylight with glazed upstand
5. 150 mm timber frame upstand with insulation between. GRP roof lapped up and dressed under skylight
6. New warm roof build up
7. Blocking to engineer's specifications
8. Plasterboard bonded insulation fixed to existing brickwork on dot and dabs
9. New I-beam at party wall
10. Reclaimed London stock brick wall, pointing to be recessed
11. Reclaimed structural and ornamental column

The skylight opens up the space, making it feel more expansive and airy. From an aesthetic point of view, it adds an architectural feature that enriches the spatial experience.

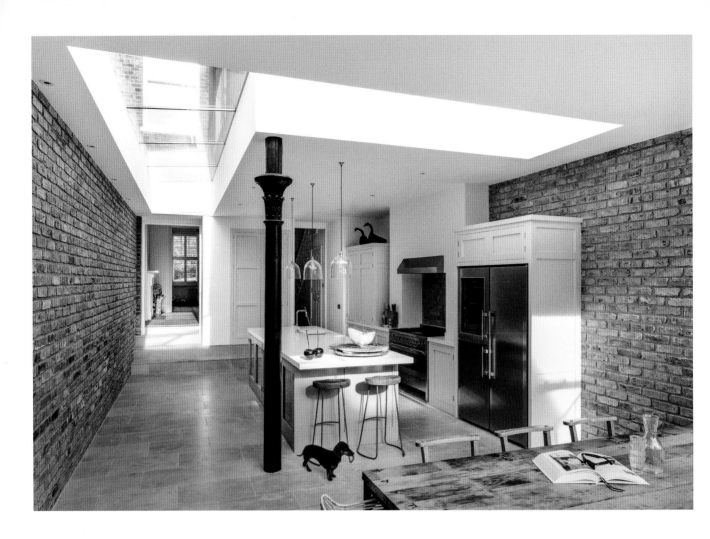

The skylight enhances the sense of space and almost suggests the house is floating above the kitchen. The column was reclaimed from an old bandstand. It gives the kitchen some character, while creating its own engineering challenge, as it was not custom-designed for the space.

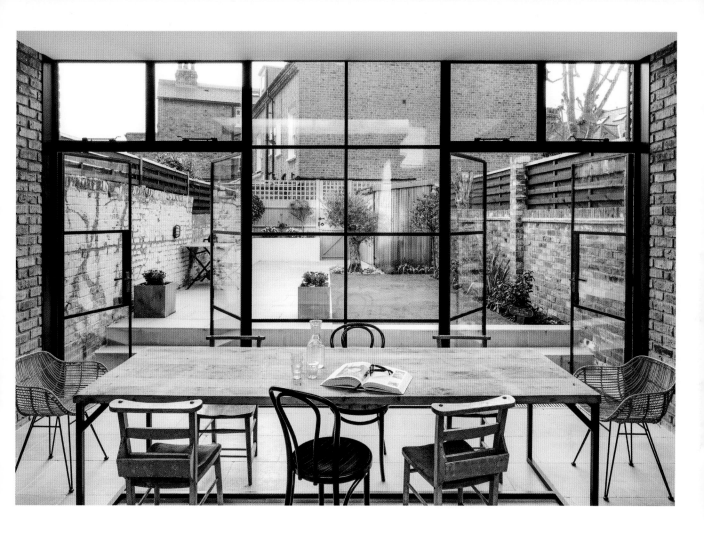

Original finishes and features such as the parquet flooring and the staircase millwork remain in stark contrast with the minimalistic extension.

**Credits**

Architect:
GRANIT Architecture and Interiors
www.granit.co.uk

Structural engineer: Mitchinson
Macken, Chartered Structural and
Civil Engineers
www.mitchinsonmacken.co.uk

**Appliances and Materials**

Hallway floor: Existing tiles, refurbis-
hed
Kitchen: Bespoke joinery by Higham
Kitchen doors: Crittal Style Doors by
Fabco Sanctuary
Kitchen tiles: Montpellier Gris flagsto-
ne by Pietra Tiles
Kitchen walls: London stock brick
Sitting room: Parquet flooring
Skylight: Custom glazing by Klent Blaxill

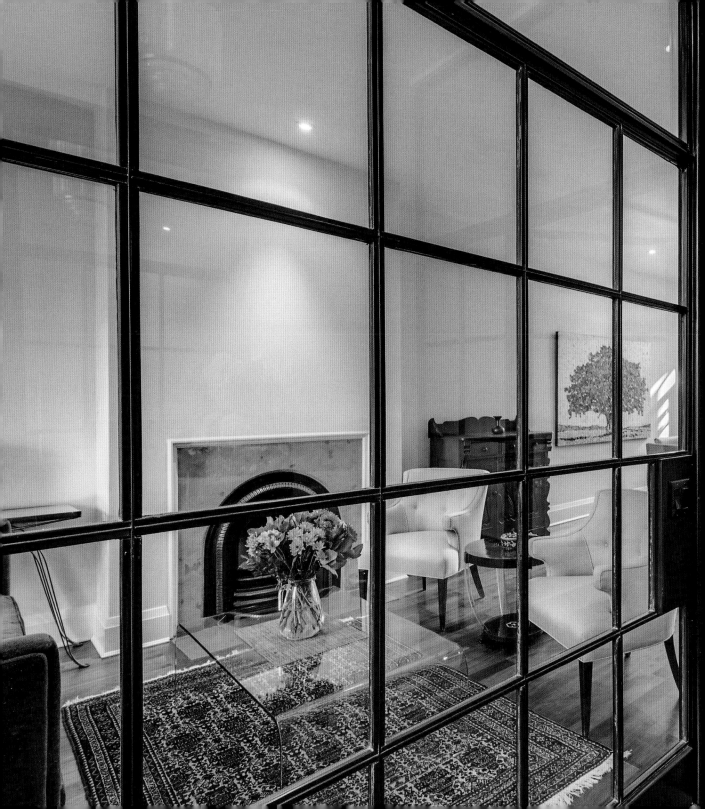

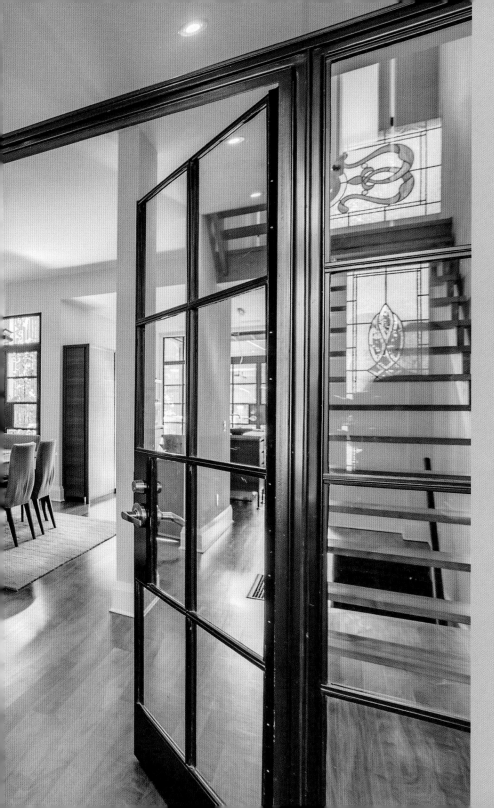

Project team: Gloria Apostolou, Principal

**www.postarchitecture.com**

> OPEN UP INTERIOR SPACES TO BRING IN VIEWS OF THE SOUTH-FACING REAR YARD AND TO BRIGHTEN THE INTERIORS

> INTEGRATE THE OWNER'S ANTIQUE FURNITURE PIECES AND ROCK AND DRIFTWOOD COLLECTIONS INTO HER CITY DWELLING

> MAINTAIN SOME OF THE HISTORICAL FEATURES, WHERE POSSIBLE

> GIVE THE MASTER BEDROOM A SENSE OF PRIVACY, AS OPPOSED TO THE OTHER SPACES, WHICH SHOULD BE INTERCONNECTED WITH FLEXIBLE BOUNDARIES ABLE TO CHANGE AS NEEDED, AND OPEN TO DYNAMIC VIEWS

A MASTER PLAN FOR A THREE-STORY, NINETEENTH-CENTURY VICTORIAN ROW HOUSE OPENS UP THE SPACES TO BRING IN VIEWS OF THE SOUTH-FACING REAR YARD AND TO BRIGHTEN THE INTERIORS.

"Nothing about the interiors reflected the style of our client. She had lived in the house for twelve years without even repainting the rooms, because she wanted it to be thought out beforehand. She said she bought the house for the flowering lilac tree that was just outside the kitchen. At the time the owner bought the property in the late 80s, it cost more than her three siblings' houses in the country put together. Phasing the work, allowed her construction budget to also grow with the value of the housing market. She could easily sell it today for twice what she put into the remodel.

The client decided to tackle only the upper levels of the house—ground, second and third—in the first phase of construction, due to budget constraints. The owner just wanted the master bedroom to have a sense of privacy, which left all the other spaces open to dynamic views, interconnected spaces and flexible boundaries which could change as needed. Sliding doors, screens, and flexible spaces were used to maximize the use of the house. Ten years later, we were brought back in to underpin the basement, and address front and rear yard access to the house with a new, modern landscaping treatment in mind.

The client's motto throughout the design process was that you had to love what you are doing/building or not bother, and she exercised that philosophy with each design choice she made along the way, halting construction when funds ran low, then resuming when she was ready. This project was built over a period of twelve years."

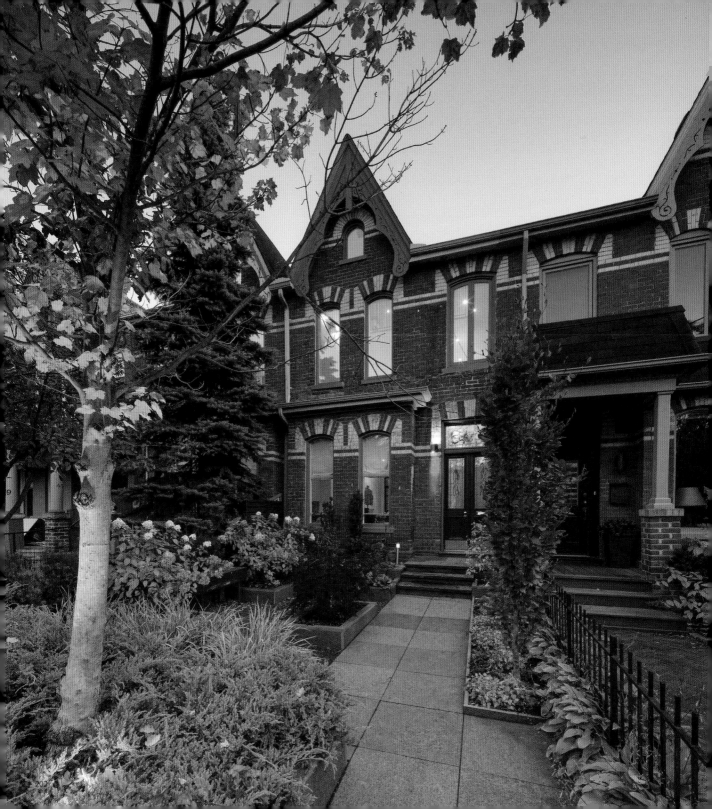

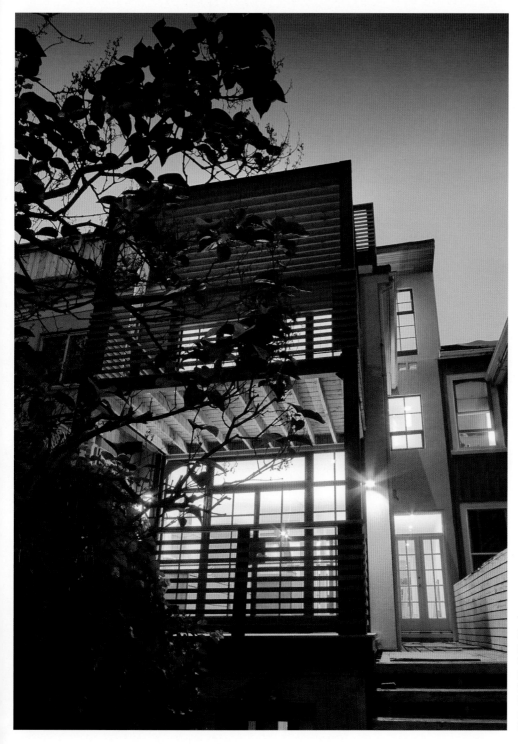

The front of the house is Heritage Protected, which means that any proposed changes to this facade would have to be of the 1880s, the period when it was built. The street facade, therefore, hasn't changed, but the rear of the house was opened up with large windows, from the basement to the top floor.

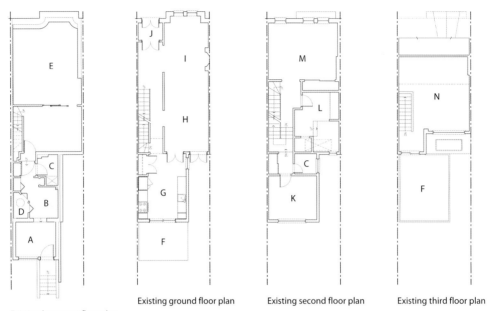

Existing basement floor plan

Existing ground floor plan

Existing second floor plan

Existing third floor plan

A. Mudroom
B. Laundry room
C. Bathroom
D. Mechanical room
E. Studio

F. Deck
G. Kitchen
H. Dining area
I. Living area
J. Vestibule

K. Bedroom
L. Master bathroom
M. Master bedroom
N. Study

The existing house had small rooms, with small windows to the front and rear, as was typical of that era. The house was 16-feet wide, with the back section of the house stepping in for a total width of 11 feet for the kitchen and the master bedroom above, on second floor.

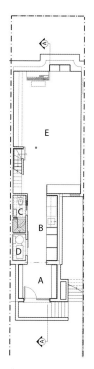

New basement floor plan

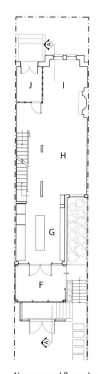

New ground floor plan

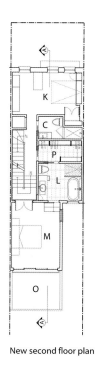

New second floor plan

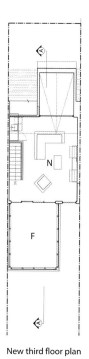

New third floor plan

A. Garden room
B. Storage / laundry area
C. Bathroom
D. Mechanical room
E. Music room
F. Deck

G. Kitchen
H. Dining area
I. Living area
J. Vestibule
K. Guest room / office
L. Master bathroom

M. Master bedroom
N. Den/TV room
O. Flat roof below
P. Walk-in closet

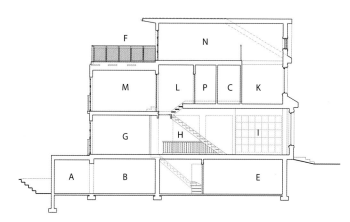

New building section AA

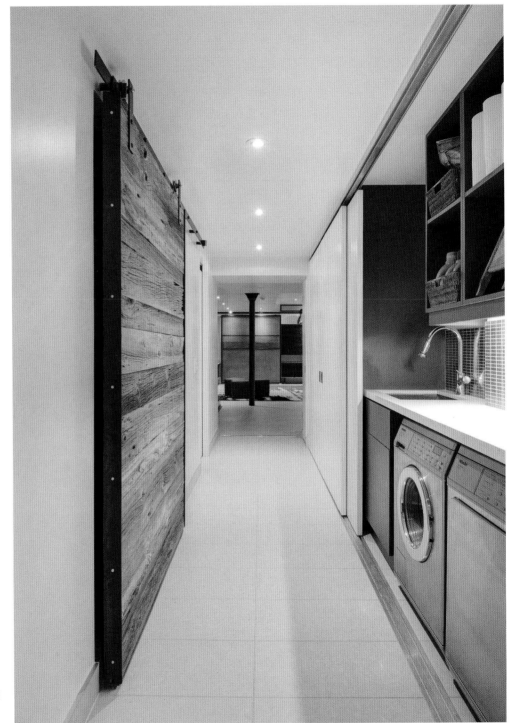

The basement was reconfigured to serve as a music room as well as an overflow space for large family gatherings. The basement also accommodates a garden room, laundry room, bathroom, mechanical room, and storage, freeing up space on the upper floors.

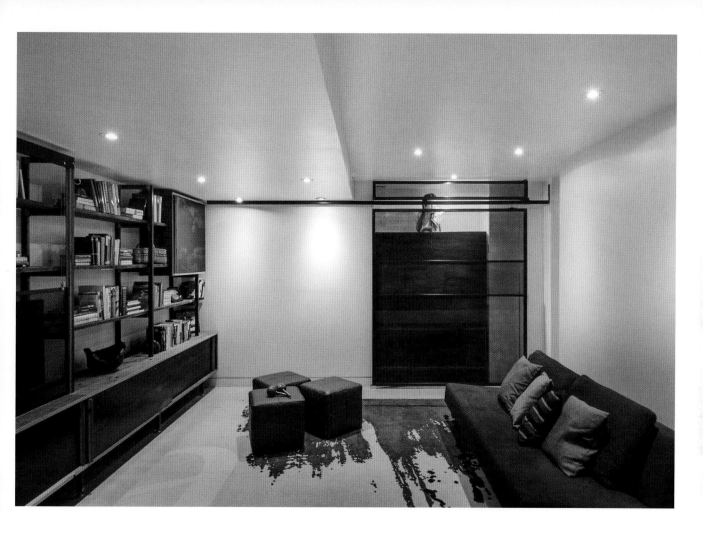

A sliding barn door was made out of salvaged boards from the client's family farm; reclaimed pine, acid-washed steel panels, and perforated metal screens were used to fabricate the large shelving unit and storage door in the music room.

The owner of the house wanted to integrate her antique furniture pieces and rock and driftwood collections into her new home. The architects decided on exposed steel and concrete as a material—and construction—palette. These finishes bridged the design sensibilities of Victorian-era industrialization and modern, bright interiors.

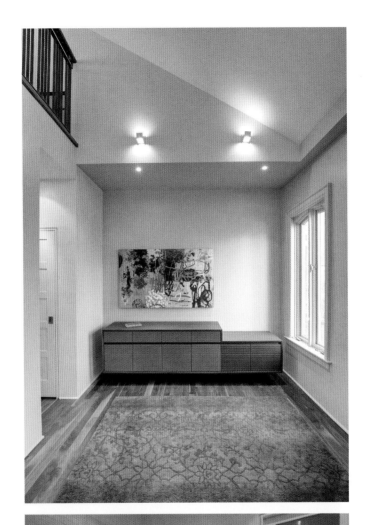

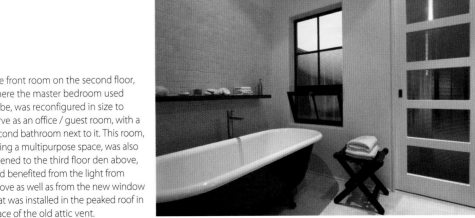

The front room on the second floor, where the master bedroom used to be, was reconfigured in size to serve as an office / guest room, with a second bathroom next to it. This room, being a multipurpose space, was also opened to the third floor den above, and benefited from the light from above as well as from the new window that was installed in the peaked roof in place of the old attic vent.

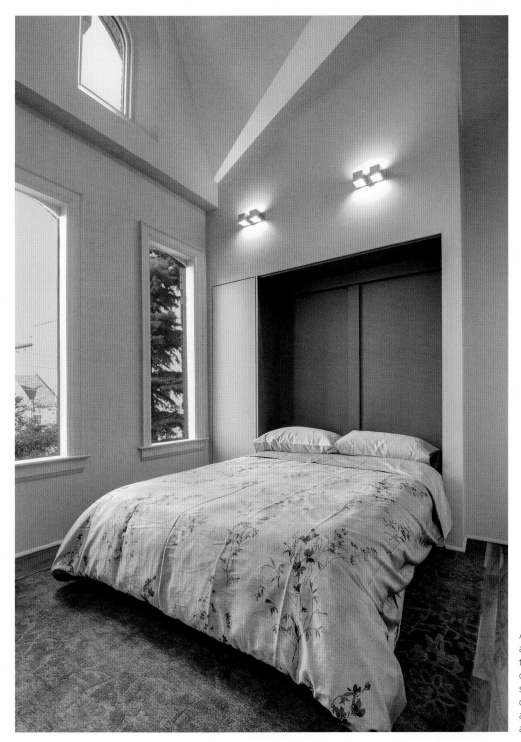

A custom Murphy bed was built and recessed into the east wall of the guest room, and a credenza was designed and built on the opposite side for office file storage. Both were devised to minimize furnishings and center the attention on the architectural features of the room.

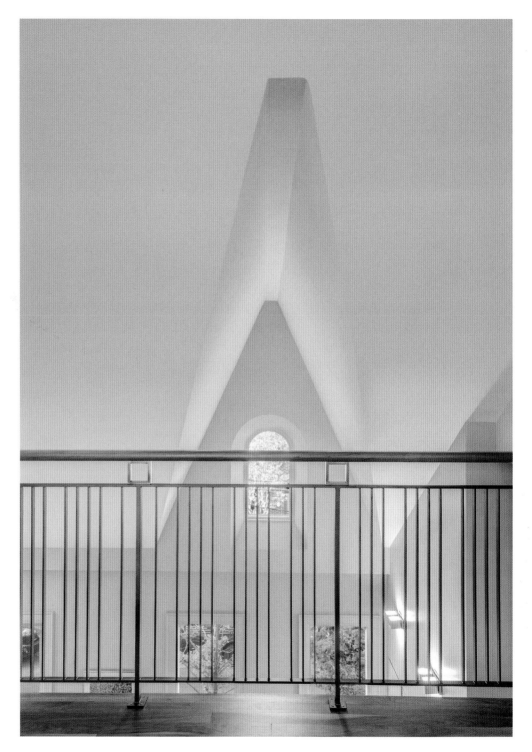

The existing roof dormer was exposed and incorporated into the cathedral ceiling over the second floor den-guestroom.

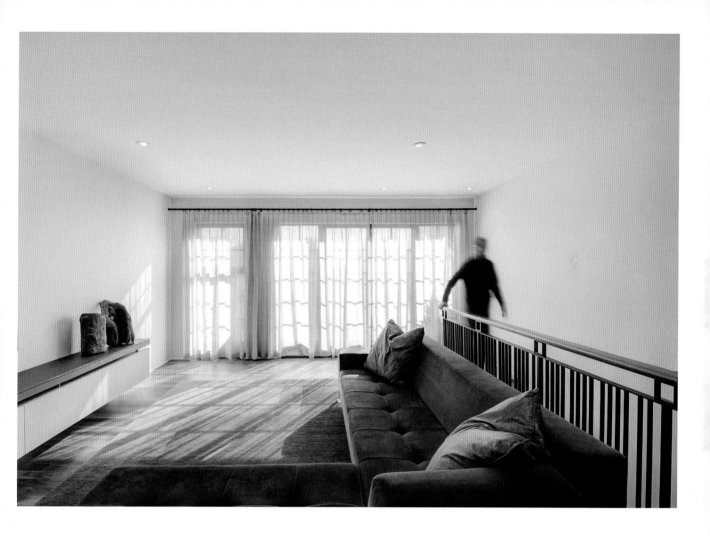

## Credits

**Architect: Post Architecture**
www.postarchitecture.com

**Interior designer (furnishings):**
Kominek Design
www.kominekdesign.com

**Structural engineer: NCK Engineering**
www.nck.ca

## Appliances and Materials

**Floating shelves:** Custom-built and wrapped in stainless steel
**Floors:** Walnut flooring
**Guardrails:** Custom steel with wood cap and handrail
**Kitchen cabinets:** Rosewood veneer
**Kitchen countertops:** Honed limestone
**Millwork and floating stairs:** Custom by EdWood Millworking

**Walls:** "Putty" and "Stucco" by Ralph Lauren

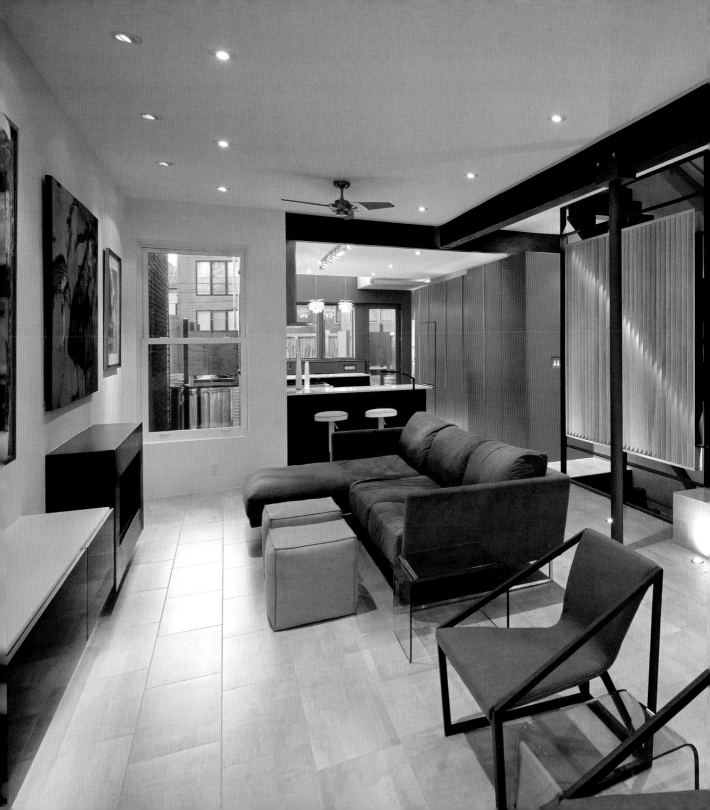

# MI CASITA

## 1,800 sq. ft.

**Washington, District of Columbia,
United States**

---

**KUBE ARCHITECTURE**

Photos © Paul Burk

Project team: **Richard Loosle-Ortega**, Principal,
Designer; **Andrew Baldwin**, Design Associate

**www.kube-arch.com**

> INCORPORATE COLOR AS A KEY ASPECT OF
  THE DESIGN

> MAXIMIZE NATURAL LIGHTING

> HIGHLIGHT MATERIALITY

AFTER MORE THAN THIRTY YEARS OF TRAVELING AND LIVING AWAY FROM HER HOMELAND, PUERTO RICO, CARMEN DECIDED SHE WANTED HER DC ROW HOUSE TO BE REMINISCENT OF HER ISLAND HOME.

"While we might have grown accustomed to finding neutrals as the only colors in a scheme in most contemporary homes, the interior renovation of this DC row house might come out as bold with the use of large planes of bright orange, yellow, and cyan. Not that there is no white or beige or gray; in fact, they are all included and widely used throughout the house and serve as a contrasting backdrop to the brightly colored surfaces. These splashes of color are carefully and strategically placed so they don't overpower the spaces. Rather, they create an invigorating feel, while at the same time define the character of different areas, such as the kitchen on the ground floor or the bank of cabinets on the second floor.

Light and materiality are two other integral components of the design. All three complement and reinforce one another."

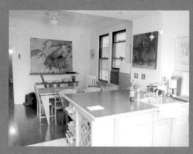

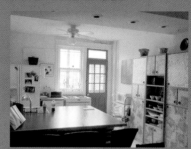

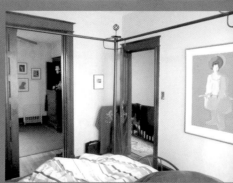

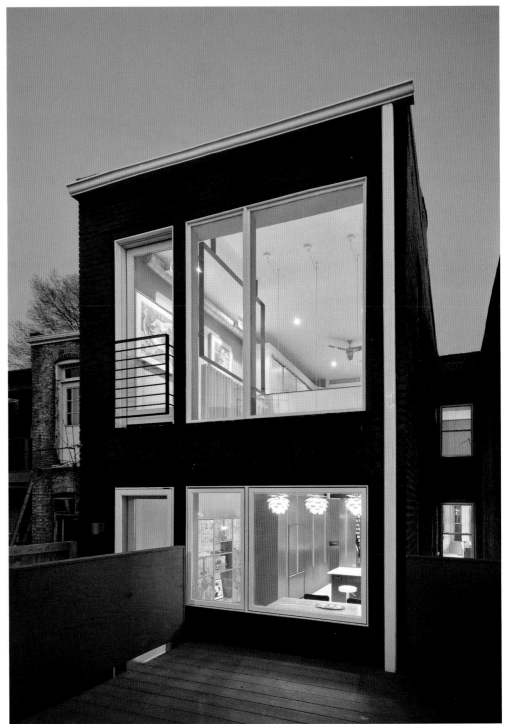

Interior walls were removed and large windows installed on both levels of the rear façade, accentuating a double-height space. The goal was to let as much natural light into the home as possible, brightening the interior.

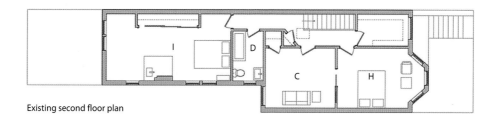

Existing second floor plan

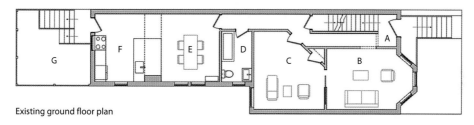

Existing ground floor plan

A. Entry hall          F. Kitchen
B. Living room         G. Deck
C. Lounge              H. Master bedroom
D. Bathroom            I. Bedroom
E. Dining area

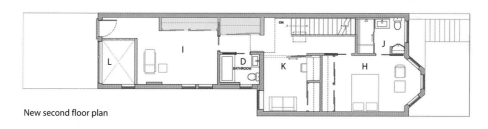

New second floor plan

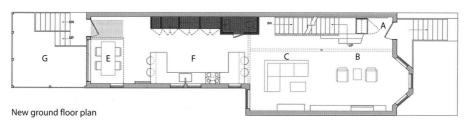

New ground floor plan

A. Entry hall          G. Deck
B. Living area         H. Master bedroom
C. Lounge              I. Bedroom/lounge
D. Bathroom            J. Master bathroom
E. Dining area         K. Study
F. Kitchen             L. Open to below

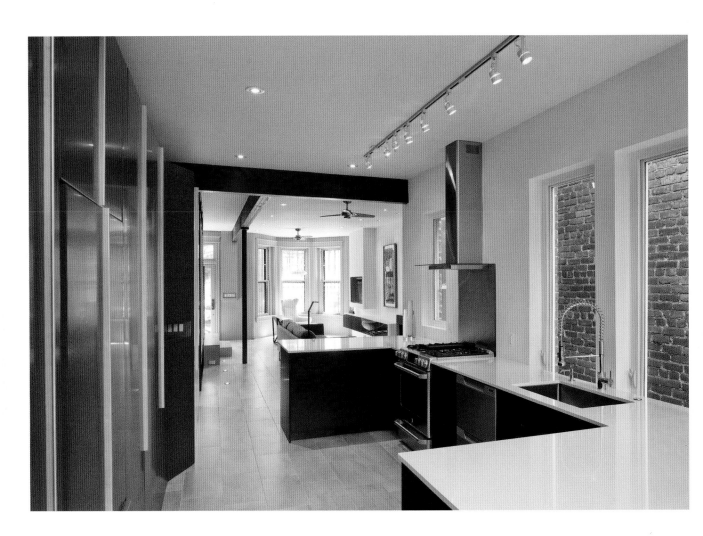

A long storage unit and powder room
are concealed behind panels painted
bright orange. They line the wall
opposite the kitchen, demarcating
the area. Orange and yellow were not
randomly chosen, they are endemic
to Puerto Rico.

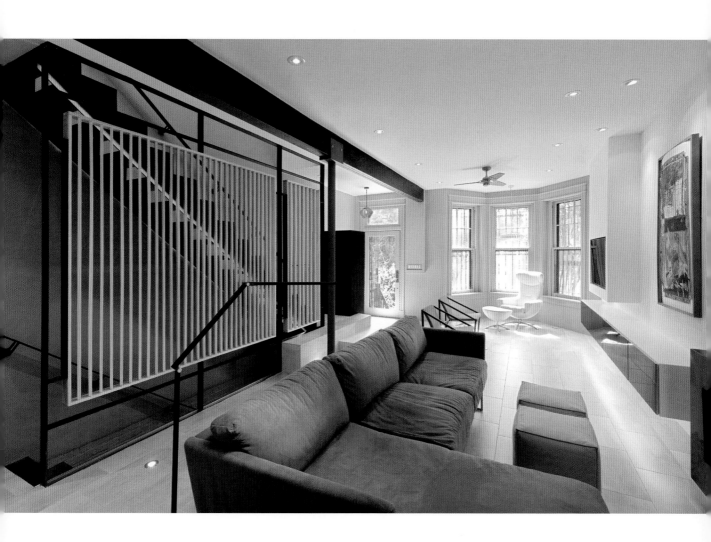

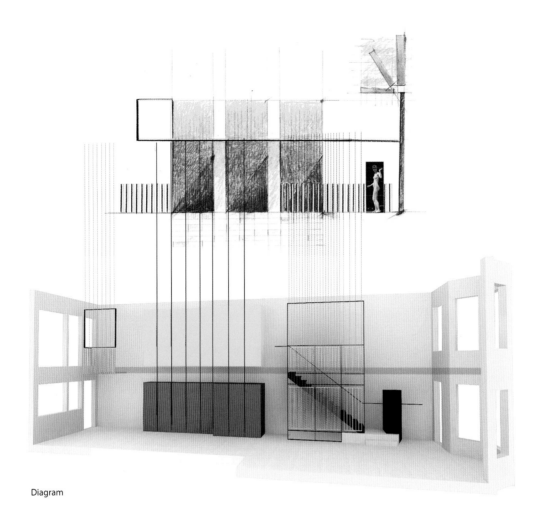

Diagram

The wood screen at the staircase is a
whitewashed poplar, and is framed
with blackened steel. The poplar
reappears on the second level and
at the rear "bridge," terminating at a
Juliette balcony.

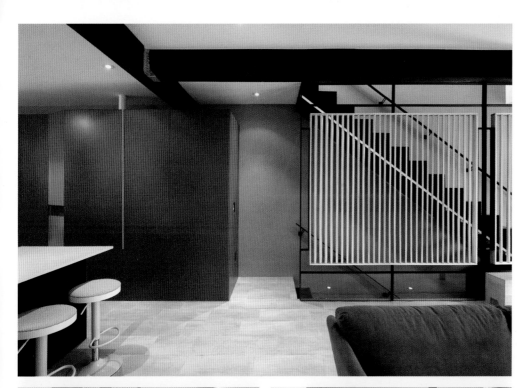

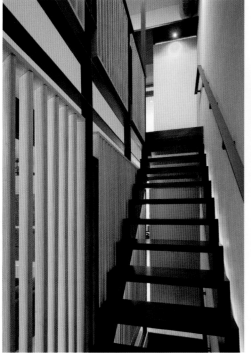

An existing skylight was enlarged and the stairs redesigned to have open risers. The living space flooring is white porcelain tile, while the second floor is dark bamboo.

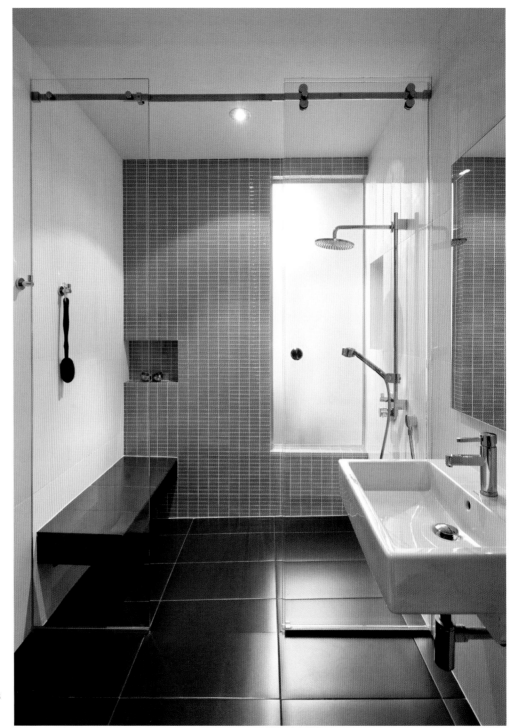

The black ceramic tile flooring in master bathroom extends into the curbless shower past the glass panels and sliding door, making the room feel roomier.

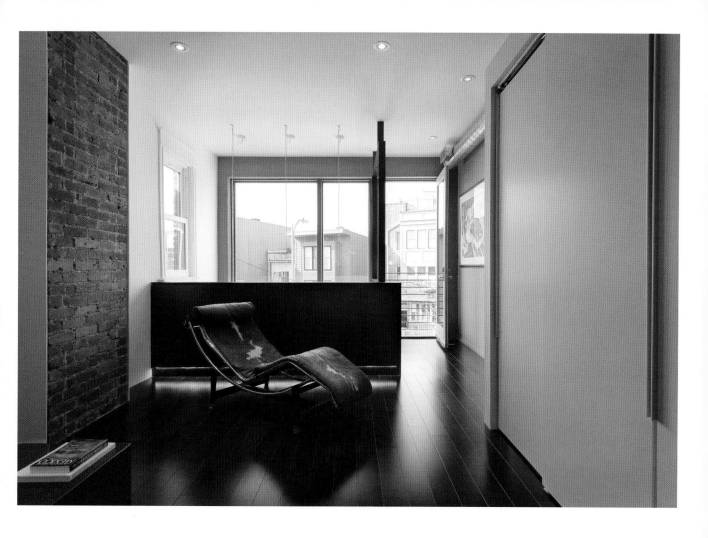

**Credits**

**Architect: KUBE Architecture**
www.kube-arch.com

**General Contractor:**
**Metrix Construction**
www.metrixconstruction.com

**Steel: Metal Specialties**

**Appliances and Materials**

**Flooring:** Porcelaine tile (first floor);
pre-finished bamboo (second floor)
**Kitchen:** IKEA base cabinets; storage
wall units in MDF panels, spray-painted
in red; Caesarstone countertops
**Stairs:** Whitewashed poplar screen

# AVENUE G HOUSE

## 3,250 sq. ft.

**Austin, Texas, United States**

---

**ALTERSTUDIO ARCHITECTURE**

Photos © Paul Bardagjy, Denise Prince

Project team: **Ernesto Cragnolino**, FAIA, Partner;
**Kevin Alter**, Partner; **Matt Slusarek**, Associate;
**Keune Shawn Peter; Mariana Moncada**

**www.alterstudio.net**

> EXPAND AND ADAPT A 1950s DUPLEX AS A
SINGLE-FAMILY RESIDENCE

> ADD NEW DEPTH AND SPACIOUSNESS TO A
COMPARTMENTALIZED HOUSE

> SENSITIVELY INTEGRATE A MODERN
BUILDING WITHIN A HISTORIC
NEIGHBORHOOD CONTEXT

> ACCOMMODATE THE CLIENT'S LIFESTYLE,
WHICH IS INTERTWINED SIMULTANEOUSLY
IN PUBLIC AND PRIVATE REALMS

DESIGNED FOR A COUPLE WITH THREE CHILDREN, THE AVENUE G HOUSE IS AN EYE-CATCHING MODERN CONSTRUCTION, YET RESPECTFUL OF ITS NEIGHBORS AND APPRECIATIVE OF ITS HISTORIC CONTEXT.

"The Avenue G House is an addition to and renovation of a former 1950s duplex located at stone's throw from Austin's Hyde Park National Historic District. Locally made brick façades and steel casement windows were maintained to retain the character of the existing building. Because the house was not within the protected-area boundaries, we didn't have to face any architectural commission. Thus, we were able to employ a vocabulary of our choosing to devise a second floor addition more akin to the personality of our clients.

Particularly unusual in this neighborhood of houses with discrete rooms, the visitor enters an unexpected sense of openness through the depth of the house. Two double-height spaces further increase the sense of space and invite light deep into the center of the house, while opposing interior box windows further suggest a sense of communication across this space."

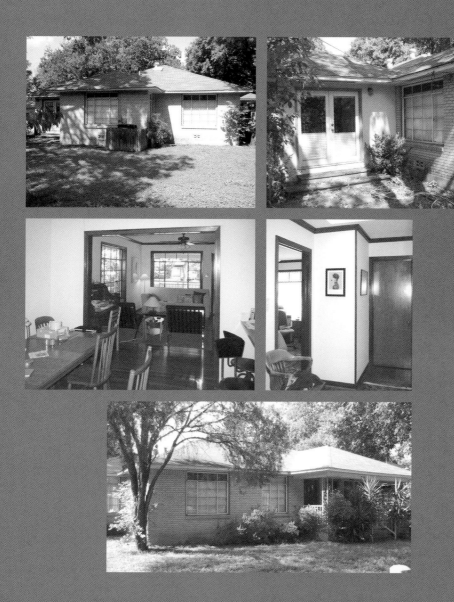

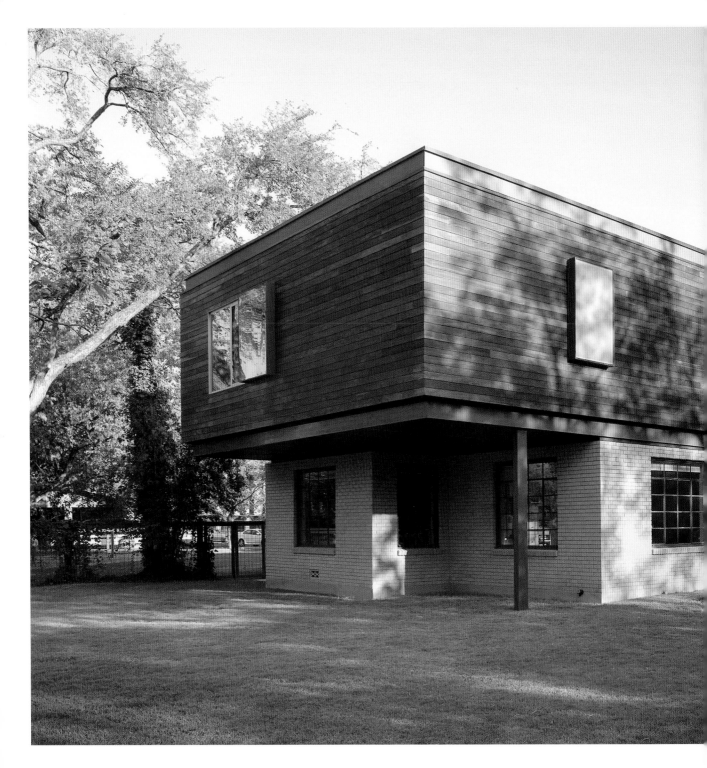

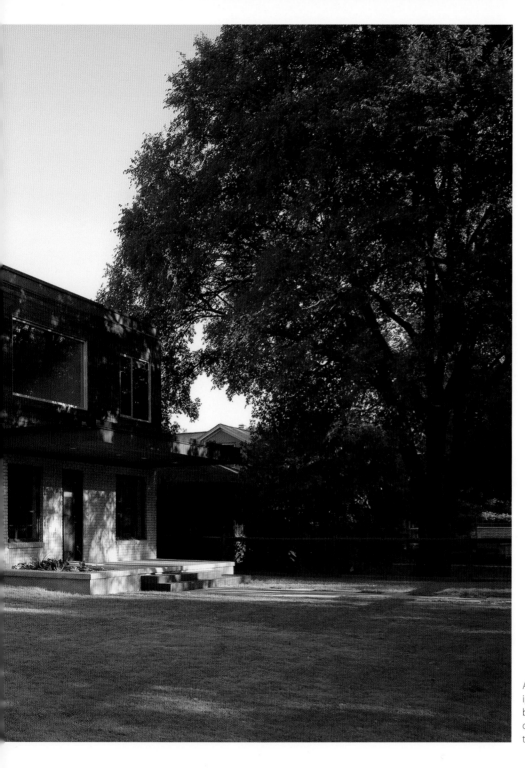

A simple, rectangular volume clad in ipe wood sits proudly atop the original brick structure, making Avenue G a compelling modern home among traditionally built houses.

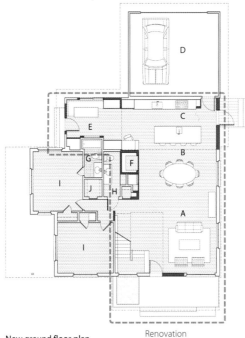

New ground floor plan

Renovation

New second floor plan

Addition

A. Living area    I. Bedroom
B. Dining area    J. Closet
C. Kitchen    K. Open to below
D. Garage    L. Family room
E. Breakfast nook    M. Laundry room
F. Pantry    N. Dressing room
G. Bathroom    O. Master bathroom
H. Powder room    P. Master bedroom

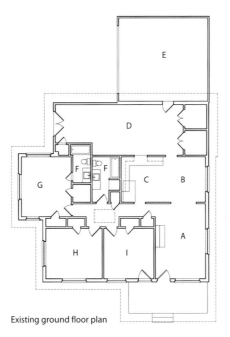

The ground floor plan is organized around a core of utilitarian rooms, leaving a generous open space around it. Up on the second floor, wall panels slide to connect alternating spaces.

Existing ground floor plan

A. Living area    F. Bathroom
B. Dining area    G. Master bedroom
C. Kitchen    H. Study
D. Exercise/play room    I. Bedroom
E. Garage

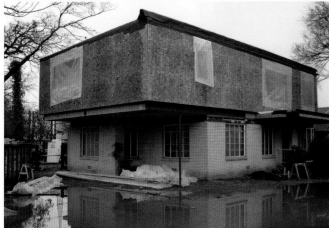

Building sections

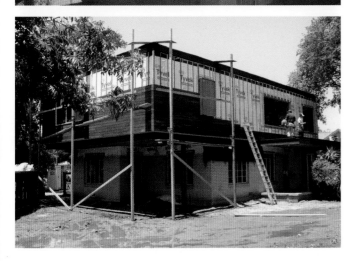

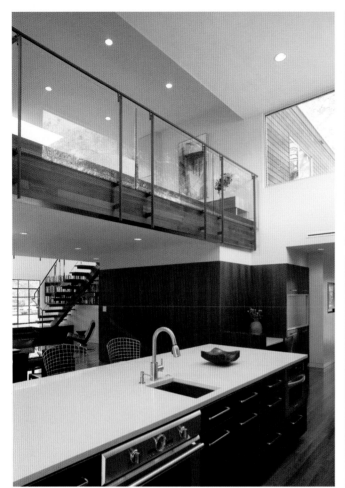
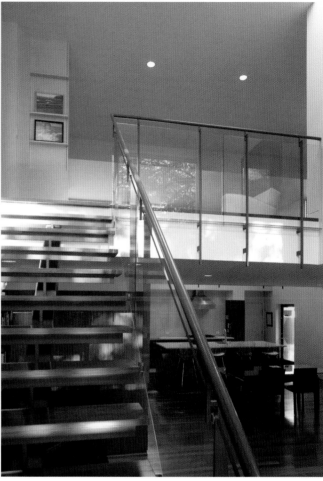

Throughout the house, ungraded ipe
floors lend a sense of warmth, while
a steel staircase, subtly contained by
glass guardrails, ascends to a lofty
family room.

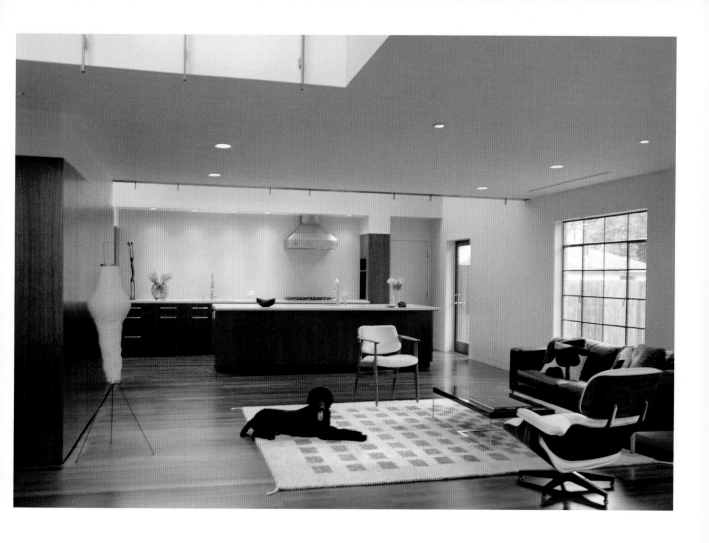

The kitchen is placed under a
double-height space, benefiting from
abundant, even light flooding the
interior through a high window.

Finished in book-matched walnut, the
central core ties in with the kitchen
island and flooring, while echoing the
ipe-clad exterior walls of the addition.

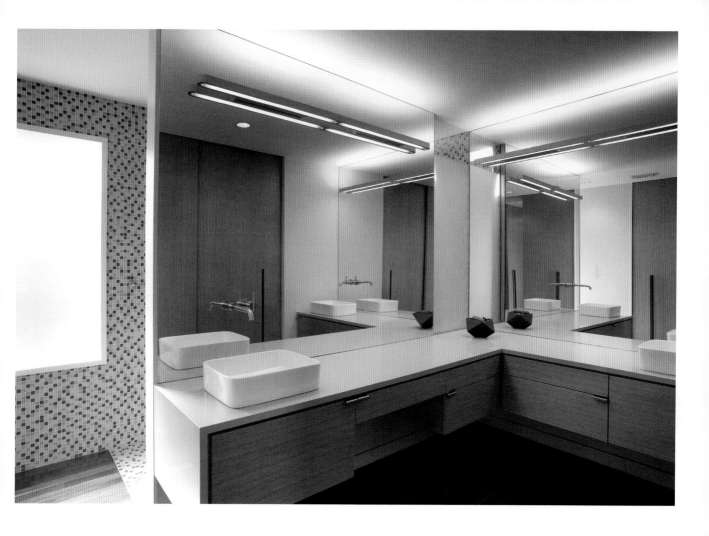

## Credits

**Architect: Alterstudio Architecture**
www.alterstudio.net

**General contractor:**
**Melde Specialty Construction**

**Structural engineer: MJ Structures**
www.mjstructures.com

## Appliances and Materials

**Cabinetry:** Book-matched walnut, custom maple veneer in master bathroom
**Countertops:** Caesarstone in kitchen
**Flooring:** Ungraded ipe throughout
**Hardware:** Sugatsune, plus custom recessed steel pulls for master bedroom and master bathroom doors
**Kitchen appliances:** Wolf oven, Sub-Zero fridge

**Plumbing:** Danze fixtures in master bathroom
**Skylights:** Velux
**Windows:** Gerkin, plus existing casement windows

# FERRYHILL HOUSE

## 1,615 sq. ft.

Aberdeen, Scotland, United Kingdom

—

**BROWN + BROWN ARCHITECTS**

Photos © Nigel Rigden

Project team: **Kate Brown**, Partner;
**Andrew Brown**, Partner;
**Blair Macintyre**, Associate

www.brownandbrownarchitects.com

> OPEN UP KITCHEN TO LIVING AND
DINING AREA

> STRIP OFF 1970s FINISHES AND MATERIALS
TO EXPOSE ORIGINAL FEATURES.

A VICTORIAN TERRACE GETS A SECOND LIFE WITH SCANDINAVIAN-STYLE INTERIORS. ITS OWNERS, EMILY AND ANDREW, WERE HANDS ON WITH SOME OF THE REMODEL TASKS.

"The remodel project of a Victorian terrace seemed fairly straightforward, with no apparent need for complicated structural, plumbing, or electrical work. With these issues out of the way, we could focus on stripping the interior of the house of its 1970s decorative elements. During the process, Emily and Andrew decided to make some structural changes. According to Emily, they were hoping to take down a wall between the dining and living rooms, but the planning department rejected it as the house is protected with a heritage designation bylaw. One change that did get approved was the removal of a nonbearing wall that separated the kitchen and the dining room.

The owners were hands-on in the remodel. That included the meticulous and laborious removal of layers of finishes, including carpet and linoleum flooring, as well as wood paneling covering walls and ceilings. The idea was to expose all original features. In some areas, cornices and skirting were badly damaged or completely gone, but we were able to 3-D laser scan the well-preserved parts so we could replicate them and use the new pieces where we needed them.

The renovation wasn't as easy as Emily and Andrew originally thought. Their experience in dealing with builders was a big challenge. They had moved temporarily into a rental place during the scheduled duration of the works, and while they actually took on some tasks, work went over schedule. But as Emily puts it, it was a stressful journey at times, but nevertheless a very rewarding one in retrospect".

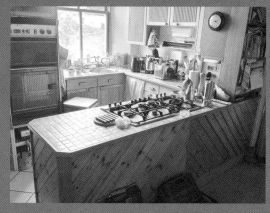

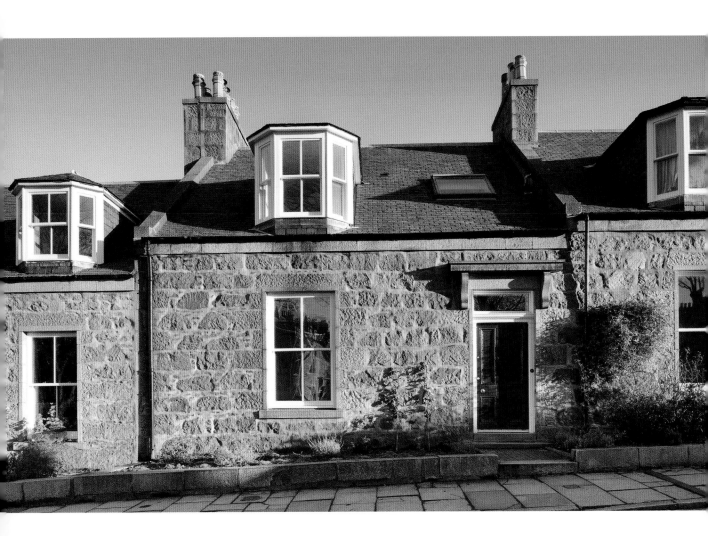

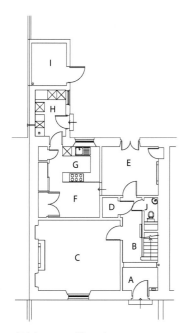

Existing ground floor plan

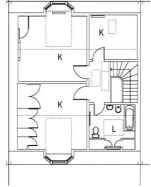

Existing second floor plan

A. Entry
B. Hall
C. Living room
D. Closet
E. Sitting room
F. Dining area

G. Kitchen
H. Utility
I. Garden shed
J. Powder room
K. Bedroom
L. Bathroom

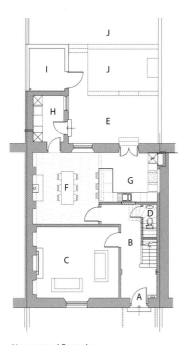

New ground floor plan

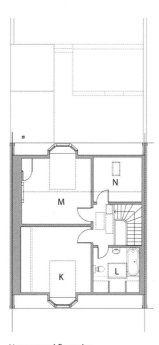

New second floor plan

A. Entry
B. Hall
C. Living room
D. Powder room
E. Stone terrace
F. Dining area
G. Kitchen

H. Utility room
I. Garden shed
J. Garden
K. Bedroom
L. Bathroom
M. Master bedroom
N. Guest bedroom

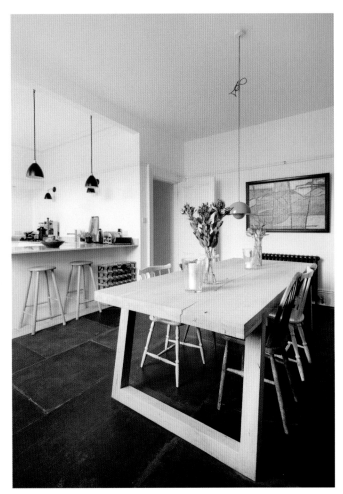
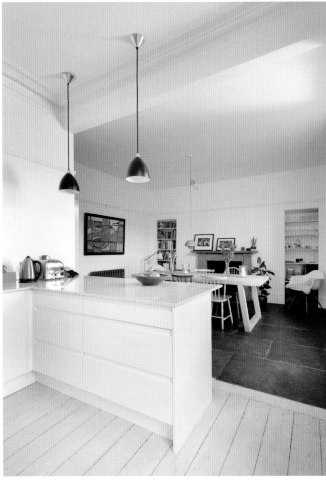

Whenever there's substantial
stripping work to do, there are
surprises. Emily said they were
told that concrete lay beneath the
laminate flooring in the dining area.
To everyone's surprise, the owners
found the original flagstones when
they pulled the laminate flooring.

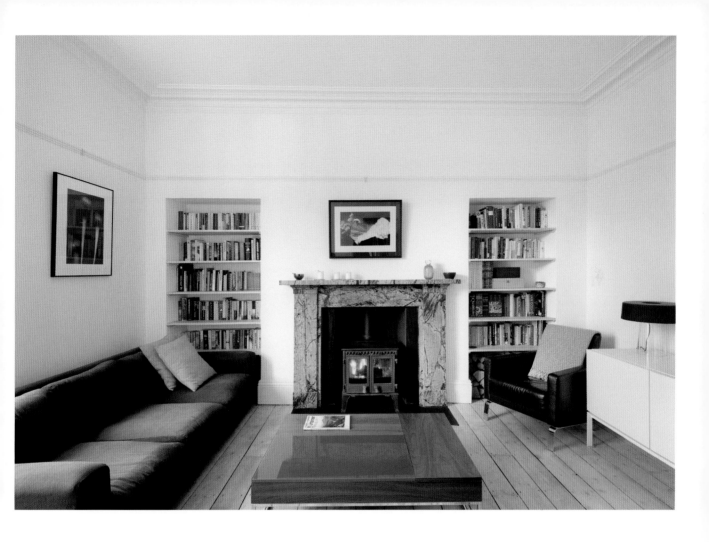

Having stripped back the fireplaces and replaced the hearts, the owners realized just how expensive slate is and how much money they had saved by finding the flagstones.

In addition to repairing and sealing the flagstone floor, Emily and Andrew sanded and finished the wood floors and staircase with a white oil stain. They had lived in Copenhagen and had raw pine floors in their place that had to be cleaned weekly using lye soap. They wanted the same look with lower maintenance.

**Credits**

**Architect:** Brown + Brown Architects
www.brownandbrownarchitects.com

**General contractor:** G&K Construction

**Structural engineer:** Rubislaw Associates

**Appliances and Materials**

**Bathroom:** Tiling by Saloni and sanitaryware by Duravit
**Flooring:** Existing timber flooring, treated with white oil and existing flagstone flooring in the kitchen

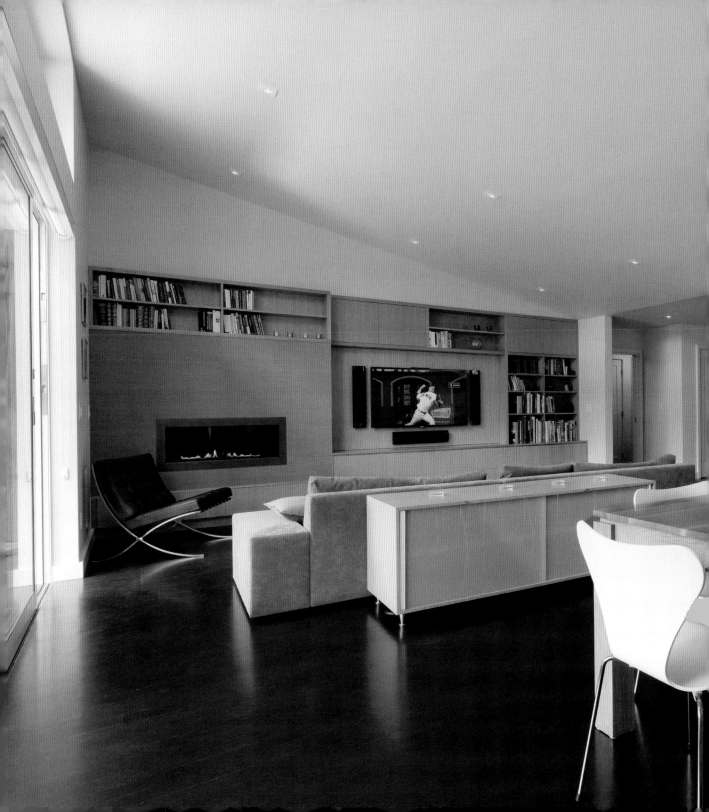

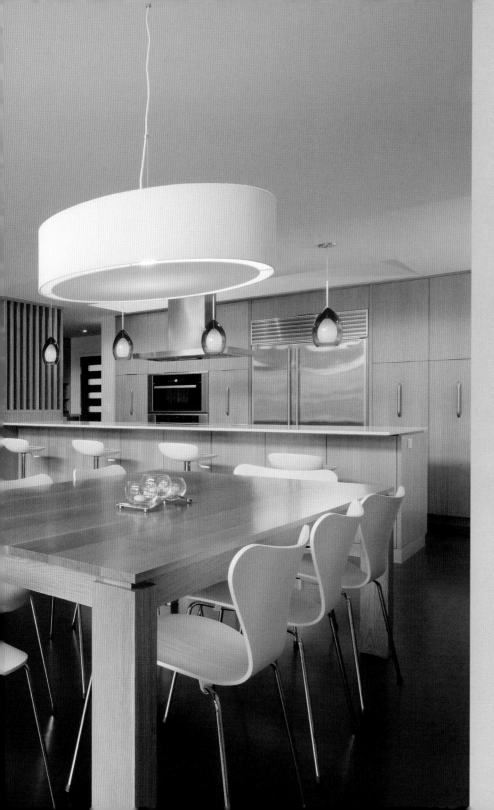

ROSSINGTON ARCHITECTURE

Photos © Tyler Chartier, Phil Rossington

Project team: Phil Rossington, Principal
Jackie McKay Detamore

www.rossingtonarchitecture.com

> OPEN UP PUBLIC SECTION OF THE HOUSE
  TO CREATE A LARGE AREA SUITABLE FOR
  ENTERTAINING

> REPLACE EXISTING EIGHT-FOOT CEILINGS
  WITH NEW SHED ROOF TO VISUALLY EXPAND
  THE LIVING AREA TOWARD THE BACKYARD

> CREATE A TRUE INDOOR-OUTDOOR FEEL

> ALLOW THE COOK TO INTERACT WITH FAMILY
  AND GUESTS WHILE COOKING

## A MERE EIGHT-FOOT EXTENSION TO A SMALL 1960s HOME WAS THE CATALYST OF A FANTASTIC TRANSFORMATION.

"The owners bought the house with the notion of remodeling it from the very beginning. They renovated the kitchen by themselves when they moved in years ago, but didn't open it up to the rest of the house. It is the open feel that they were now seeking, decompartmentalizing the house and expanding the access to the back patio.

This project added eight feet to the living/dining room and blew out the interior walls of the public portion of the house, creating a modern, open, comfortable living space, showcasing the kitchen, for the husband is a great cook and loves to entertain with friends and family. The renovation highlights the possibilities of how a relatively minor addition can stunningly transform a 1960s builder house into a modern, custom home."

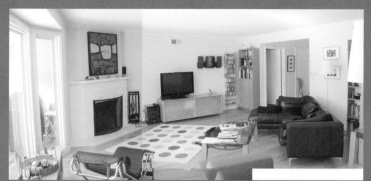

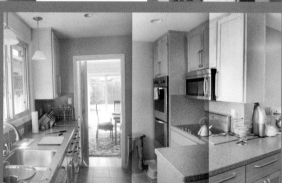
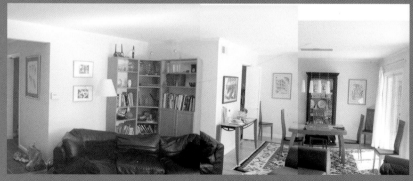

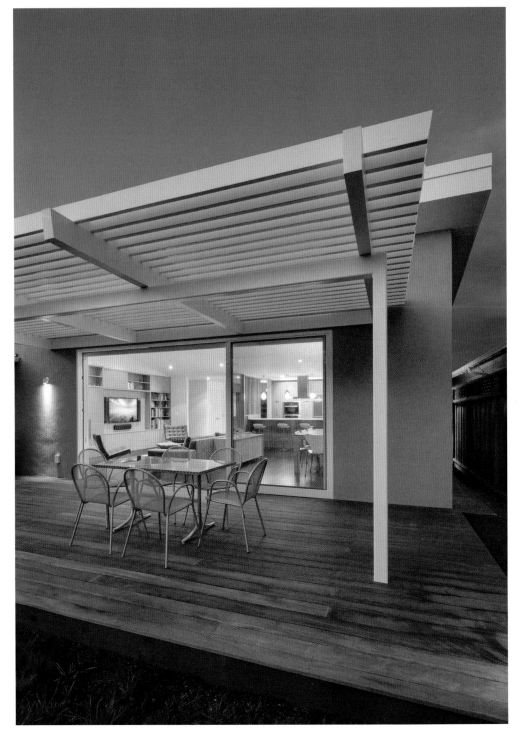

A 16-foot-wide sliding Fleetwood door connects the space to the interior, where an ipe deck and painted steel and wood trellis create a comfortable outdoor dining experience.

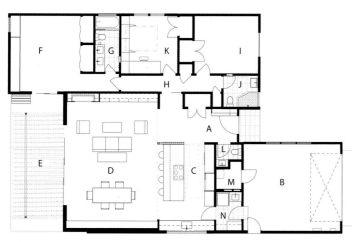

**New floor plan**

A. Entry
B. Garage
C. Kitchen
D. Living/dining area
E. Patio
F. Master bedroom
G. Master bathroom
H. Hall
I. Bedroom
J. Bathroom
K. Office/guest bedroom
L. Powder room
M. Utility room
N. Laundry room

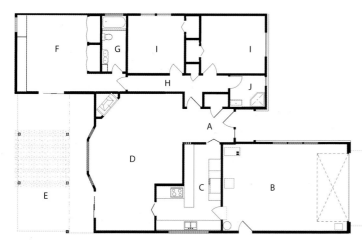

**Existing floor plan**

A. Entry
B. Garage
C. Kitchen
D. Living/dining room
E. Patio
F. Master bedroom
G. Master bathroom
H. Hall
I. Bedroom
J. Bathroom

A small powder room was added just off the front door and utility, and laundry rooms were created by stealing some space from the garage.

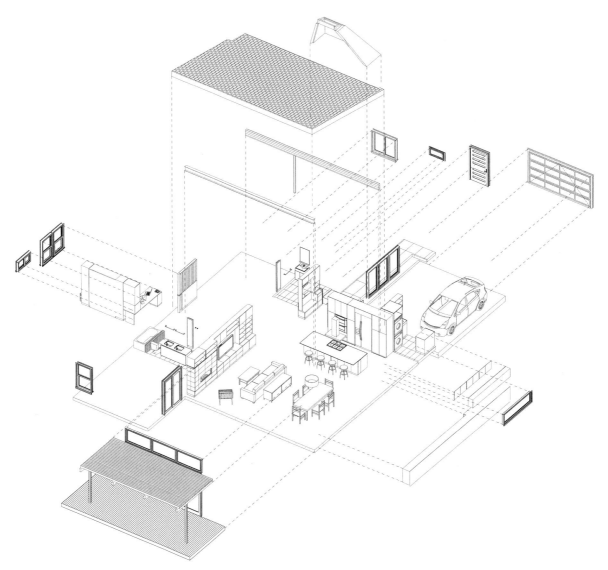

Exploded axonometric view

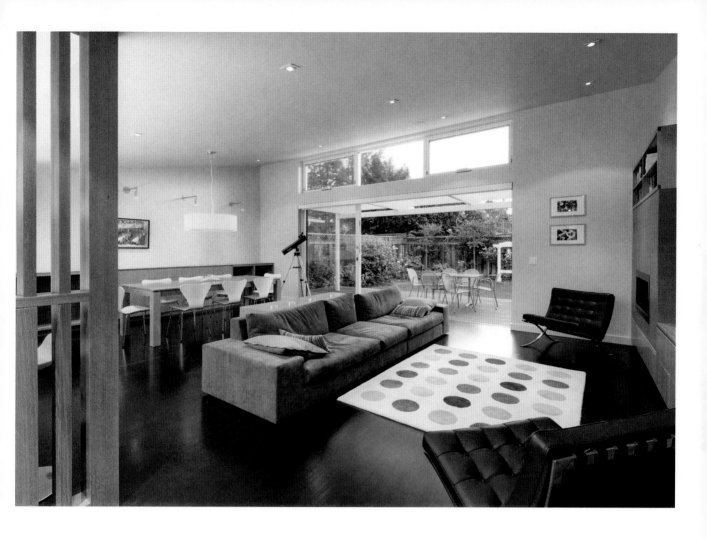

The eight-foot ceilings were removed and a new shed roof was added, visually expanding the living room toward the rear yard. The operable transom windows create a chimney effect, ushering warm air up and out of the house on warmer days.

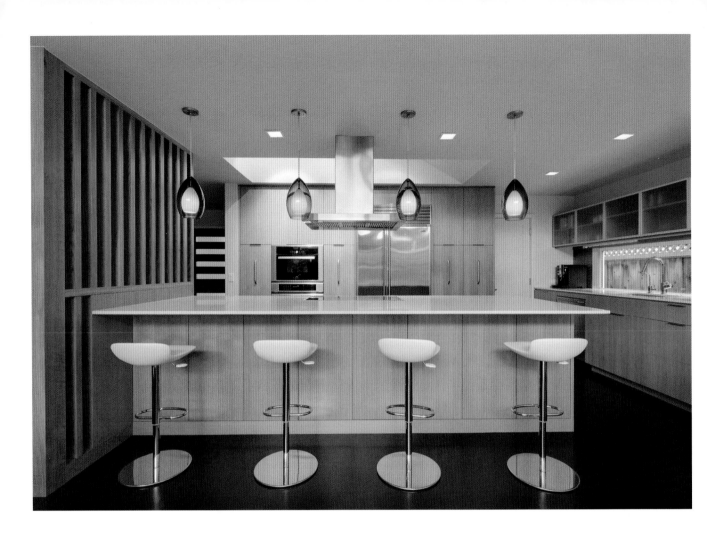

A large island separates the kitchen from the living / dining room and is anchored by a wood screen that helps define the entry and visually separates the kitchen from the front door and bedroom wing.

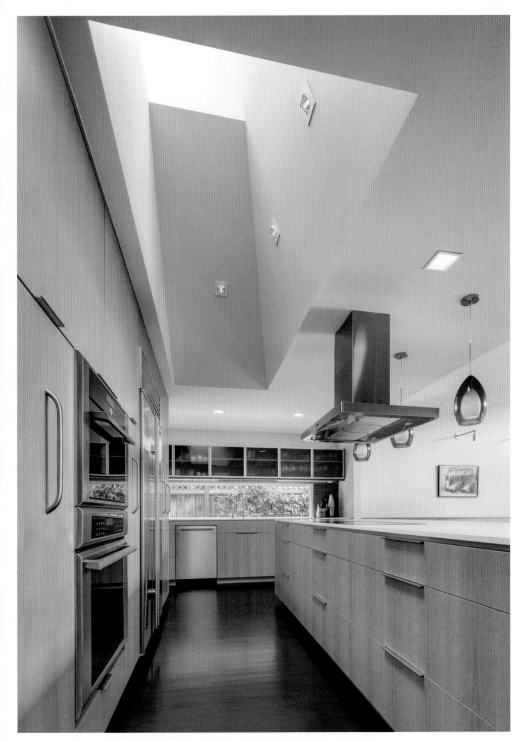

A skylight with large canted shaft provides a similar defining effect in the kitchen, while balancing the natural light in the space.

Rift-sawn oak cabinets were chosen specifically to contrast with the espresso-stained floors and to act as a unifier throughout the house.

## Credits

**Architect:** Rossington Architecture
www.rossingtonarchitecture.com

**Color consultant:** Gale Melton Design
www.galemelton.com

**General contractor:**
De Mattei Construction
www.demattei.com

**Structural Engineer:** FAR Associates
www.farengineers.com

## Appliances and Materials

**Appliances:** Thermador oven, Gaggenau range, Faber range hood, Sub-Zero refrigerator
**Bathroom plumbing fittings:** Toto, Kohler, Lacava, Hansgrohe
**Cabinets:** Custom by Andersen Quality Woodworking
**Countertops:** Caesarstone
**Fireplace:** Heat & Glo
**Flooring:** Rift-sawn white oak with DuraSeal ebony finish
**Hardware:** Inox, Linnea, Hafele, Mockett, Smedbo
**HVAC equipment:** HTP Lochinvar boiler with Warmboard radiant system
**Kitchen plumbing fittings:** Hansgrohe
**Paints and stains:**
Benjamin Moore, "Aura"
**Skylights:** Velux
**Windows:** Fleetwood

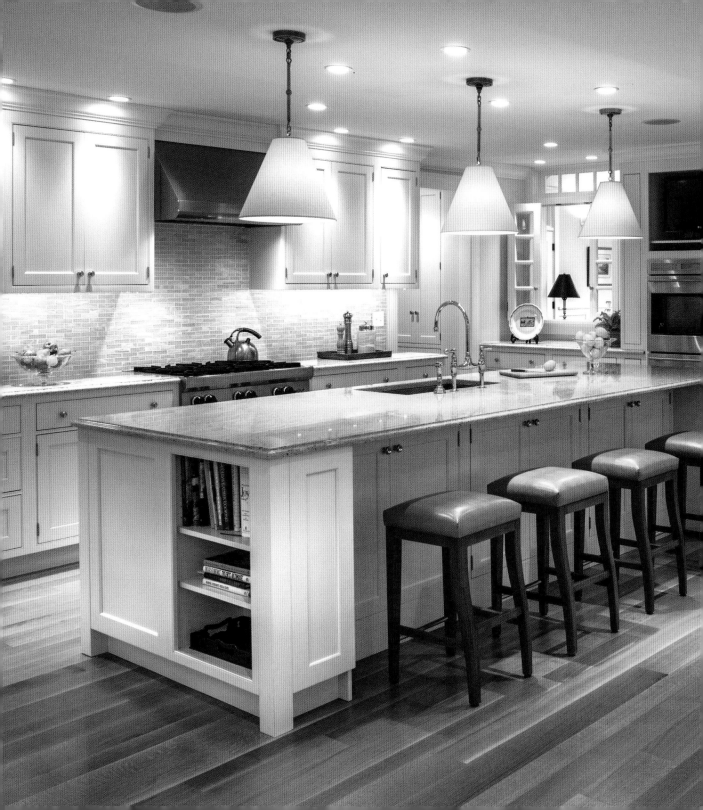

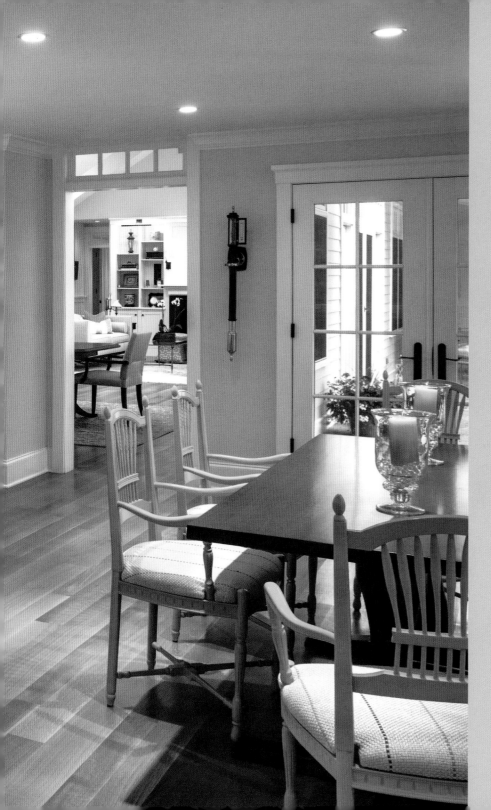

# STONY LANE

## 4,350 sq. ft.

Gladwyne, Pennsylvania, United States

---

**JMS ARCHITECTURE LLC**

Photos © Tom Crane Photography

261

Project team: Jeffrey M. Spoelker AIA, Principal

**www.jmsarchitecture.com**

> PROVIDE AN EFFICIENT FLOOR PLAN

> BRIGHTEN UP THE INTERIORS

> MAKE THE MOST OF THE VIEWS TO THE
SURROUNDING NATURAL LANDSCAPE

## A STUNNING TRANSFORMATION FROM ORIGINAL TO CURRENT DESIGN.

"Aimed at producing a result that is aesthetically pleasing, functional, and cost effective, this extensive renovation maintained the existing exterior walls of the house and added porches and bays to improve the connection between interior and exterior spaces. Making the most of outdoor living was a priority. The transformation sought to better connect the confined, gloomy interior spaces with the outside world.

On the other hand, the remodel amplified the home's common spaces, providing a more efficient floor plan that admits abundant natural lighting. A simple palette of materials rounded off the renovation project and maintained a balance between the traditional elements of the original house and the modern reforms."

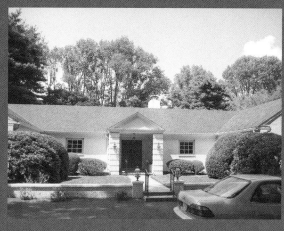

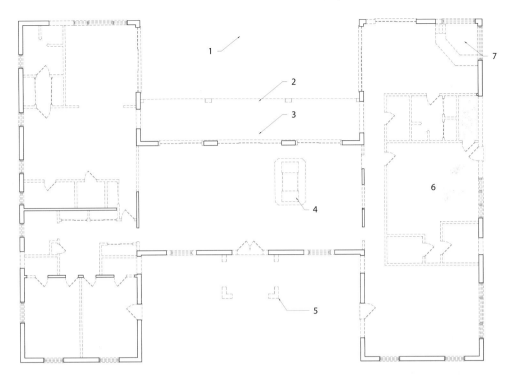

## Demolition plan

1. Remove swimming pool and concrete terrace from house to retaining wall
2. Remove entire wall and roof, including doors, thresholds, brick piers, and roofing materials
3. Remove tile floor and concrete slab, including existing ductwork and grill
4. Demolish existing chimney and fireplace to chimney base
5. Remove full entry portico, including roof structure and foundation/footing material
6. Remove all existing kitchen cabinets and appliances
7. Demolish existing sunken bar; infill framing

**General notes:**
- Walls to be removed shown dashed
- All windows and doors to be removed and replaced
- Interior face of all exterior walls to remain
- All existing flooring material to be removed to expose subfloor
- All existing fixtures to be removed
- All existing light fixtures to be removed unless otherwise noted

The significant demolition work opened up the interior of the house to take advantage of its maximum potential. It offered a blank canvas that allowed for an organization of the required spaces that suited the lifestyle of the owners.

Schematic design. Proposed second floor plan

Schematic design. Proposed east elevation

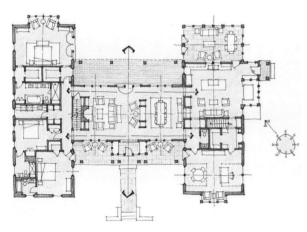

Proposed ground floor plan option B

Proposed north elevation

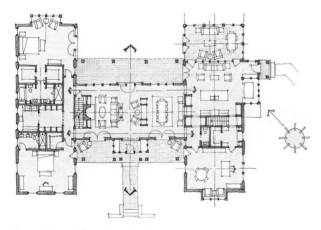

Proposed ground floor plan option A

Proposed south elevation option A

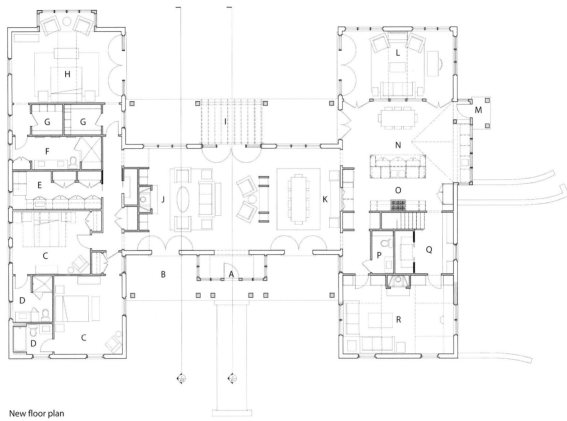

**New floor plan**

A. Entry
B. Front terrace
C. Guest bedroom
D. Guest bathroom
E. Laundry room/storage
F. Master bathroom
G. Walk-in closet
H. Master bedroom
I. Rear deck

J. Living area
K. Dining area
L. Enclosed porch/his office
M. Back entry
N. Breakfast area
O. Kitchen
P. Powder room
Q. Pantry
R. Study/her office

New north elevation

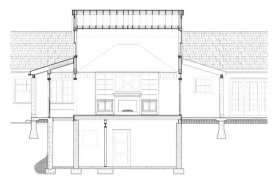

Entry section

New east elevation

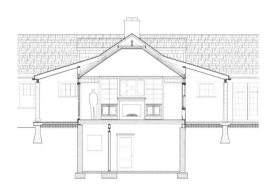

Living room section

New south elevation

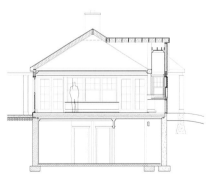

Kitchen section

New west elevation

Kitchen north elevation

Kitchen west elevation

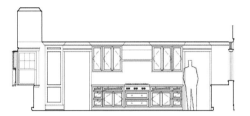

Kitchen south elevation

Kitchen east elevation

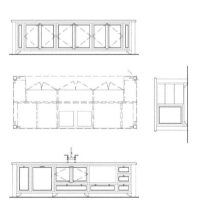

Kitchen island elevations

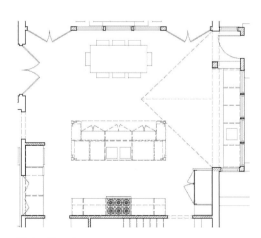

Kitchen floor plan

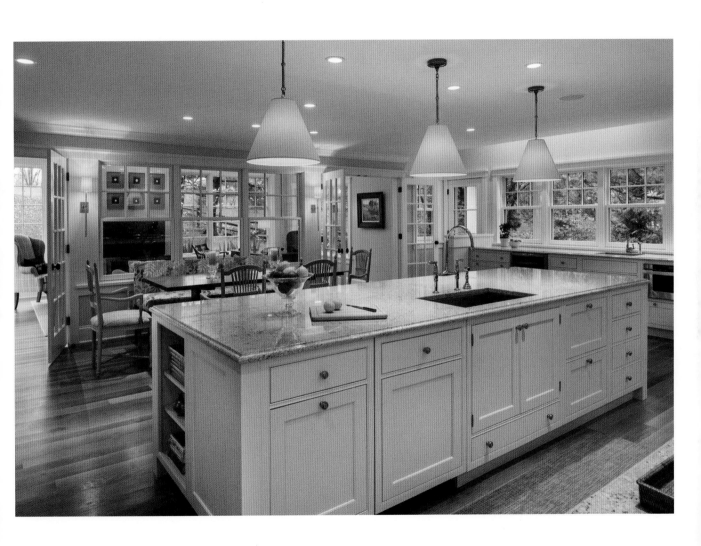

As in many open concept houses, the kitchen takes center stage, blending with adjacent areas, perfect for socializing with family and guests.

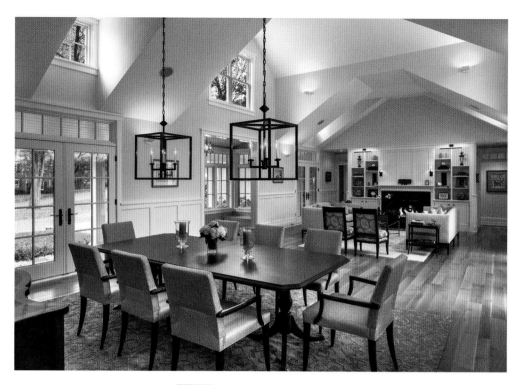

Living area north elevation

Living area west elevation

Living area south elevation

Living area east elevation

Dining area partition
elevation

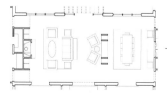

Dining area floor plan

The living and dining areas share
a central one and a half story
communal space. This space is open
to the north-facing rear deck, which
is on axis with the house entrance.

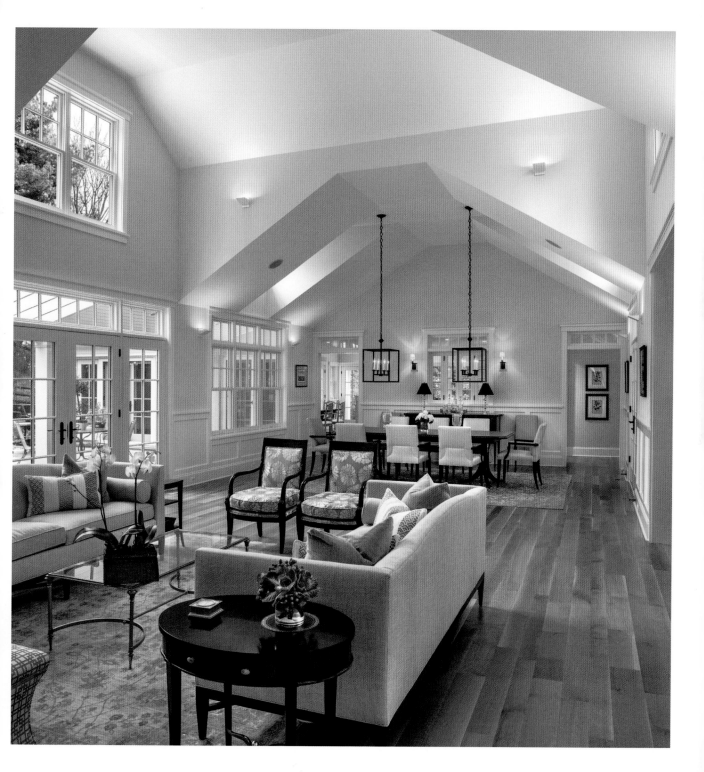

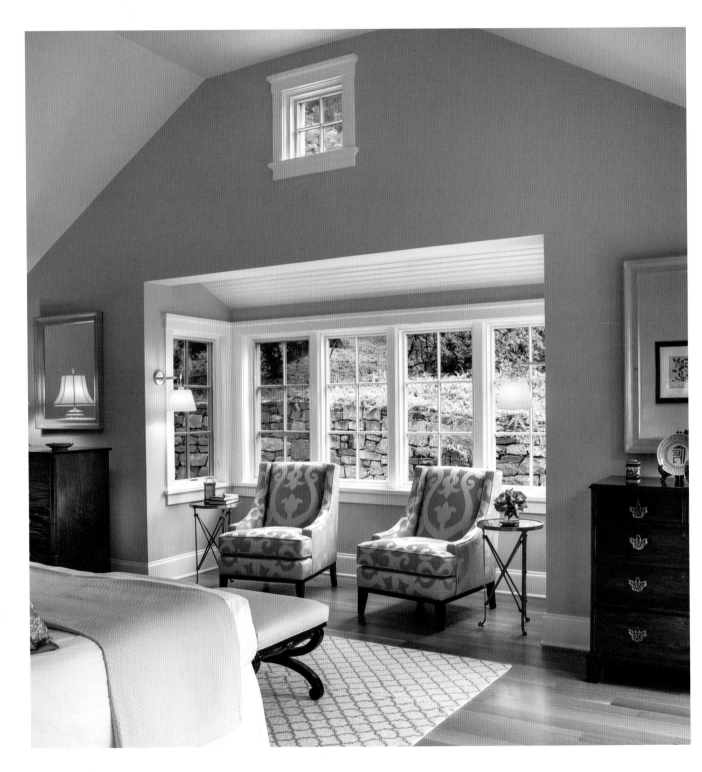

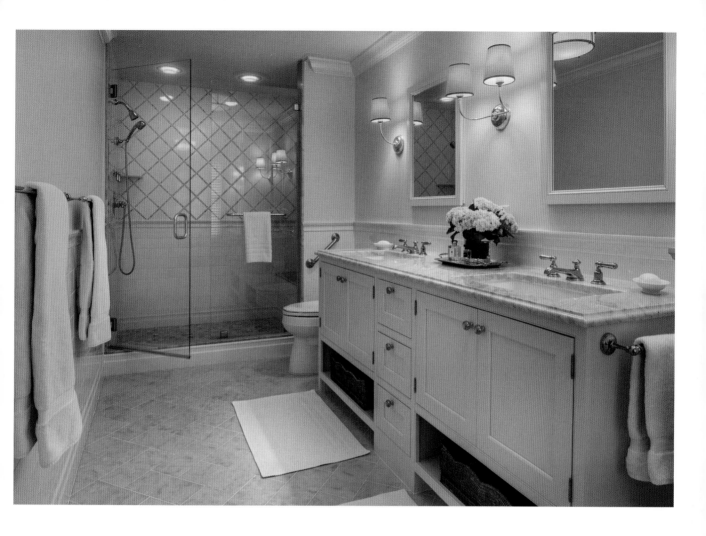

## Credits

**Architect:** JMS Architecture LLC
www.jmsarchitecture.com

**General contractor:**
E.B. Mahoney Builders
www.ebmahoney.com

**Landscape architect:**
Jonathan Alderson Landcape Design
www.jonathanalderson.com

**Interior designer:**
Karen Pelzer Interior Design

**Structural engineer:** Harrison-Hamnett
www.hhccse.com

## Appliances and Materials

**Appliances:** Wolf, Sub-Zero, and Bosch
**Cabinetry:** Brookhaven by Wood-Mode
(Wall & Walsh supplier)
**Hardwood flooring:** Random with
white oak
**Kitchen counters and backsplash:**
Granite and porcelain tile
**Paint:** Benjamin Moore
**Plumbing fixtures:** Ferguson Enterprises, Perrin & Rowe, Kohler, and Grohe

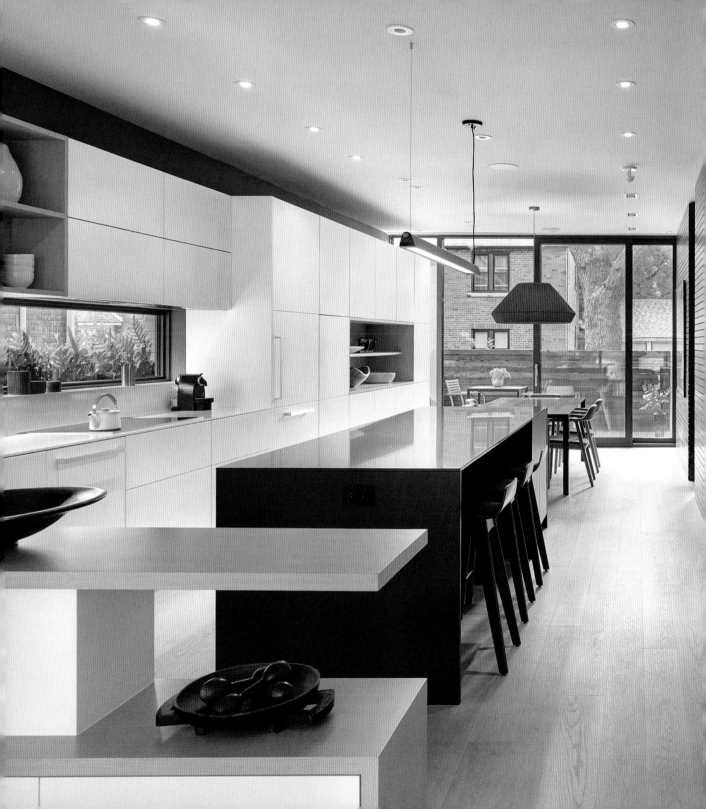

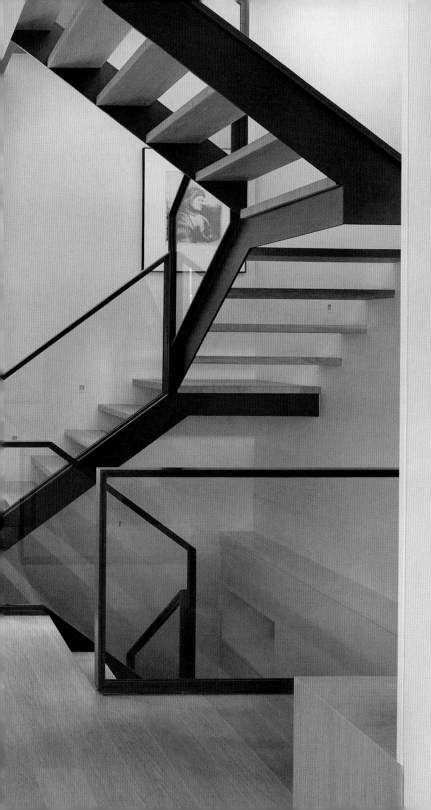

# SKYGARDEN HOUSE

## 2,420 sq. ft.

Toronto, Ontario, Canada

———

**DUBBELDAM ARCHITECTURE + DESIGN**

Photos © Shai Gil

Project team: Heather Dubbeldam, Principal Architect; Oliver Dang; Jacob JeBailey; Suzanna MacDonald; Amber Baechler; Derek Chaves

**www.dubbeldam.ca**

> **OPEN UP HOUSE INTERIOR TO OUTDOOR SPACES ON ALL LEVELS**

THE OWNERS USED TO SPEND THEIR WEEKENDS AT A HOME IN THE COUNTRY, LOCATED NEXT TO A STREAM AND SURROUNDED BY TREES. FOR THEIR NEW URBAN HOME, THEY WANTED TO EMULATE THIS BUCOLIC EXPERIENCE.

---

"The house provides outdoor living spaces on multiple levels to address the owners' desire for a better connection with the natural surroundings. Most of the rooms open up to a series of outdoor spaces, each with its own unique character and varying level of privacy. Even the existing porch at the front of the house is turned into a private outdoor dining area enclosed by a five-foot-high wooden screen. This expansion beyond the interior spaces makes the house feel larger than it actually is.

On the third floor, two significant outdoor spaces provide green respite. At the front of the house, half of the master bedroom is given over to an intimate exterior space with a recessed planter. Intimately connected to the master suite, this "skygarden" functions as a unique outdoor room, open to the sun, wind, and stars. At the back of the house, an exposed roof-deck has views over the neighborhood and into the extensive green canopy surrounding the house."

---

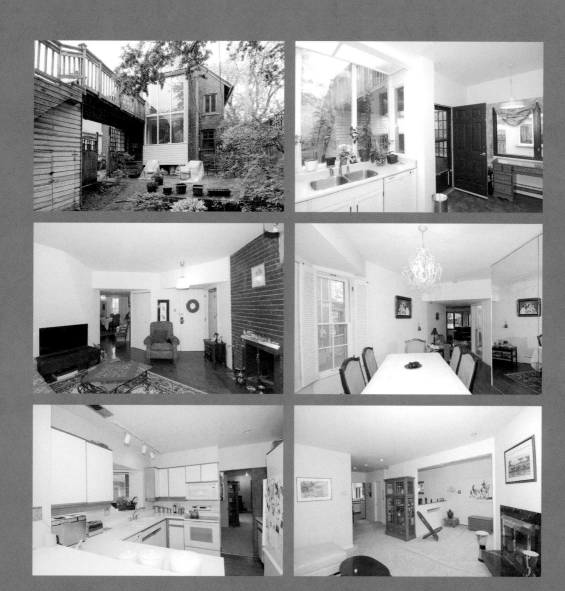

Existing third floor plan

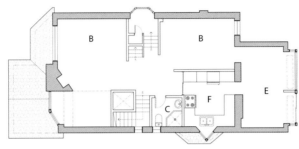

Existing second floor plan

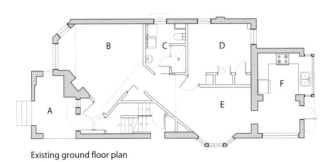

Existing ground floor plan

A. Vestibule     F. Kitchen
B. Living room     G. Sunroom
C. Bathroom     H. Master bedroom
D. Bedroom     I. Roof deck
E. Dining room/
    sunroom

Working with the existing footprint
of a century-old detached house in
the city's midtown neighborhood,
only the two exterior sidewalls were
retained. The interior was completely
gutted. With no obstacles, the new
layout is fluid and the connection
between rooms is optimized.

New third floor plan

New second floor plan

A. Outdoor dining area
B. Vestibule
C. Powder room
D. Dining area
E. Kitchen
F. Living area
G. Rear entrance
H. Rear deck
I. Patio
J. Garage
K. Master bedroom
L. En suite bathroom
M. Walk-in closet
N. Study
O. Laundry room
P. Skygarden
Q. Bedroom
R. Bathroom
S. Roof deck

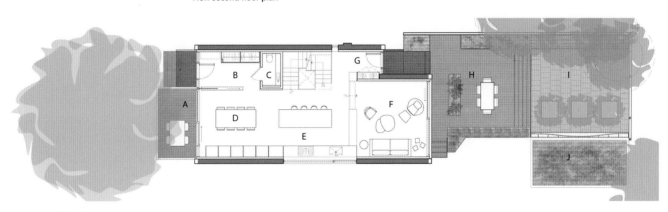

New ground floor plan

The landscaped rear yard features an ash wood deck off the living area for outdoor dining when the weather allows it. A few steps down, another zone, defined by granite pavers, is planted with a row of honey locust trees that offer dappled light and shade in summer to make the most of the sizable backyard.

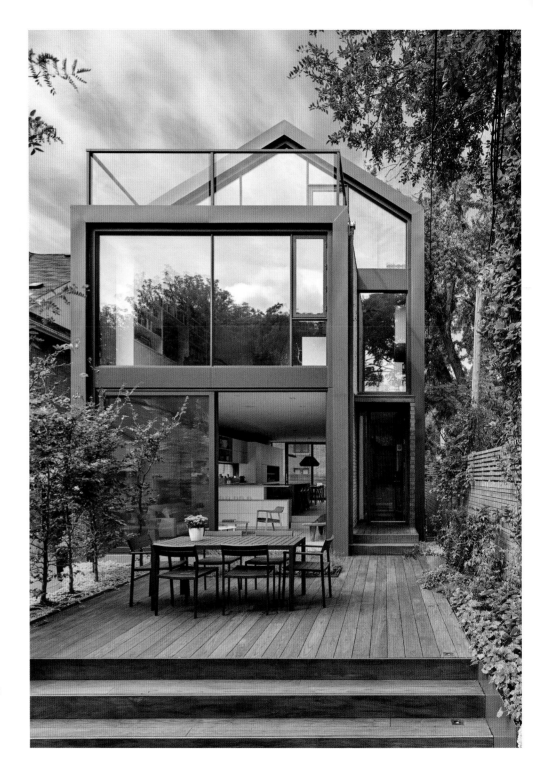

Skygarden House offers a graphic
interpretation of the traditional
pitched roof, referencing the
domestic scale and form of the
neighboring houses.

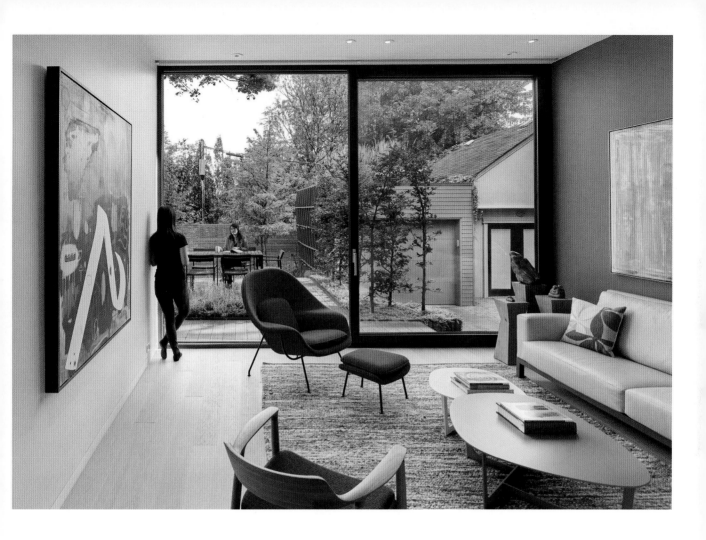

Floor-to-ceiling glass walls made of a combination of windows, doors, and spandrel panels frame views of the outdoors and bring natural light and the changing seasons into the interior.

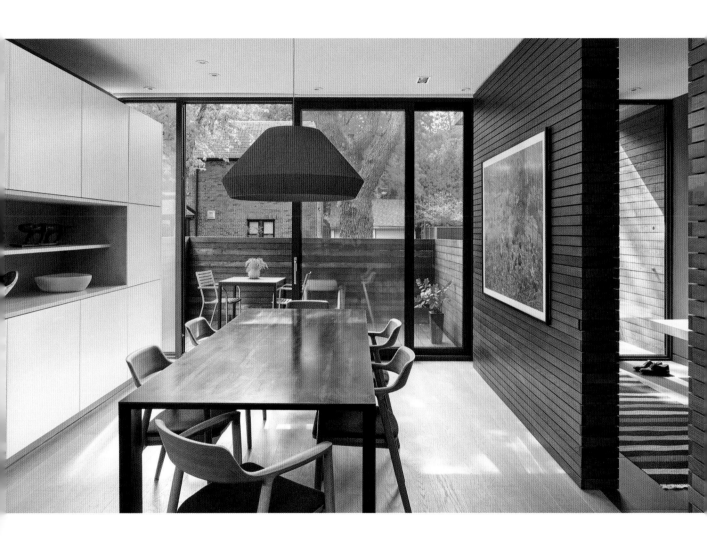

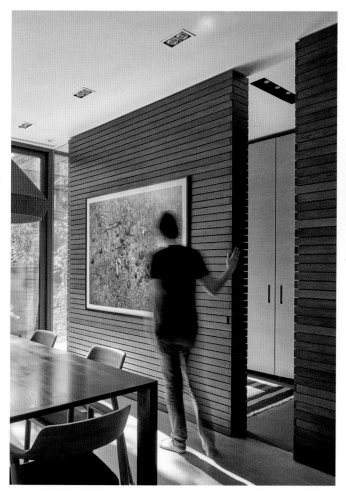
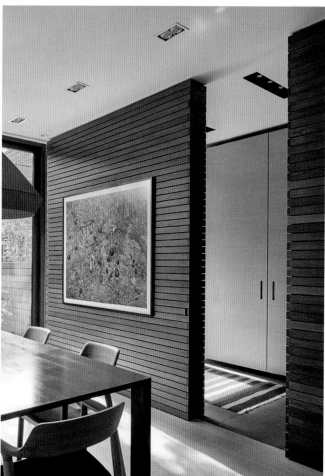

The flexible layout of the ground floor also offers the owners the option to alter the configuration of the dining area thanks to a sliding panel.

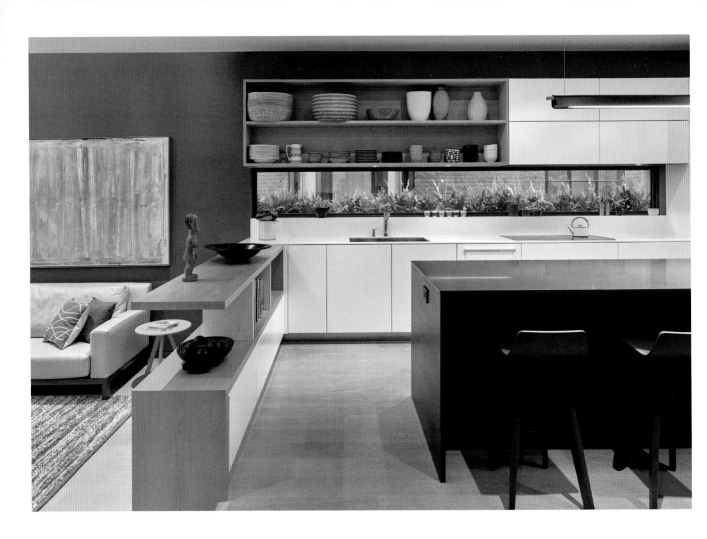

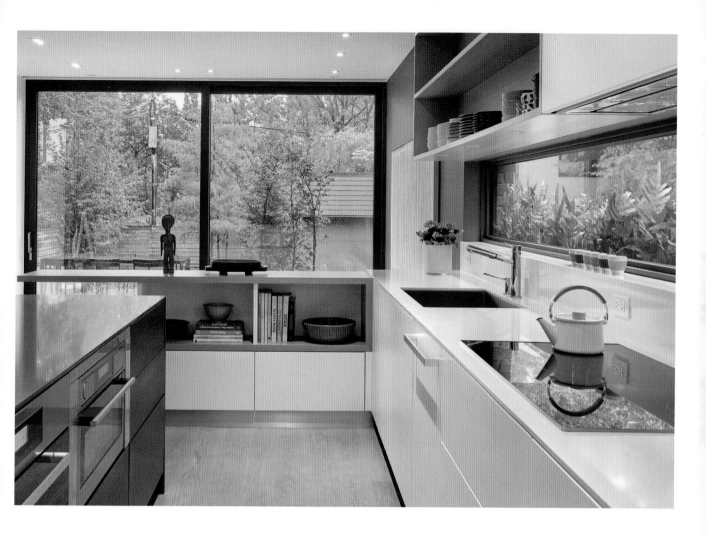

The expansive, crisp white surfaces of the kitchen cabinetry contrast with different elements within, such as the dark-stained oak slats of the movable vestibule screen and wall, the generous kitchen island with a charcoal Silestone countertop, and the white oak shelving dedicated to the display of the owner's collected belongings.

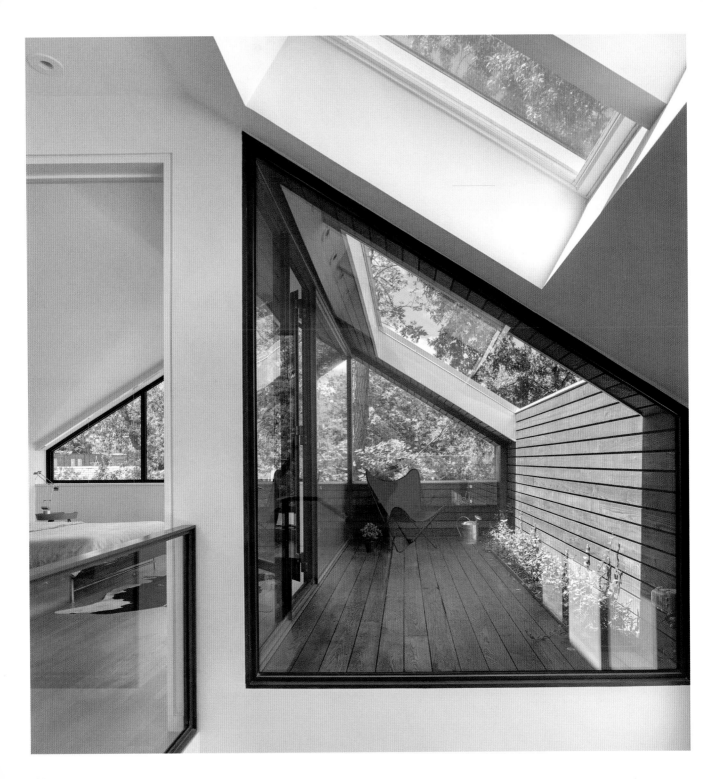

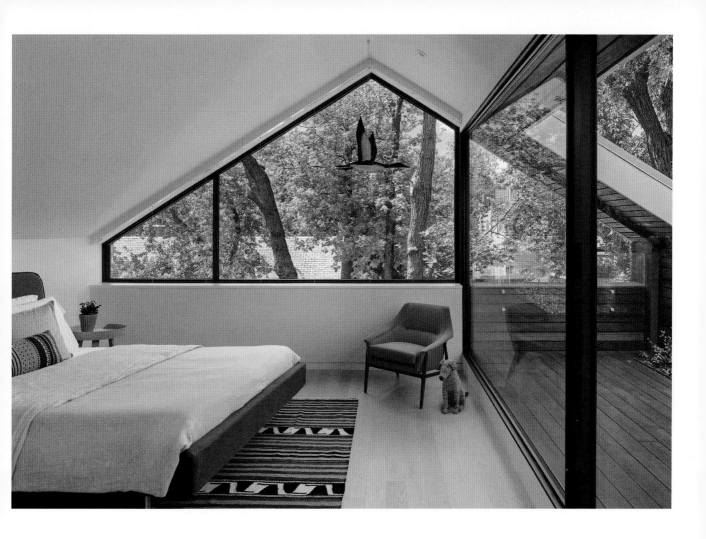

The "skygarden" acts as an extension of the master bedroom. The warm ash cladding gives this outdoor space an intimate feel, while an opening carved into the roof allows for natural light, access to rainwater, and ample views of green.

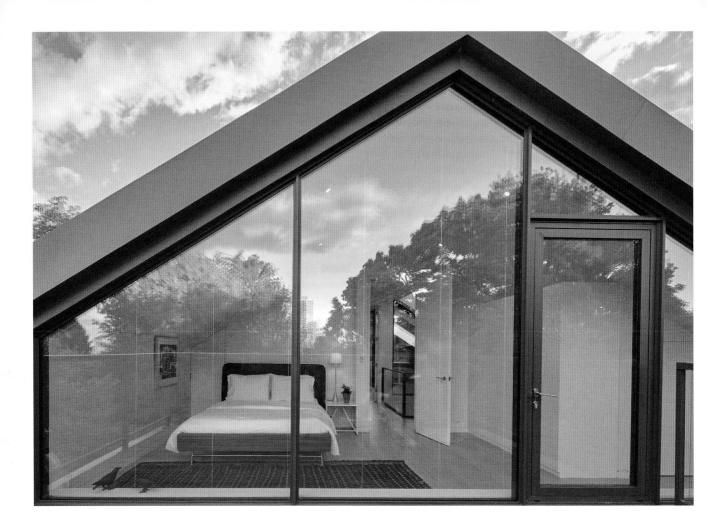

The new roof pitch was made less
steep. In the attic, this allowed for
taller ceiling height at the eaves, and
therefore better use of the space. It
made for one of the most appealing
spaces in the house.

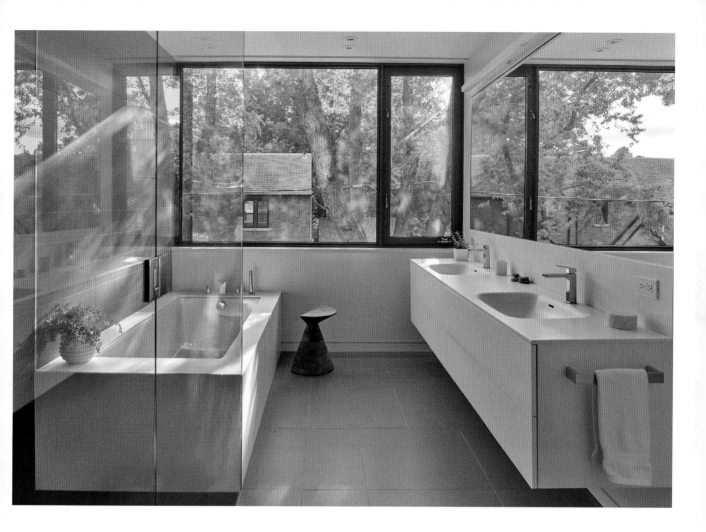

## Credits

**Architect:**
Dubbeldam Architecture + Design
www.dubbeldam.ca

## Appliances and Materials

**Flooring:** Admonter white Oak by Moncer
**Millwork:** by Lakeland Interiors, Kobi's Cabinets, and Gibson Greenwood
**Stone:** "Marengo" by Silestoneat kitchen counter and backsplash; "White Zeus by Silestone at kitchen island counter; "Glacier white" by Corian at basement bathroom, en suite bathroom, and third floor bathroom

**Tile:** Architecture series, "dark grey" by Stone Tile at vestibule and rear entrance; SRN Carrara by Saltillo Tiles at powder room; EVP Steel Gray by Saltillo Tile at basement bathroom floor and walls; "Edge smoke" by Stone Tile at basement bathroom shower floor; "Ageless white" by Stone Tile at laundry room; Architecture series "Medium grey" by Stone Tile at en suite bathroom;

"Ageless white" by Stone Tile at third floor bathroom floor; "Edge black" by Stone Tile at third floor bathroom walls and shower floor
**Windows:** Custom windows and Bigfoot sliding rear doors by Just Aluminum & Glass; window shades by Solarfective; skylights by Velux

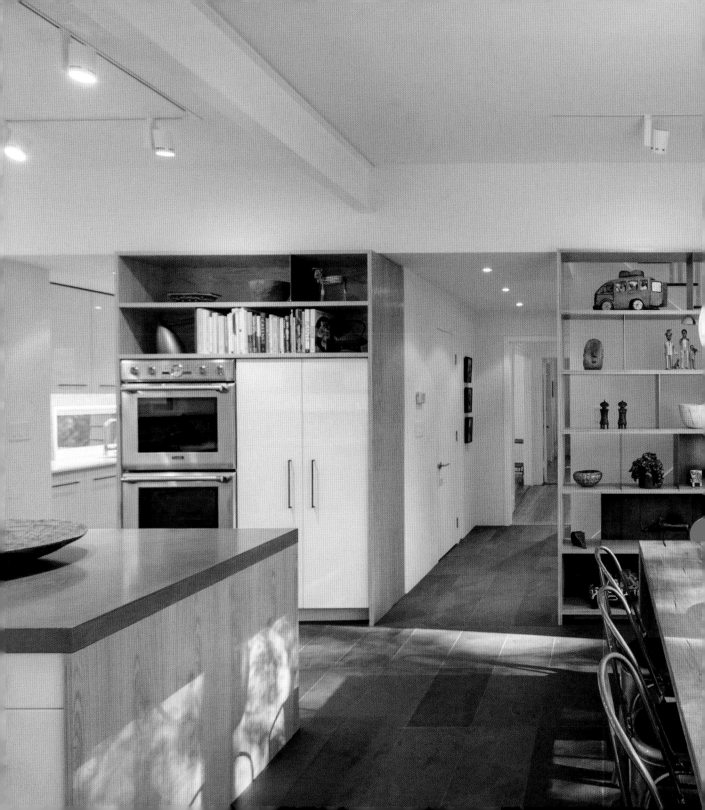

# PROFESSORS ROW RENOVATION

## 1,600 sq. ft.

**Cambridge, Massachusetts, United States**

—

**AAMODT PLUMB ARCHITECTS**

Photos © Jane Messinger

Project team: Mette Aamodt, Andrew Plumb, Rachel Gealy

**www.aamodtplumb.com**

> OPEN HOUSE TO THE GARDEN

> PROVIDE THE HOUSE WITH A MODERN, YET CRAFTED STYLE

> PROVIDE PLENTY OF SHELVING SPACE FOR THE DISPLAY OF THE OWNERS' COLLECTION OF AFRICAN ARTWORK

A RAMBLING CAMBRIDGE SHINGLE-STYLE HOME IS TRANSFORMED INTO A MODERN GALLERY FOR ARTWORK, ARTIFACTS, SCHOLARLY PURSUITS, AND FAMILY GATHERINGS.

"The house was recently purchased by a pair of Harvard anthropology professors specializing in Africa and African American Studies. Both modern minimalists at heart, they hoped for a house transformation that could afford a setting for the display of their enormous collection of African art. They also wanted a home with a flexible layout so they could host family and friends, as well as conduct research projects in the comfort of their own home.

To bring the house up to date, we gutted the kitchen, which was the area of the house that needed most work. The ceiling was lifted, gaining in spaciousness. But the most significant change was brought in by new floor-to-ceiling windows framing the northwest corner of the kitchen and allowing unobstructed views of the garden. By doing so, we achieved another goal set by the clients: make the garden an integral part of the house remodel.

The kitchen redesign combines custom-made and off-the-shelf elements, resulting in an innovative and interesting juxtaposition of raw and refined elements that offered a high-quality look, yet allowed us to keep the costs down. This set the tone for the redesign of the entire house and created the ideal setting for the display of the artwork collection."

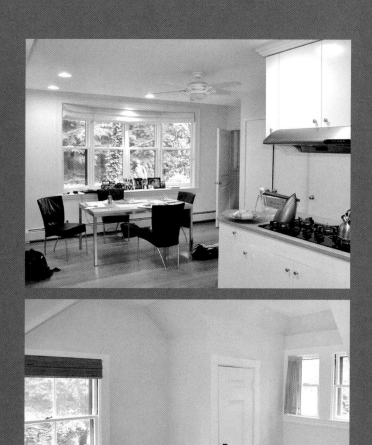

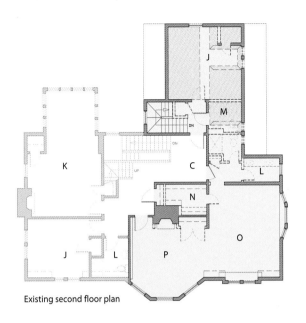

Existing second floor plan

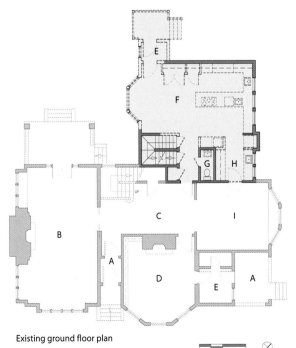

Existing ground floor plan

A. Entry
B. Great room
C. Hall
D. Library
E. Mudroom
F. Kitchen
G. Powder room
H. Pantry
I. Dining room
J. Bedroom
K. Office
L. Bathroom
M. Laundry room /
bathroom
N. Master bathroom
O. Master bedroom
P. Study

0    5'    10'

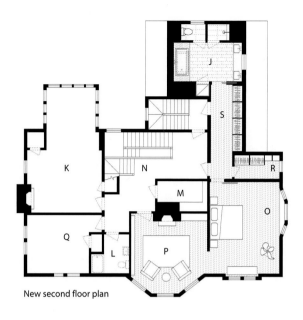

New second floor plan

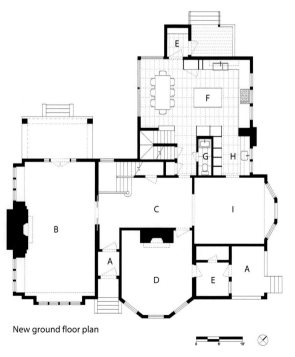

New ground floor plan

A. Entry
B. Living room
C. Gallery
D. Study
E. Mudroom
F. Kitchen
G. Powder room
H. Pantry
I. Dining room
J. Master bathroom

K. Office
L. Bathroom
M. Linen closet
N. Stair hall
O. Master bedroom
P. Master study
Q. Guest bedroom
R. Closet
S. Dressing gallery

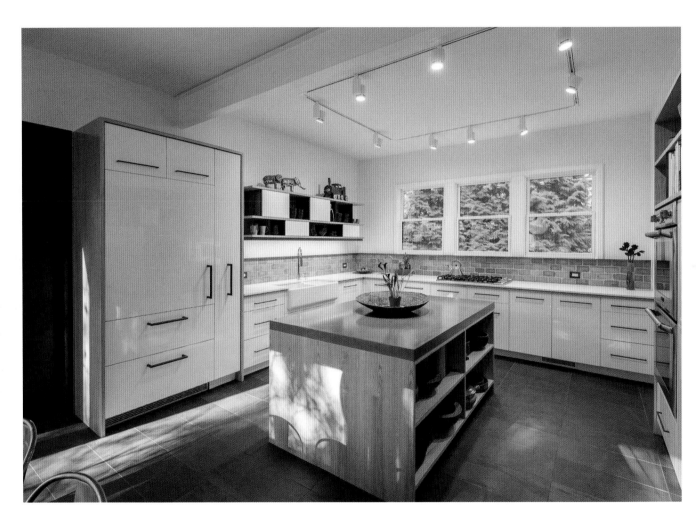

Plywood enclosures were wrapped around semicustom cabinets to give a custom look at an affordable price. This combination of high-gloss cabinets, custom plywood and raw steel shelves, and concrete countertop gives the kitchen a modern but crafted feel.

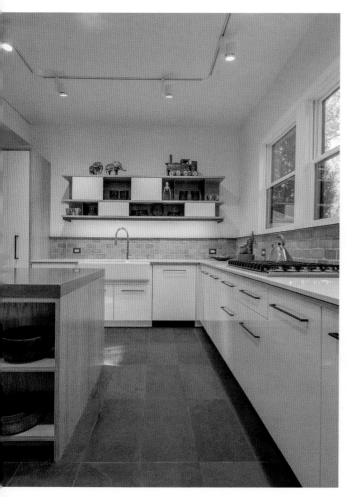
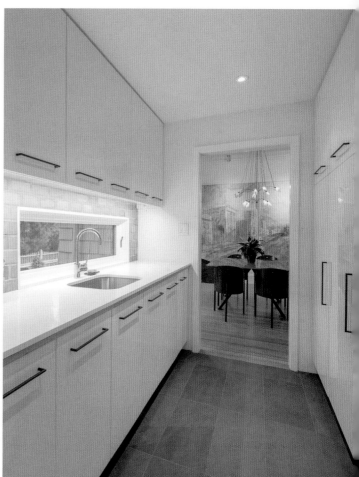

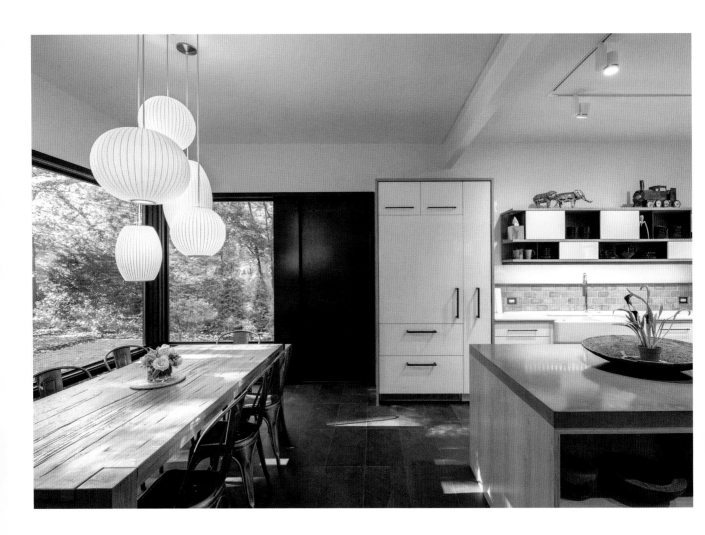

The exposed joinery of the shelving
and cabinet enclosures reveals the
hand of the carpenter and provides
a wonderful setting for the owner's
collection of African bowls and
primitive artwork.

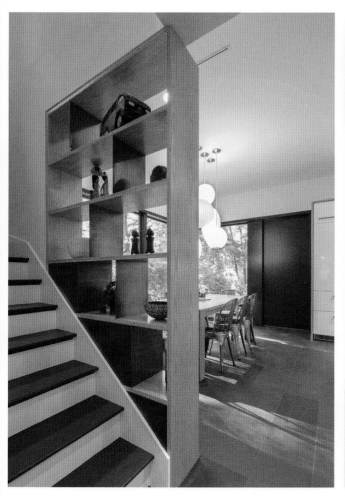

The tall shelf unit acts as a screen for the back stair but still allows views through it of the garden. This unit is particularly well suited to the display of African artifacts, as they can be seen from all sides.

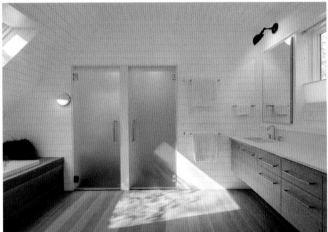

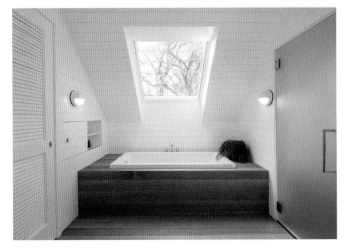

A master suite was created in an area of the second floor that was a rabbit's warren of small rooms and closets. The bedroom and sitting area were connected by a dressing gallery to a clean new master bathroom with wood-enclosed tub bathed in sun from a skylight.

## Credits

**Architect: Aamodt / Plumb Architects**
www.aamodtplumb.com

**General contractor: Shepherd PMC**
www.shepherdpmc.com

## Appliances and Materials

**Bathroom floor and vanity:** Red oak
**Cabinets:** Brookhaven with high-gloss panels
**Countertops:** Concrete and Caeserstone
**Custom shelves:** Baltic-birch plywood with red-oak veneer
**Kitchen backsplash:** Handmade concrete tiles from Etsy
**Kitchen flooring:** Black slate

**Steel shelves:** Cold-rolled steel
**Windows:** Marvin

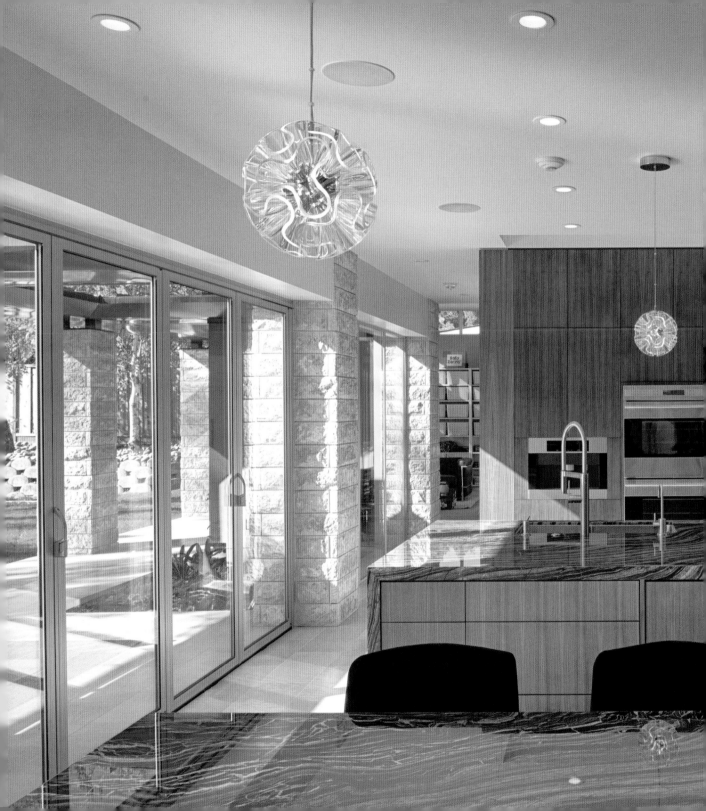

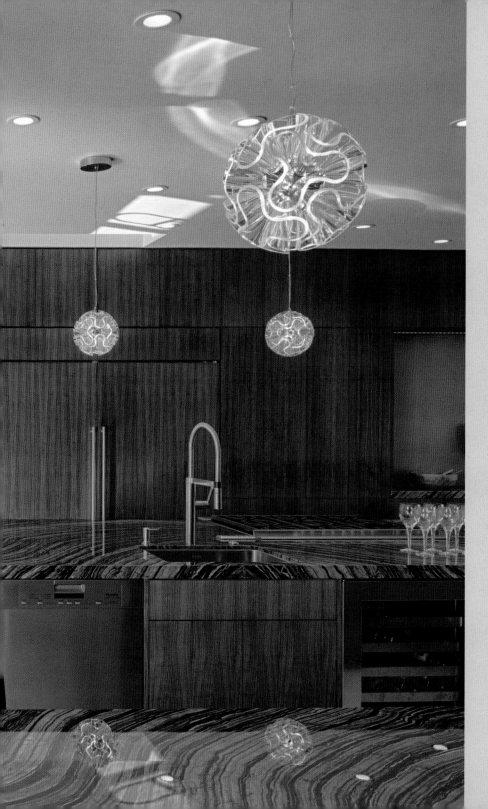

# SARATOGA RESIDENCE

## 3,879 sq ft

Saratoga, California, United States

---

**CAST ARCHITECTURE**

Photos © CAST Architecture

Project team: Matt Hutchins, AIA, Principal

**www.castarchitecture.com**

> INCREASE STORAGE CAPACITY OF
BEDROOMS, LIVING ROOM, KITCHEN AND
BATHROOM

> CREATE MORE COUNTER SPACE IN THE
KITCHEN AND TAKE ADVANTAGE OF
UNDERUTILIZED SPACE

> OPEN UP KITCHEN TO DINING ROOM

## A DRAMATIC KITCHEN ISLAND BECOMES THE HEART OF A HOUSE DESIGNED FOR ENTERTAINING.

"The house is a complete reboot of a 1969 faux colonial. We removed all the signs that made reference to that period and focused on the creation of a home with seamless indoor-outdoor living. A new stone arcade redefines a dining and lounge area, as well as a series of planted areas. The arcade provides the house interior with shade, while reinforcing a horizontal configuration in keeping with the strict planning regulations of the area.

The house features seamless indoor-outdoor living, with gardens and terraces linking the house to the landscape. The palette of natural materials is understated, yet rich in textures.

Designed for entertaining, the house features a dramatic a 14-foot × 5-foot kitchen island and generous storage concealed in full-height cabinets."

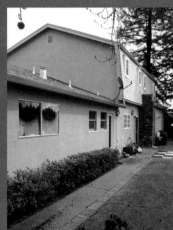

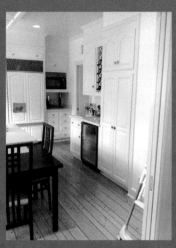
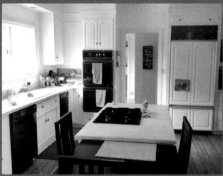

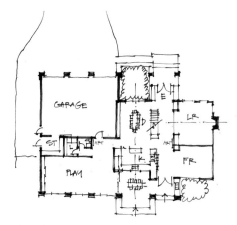

Floor plan option A

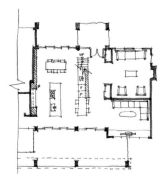

Kitchen, dining, and living plan option A

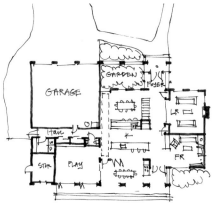

Floor plan option B

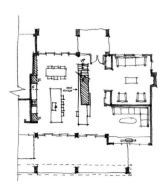

Kitchen, dining, and living plan option B

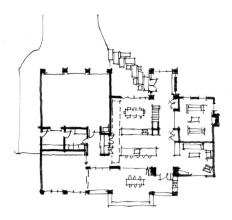

Floor plan option C

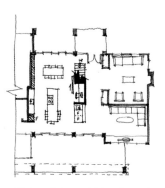

Kitchen, dining, and living plan option C

View from front entry

View from back patio

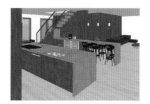

View from playroom / mudroom hallway

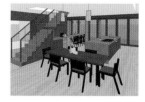

View from front dining room

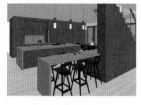

View from family room / front-entry hall

View from family room

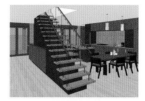

View from front entry

View from back patio

View from playroom / mudroom hallway

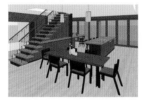

View from front dining room

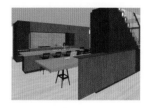

View from family room / front-entry hall

View from family room

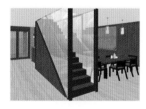

View from front entry

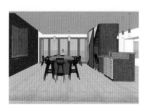

View from back patio

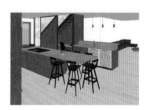

View from playroom / mudroom hallway

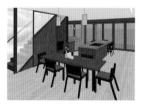

View from front dining room

View from family room / front entry hall

View from family room

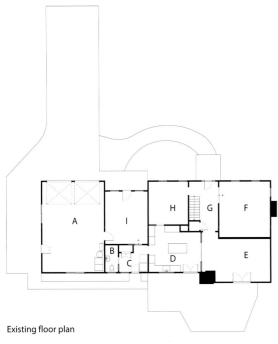

**Existing floor plan**

A. Garage
B. Powder room
C. Laundry room
D. Kitchen
E. Family room

F. Living area
G. Entry
H. Dining area
I. Playroom

**New floor plan**

A. Garage
B. Powder room
C. Laundry room
D. Kitchen
E. Family room
F. Living area
G. Entry
H. Dining area

I. Playroom
J. Storage
K. Mudroom
L. Garden
M. Terrace
N. BBQ
O. Hot tub

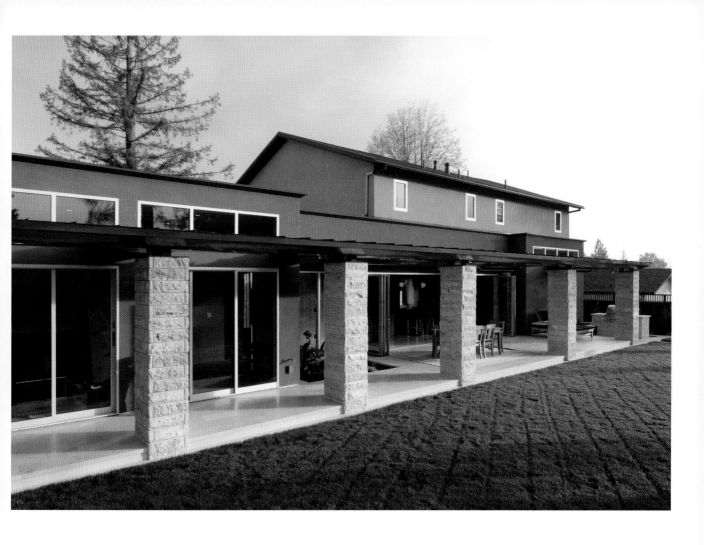

A pergola along the entire back façade extends the social areas of the house to the outdoors and provides a sheltered area for comfortable outdoor dining adjacent to the verdant garden.

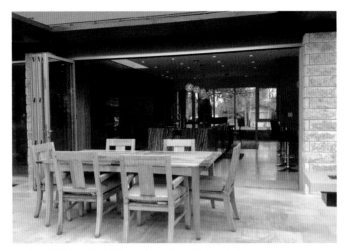

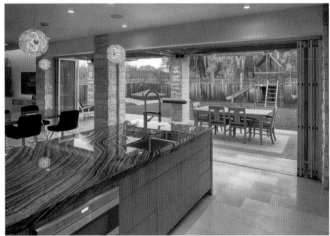

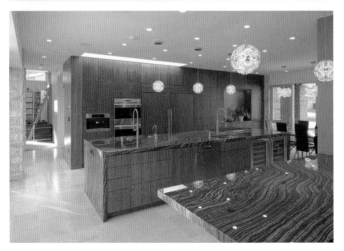

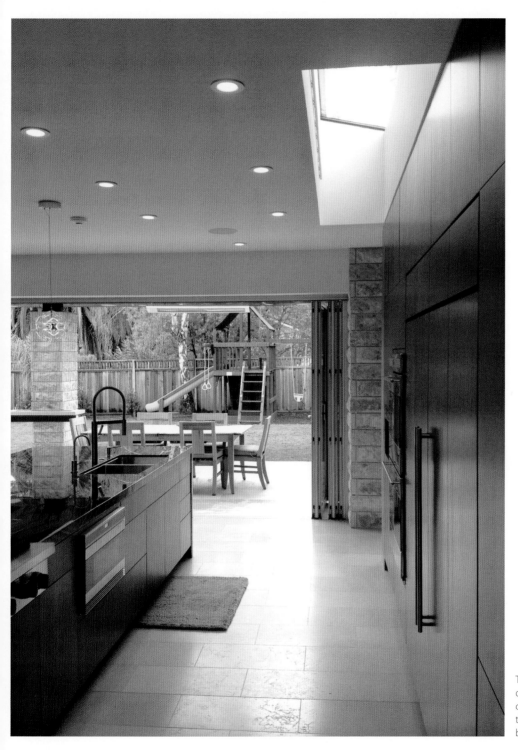

The dining area, the kitchen, and the outdoor dining area are arranged to connect the front and rear gardens through large glass windows and bifold doors.

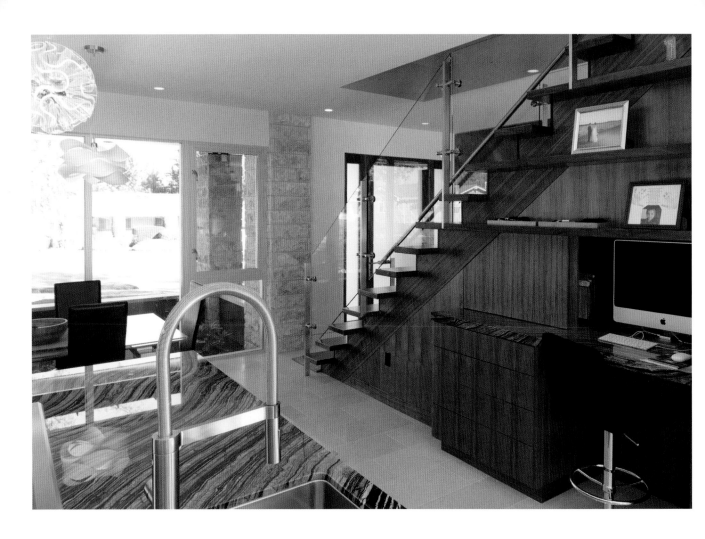

The staircase acts as an organizing
element of the open social space. It
partially separates the kitchen and
dining area from the family room and
living area.

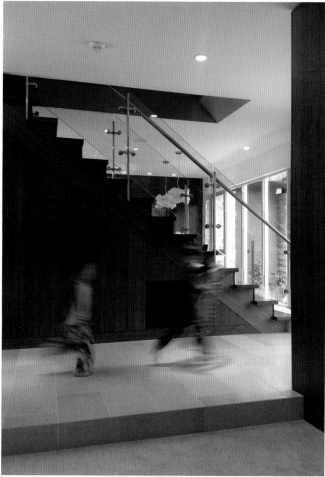

## Credits

**Architect: CAST Architecture**
www.castarchitecture.com

**General contractor:**
**De Mattei Construction**
www.demattei.com

## Appliances and Materials

**Appliances:** Wolf cooking range, Sub-Zero refrigerator, Miele dishwasher and coffee maker
**Cabinetry:** Clear-stained walnut by The Cutting Edge Cabinetry
**Countertop:** "Silver Wave" marble
**Fixtures and sinks:** Franke
**Railings and counter base:** Custom stainless steel by CAST Architecture

**Stone flooring and columns:** "Jerusalem Gold" limestone by Francisco Tile

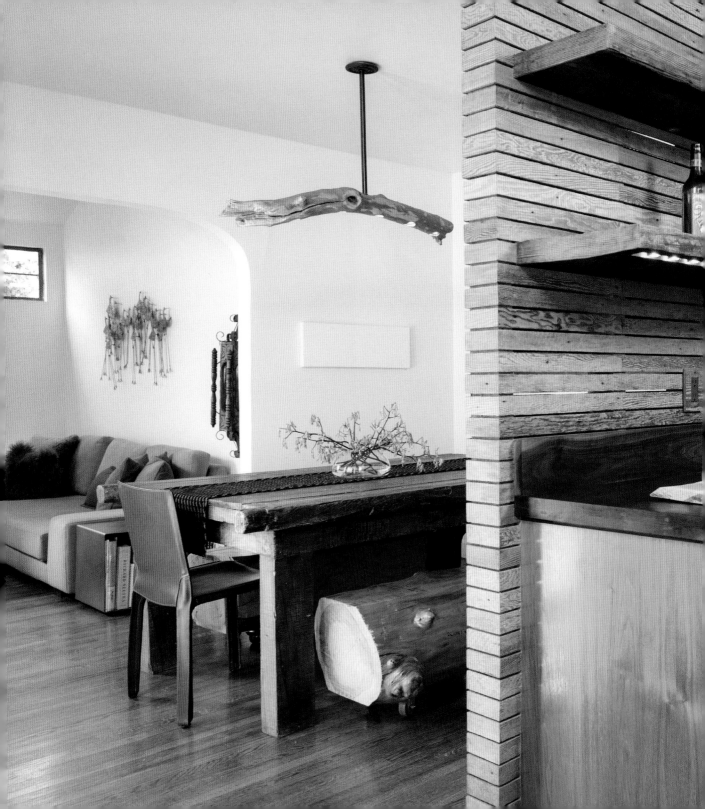

# BOISE RESIDENCE

## 1,140 sq. ft. *

Los Angeles, California, United States

---

**HSU MCCULLOUGH**
**ARCHITECTURE / INTERIOR DESIGN**

Photos © Clark Dugger

* Garage excluded

Project team: Chris McCullough and Peggy Hsu

**www.hm.la**

> FULLY REMODEL THE HOUSE ON A MODEST
>   BUDGET

> IMPROVE INTERIOR-EXTERIOR CONNECTION

> MAKE HOUSE FEEL LARGER WITHOUT
>   ADDING SQUARE FOOTAGE

PEGGY HSU AND CHRIS MCCULLOUGH ARE PARTNERS BOTH IN LIFE
AND IN BUSINESS. THEY UNDERTOOK THE CHALLENGING PROJECT
OF REMODELING THEIR OWN HOUSE.

---

"Our project consisted in the conversion of a nondescript bungalow into
a contemporary rustic/Spanish-revival-style home. The existing house
had been a rental property since the 1980s, when we purchased it. The
5,700-square-foot lot comprises a 1,140-square-foot house with two bed-
rooms and one and a half bathrooms, and a 350-square-foot detached ga-
rage.

The goal was to completely remodel the entire house, but we didn't want
to increase the existing area of the house. Refurbishing included replacing
all windows and exterior doors with period-appropriate finishes—all on a
modest budget. We had a pretty clear idea of what we wanted our house to
look like in terms of design aesthetics. Inspiration came from the architec-
ture of Luis Barragán, and the use of wood in traditional Japanese homes.
Also, we are both passionate about finding vintage treasures at architectural
salvage yards. It's not just about giving found materials and items new life,
but it's also about lending a sense of history and uniqueness to a place.

With the exception of some casual design advice offered to friends, the re-
model of the house was our first project together. Challenging? Definitely.
The major challenge was living in the house through construction, some-
thing we don't recommend, let alone would do again. In all, despite minor
difficulties, we still found small pleasures in this DIY projects that made the
experience more worthwhile."

---

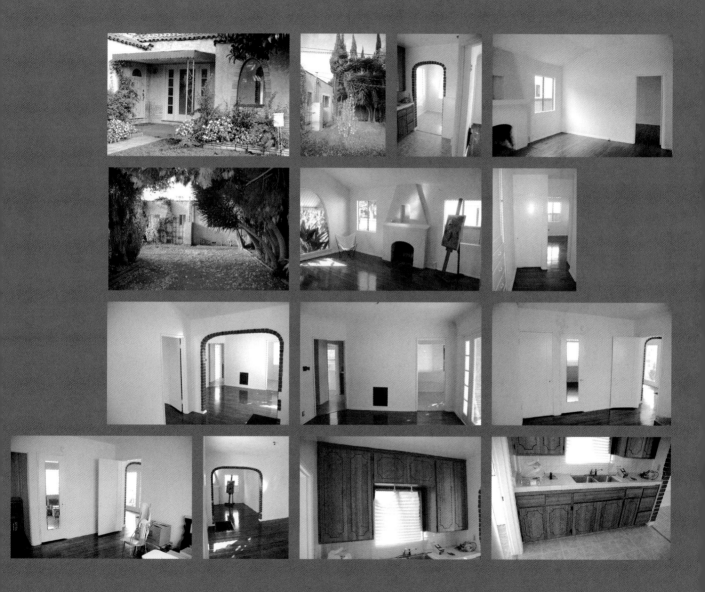

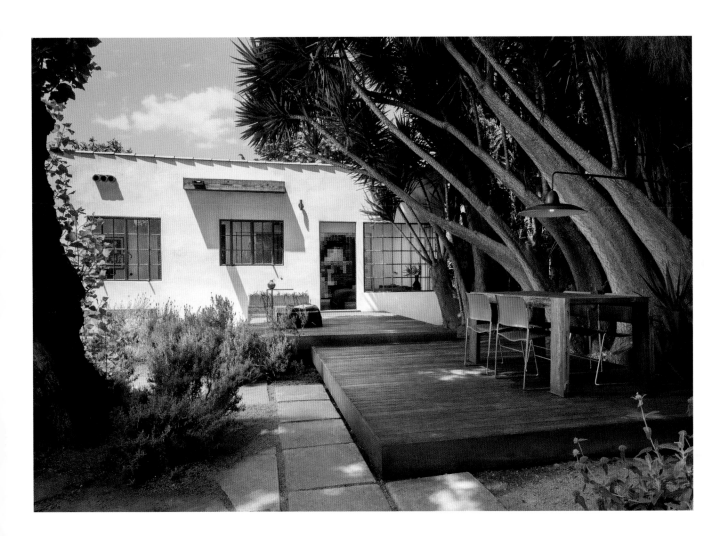

The main goal was to make the front and rear yards exterior living spaces that connected to the adjacent interior spaces, and to make the small house appear much larger.

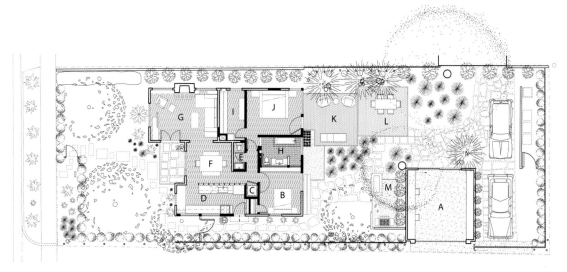

**New floor plan**

A. Garage
B. Guest bedroom
C. Washer / dryer
D. Kitchen
E. Powder room
F. Dining area
G. Living area
H. Master bathroom
I. Master closet
J. Master bedroom
K. Living deck
L. Dining deck
M. Fire pit

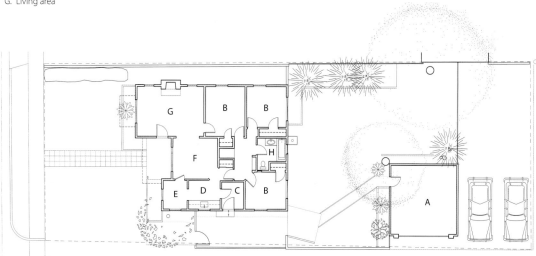

**Existing floor plan**

A. Garage
B. Bedroom
C. Laundry room
D. Kitchen
E. Breakfast nook
F. Dining room
G. Living room
H. Bathroom

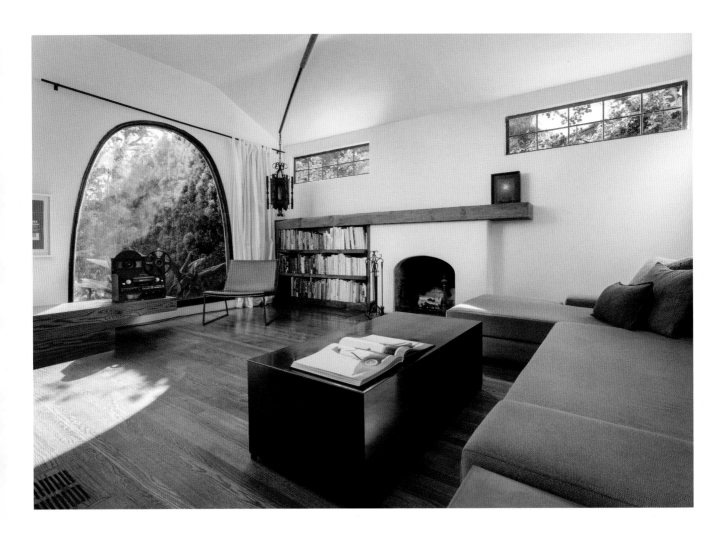

The interior was rearranged to enhance
the connection with the yards. The
mature trees on the property provide
privacy in the existing urban setting
as well as visual interest.

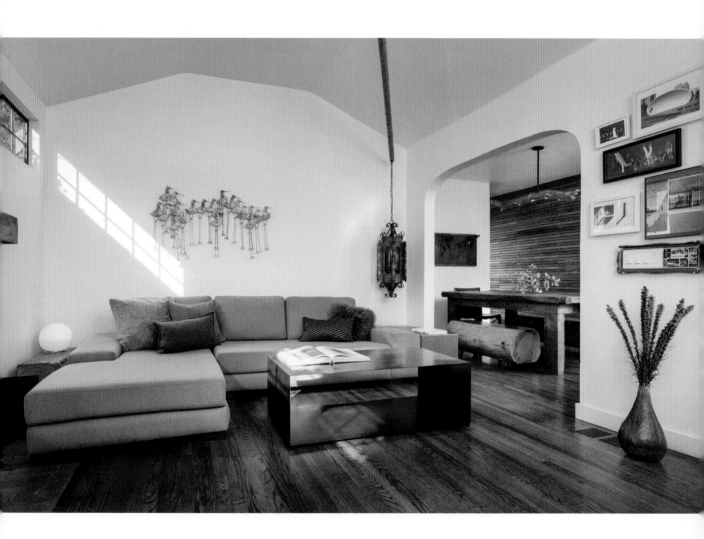

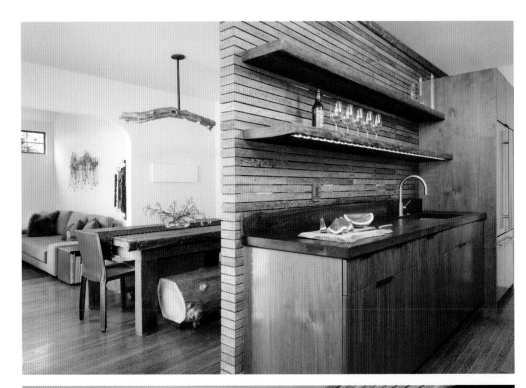

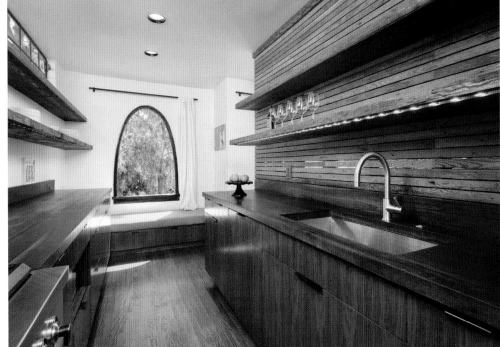

While the areas are somewhat demarcated by partition walls, circulation is continuous throughout the house. Such is the case of the kitchen wall, which was a compromise between Chris and Peggy: one wanted to open the rooms up to each other, and the other wanted to keep the kitchen closed, like a traditional kitchen from a time when the original house was built.

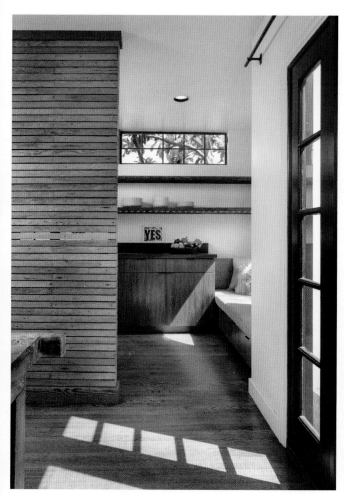
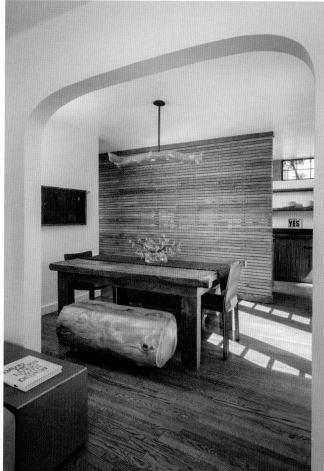

Kitchen elevations

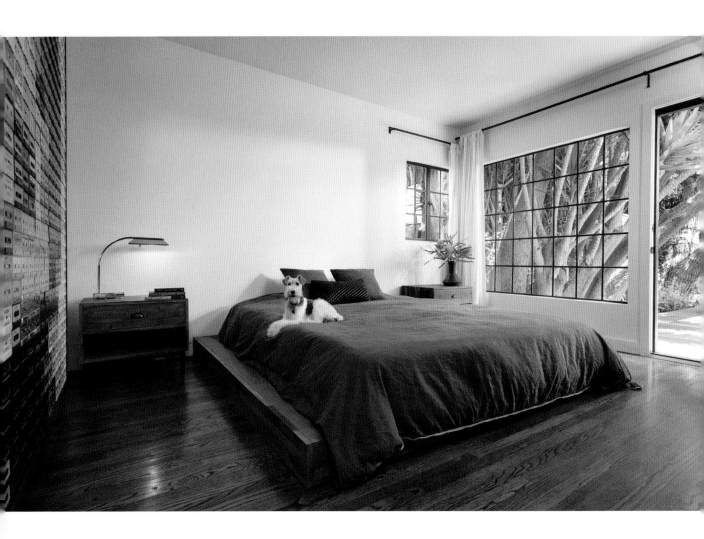

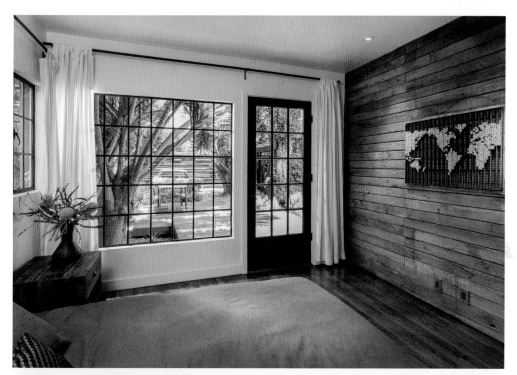

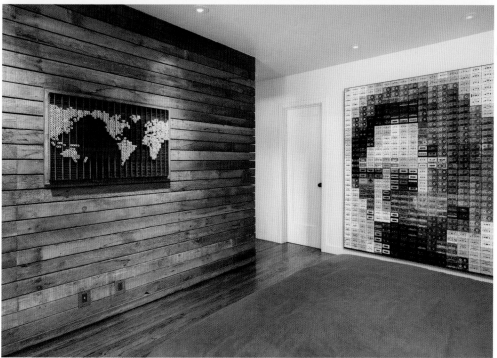

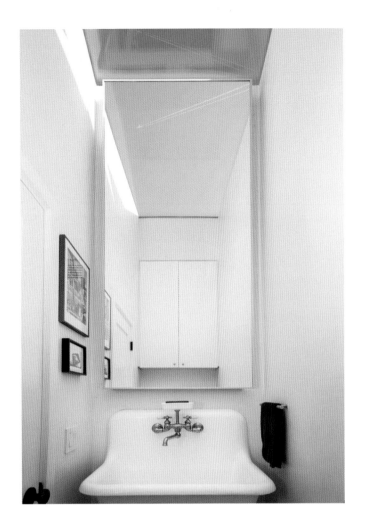

Master bathroom elevations

A skylight floods the powder room with
natural light making it feel spacious
despite the limited dimensions. The
mirror above the sink visually expands
the space.

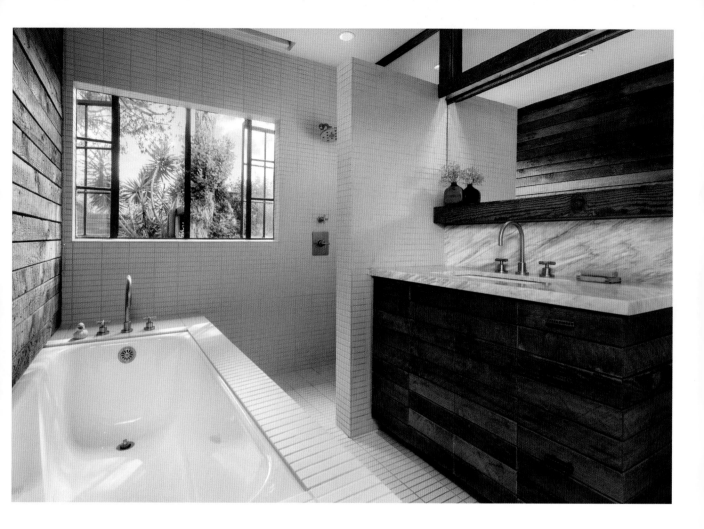

## Credits

**Architect, interior Designer, and landscape designer:** Hsu McCullough
www.hm.la

## Appliances and Materials

**Appliances:** Jenn-Air
**Bathroom cabinets:** Custom reclaimed salvaged lumber face
**Bathroom stone countertop:** Marble Unlimited "Calacatta Gold"
**Bathroom tile:** Eco-Gres, white
**Bathroom wood wall:** Reclaimed wood from removed interior walls
**Flooring:** 2" wide red oak hardwood flooring with Minwax Jacobean stain

**Baseboards at painted walls:** Poplar and ICI Paints "Swiss Coffee", semi-gloss sheen
**Doors:** Existing and ICI Paints "Swiss Coffee", semi-gloss sheen
**Door hardware:** Baldwin 5015 Estate Knob, Oil Rubbed Bronze
**Kitchen coutertops:** Solid American black walnut
**Kitchen cabinets:** Walnut veneer

**Walls and ceilings:** ICI paints, "Swiss Coffee", eggshell sheen
**Steel window frames at exterior:** ICI paints, "The Dark Side"

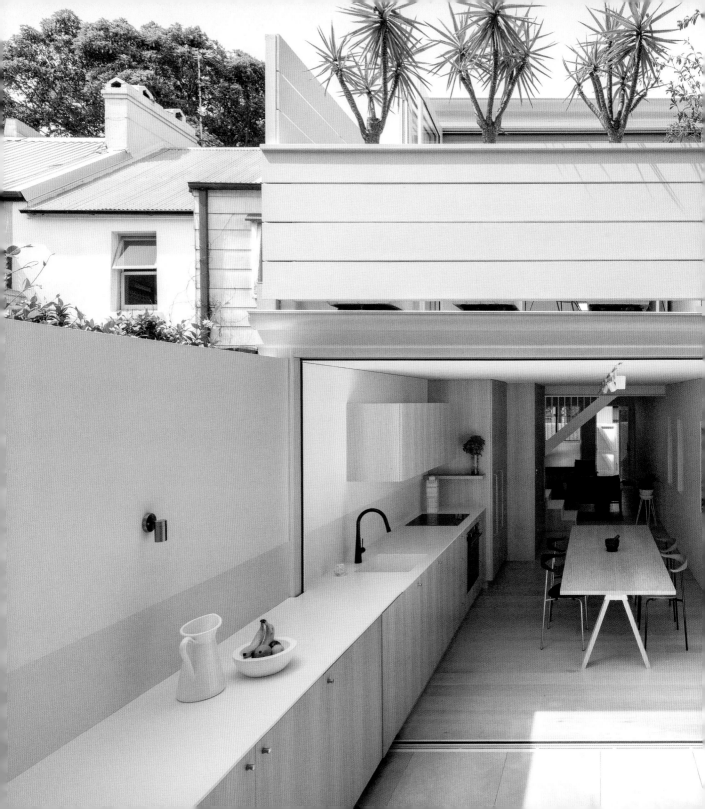

# SURRY HILLS HOUSE

## 883 sq. ft.

Sydney, New South Wales, Australia

———

**BENN + PENNA ARCHITECTS**

Photos © Tom Ferguson

Project team: Andrew Benn, Sean Tran,
Kirsty Hetherington, Michelle Dunas,
Courtney Raad.

**www.bennandpenna.com**

> TRANSFORM THE ENTIRE GROUND FLOOR INTO
  A CONTINUOUS INDOOR-OUTDOOR SPACE

> PROVIDE ADDITIONAL BEDROOM AND
  PRIVATE TERRACE ON THE SECOND FLOOR

## THE PROJECT TRANSFORMS WHAT WAS PREVIOUSLY A DARK AND INTROVERTED HOME INTO ONE OF ABUNDANT NATURAL LIGHT AND GENEROUSLY PROPORTIONED SPACES.

"This project is an alteration and addition to a tiny inner-city terrace, including new bedrooms, bathrooms, kitchen, courtyard, and living spaces. The design locates the new bedroom and bathrooms spaces above an open plan living area that opens onto intimate garden spaces at either end of the property. The inhabitants are now able to use the entire ground floor as a continuous indoor-outdoor space, heightening the experience of leisure activities in the house. The project also provides an additional bedroom and private terrace above for more intimate enjoyment.

Modest in scale, the new built form is a subtle play on the elongation of dwellings predominant in the narrow lots of Surry Hills. The pared-back and understated interior is designed to foreground the rich texture of Surry Hills brickwork surrounding the site."

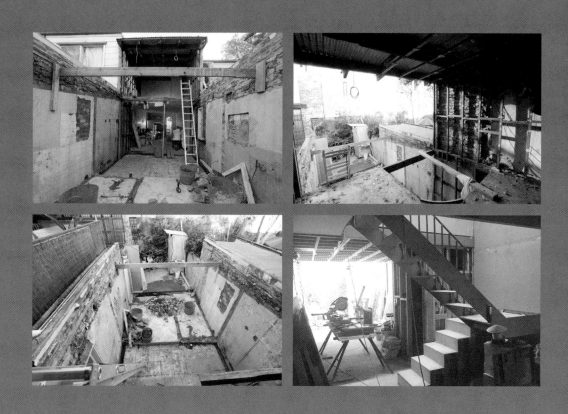

Existing second floor plan

New second floor plan

Existing ground floor plan

New ground floor plan

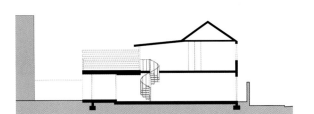

Existing building section

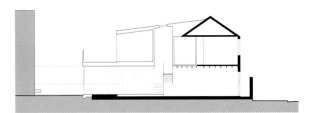

New building section

Conceptual sketch

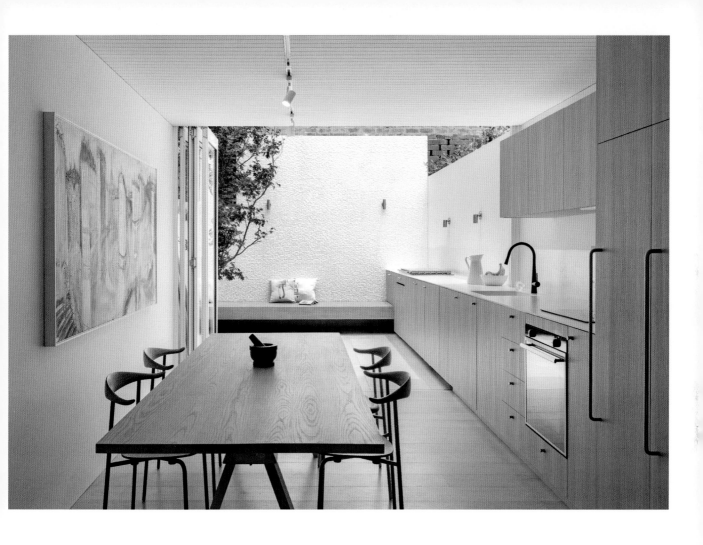

A wall of white mosaic tiles lines the back wall of the courtyard, reflecting northern light back into both the garden and rear kitchen space.

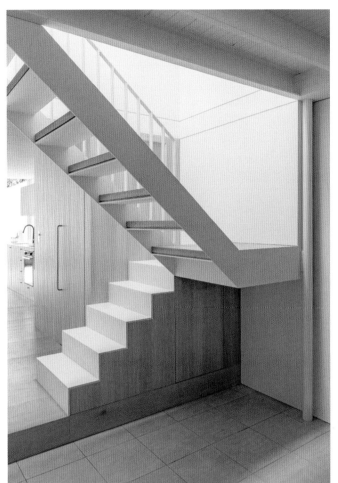
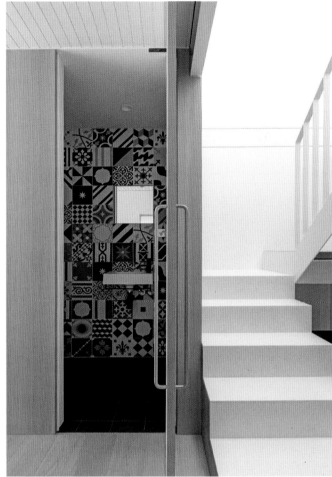

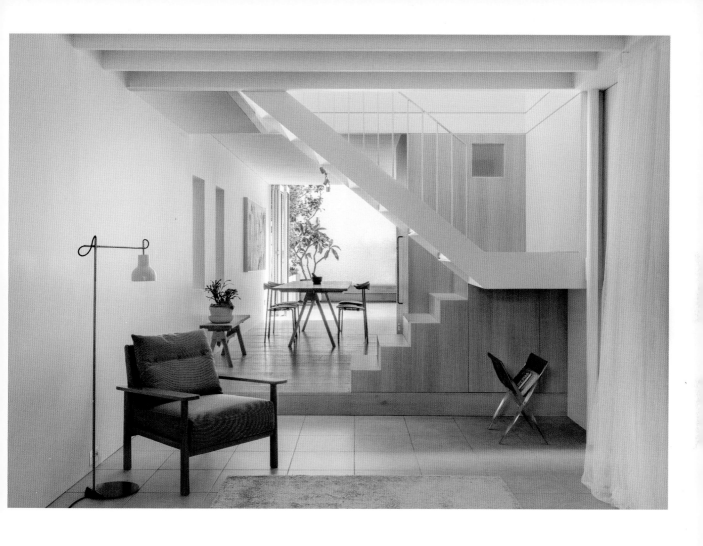

The staircase sits on the raised wood floor, which delineates the area of the kitchen and dining area. With its surface flush with the courtyard pavement, the connection between the interior and the exterior is seamless.

337

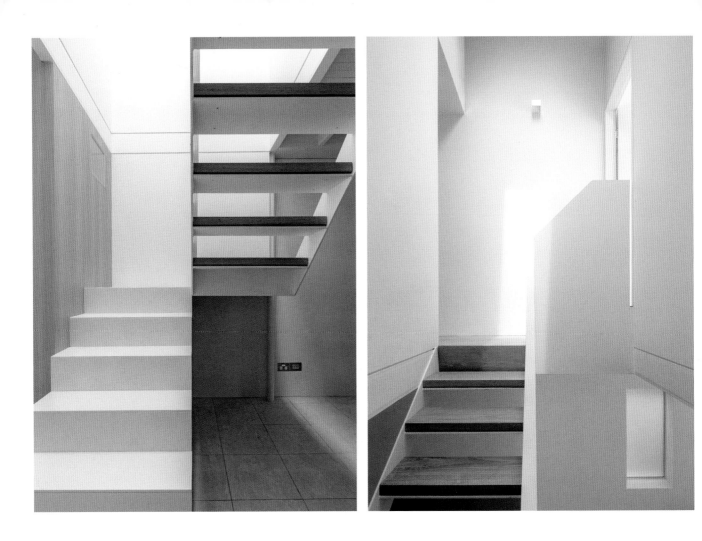

A delicately detailed steel stair rises through the middle of the building and guides natural light from a large skylight above into the center of the house.

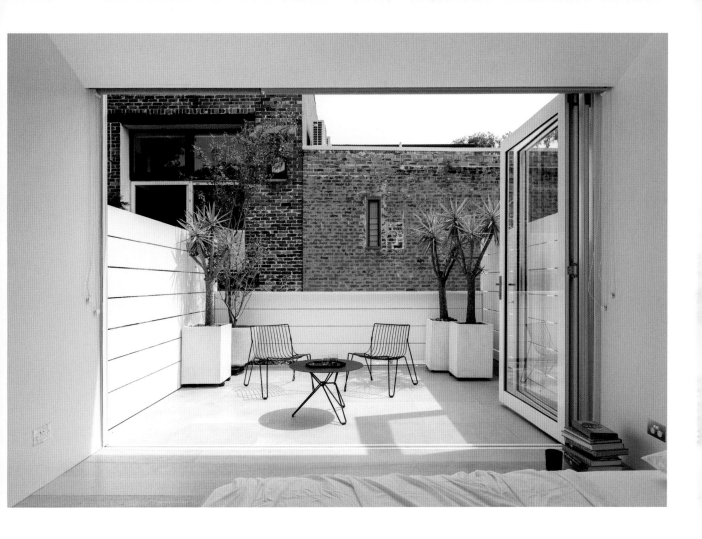

**Credits**

Architect: Benn + Penna Architecture
www.bennandpenna.com

Builder: ADON Constructions

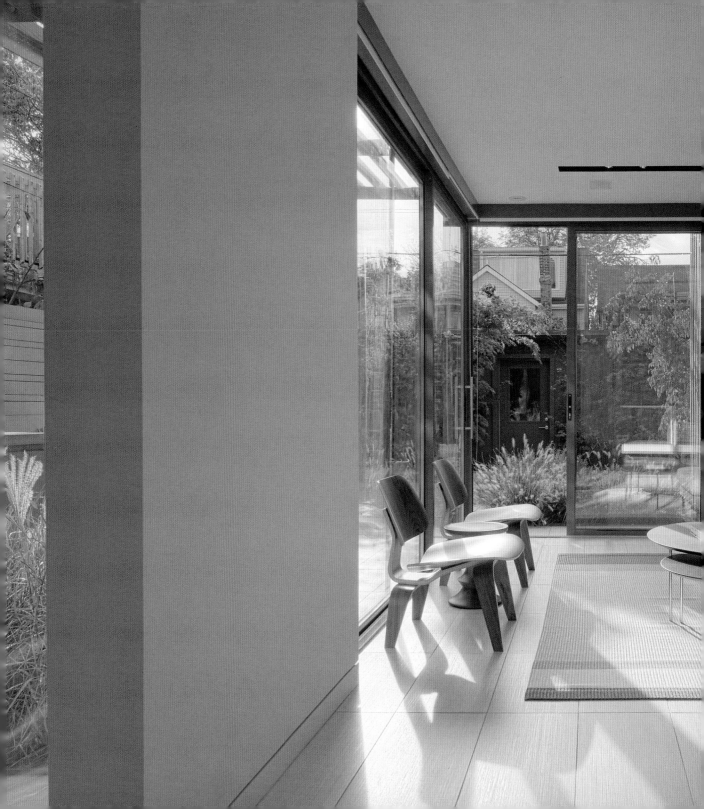

# THROUGH HOUSE

## 1,450 sq. ft.

Toronto, Ontario, Canada

---

**DUBBELDAM ARCHITECTURE + DESIGN**

Photos © Bob Gundu

Project team: Heather Dubbeldam, Principal Architect; Jason LeBlanc; Oliver Dang; Jacob JeBailey; Bindya Lad; Johanna Bollozos; Lynden Giles; Suzanna MacDonald

**www.dubbeldam.ca**

> REVITALIZE DARK, CRAMPED INTERIOR OF SMALL VICTORIAN HOUSE

> EXPAND LIVING SPACE TO REAR GARDEN

> DELINEATE ROOMS THROUGH MATERIAL AND CUSTOM ELEMENTS, WHILE KEEPING SPACES CONNECTED

> UTILIZE SUSTAINABLE STRATEGIES TO MITIGATE ENERGY COSTS

A BUSY DOCTOR COMMISSIONED THE RENEWAL OF A 128-YEAR-OLD HOUSE TO FULFILL HIS DESIRE FOR A MODERN AND LIGHT-FILLED HOME WITH A CONNECTION TO THE OUTDOORS.

"The house occupies a narrow lot in a densely populated neighborhood, with front and back yards that are private buffers between the home and the street. The renovation was aimed at expanding the living area, but it was decided that the footprint of the house would not be increased to maintain the sizable yards and the intimacy they provided.

First some walls were removed to open up the space. Second the layout was reconfigured using built-in elements and changing ceiling heights in order to define areas. Clean lines and finishes in contrasting colors rounded off a design that emphasizes linearity and visually stretches the space, directing the sight lines towards the backyard.

At the rear of the L-shaped house, large floor-to-ceiling glass panes on three sides blur the boundaries between interior and exterior. The kitchen countertop extends beyond the glass wall, becoming a BBQ, and the flooring material used throughout the ground floor runs outside to form an outdoor patio. Through House lives up to its name, opened from front to back, yet boasts a strong sense of intimacy."

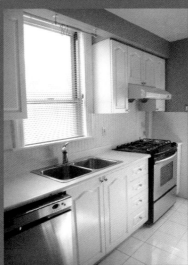

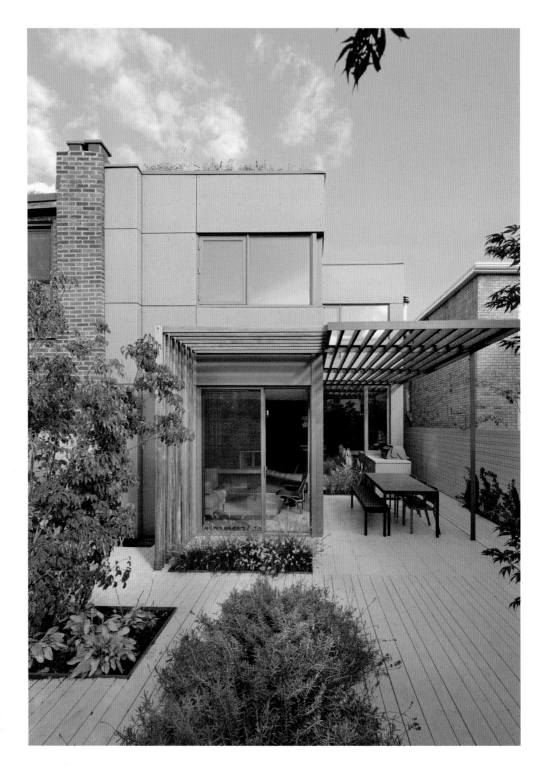

In the open corner, an overhead wood and steel trellis acts as a transition from the inside to the outside, creating the feeling of an exterior ceiling and defining an intimate outdoor room.

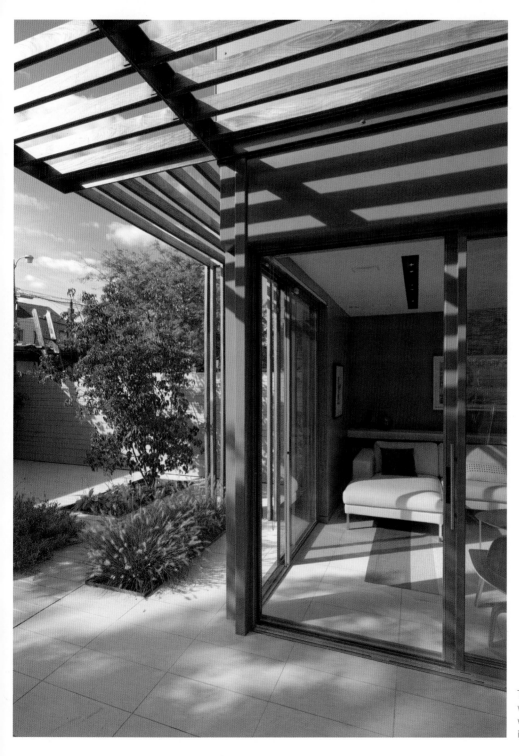

The trellis also provides the south and west walls with shade in the summer, while allowing light to reach deep into the interior in the winter.

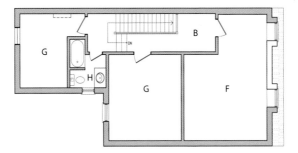

Existing second floor plan

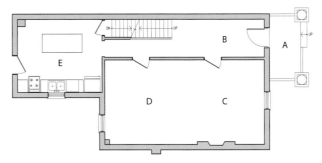

Existing ground floor plan

A. Front porch
B. Hall
C. Living room
D. Dining room

E. Kitchen
F. Master bedroom
G. Bedroom
H. Bathroom

The original layout had almost no connection with the backyard. With only small openings at the front and rear of the house, the interior received little natural light and felt even more disconnected from the outdoors.

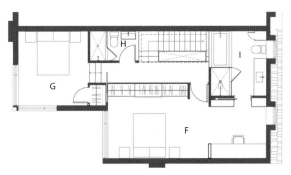

**New second floor plan**

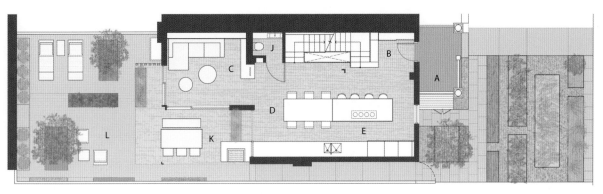

**New ground floor plan**

A. Front porch
B. Vestibule
C. Living room
D. Dining room
E. Kitchen
F. Master bedroom
G. Guest bedroom
H. Bathroom
I. Master bathroom
J. Powder room
K. Outdoor dining area
L. Terrace

The configuration of the layout and the geometry of its components extend beyond the rear walls, making the backyard an extension of the living area.

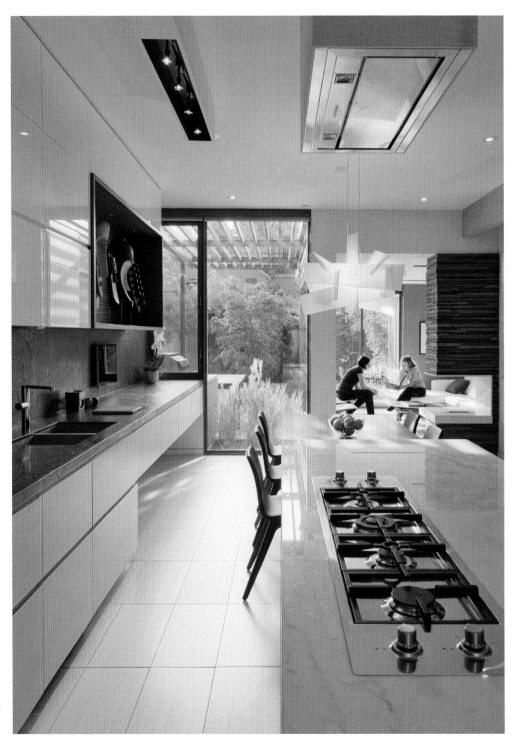

The kitchen's stone countertop extends along the south wall through the dining room and outside, morphing into a built-in BBQ.

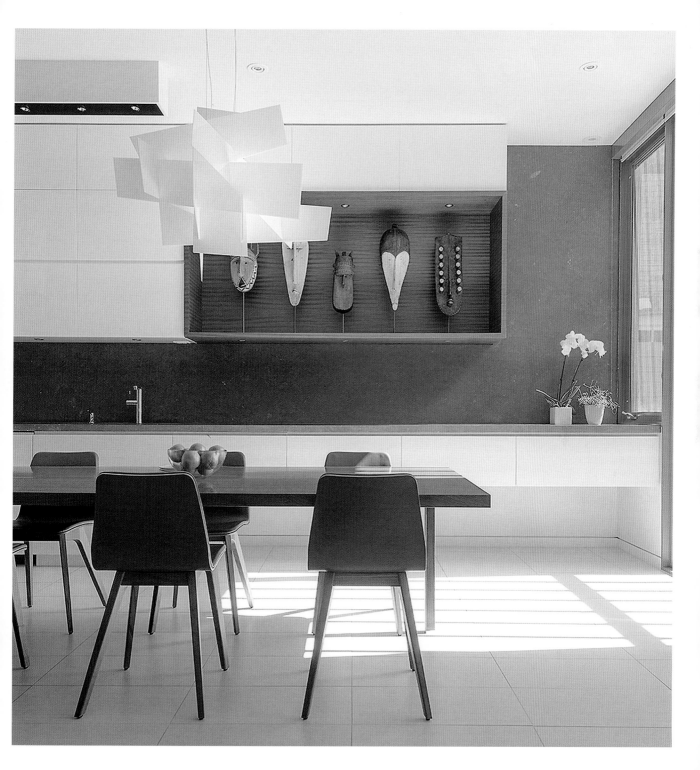

An open-riser staircase and an operable skylight allow for natural ventilation. In keeping with the desire to create bright, open spaces, the guardrail, made of translucent panels in various shades of blue, and translucent glass partitions on the upper floor, concealing two bathrooms, cast a soft blue light onto the surrounding surfaces.

## Credits

**Architect and landscape designer:**
Dubbeldam Architecture + Design
www.dubbeldam.ca

**Landscape contractor:**
Oriole Landscaping
www.oriolelandscaping.com

**Millwork:** Kobi's Cabinets, Caledon
Woodworks (www.caledonwood-works.com), Lakeland Interiors (www.lakelandinteriors.ca)

**Softscape:** Holbrook & Associates
www.ronaldholbrook.com

## Appliances and Materials

**Appliances:** Foster Quadra cooktop,
Miele integrated model G2002 dis-hwasher, Sub-Zero 700TC integrated
model refrigerator
**Flooring:** Stone tile "Bamboo Oyster"
at ground floor, Sullivan Source
"Winston Woods Oak" at second floor,
Olympia Tile "Floor White" at second
floor bathroom
**Kitchen counter:** Marble Trend "Cascade

Taupe" anticato limestone
**Kitchen backsplash:** Marble Trend
"Cascade Taupe" honed limestone
**Kitchen island counter:** Stone Tile
Statuario marble
**Walls:** Olympia Tile "Gatineau White
Matte" at basement and second floor
bathroom walls, Stone tile "Pavimenti
Perla at powder room, Stone Tile "Kris-tal Cielo" at second floor shower walls

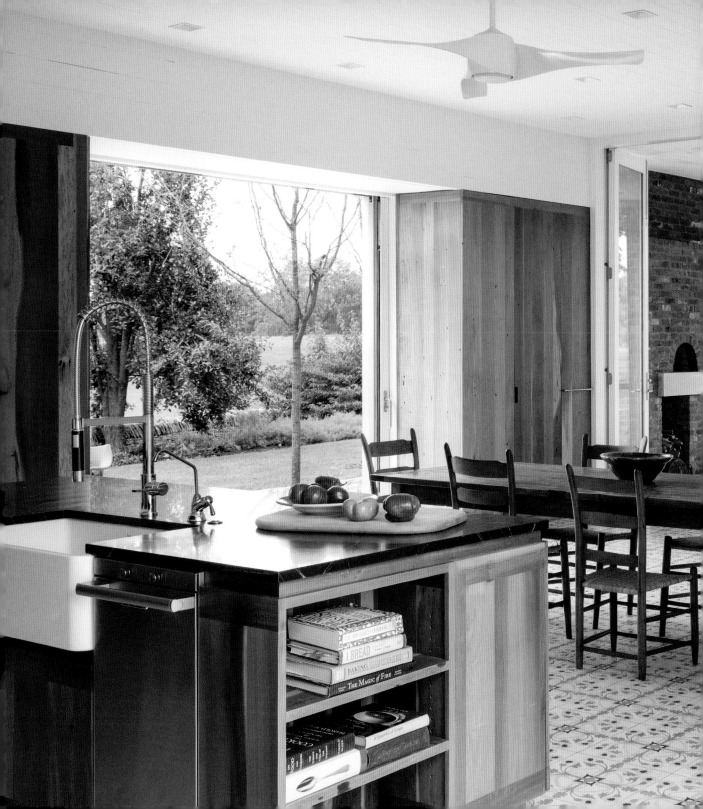

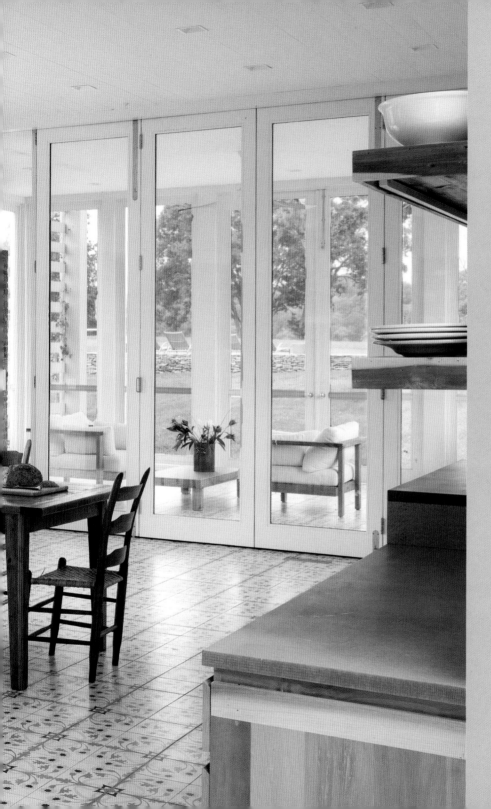

## TENNESSEE FARM
### 14,000 sq. ft. *

**Williamsport, Tennessee, United States**

—

**HS2 ARCHITECTURE**

Photos © Caroline Alison

\* Original house, addition, and guesthouse

Project team: Jane Sachs, Principal; **Thomas Hut**, Principal; **Tim McQuestion**, Project Architect

**www.hs2architecture.com**

> CREATE AN ADDITION THAT MAINTAINS THE RURAL CHARACTER OF THE SITE

> NEW DESIGN WITH A COMMITMENT TO SUSTAINABLE DESIGN

> CREATE A STRONG YET PROGRESSIVE SENSE OF ARRIVAL TO THE SITE

> KITCHEN TO OPEN UP TO THE SURROUNDING LANDSCAPE

## THE PROJECT INCLUDES THE COMPLETE REMODEL OF AN ORIGINAL FARMHOUSE CIRCA 1850s, AND THE CONSTRUCTION OF A TWO-STORY ADDITION, AND A GUESTHOUSE WITH PARKING.

"Although we doubled the home's living space, we preserved the understated bucolic feeling of the approach by the careful placement of the addition, the guesthouse, and the garage. At the end of a long drive, the original farmhouse maintains its historical appearance on the hill. It is not until one drives around to the garage that the addition and the guesthouse come into view.

To maintain the rural context of the site, the addition looks like a modern barn. The material choice of exterior siding, windows, and chimney are all modern solutions that harken to the historical detailing of the farmhouse. The addition houses a large eat-in kitchen and screen porch, and a master bedroom with sleeping porch. A small guesthouse with a garage stands to the north.

With the help of a local architect who specializes in historical preservation, the original farmhouse was faithfully restored, while a commitment to sustainable design defined every aspect of the project. All the lumber from various structures, which were too damaged to be restored, was reclaimed, cleaned, and reused to become the wood paneling, new doors, and millwork for the restoration of the original house, the addition, and the guesthouse."

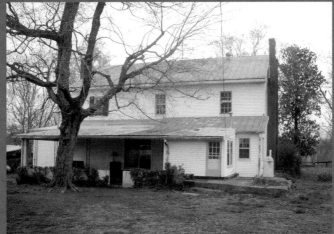

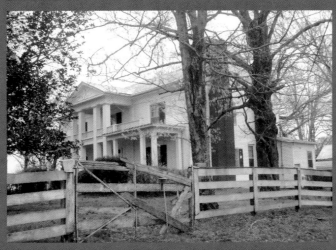

Site plan

320628

A. Main house
B. Addition
C. Guest house
D. Pool

The rear courtyard, created by the
relationship between the original
house and the two-story addition,
reinforces a feeling of intimacy.

Existing third floor plan

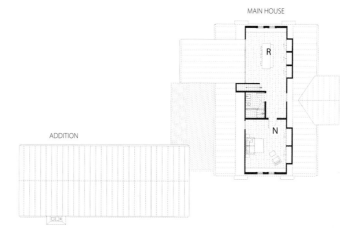

New third floor plan

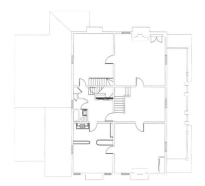

Existing second floor plan

New second floor plan

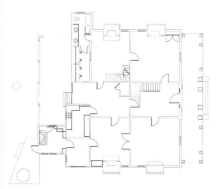

Existing ground floor plan

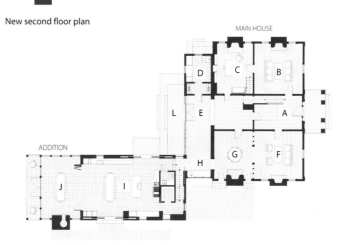

New ground floor plan

A. Entry hall
B. Family room
C. Study
D. Mudroom
E. Rear hall
F. Living room
G. Dining room
H. Wet bar
I. Kitchen
J. Screen porch
K. Sleeping porch
L. Deck
M. Master bedroom
N. Bedroom
O. Master bathroom
P. Bathroom
Q. Closet
R. TV room

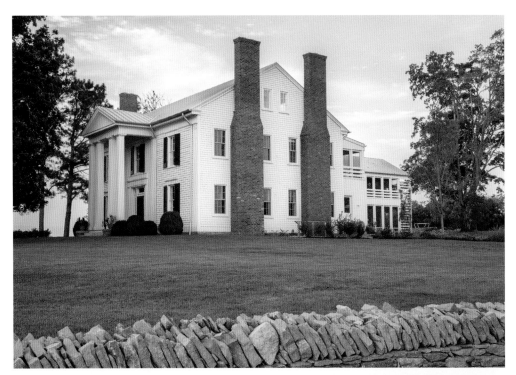

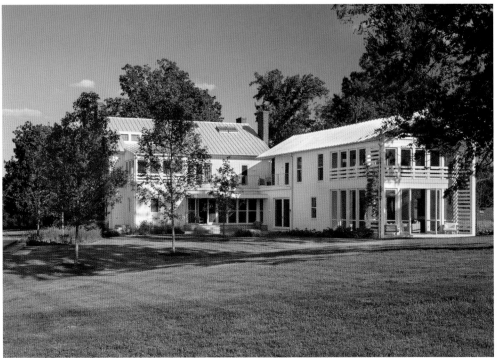

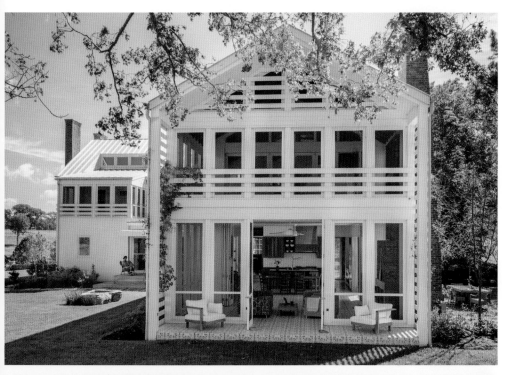

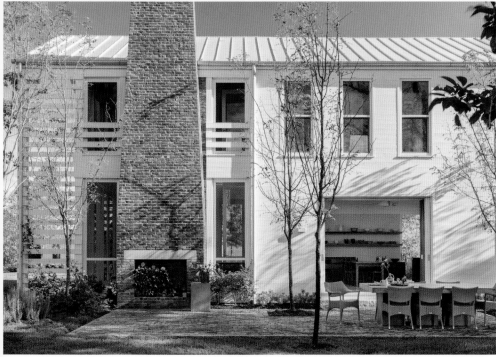

The addition, which cues from the original house, was sited to maximize passive solar in the winter, and windows were placed to encourage cross ventilation in the summer. To the south of the new kitchen, a copse of trees creates an outdoor dining area and blocks the southern sun.

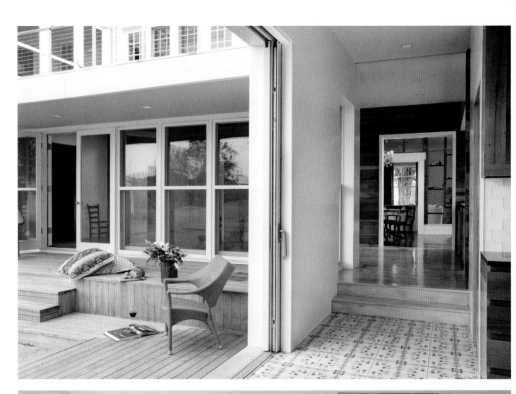

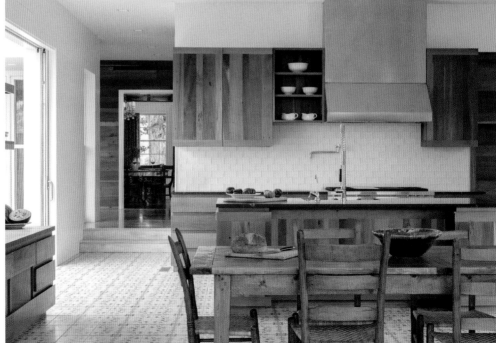

A commitment to sustainable design defined every aspect of the project. All the lumber from various structures, which were too damaged to be restored, was reclaimed, cleaned and reused to become the wood paneling, new doors and millwork for the addition and the guesthouse.

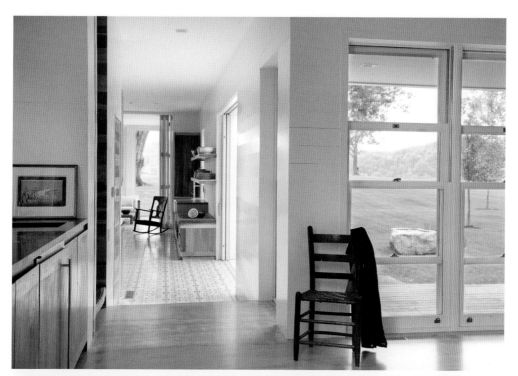

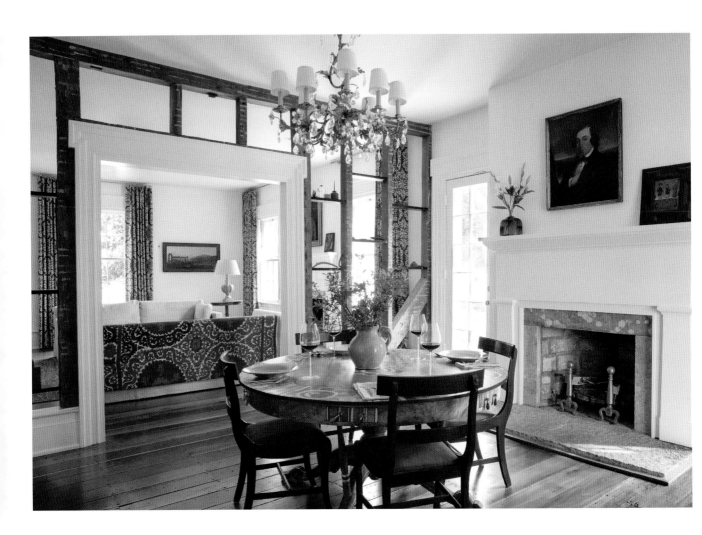

The only modern intervention in the original house is the exposed wood structure between the living and dining rooms, which works in combination with the original wood base and trim.

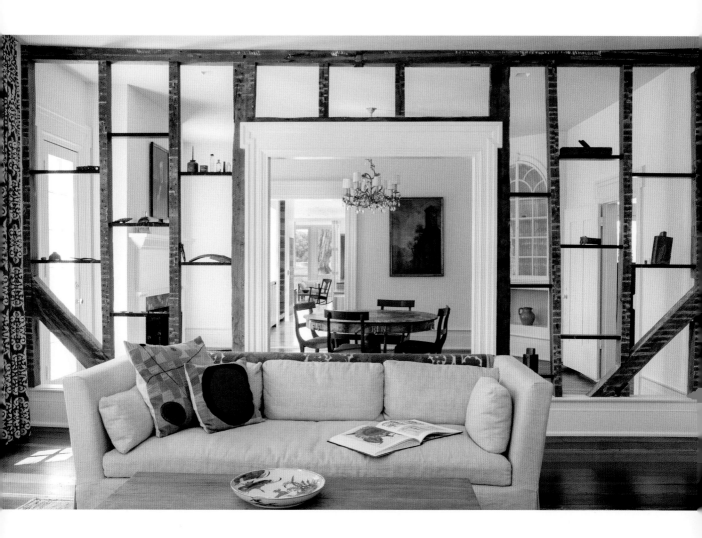

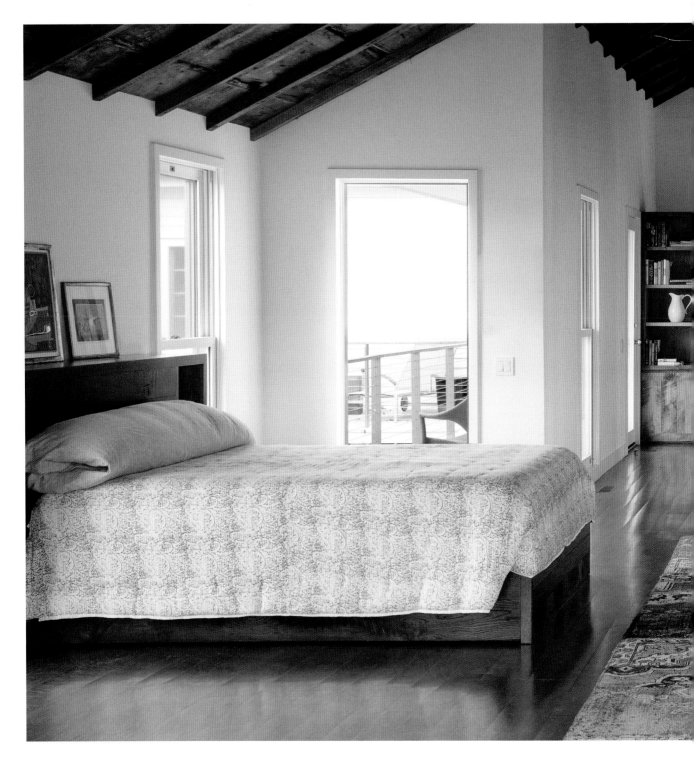

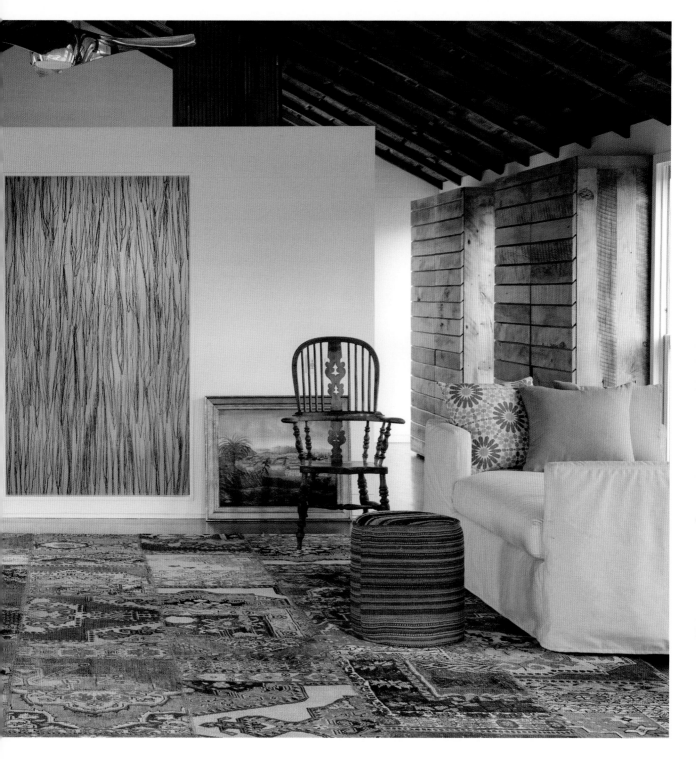

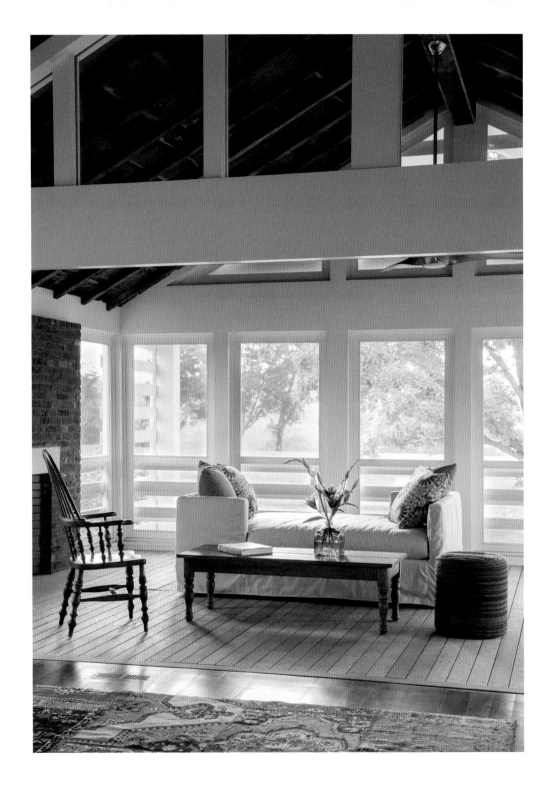

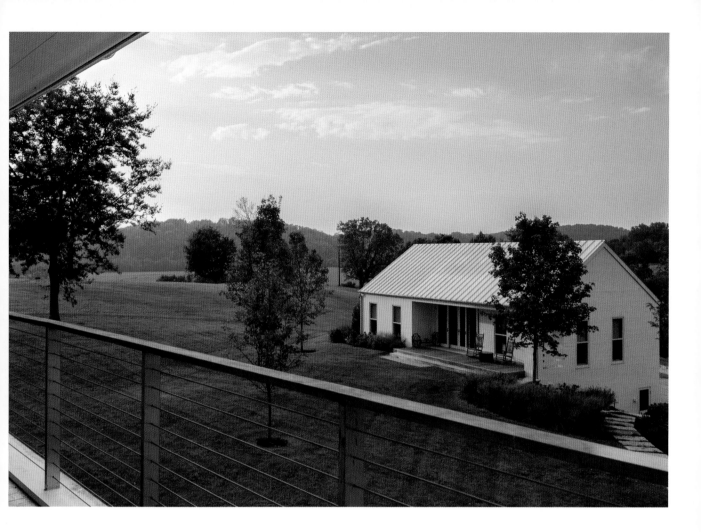

## Credits

**Architect:** HS2 Architecture
www.hs2architecture.com

**General contractor:**
Ramsey-Daugherty Company
www.ramseydaugherty.com

**Landscape architect:** Hawkins Partners
www.hawkinspartners.com

**Local architect:** Centric Architecture
www.centricarchitecture.com

**Mechanical engineer:** Power
Management
www.powermgmt.com

**Structural engineer:** EMC
www.emcnashville.com

## Appliances and Materials

**Appliances:** Sub-Zero & Wolf microwave drawer oven, dual fuel range, hood, and botom freezer refrigerator; Asko dishwasher, and Viking trash compactor
**Bedroom ceiling:** Reclaimed wood from old attic ceiling
**Bedroom shower wall:** 3Form
**Countertop:** Eco friendly paper-based fiber composites and soapstone sink counter by Richlite.

**Flooring:** Reclaimed old growth poplar throughout
**Kitchen floor:** 8" × 8" Moroccan tile by Villa Lagoon Tile
**Master bathroom:** 3" × 6" Thasos floor tile, painted white bead board with glass mosaic tile walls, and custom millwork in reclaimed old growth oak
**Millwork:** All custom in old poplar

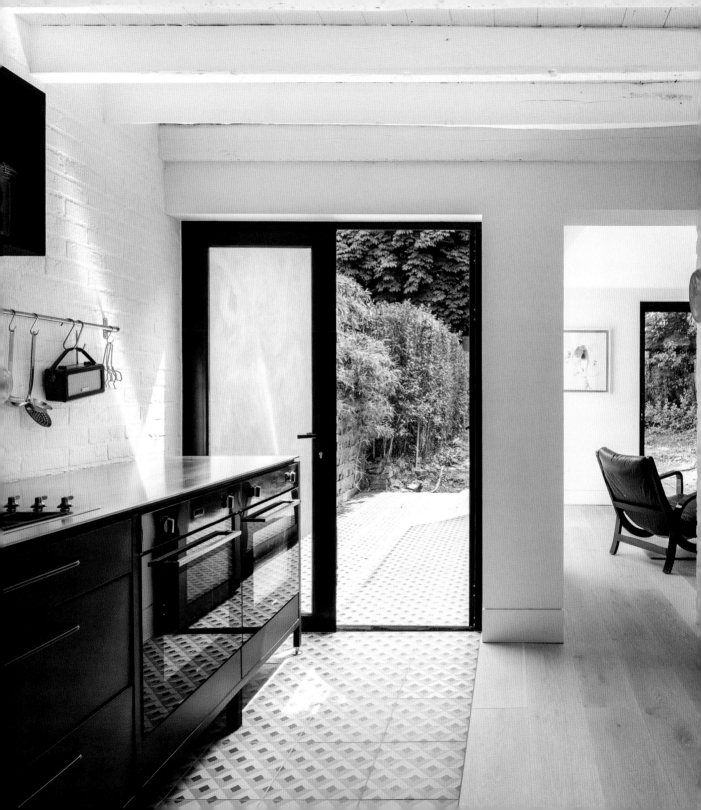

# PAGES LANE

## 1,948 sq. ft.

London, England, United Kingdom

---

**KIRKWOOD McCARTHY**

Photos © David Butler, Fiona Kirkwood

369

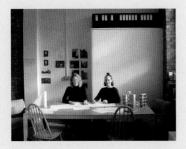

Project team: Fiona Kirkwood,
Sophie McCarthy

**www.kirkwoodmccarthy.com**

> TO CREATE A FLEXIBLE FAMILY HOME THAT OFFERED A VARIETY OF LIVING SPACES, EQUAL SIZED CHILDREN'S BEDROOMS AND A NEW MASTER BEDROOM WITH EN SUITE

> PROTECT AND INTEGRATE ELEMENTS OF THE ORIGINAL CHARACTER WITHIN A NEW MORE CONTEMPORARY LAYOUT

> MAXIMIZE THE SOUTH FACING GARDEN AND A SEAMLESS INTEGRATION BETWEEN INTERNAL AND EXTERNAL SPACES

> PRESERVE A MOUNTAIN ASH TREE IN THE REAR GARDEN

A NEW GROUND FLOOR WING, COURTYARD, AND LOFT DORMER ENHANCE THE LAYOUT OF A VICTORIAN SEMIDETACHED, ACHIEVING INTERLINKED LIVING SPACES THAT CAPTURE SUNLIGHT AND ENGAGE WITH THE OUTDOORS.

"The property was from a deceased individual's estate and was in severe disrepair, requiring significant clearing and some demolition. A lean-to conservatory was a more recent rear extension. It was out of character with the original property and was near collapse. By removing it, we strengthened the original character of the house.

The backyard was heavily overgrown, so we isolated key trees and plants to preserve, and the rest of the garden was cleared and leveled. The internal strip-out revealed localized rot and insufficient footings, so new strip foundations to the ground floor were poured and floor joists replaced and/or upgraded.

The footprint and form of extension elements is decisive and controlled. The new ground floor wing is pulled away from the original house, creating a private courtyard space that unifies old and new elements of the property to achieve a cohesive residence. The form of the zinc-clad ground floor addition wasn't generated randomly. Its design was guided by existing site features such as the building footprint, its aspect, and the presence of a mature mountain-ash tree. The extension leans away from the canopy of this tree, pitching in height toward the house to create a vaulted ceiling over the new dining and living area, and lowering toward the courtyard to preserve sunlight access to the existing ground floor rooms and the garden outlook from the second floor bedroom window. Openings in the existing external wall are maintained and provide access points to the new extension, a cost-effective approach that avoids excessive demolition and structural steel, while characterizing the internal experience of interplay between old and new. In all, the layout and material palette present a considered and careful enhancement of the existing property to suit the varying and changing needs of family life."

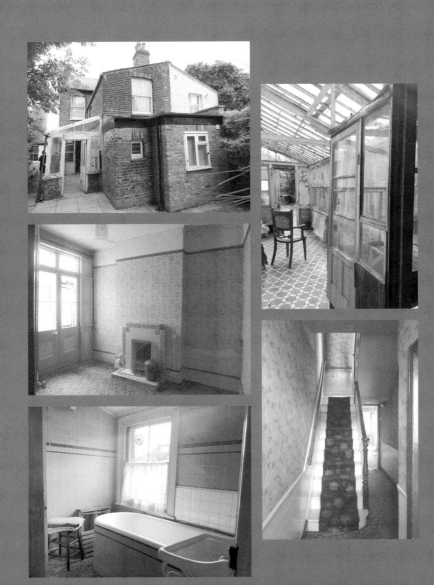

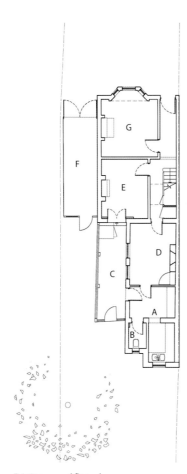

Existing second floor plan

A. Kitchen      F. Utility yard
B. Toilet room  G. Living room
C. Conservatory H. Bedroom
D. Dining room  I. Bathroom
E. Study

Existing ground floor plan

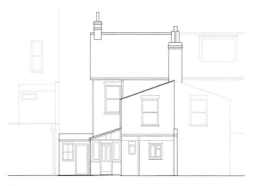

Existing rear elevation

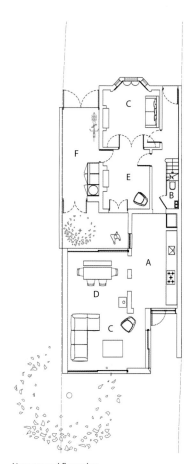

New ground floor plan

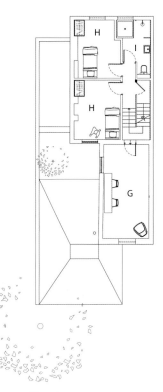

New second floor plan

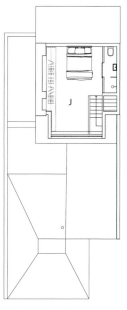

New third floor plan

A. Kitchen
B. Powder room
C. Living area
D. Dining area
E. Study
F. Utility room
G. Recreation room
H. Bedroom
I. Bathroom
J. Master ensuite

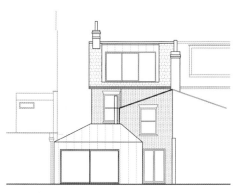

New rear elevation

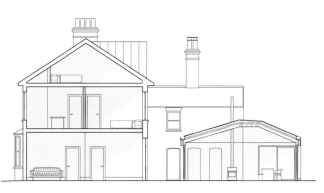

New longitudinal building section

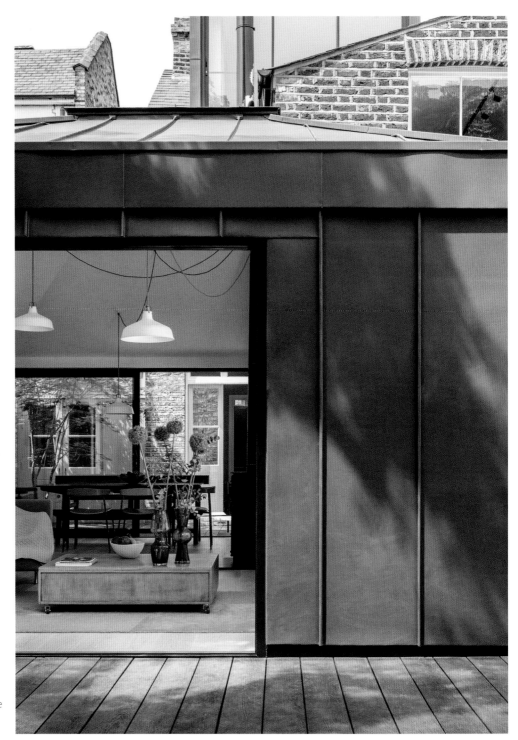

At once widening the existing footprint and better capturing the southern garden aspect, the courtyard installs a sun-filled sequence between the various zones of the house. New vistas are created through the full length of the property, so that all internal rooms enjoy garden views.

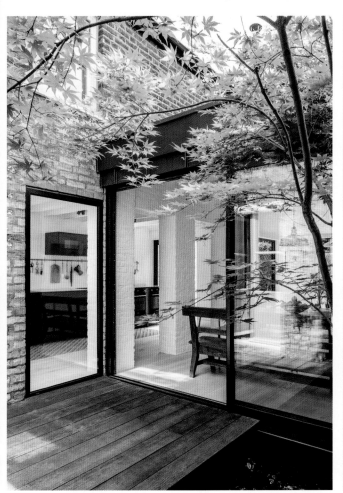

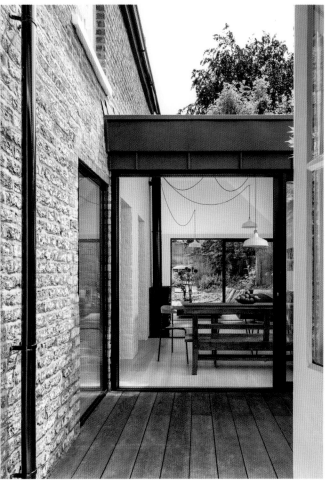

The graphite-zinc cladding defines new elements from the existing slate and brick. The subtlety of these differences ensures the residence has a unified elegance; interventions are meaningful and serve to define the property's history.

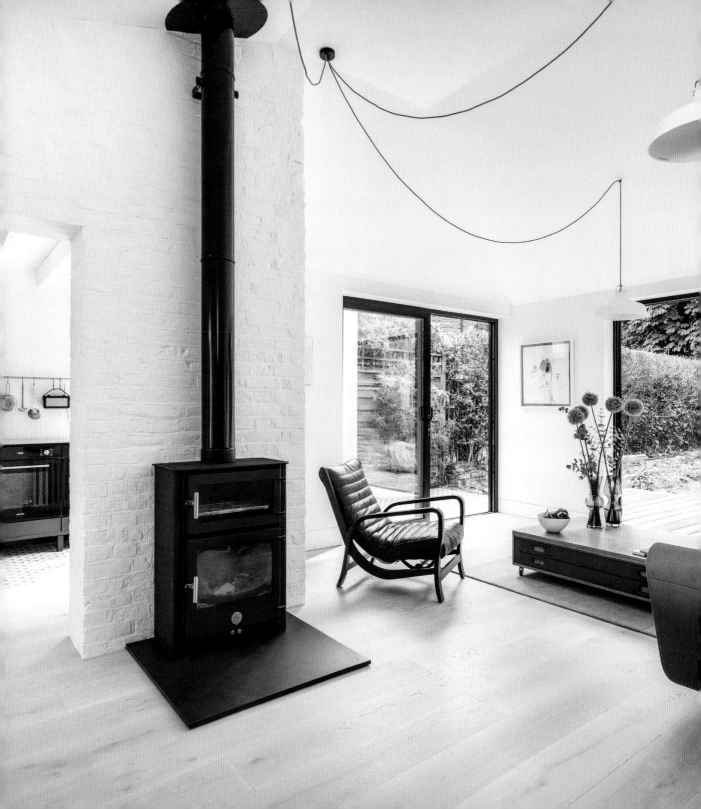

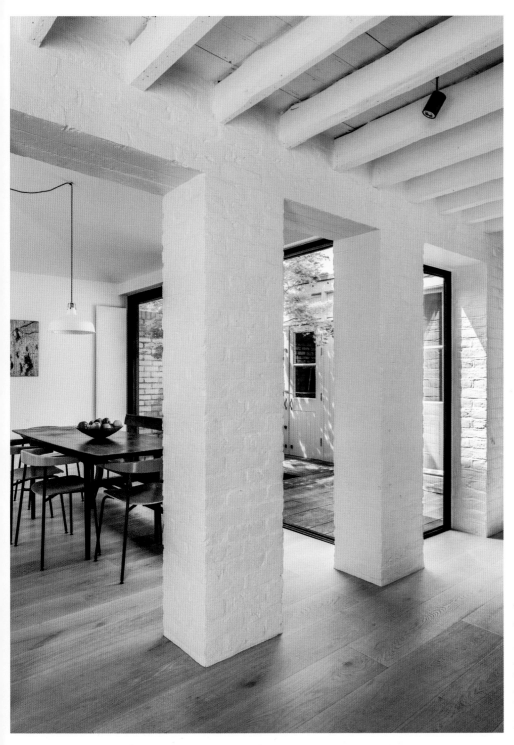

The design integrates the original external walls with the new internal layout, giving the residence a new storytelling vernacular. Existing openings in the original external wall are preserved, creating multiple access points into the new extension, while the vaulted ceiling amplifies the sense of light, space, and openness in the new garden wing.

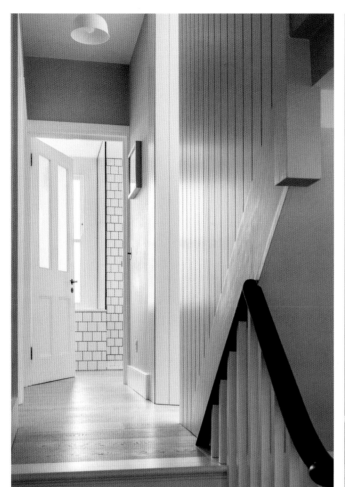
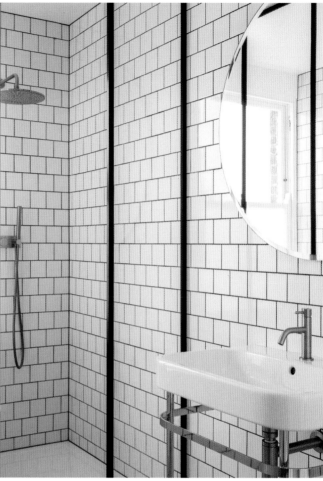

The family bathroom is contemporary and light filled, adhering to the simple black and white palette used for new elements of the residence.
The new loft master bedroom is a treehouse-like space with framed garden views, an en suite, and full-length built-in storage.

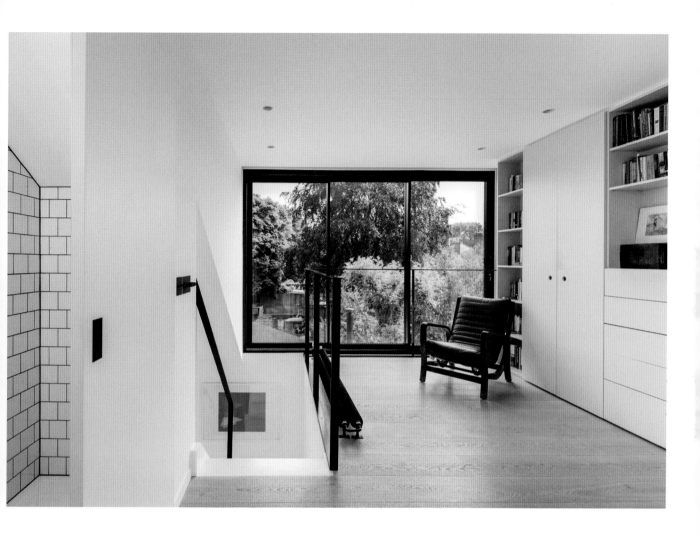

**Credits**

Architect: Kirkwood McCarthy
www.kirkwoodmccarthy.com

General contractor: Fine Renovate
www.finerenovateltd.co.uk

Structural engineer: Symmetrys
www.symmetrys.com

Glass sliding doors: Northolt Glass
www.northoltglass.co.uk

Zinc cladding: VMZinc
www.vmzinc.com

Flooring: Havwoods
www.havwoods.co.uk

Decking: Millboard
www.millboard.co.uk

Kitchen: Steelplan
www.steelplan.com

Lighting: Modern Lighting Solutions
www.modernlightingsolutions.co.uk

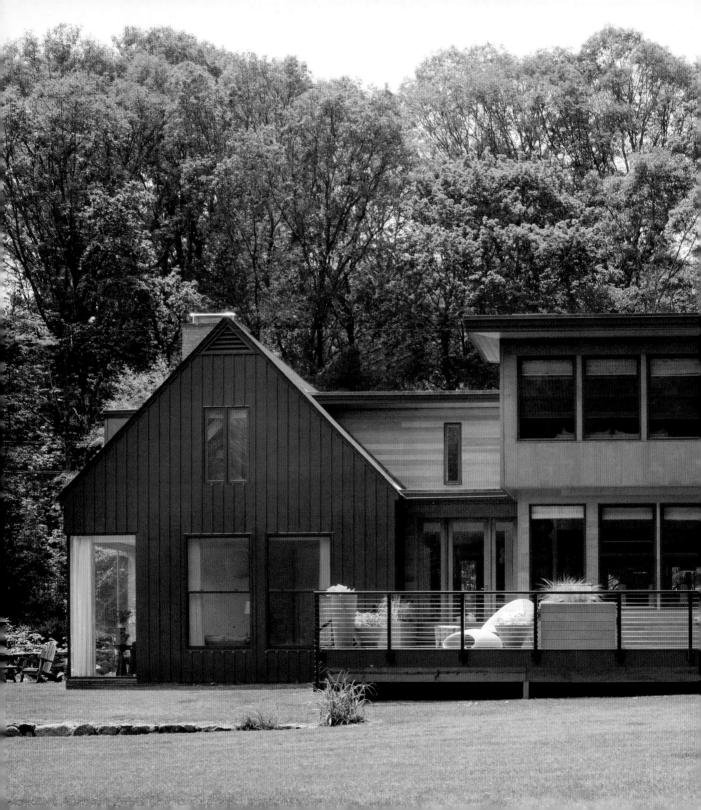

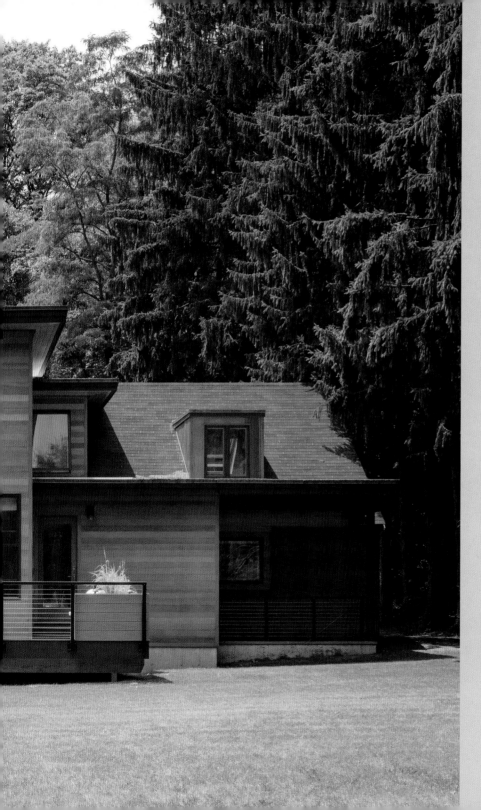

# BEAVER POND RESIDENCE

## 3,284 sq ft

### Lincoln, Massachusetts, United States

---

**INCITE ARCHITECTURE AND ANNIE
HALL INTERIORS**

Photos © Michael Lee, Greg Premru

©Andrea Jollat

Project team:

Bill Hubner and Melissa Demers

www.**incitearchitecture**.com

Annie Hall

www.**anniehallinteriors**.com

> CONVERT AN EXISTING JUNK ROOM INTO A
  TWO-CAR GARAGE

> EXPAND THE KITCHEN AND DINING AREA

> IMPROVE THE CONNECTION BETWEEN
  INTERIOR AND EXTERIOR

> CREATE A MASTER BEDROOM WITH AN
  ADJACENT MASTER BATHROOM AND
  DRESSING ROOM

THE HOUSE WAS SOLIDLY BUILT, BUT SUFFERED FROM A FEW DE-
SIGN DEFICITS THAT WERE EASILY RECTIFIED BY ONE BOLD MOVE:
A TWO-STORY ADDITION.

---

"The addition on the ground floor allows for a more expansive kitchen and
dining area with better viewing of the backyard, ease of living, and entertain-
ment. Since budget was a consideration, we retained the structural beam
above a new island, but made it less pronounced by cladding it in teak ply-
wood to match the kitchen's ceiling and backsplash. A new mudroom con-
nects the expanded kitchen with the exterior and to a former junk room
that was converted into a much-needed garage. On the same level to the
east, the original sunken living room stayed as is, but we connected the new
kitchen and dining area through a more direct circulation path across the
entry foyer. The second floor addition includes a master bedroom, dressing
area, and bathroom. It incorporates a number of smaller rooms that formerly
lined the hallway.

Not only did the remodel and addition increase the square footage of the
house, but it also improved the connection with the outdoors and between
the different parts of the house."

---

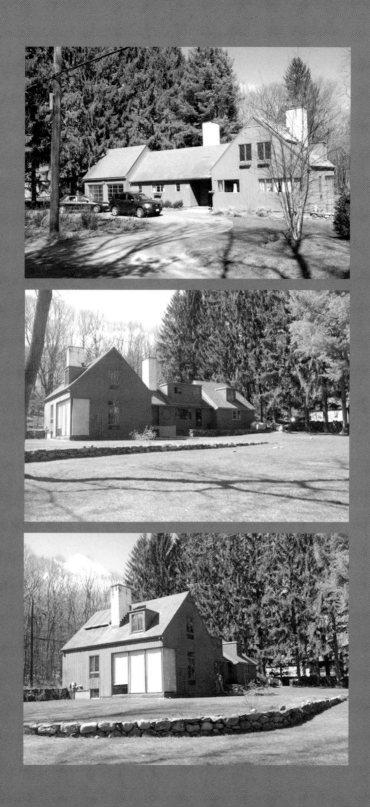

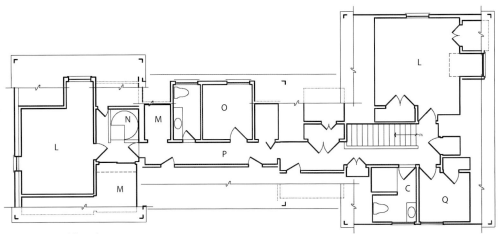

Existing second floor plan

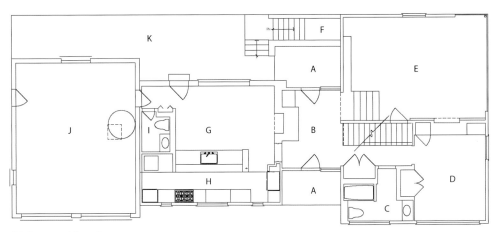

Existing ground floor plan

A. Porch
B. Foyer
C. Bathroom
D. Guest bedroom
E. Living room
F. Pit

G. Dining area
H. Kitchen
I. Powder room
J. Recreation room
K. Terrace
L. Bedroom

M. Closet
N. Spiral staircase
O. Office
P. Hall
Q. Dressing room

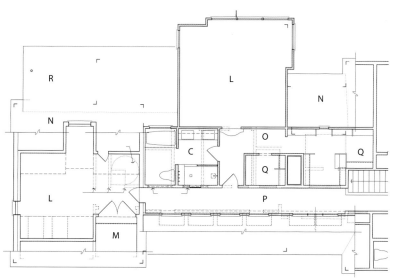

New second floor plan

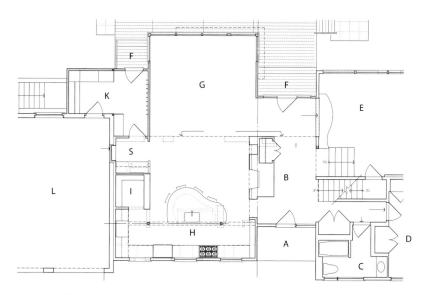

New ground floor plan

A. Porch
B. Foyer
C. Bathroom
D. Guest bedroom
E. Living room
F. Landing
G. Sitting/dining area

H. Kitchen
I. Pantry
J. Garage
K. Mudroom
L. Bedroom
M. Closet
N. Existing roof

O. Dressing room
P. Hall
Q. Walk-in closet
R. New roof below
S. Home office

Aside from adding square footage to the original house, the extension also improves the rooms' proportions and the circulation flow between them.

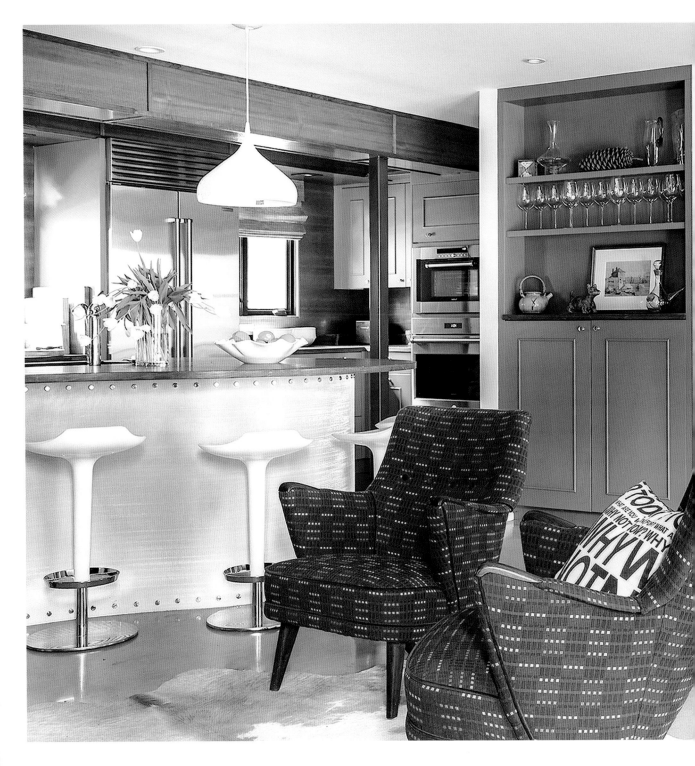

Removing the overhead cabinets opened up the views to the backyard, while the sculptural island beneath plays down the linearity of the kitchen.

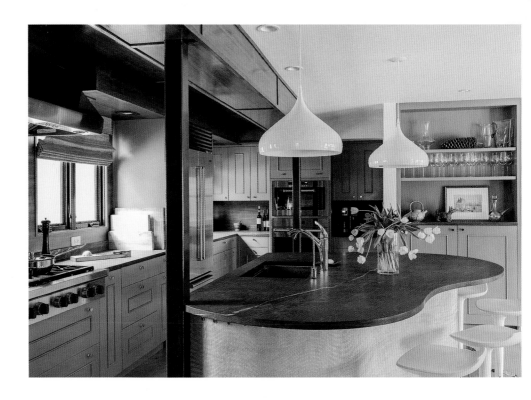

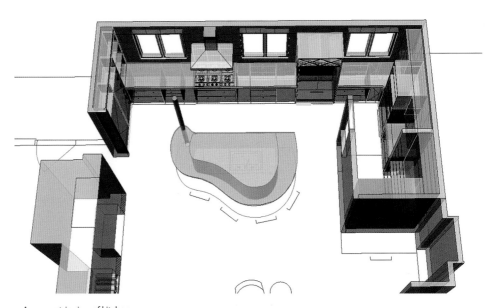

A new walk-in pantry adjacent to the kitchen, a home office nook, and mudroom add to the functionality of the living area.

Axonometric view of kitchen

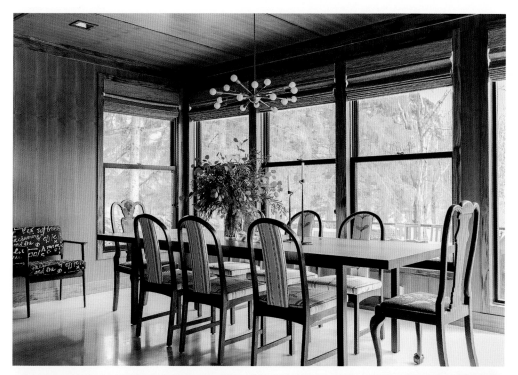

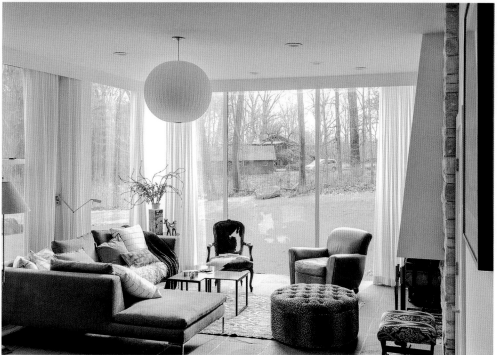

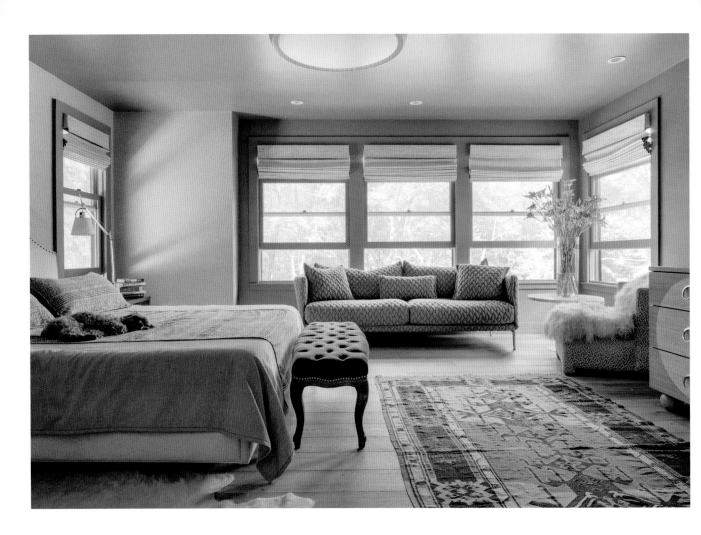

The second floor addition is a new
master suite that absorbs most of
the small rooms that run east west.
The once long and gloomy hall is
transformed into a light-filled gallery.

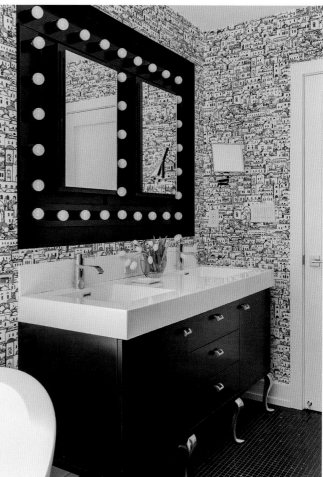

## Credits

**Architect:** Incite Architecture
www.incitearchitecture.com

**Interior Designer:** Annie Hall Interiors
www.anniehallinteriors.com

**Structural engineer:** Phelan Engineering
www.phelanengineering.com

## Appliances and Materials

**Bedroom walls:** Grasscloth from Philip Jeffries
**Counter and cooktop backsplash:** Soapstone
**Kitchen and dining room floor:** Concrete
**Master bathroom walls:** Cole & Son wallpaper
**Second floor flooring:** Engineered wood with white oak veneer

# JUNCTION SHADOW HOUSE

## 1,965 sq. ft.

Toronto, Ontario, Canada

---

**POST ARCHITECTURE**

Photos © Revelateur Studio

Project team: Gloria Apostolou, Principal

**www.postarchitecture.com**

> DEMOLISH SUNROOM IN DISREPAIR

> DEMOLISH AND REBUILD MUDROOM

> REPAIR SEWAGE SYSTEM

> CONVERT THIRD FLOOR INTO ONE SINGLE
  OPEN SPACE WITH ROOFTOP DECK

> OPEN UP KITCHEN TO MAIN LIVING SPACE

> PROVIDE DOG CLEANING AREA WITHOUT
  GOING THROUGH THE HOUSE

THE CLIENTS HAD BOUGHT A SEMIDETACHED HOUSE WITH A BUDGET OF $200,000 TO RENOVATE IT. HOWEVER, WHEN THEY SAW THE DESIGN POSSIBILITIES THAT OPENING UP THE ROOF OF THE THIRD FLOOR HAD TO OFFER, THEY FELL IN LOVE WITH IT AND THREW THEIR BUDGET OUT THE WINDOW.

"The clients easily bought into the idea of transforming the third floor into one large den and TV room, complete with a rooftop deck. But we soon found out there was no easy path to that dream retreat. Demolition revealed that our clients were into much more costly repairs than they originally estimated.

A sunroom over the front porch was supported by hollow posts that had no footings. The floor of the sunroom was the actual ceiling of the porch, which certainly made for a minimal load, but was starting to rot due to improper water protection. The masonry wall at the front of the house had been removed to make a wide opening into the framed addition, but only one withe of brick was left in place to support the third floor above.

The sunroom had to come down, and it would be too expensive to rebuild it. But the complicated part was that this semidetached home shared framing members with the neighboring half to the west and any alterations we thought of doing in our clients' property was likely to affect the neighbors on both sides. This was the case for the reconstruction of the mudroom and the repair of the sewage/waste system. This situation instigated talks not only with the neighbors, but with city officials as well. All the issues were eventually sorted out, some more easily than others, but we finally delivered a quality home design that exceeded the expectations of our clients."

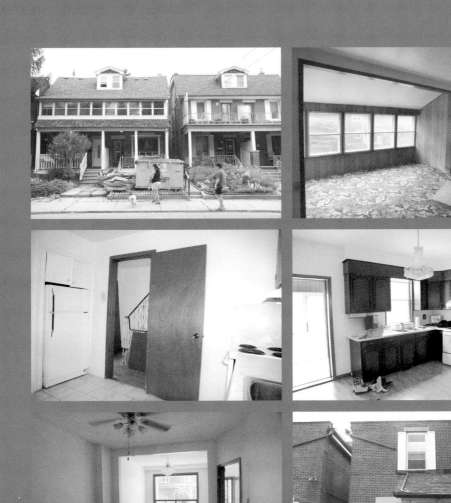

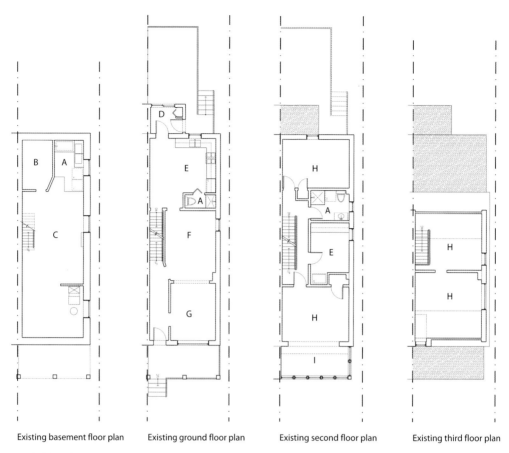

Existing basement floor plan   Existing ground floor plan   Existing second floor plan   Existing third floor plan

A. Bath/laundry room   F. Dining room
B. Storage            G. Living room
C. Rec room           H. Bedroom
D. Mudroom            I. Sunroom
E. Kitchen

With the structural repairs addressed,
the interior spaces were laid out with
minimal partitioning to maximize
natural lighting and optimize
circulation flow.

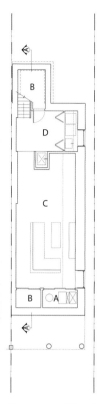

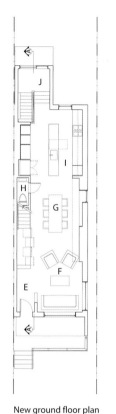

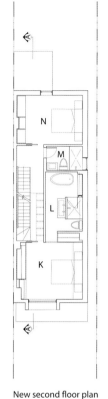

New basement floor plan    New ground floor plan    New second floor plan    New third floor plan

A. Mechanical room
B. Storage
C. Recreation room
D. Laundry room /
   dog shower
E. Entry
F. Living area
G. Dining area
H. Powder room

I. Kitchen
J. Mudroom
K. Master bedroom
L. Master bathroom
M. Bathroom
N. Guest bedroom
O. Den/TV room
P. Roof deck

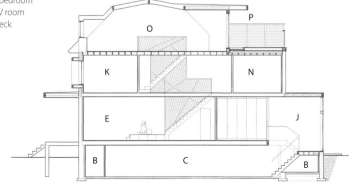

New building section AA

The master bedroom has a large
dormer protecting its window,
homage to the bay windows that line
the street. It provides some shade, as
the window faces south and receives
sun most of the day. The second
bedroom and bathroom occupy the
back section of the house.

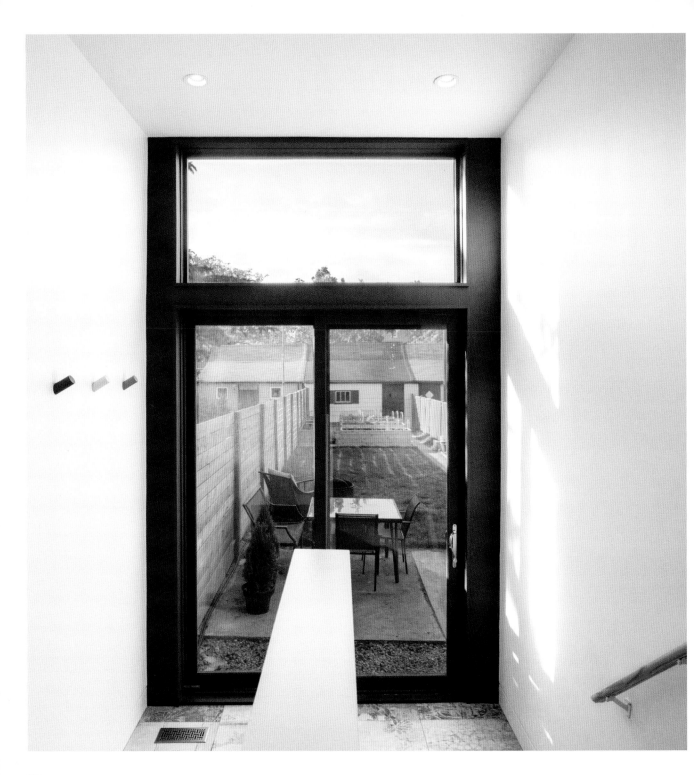

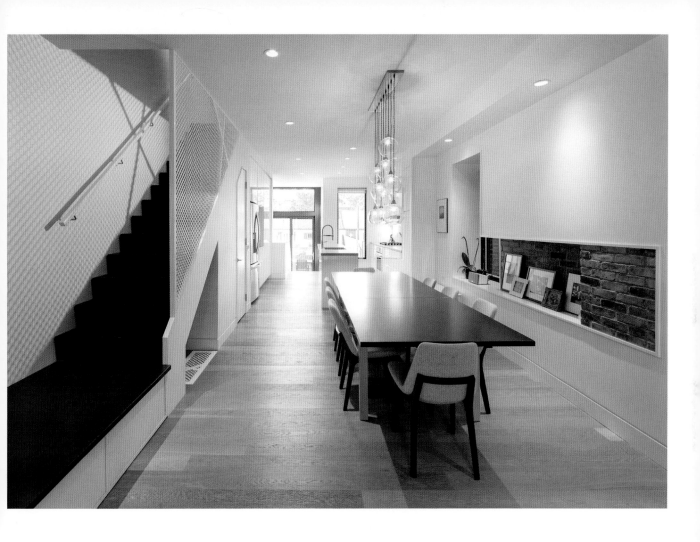

Natural daylight was not possible from all sides, so the design focused on maximizing it from the south end of the house, and drawing it in as far as possible. The open plan of all floors facilitated the flow of natural light throughout the house.

A limited color palette of white, black, gray, and an occasional pop of color brighten up the interior, enhancing its open character. The spaces are visually interconnected through a feature staircase with perforated metal guardrails, which, like the color scheme, provide a sense of amplitude, while creating a compelling play on light and shadow.

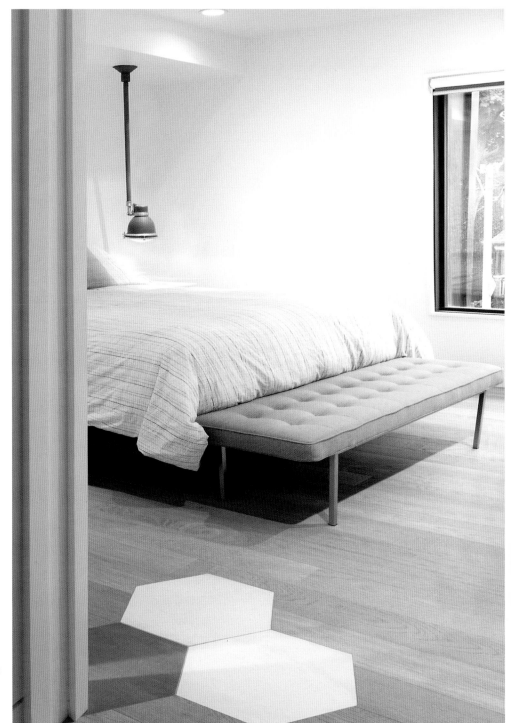

The master bedroom and guest room on the second floor have pocket doors, sliding into the wall cavities to allow views right through the house when the bedrooms are not in use.

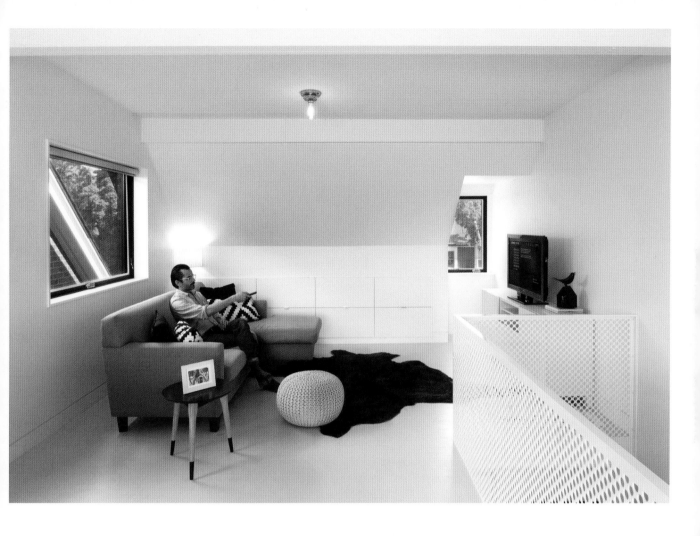

**Credits**

**Architect: Post Architecture**
www.postarchitecture.com

**Appliances and Materials**

**Floors:** Engineered white oak by Relative Space, red oak painted white, 15" hex tiles in "Sabbia" and "Nero" by Céragrès
**Guardrail:** Custom-built perforated metal guardrail, powder-coated white

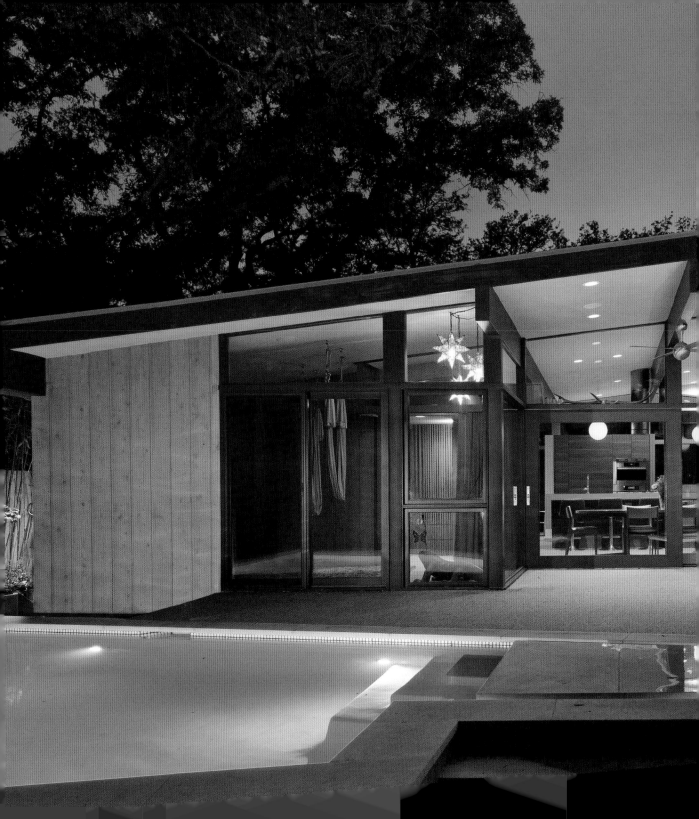

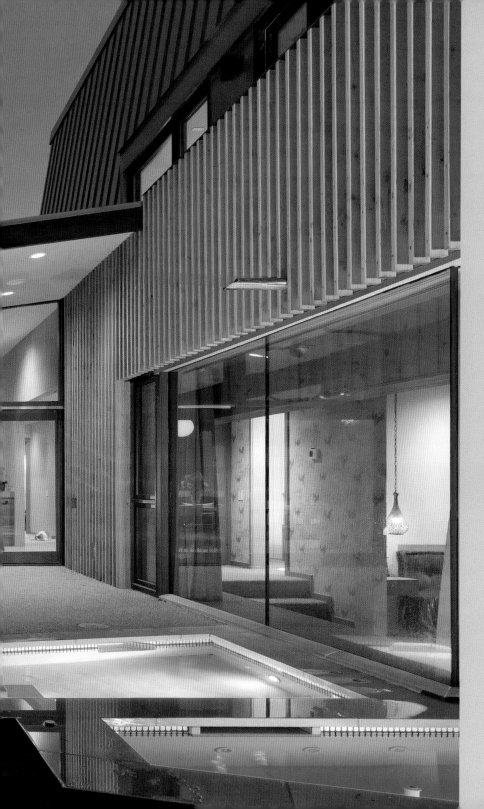

## BRADY LANE RESIDENCE

### 3,000 sq. ft.

**Austin, Texas, United States**

**WEBBER + STUDIO, ARCHITECTS**

Photos © Andrea Calo, Chris Archer,
Paul Bardagjy

Project team: David Webber AIA,
Brockett Davidson, Jason Davis, Tyler Frost,
Michael Hargens, Joel Nolan, Mark Odom

www.webberstudio.com

> CREATE A BALANCE BETWEEN THE EXISTING
AND NEW STRUCTURES, BUT ALLOW FOR
EACH TO STAND WITH ITS OWN CHARACTER

> SITE AND DESIGN THE ADDITION AROUND
EXISTING LANDSCAPE FEATURES

> CONNECT INDOOR AND OUTDOOR SPACES

THIS REMODEL AND ADDITION WAS DESIGNED TO COMPLEMENT
A 1968 HOUSE INITIALLY DESIGNED BY LOCALLY ACCLAIMED MID-
CENTURY MODERNIST, A. D. STENGER.

"Hemmed in by extensive setbacks and impervious cover limitations, a
1,500-square-foot addition to the original 1,500-square-foot house had no-
where to go but up. While exploring various design possibilities to integrate
the addition with the existing house without compromising its original char-
acter, I drew inspiration from Stenger's own prolific portfolio, which included
an A-frame five houses away.

Introducing opposing impulses by adding a vertical, reinterpreted A-frame
to the horizontal, roughly equivalently sized, low-slung original house al-
lowed me to maintain balance between old and new. It also allowed each to
stand on its own merits and, by contrast, reinforce the other. The new design
offers a bold gesture that paradoxically provides balance. Its boldness gives
freedom to the existing structure, which remains understated and relaxed,
from an organizational and material standpoint. It also provides for the ca-
sual indoor-outdoor living that the client sought, and for which this style of
house was originally conceived.

Having grown up trick-or-treating in this same neighborhood as a child, I
always admired the original Japanese-inspired design, which, coincidently,
was the aesthetic that the owner was seeking. The casual nature of the
California/Japanese-influenced design was expressed through relaxed and
earthy materials running continuously from inside to outside."

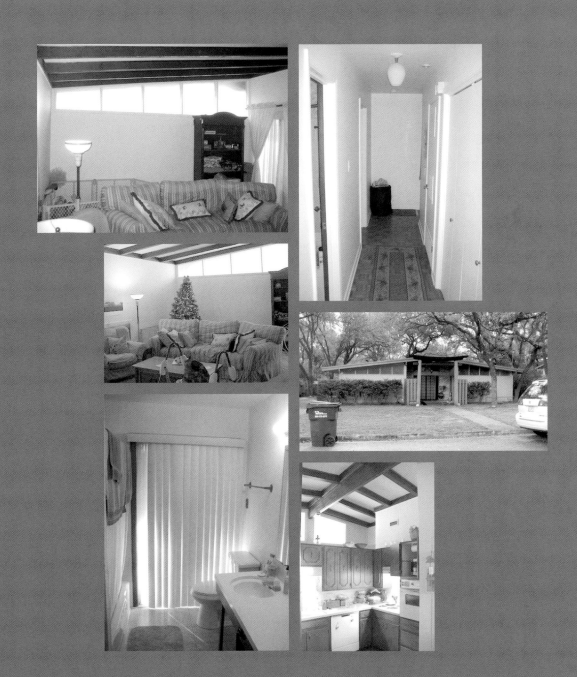

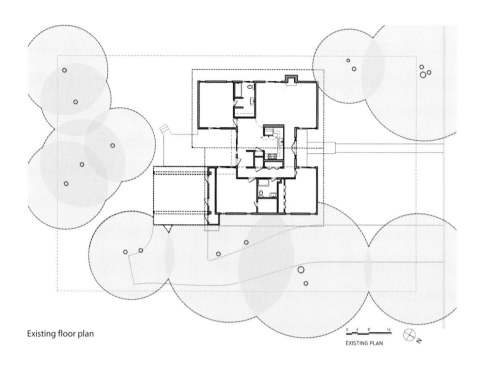

Existing floor plan

EXISTING PLAN

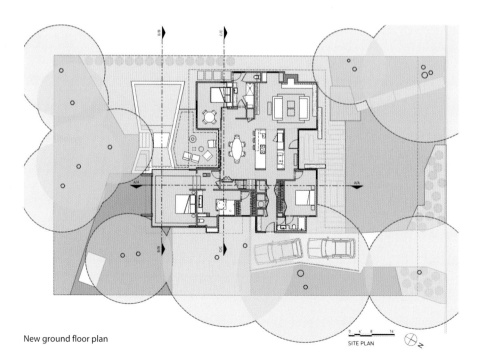

Due to additional site constraints, the pool and carport plan configurations deflect to accommodate two mature trees, a design that the concept of wabi-sabi, which, true to the home's Japanese-inspired roots, emphasizes beauty in nature's imperfections.

New ground floor plan

SITE PLAN

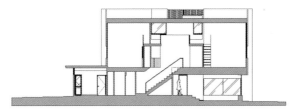

Section AA

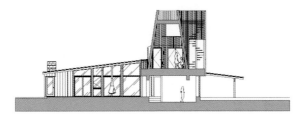

Section BB

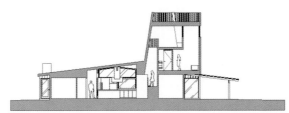

Section CC

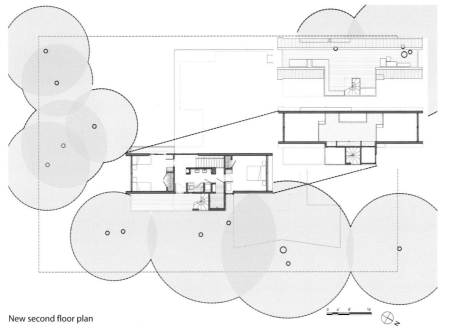

New roof deck plan

New loft floor plan

New second floor plan

0  4'  8'    16'

N

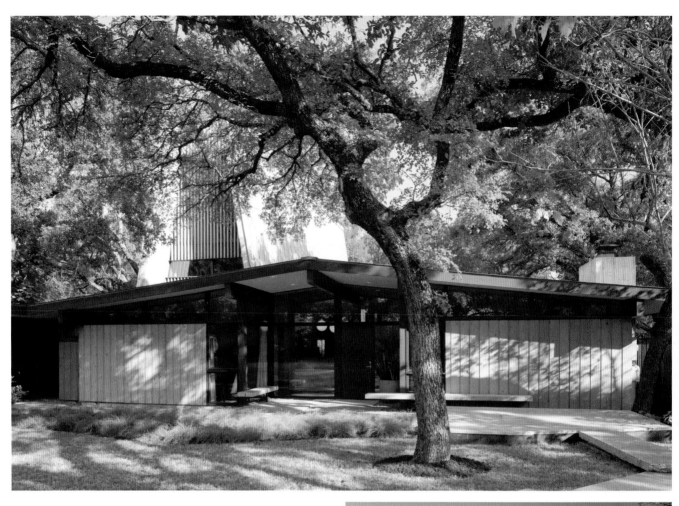

The A-frame opens at the roof and incorporates a deck with dramatic views, and the vertical wood shading at its ends protects two bedrooms and a conjoining play loft from harsh summer sun.

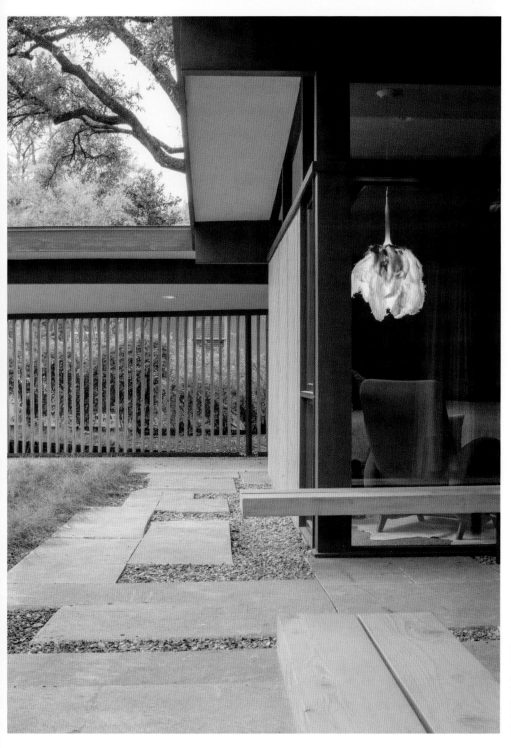

Epoxy pebble flooring runs
throughout the main level. Stained
cedar siding at the exterior wraps
interior zones and is complemented
by heavy timber millworks used
variably as shelving, vanity tops, and
benches, both inside and out.

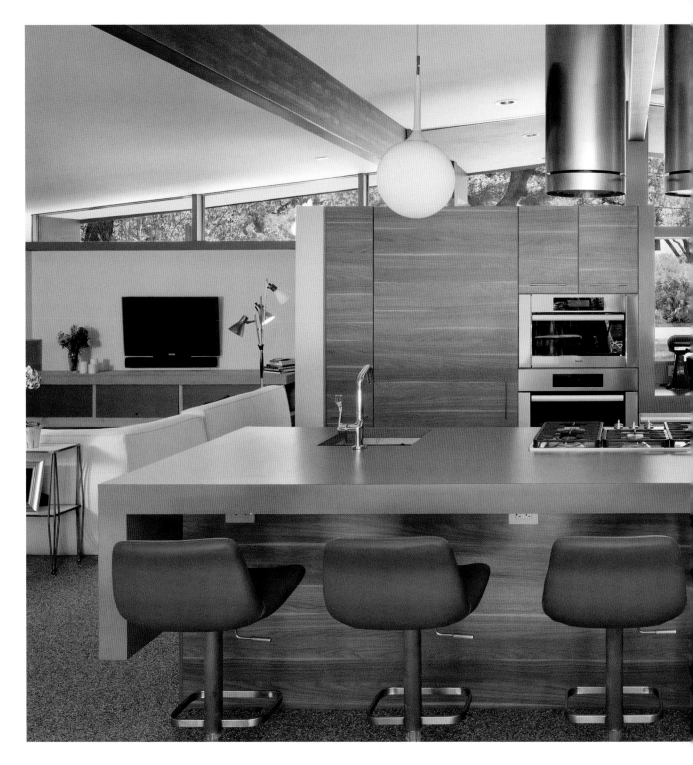

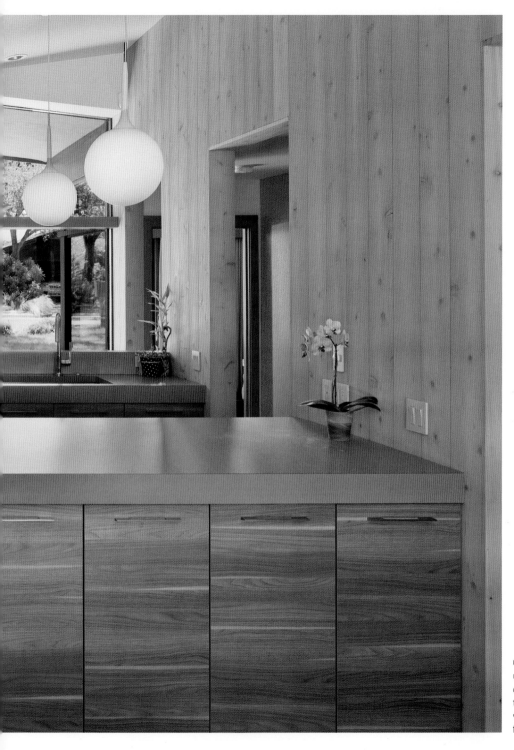

Contrasting with the muted tones used throughout, a bright-orange countertop recalling materiality from the home's original era combines with walnut laminate and epoxy pebble flooring to act as bold accents.

Multifunctional details such as
a Murphy bed, a return-air grill,
and sliding room partitions are
concealed within the timber millwork
throughout the house.

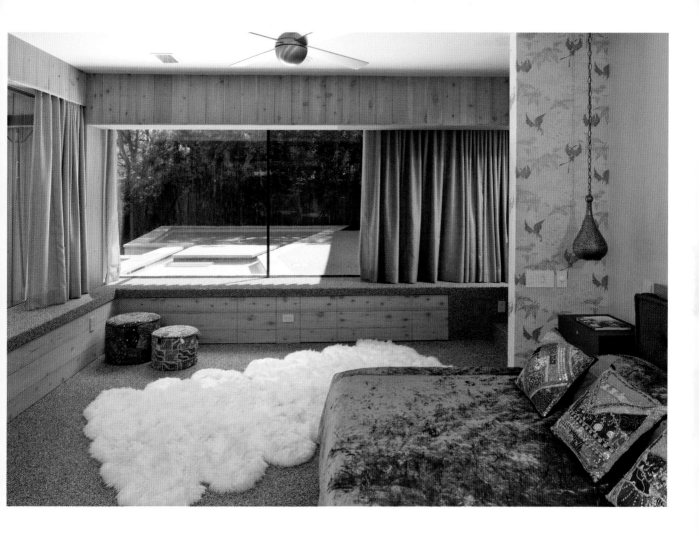

## Credits

**Architect:** Webber + Studio, Architects
www.webberstudio.com

**Builder:** w + inc
www.wplusinc.com

**Structural engineer:** Way Consulting
Engineers
www.wayengineering.com

**Interior designer:** Roni Kotuniak
www.verokolt.com

## Appliances and Materials

**Appliances:** Miele
**Built-in drawer fronts throughout:**
Abet Laminati
**Countertops:** "Citrus Orange" laminate
by Wilsonart
**Fireplace:** Linear Burner System by Spark
Modern Fires with concrete surround
**Floors:** PebbleTec on main floor,
eco-friendly carpet upstairs, and stair
treads in white oak

**Interior walls:** Interior-stained tongue
& groove western red cedar
**Roof deck:** Stained western red cedar
**Spiral staircase:** Steel. Fabricated on
and off site, welded by Brandon Ariel
**Windows:** Site-built storefront and
fixed panel windows. "Weathershield"
operable windows by Exclusive Win-
dows & Doors

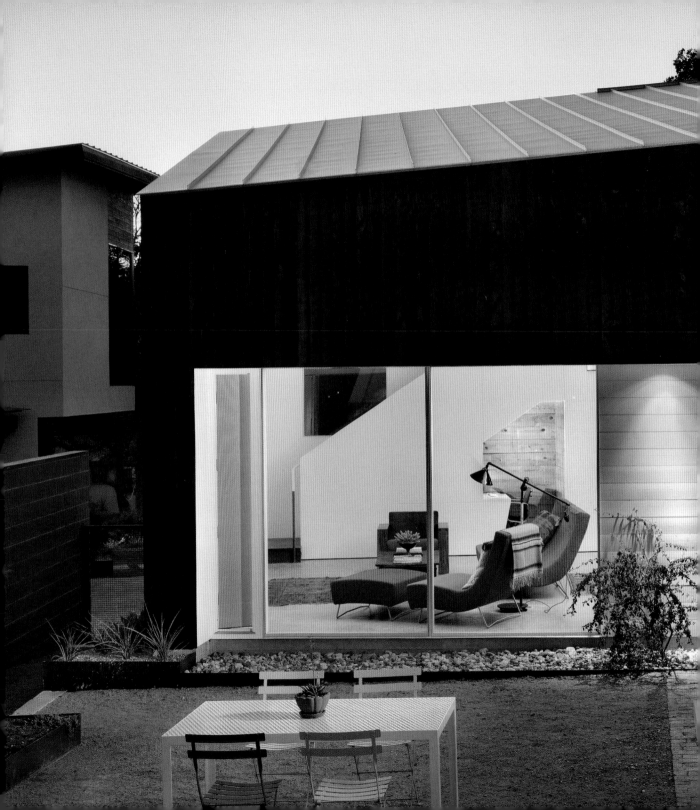

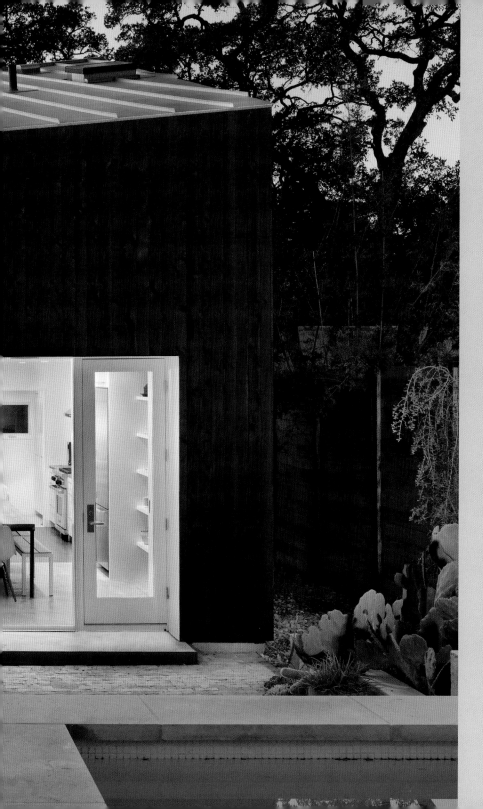

# HILLSIDE RESIDENCE

## 2,167 sq. ft.

Austin, Texas, United States

—

### ALTERSTUDIO ARCHITECTURE

Photos © Casey Dunn, Alterstudio Architecture

Project team: **Tim Whitehill**, Partner;
**Ernesto Cragnolino**, FAIA, Partner;
**Kevin Alter**, Partner;
**Matt Slusarek**, Associate; **Jonathan Schwartz**

**www.alterstudio.net**

> SAVE AN EXISTING 1,000 SQ. FT. BUNGALOW FROM DILAPIDATION, ESSENTIALLY RESTORING THE ORIGINAL HOUSE

> EXPAND AND AMEND THE ORGANIZATION OF THE HOUSE TO ACCOMMODATE DISCRETE PUBLIC AND PRIVATE SPACES

> RESPECT THE EXISTING DISPOSITION OF THE HOUSE, WHILE ALTERING ITS CHARACTER

> GENERATE A SENSE OF EXPANSIVENESS THROUGH SPATIAL CONTINUITY, USE OF LIGHT, AND CONNECTION TO THE EXTERIOR

> FACILITATE ENVIRONMENTAL SUSTAINABILITY

> REFLECT ON THE CONNECTION OF THE PAST AND PRESENT, BOTH WITHIN THE HOUSE ITSELF AND REGARDING ITS RELATIONSHIP TO THE STREET AND NEIGHBORHOOD

## THE HILLSIDE RESIDENCE IS A SUBSTANTIAL RENOVATION AND EXPANSION OF A 1927 BUNGALOW.

"The existing 1,000-square-foot building was rescued from dilapidation; it was delineated abstractly in stark white and paired with a new, 1,300-square-foot sculptural volume clad in black-stained cypress. Akin to Marcel Breuer's 1943 proposition for a "bi-nuclear" house, the home is split into two zones—one for living and socializing, and the other for concentration, work, and sleeping. Inside, the two zones are defined by distinct materials and spatial characters; the combination is both gracious and provocative.

This private nucleus is accessed through a new corridor that leads to an unexpectedly tall central space, off of which are arrayed the private rooms of the house. Unlike the traditional organization of the home, the expansion opens up the public spaces to the backyard and, by contrast, is characterized by openness, dynamic spatial continuity, and abstraction. An ultimately modern sensibility in the addition provides a counterpoint to the sense of contained space in the original house. As one passes between the old and new construction, the confluence of two distinct architectural characters gives rise to questions about the various ways in which architecture both challenges and reinforces the culture of which it is a part. In effect, the ensemble is a counterproposal to the immodesties of modern evolution: rapid transition toward affluence and preference for residual building dimensions to maximize allowable floor-area ratios. Here in contrast, a new character replaces a "historically underutilized" building stock. The existing disposition of the street is maintained, albeit with a new temperament."

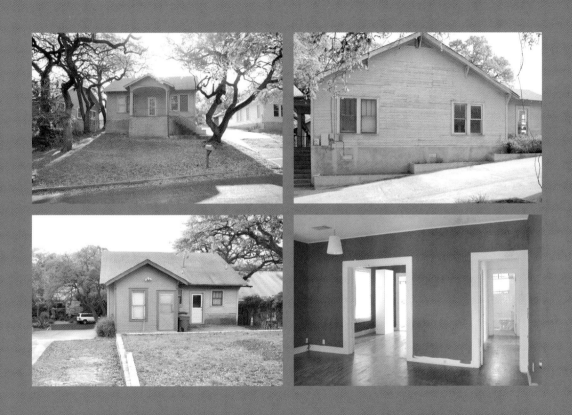

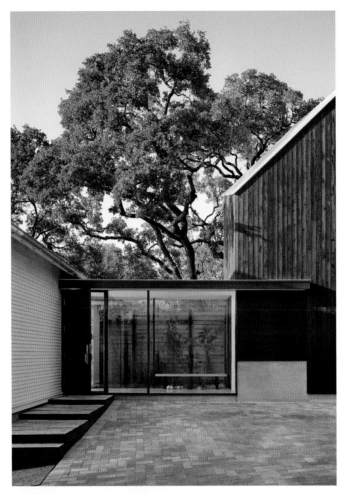

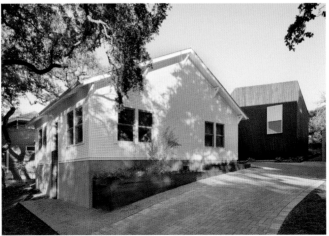

The old bungalow and the addition are connected via a glass entry bridge. By virtue of entering in the middle, both appear to be in dialogue with each other. On the other hand, the existing front porch is removed, leaving the existing bungalow's massing intact, but intriguingly unfamiliar, as it appears without any obvious way to enter from the street.

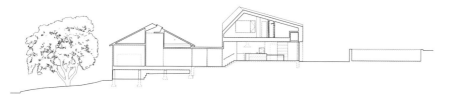

New section

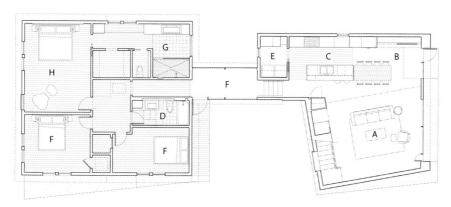

New ground floor plan

A. Living area
B. Dining area
C. Kitchen
D. Bathroom
E. Laundry room
F. Entry bridge
G. Master bathroom
H. Master bedroom
I. Home office

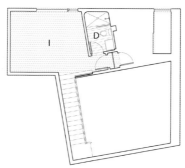

New second floor plan

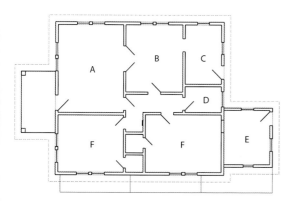

Existing ground floor plan

A. Living room
B. Dining room
C. Kitchen
D. Bathroom
E. Storage
F. Bedroom

The renovation respects the old bungalow's configuration and maintains its collection of discrete rooms, while radically altering their character through an adjustment to its organization.

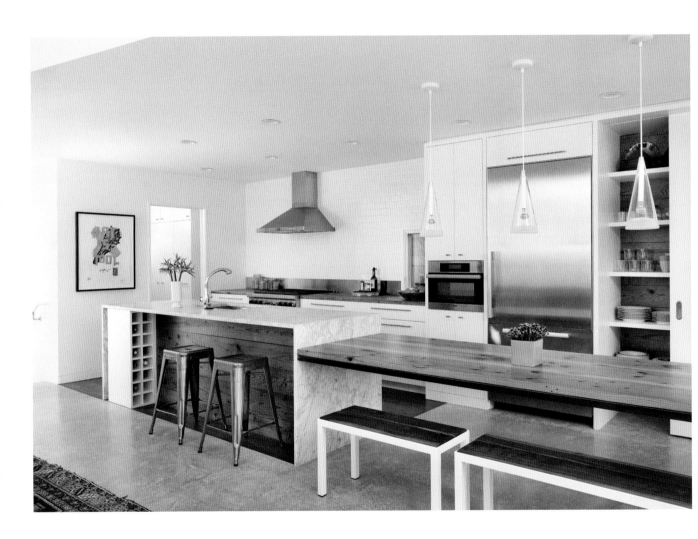

The kitchen is at the center of the new public nucleus, immediately setting a casual and multivalent tone to this great room. A Carrara marble countertop is turned down to cover the island's bulkhead and give a sense of specialness to the ensemble.

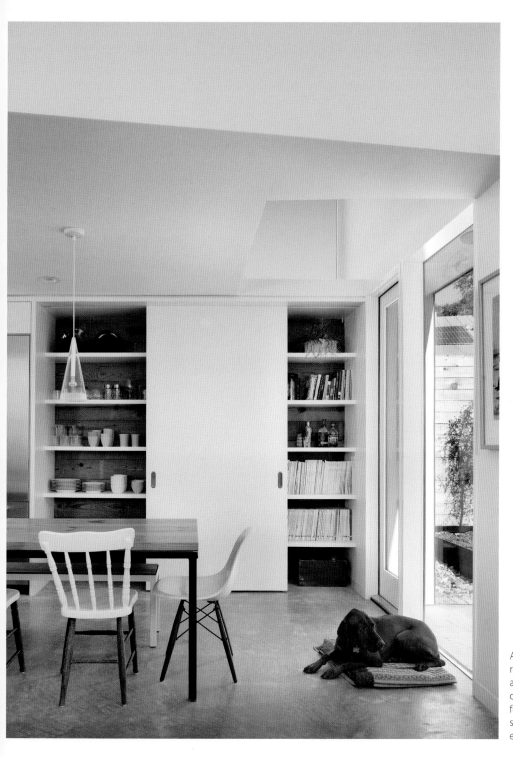

A single sliding panel alternately reveals or conceals the pantry and open storage, while carefully orchestrated windows and skylights further open the house to the sky and sun, and provide a continued sense of expansiveness to this modest home.

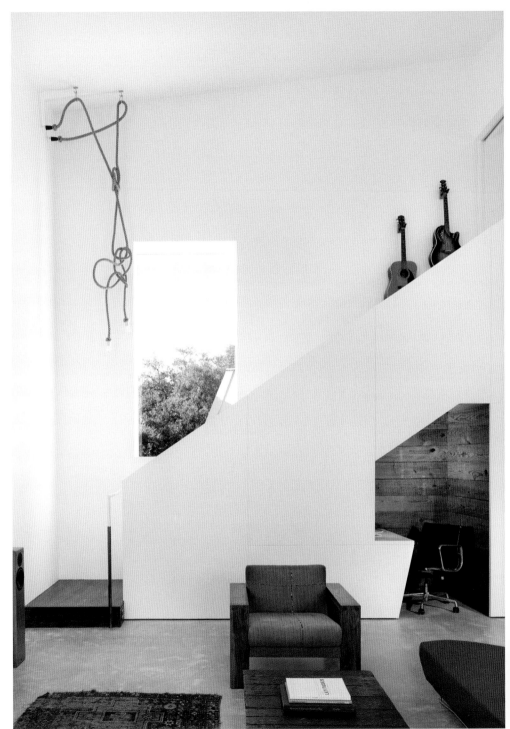

Long-leaf pine, reclaimed from the floor joists of the original bungalow, was used for wall cladding and the fabrication of a new headboard; the patina of age and previous use poses against the pristine white surfaces.

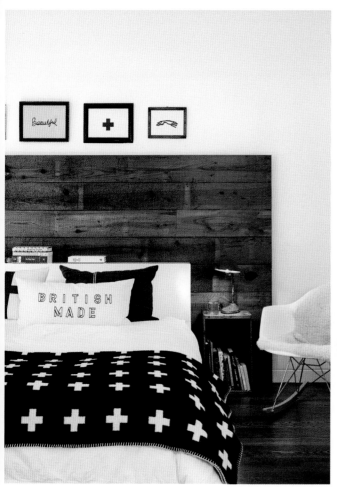

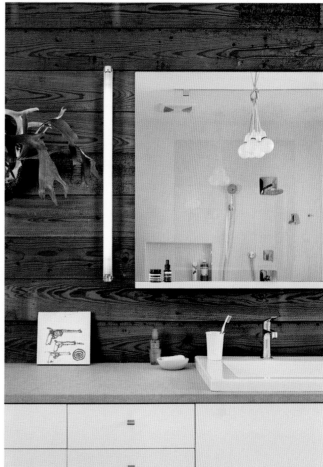

## Credits

**Architect: Alterstudio Architecture**
www.alterstudio.net

**General contractor: Ford Strei Builders**
www.fordstreibuilders.com

**Structural engineer: Duffy Engineering**
www.duffyengineering.com

## Appliances and Materials

**Flooring:** White-painted oak floors in office; mosaic house cement tiles in bathroom; split cedar posts from original foundation posts for front-entry steps
**Kitchen appliances:** Wolf Dual Fuel 36" range; Miele MasterChef speed oven; Miele 24" fridge-freezer; Miele La Perla II dishwasher
**Kitchen area furniture:** Steel/wood

benches by Austin furniture designer RAD; dowel side chair by Modernica; Marais counter stools by Tolix
**Lighting:** LED recessed lighting in kitchen by Cree; Fucsia pendant by Flos
**Living room furniture:** "The Lover" sofa" by Ligne Roset; flax rope light by t.e.; chair by Eames Aluminum Group
**Master bedroom furniture:** "Togo" chair by Ligne Roset; "Alpine" king bed

from CB2; headboard custom-made from leftover shiplap
**Office furniture:** "Strut XL" table by Blu Dot; dowel side chair by Modernica; "Photon" rug by DWR; sleeper sofa by Brimstone
**Plumbing:** Allegro E faucet by Hansgrohe; range hood by Broan

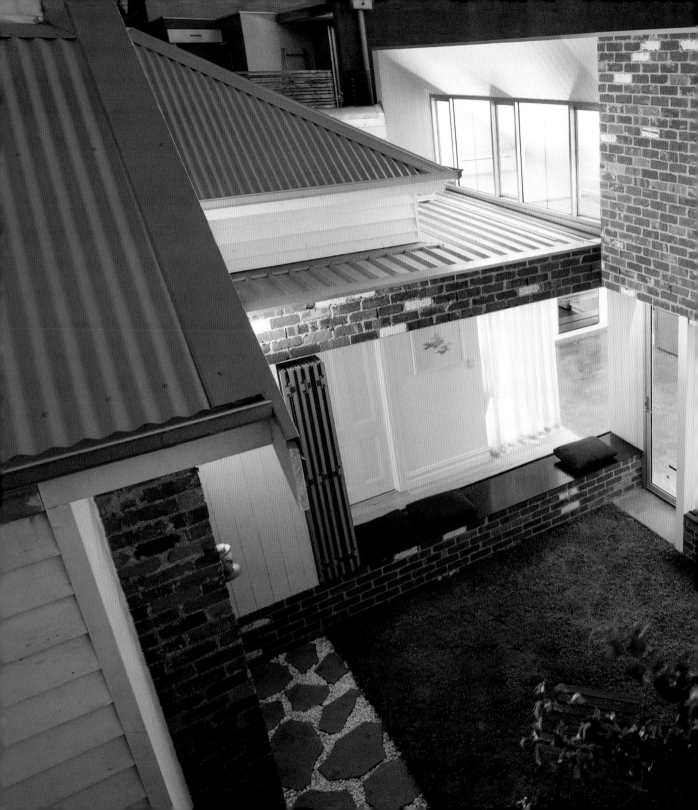

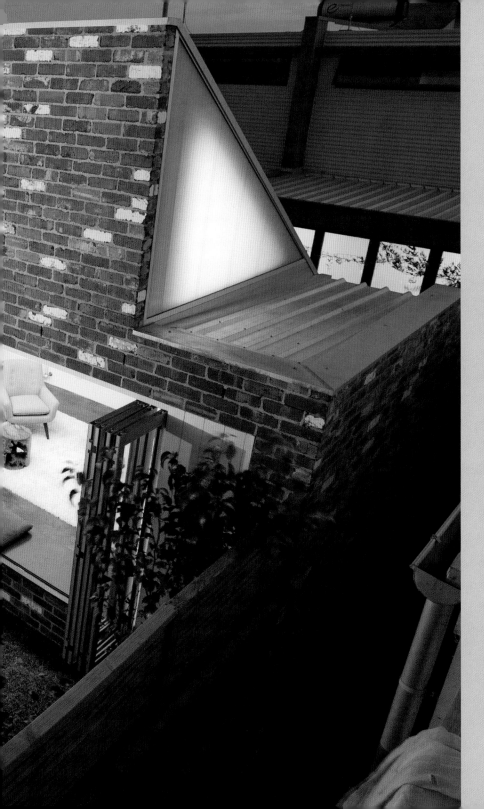

Project team: **Michael Roper**, Design Director
**Nick James**, Design Director

**www.architecturearchitecture.com.au**

> TURN THE HOUSE TOWARD THE NORTHERN ASPECT AND AWAY FROM IMPOSING NEIGHBORING BUILDINGS

> ANCHOR THE EXTENSION AROUND THE COURTYARD, PROVIDING FRAMED VIEWS FROM MANY VANTAGE POINTS AND CREATING A SENSE OF SPACIOUSNESS ON AN OTHERWISE TIGHT SITE

> CREATE AN OPEN PLAN LIVING SPACE WITH A NEW KITCHEN, BATHROOM, AND STUDY NOOK

> ALLOW FOR A FLEXIBLE USE OF THE STUDY NOOK

A MODEST EXTENSION TO A VICTORIAN HAS TURNED A DARK, CRAMPED RESIDENCE WITH A LITTLE BACKYARD TO SPARE INTO A LIGHT-FILLED HOUSE WITH FANTASTIC INDOOR AND OUTDOOR ENTERTAINING AREAS.

---

"The brief called for new open plan living areas, a new kitchen, bathroom, and study nook. Our response catered to these requirements while vastly improving the livability and environmental performance of the house.

The house and site have been transformed from unlivable to luxurious with just a few simple design moves. The use of orientation, deep thresholds, thermal mass, and operable windows has also created a low-energy passive solar house that is comfortable throughout the year.

The existing house was south facing, casting itself into shadow, with unsightly neighboring buildings imposing on all sides. We turned everything around by creating a U-shaped extension along the property boundaries. Now, the house enjoys a generous private courtyard, with sunlight throughout the year.

The material palette further assists in relaxing the otherwise clear geometries of this house. Exposed recycled brick, an echo of Abbotsford's industrial heritage, and white timber boards, a staple of the modest residential extension, subtly breach the delineation of indoors and outdoors, weaving the two together.

The internal courtyard provides a private outdoor sanctuary in what is otherwise an imposing, built-up area, and complements the house, which achieves a sense of spaciousness despite its small size, which makes the small extension even more valuable."

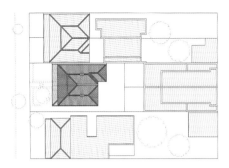

Existing site plan

New site plan

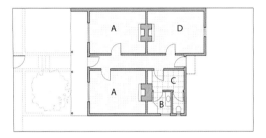

Existing floor plan

A. Bedroom
B. Bathroom
C. Laundry
D. Living room

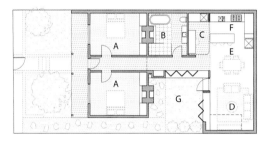

New floor plan

A. Bedroom          E. Dining area
B. Bathroom         F. Kitchen
C. Study            G. Courtyard
D. Living area

Building section

From the outside, the steep, raked roof deftly negotiates planning regulations, allowing for generous ceilings and high-level clerestory louvers. From the inside, it announces the arrival in the heart of the house.

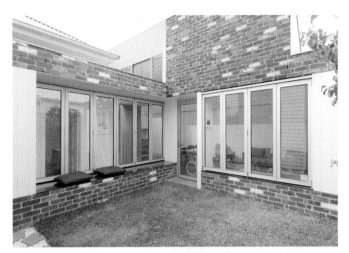

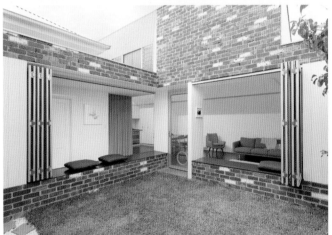

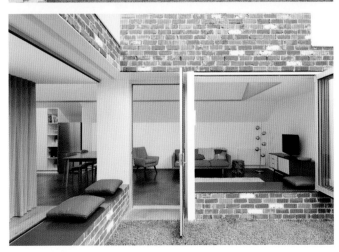

Along both sides of the courtyard, two long bench seats soften the threshold between interior and exterior. One serves the living areas, the other serves the courtyard. At the back of each bench, bifold windows draw back, allowing the house to throw itself open to the outdoors or to close off, adapting as required.

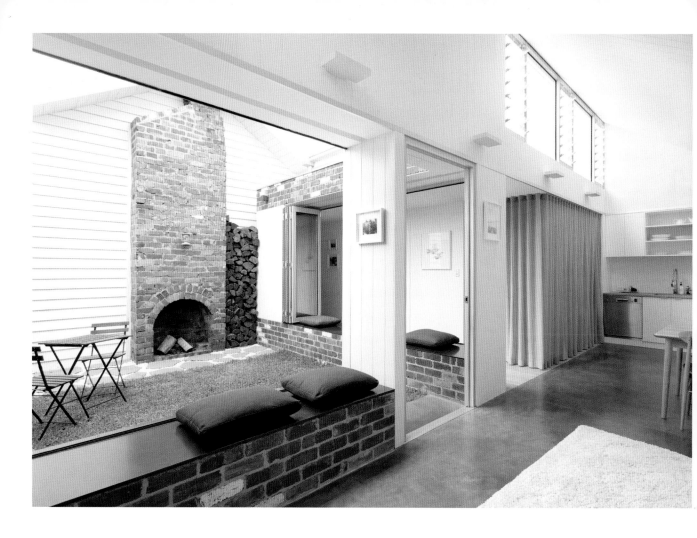

The optimized solar orientation and
the use of brick walls and a dark
concrete slab for thermal mass
ensure that this is a high-comfort,
low-energy house year round, ideal
for entertaining.

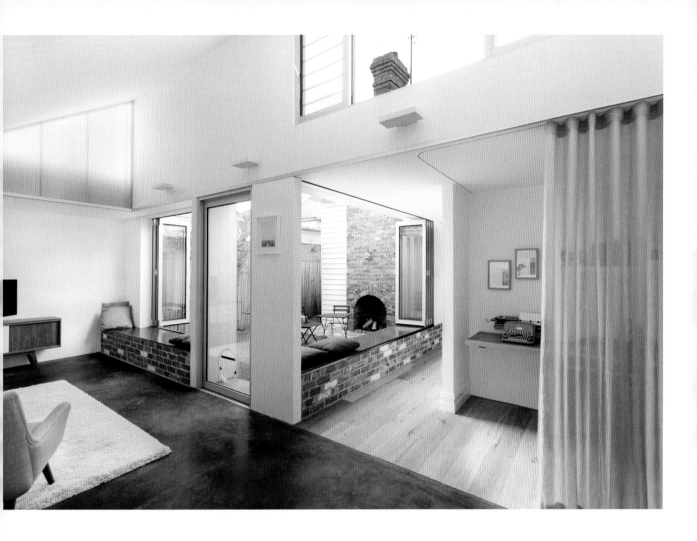

**Credits**

**Architect: Architecture Architecture**
www.architecturearchitecture.com.au

**Builder: Sinjen**
www.sinjen.com.au

**Structural engineer: Meyer Consulting**
www.meycon.com.au

**Appliances and Materials**

**Doors:** Centor E2 bi fold doors
**Exterior:** Lexan Thermoclick polycar-
bonate panels, recycled brick, cedar
timber lining boards
**Flooring:** Polished concrete floors with
pigment
**Windows:** Breezway Altair 152 louvers

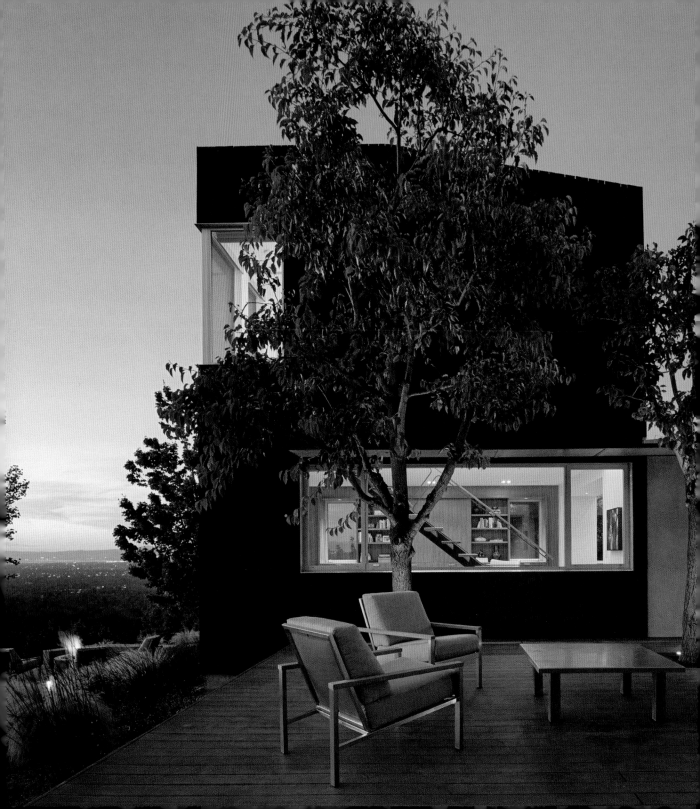

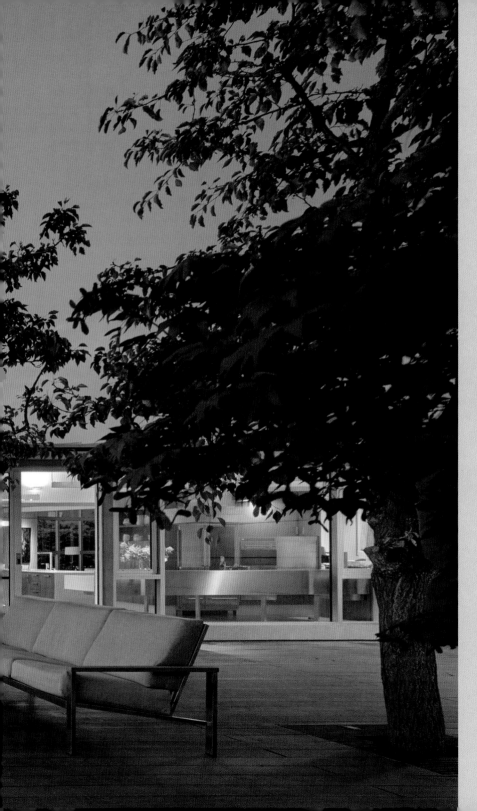

## SHOU SUGI BAN HOUSE

### 4,350 sq. ft.

Los Gatos, California, United States

———

**SCHWARTZ AND ARCHITECTURE**

Photos © Matthew Millman

Project team: Neal J. Z. Schwartz, Wyatt Arnold, Paul Burgin, Aaron Goldman, Neil O'Shea, Joshua Yoches

**www.schwartzandarchitecture.com**

> ENLARGE AND UPDATE A HOME WITH A STRONG PREEXISTING ARCHITECTURAL CHARACTER

> ADD GUEST SUITE TO THE HORIZONTAL HOME TO TAKE ADVANTAGE OF VIEWS ACROSS SILICON VALLEY

## SCHWARTZ AND ARCHITECTURE CREATED A TWO-STORY ADDITION WITH THE VISUAL WEIGHT NEEDED TO ANCHOR THE LONG AXIS OF AN EXTENDED ORIGINAL HOUSE.

"The original home occupies a prominent hilltop overlooking Silicon Valley and faces the pristine rolling hills of a nature preserve. Its design was a joint venture between Min | Day as design architect and Burks Toma Architects as architect of record. Later, Min | Day added a swimming pool and related outdoor spaces. Schwartz and Architecture devised the addition at the western end of the house and the substantial remodel of the interior.

Enlarging an existing home that has an already strong and complete architectural character can be challenging. Here, we anchored the existing one-story home with a new two-story volume, using it as punctuation mark and counterpoint to the existing composition.

The project, which also involved an extensive remodel of the existing modern residence, was inspired by dominant images and textures from the site: boulders, bark, and leaves. This led us to the idea of cladding the addition in traditional Japanese shou sugi ban burnt cedar siding both to integrate the home with the site and to create the visual weight necessary to anchor the existing exuberantly roofed horizontal building. Natural textures also prevail in the cosmetic remodeling of the living spaces, bringing a variety of shou sugi ban woods in for a lighter and more refined finish."

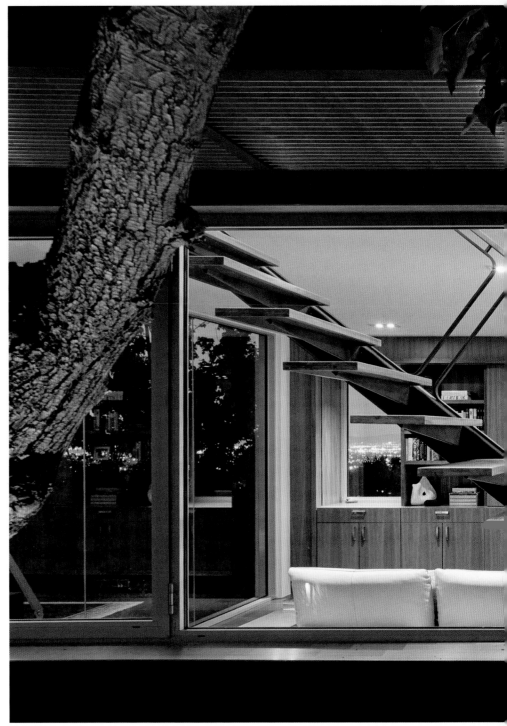

With large panoramic windows, the new family room has views of the spectacular natural surroundings. An open-riser staircase leading to a guest room on the second floor enhances the open character of the design.

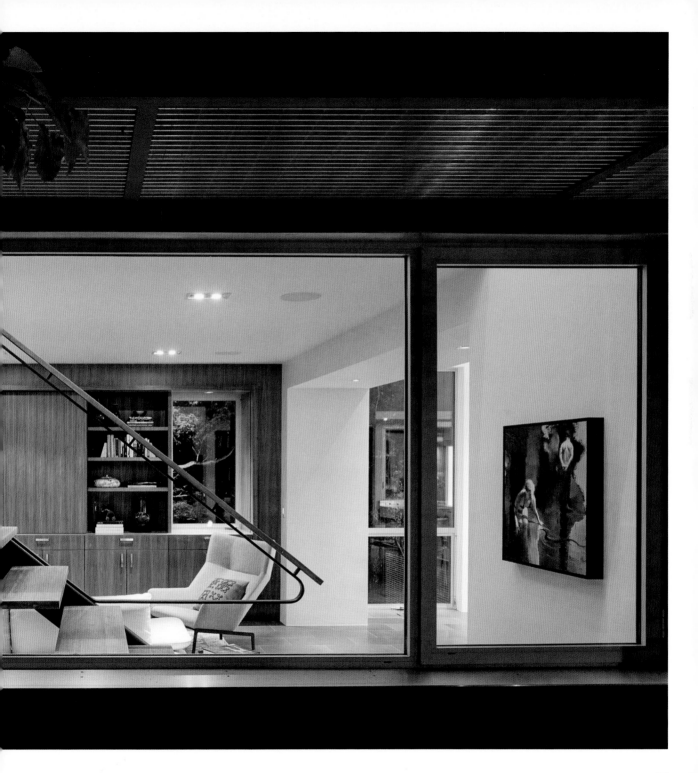

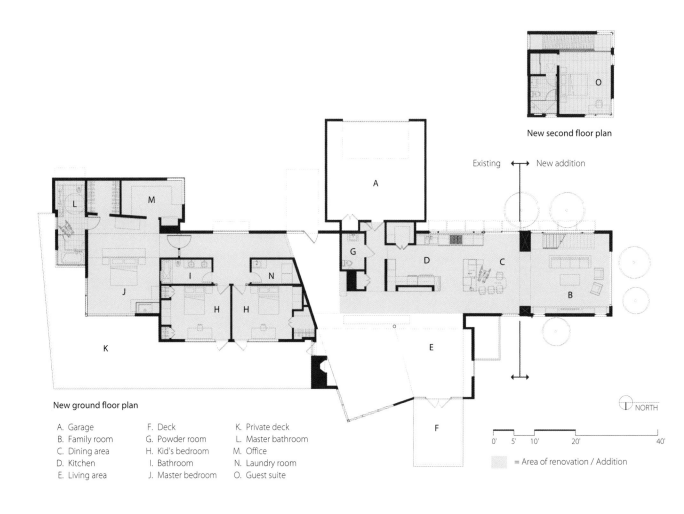

New second floor plan

Existing ←→ New addition

A

O

G

D

C

B

M

L

J

I

N

H    H

K

E

F

NORTH

New ground floor plan

A. Garage
B. Family room
C. Dining area
D. Kitchen
E. Living area
F. Deck
G. Powder room
H. Kid's bedroom
I. Bathroom
J. Master bedroom
K. Private deck
L. Master bathroom
M. Office
N. Laundry room
O. Guest suite

0'  5'  10'    20'                40'

= Area of renovation / Addition

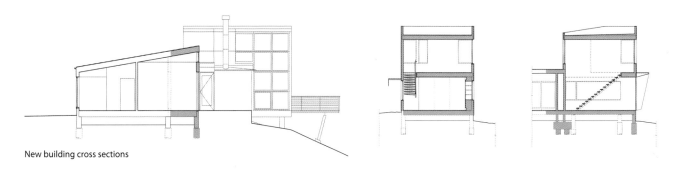

New building cross sections

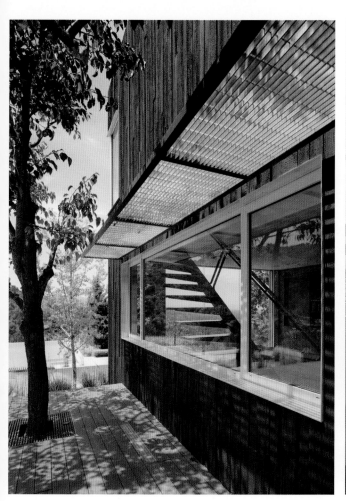
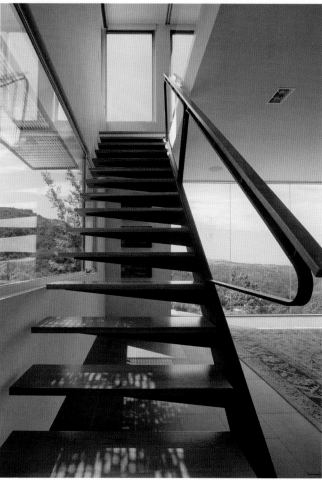

Against the spectacular natural setting, the architects balanced steel-framed stair treads and awnings that cantilever from minimal structural supports as if leaves from a slender branch.

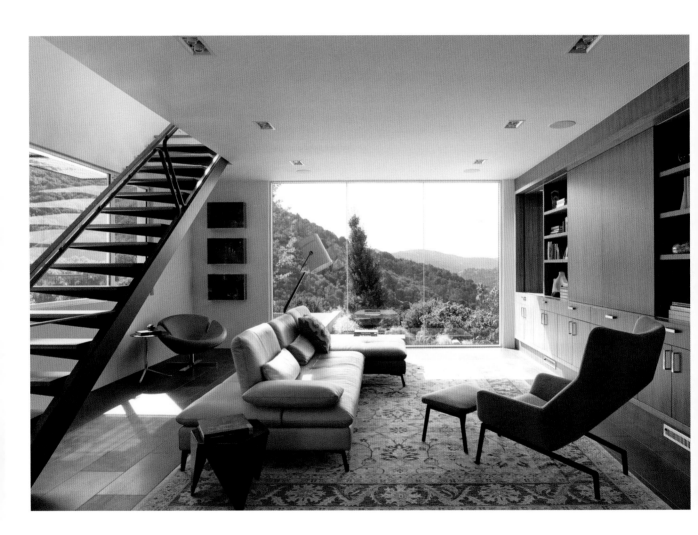

The new volume, adjacent to an
expanded accessible kitchen,
contains a family room and staircase
leading to an upper guest suite with
windows carefully located on all four
sides to frame views.

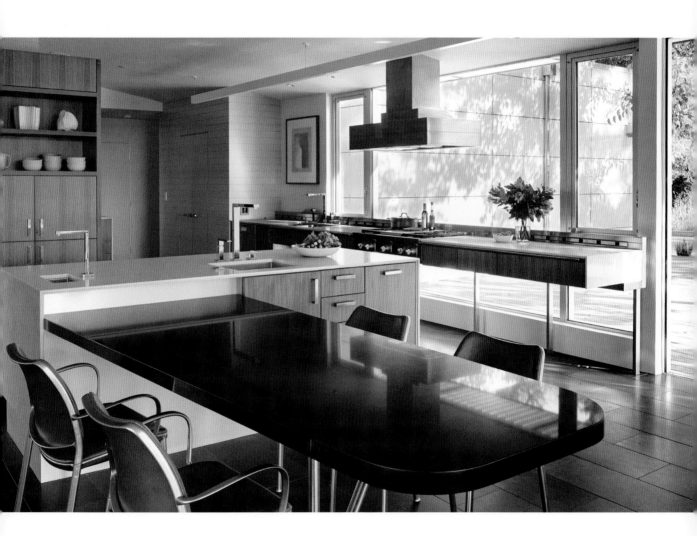

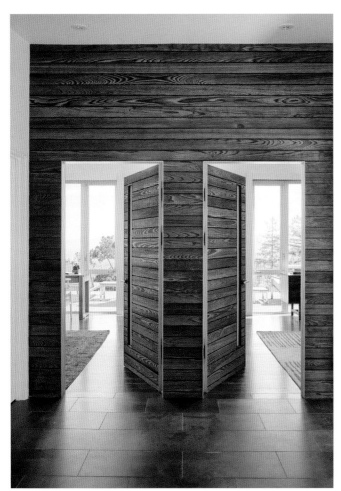

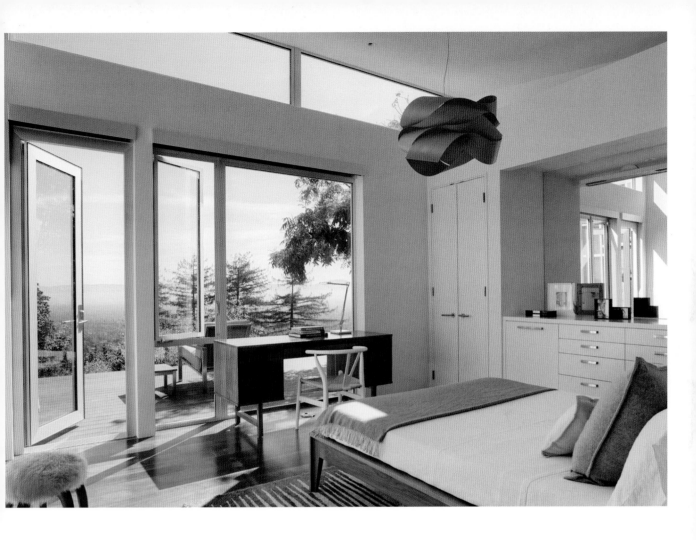

Natural finishes were implemented
to reinforce the connection with
the textures and colors found in
the landscape surrounding the house.
The bedrooms enjoy direct access to
the outdoors, while transom windows
separating the walls from the ceilings
enhance the sense of openness.

445

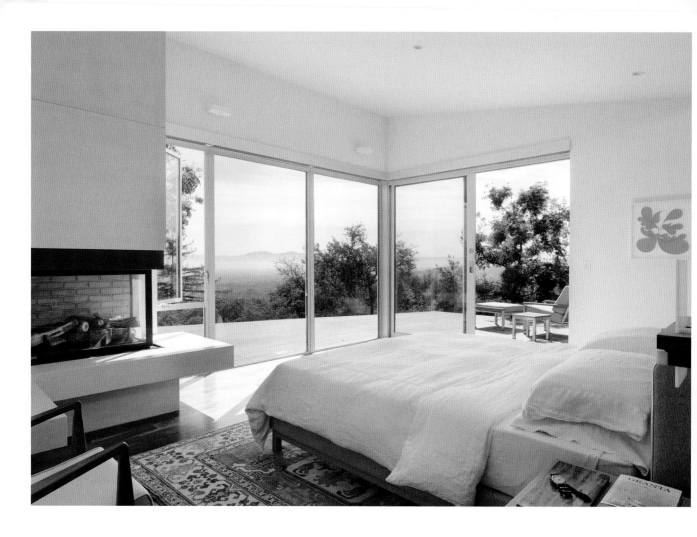

A wood deck adds to the floor
area of the bedrooms, fully
integrating these rooms with the
surrounding landscape and boasting
uninterrupted private views.

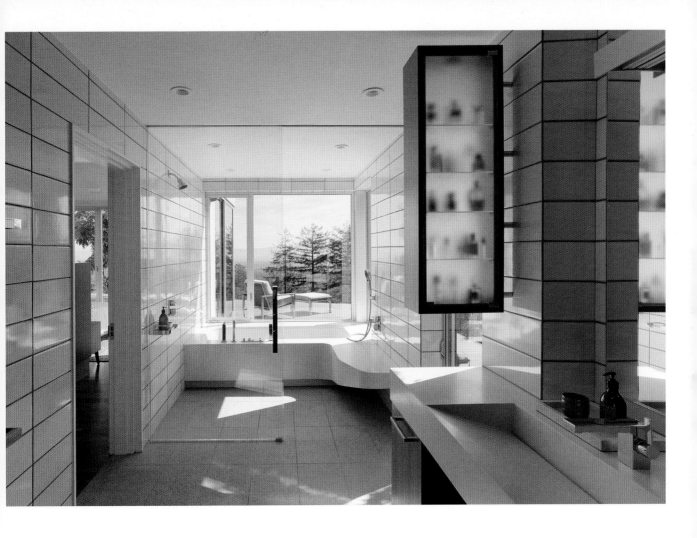

A remodeled accessible master bathroom continues the organic and textured themes of the project. A floating cabinet with translucent glass front and back casts prosaic toiletries into dappled light and shadow, recalling the textures of the trees outside.

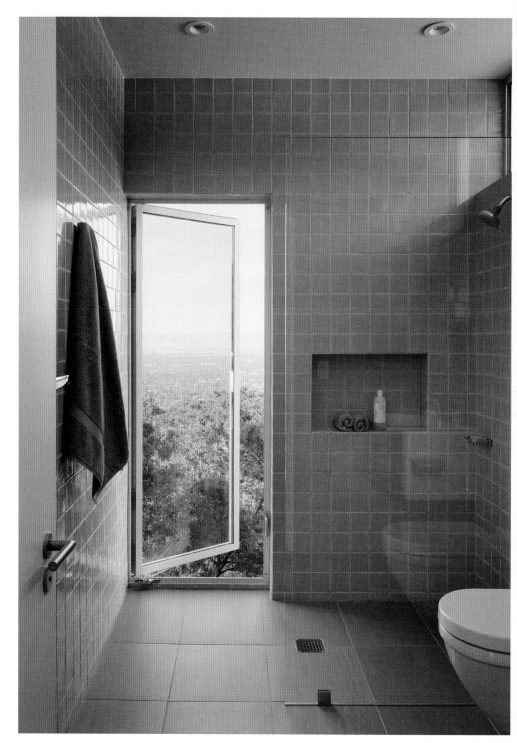

The addition includes a new family room with a guest room above. The bathroom features a door-height window in keeping with the idea of minimizing the separation between interior and exterior.

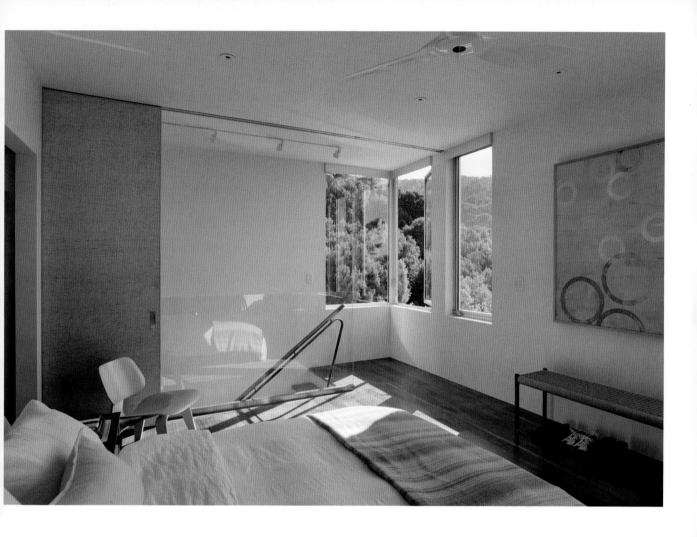

**Credits**

Architect: Schwartz and Architecture
www.schwartzandarchitecture.com

Architect of record:
Burks Toma Architects
www.burkstoma.com

General contractor:
MD Construction
www.md-construction.com

Original architect: Min | Day
www.minday.com

Shou sugi ban manufacturer:
Delta Millworks
www.deltamillworks.com

Structural engineer: iAssociates
www.iassociates.pro

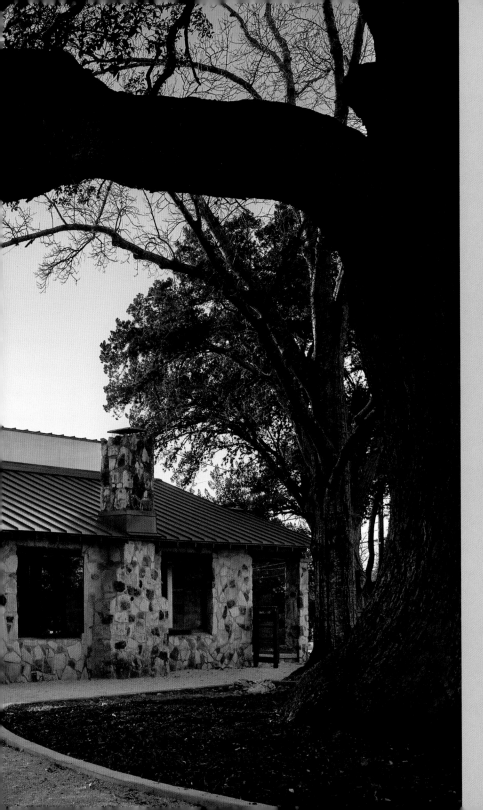

## FERRAND RESIDENCE
## 1,500 sq. ft. (current) *

New Braunfels, Texas, United States

---

### A.GRUPPO ARCHITECTS

Photos © Dror Baldinger, AIA Architectural
Photography

\* 2,600 sq. ft. (phase II)

Project team: **Andrew Nance**, AIA Principal
Architect; **Thad Reeves**, AIA Principal Architect;
**Brett Davidson**, AIA and Project Manager;
**Ana Riley**, Designer

**www.agruppo.com**

**PHASE ONE:**

> **ALLOW FOR MORE NATURAL LIGHT IN LIVING
> AREAS**

> **RECONFIGURE KITCHEN TO OPEN ONTO
> EXISTING LIVING ROOM**

> **ADD POWDER ROOM AND LAUNDRY ROOM**

**PHASE TWO:**

> **ADD MASTER BEDROOM SUITE**

> **ADD FORMAL DINING ADJACENT TO KITCHEN**

> **ADD NEW LAP POOL**

> **ADD ROOF DECK ACCESSIBLE FROM MASTER
> SUITE, OVERLOOKING DOWNTOWN NEW
> BRAUNFELS**

## A.GRUPPO ARCHITECTS DESIGNED THE FERRAND REMODEL AS WELL AS BUILDING THE PROJECT

"Situated atop a hill overlooking the Guadalupe River basin, this is the second home to occupy this site located in the original town of Braunfels. Late ninetieth century insurance maps show a previous home once stood on this property, but was razed and replaced with a traditional stone veneer wood frame bungalow sometime in the 1930's.

The home was a wonderful example of a Hill Country Bungalow with local stone veneer, and compartmentalized rooms in the original 900-square-foot structure. A later addition added a wing with a bedroom and a study, while in the 1980's a new master bedroom suite was added. The interior spaces were traditionally cellular, rather than open plan, as was common in the popular vernacular iterations of the arts and crafts movement from the 1930's in the United States.

The brief for the project was to master plan a bedroom suite, dining room, pool, and roof deck along with a complete renovation of the existing structure. Because the house was sitting within the limits of a historic neighborhood, we faced challenges of strict building regulations. Despite this fact, the intent was to juxtapose the original structure with a new, decidedly modern, yet respectful addition, rather than reproduce a culture of building that no longer exists. Materials of the addition were chosen to reach into the existing structure, resulting in a union of the two sensibilities.

The second phase will consist of a new master suite and dining room, with roof deck overlooking downtown. Both house and addition open up to the 350-year-old live oak tree on site, whose massive canopy envelops both structures."

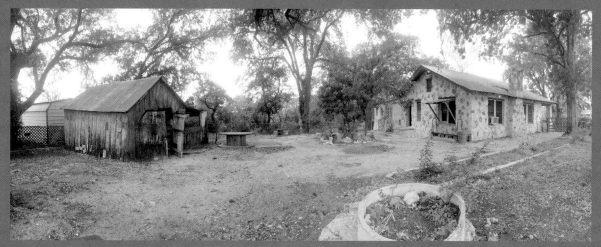

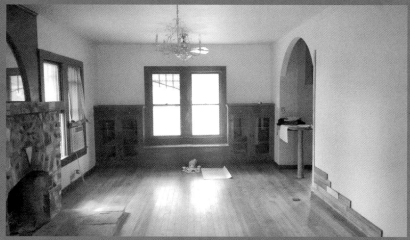

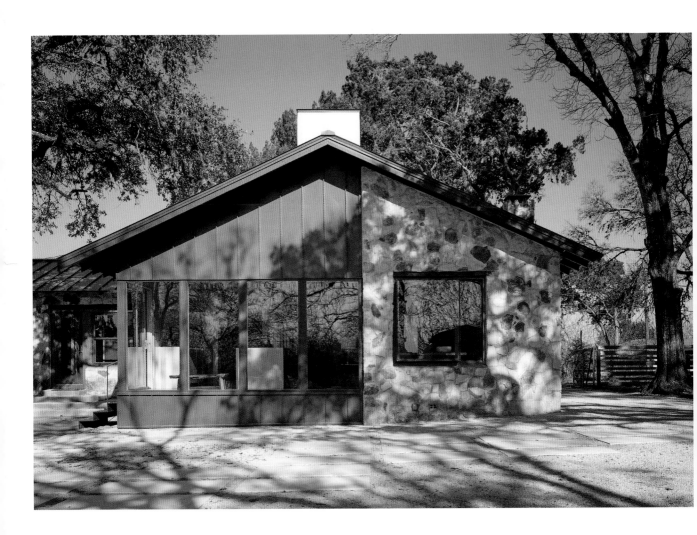

The setting's natural features,
orientation, and views played
important roles in the design of the
remodel and addition.

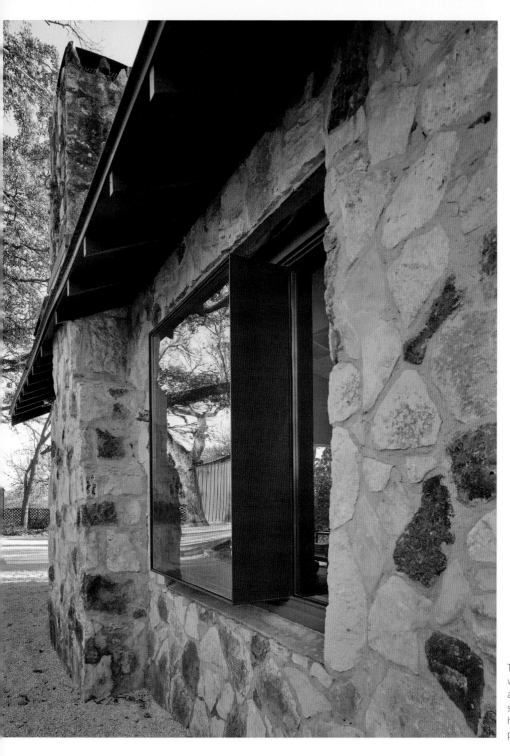

The metal siding and large glazed windows anticipate the phase two addition of the dining room and master suite. The traditional paired double-hung windows were reinterpreted as a projected window seat.

455

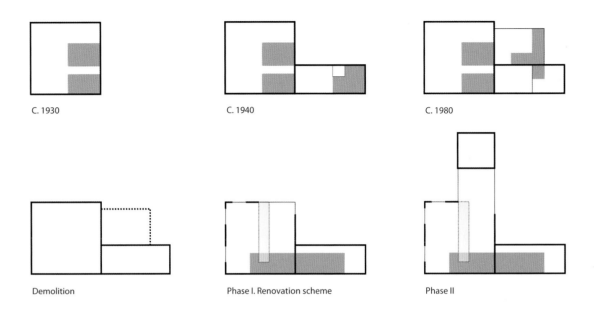

C. 1930

C. 1940

C. 1980

Demolition

Phase I. Renovation scheme

Phase II

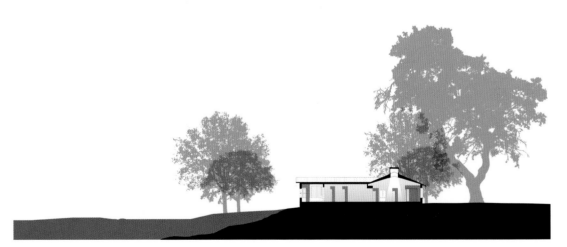

Building section

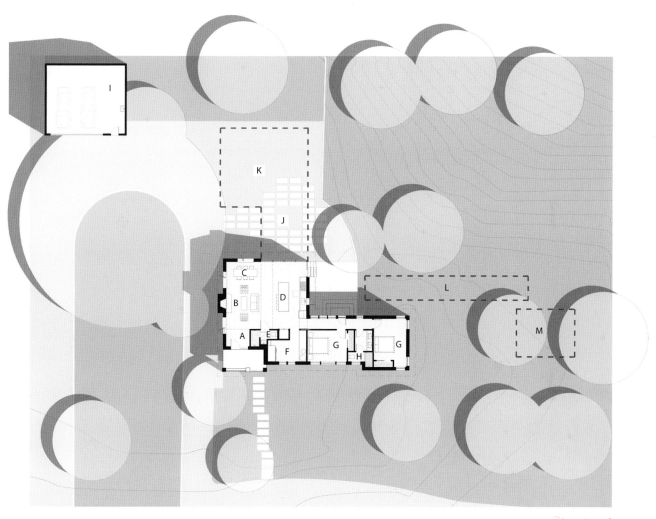

## Floor plan

A. Entry foyer
B. Living area
C. Dining area
D. Kitchen
E. Powder room
F. Laundry room
   and pantry

G. Bedroom
H. Bathroom
I. Garage
J. Future dining room
K. Future master suite
L. Future pool
M. Future cabana

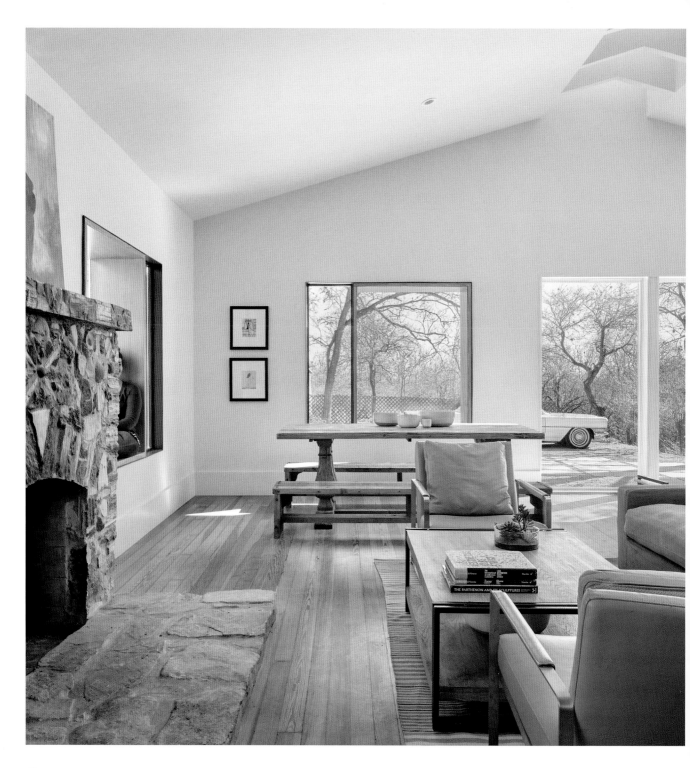

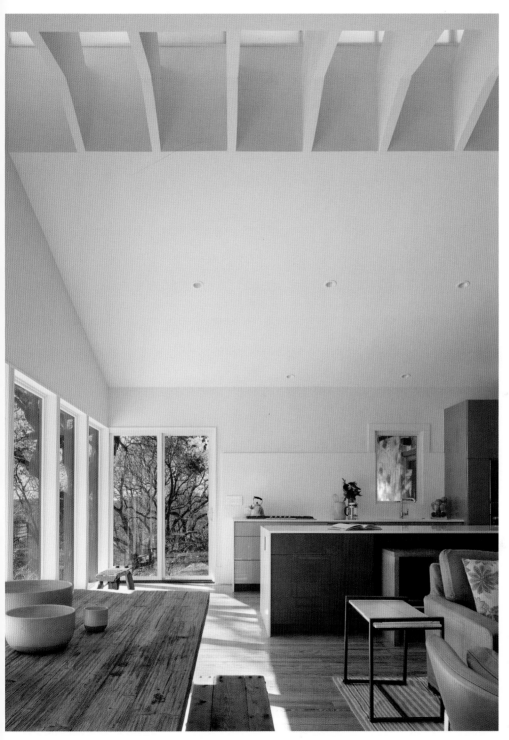

Seen throughout the renovation, a modern attitude toward materiality and light replaces existing double-hung windows with projecting steel-frame glazed openings, opening up the entire footprint of the original house to a single room containing the kitchen and the living areas.

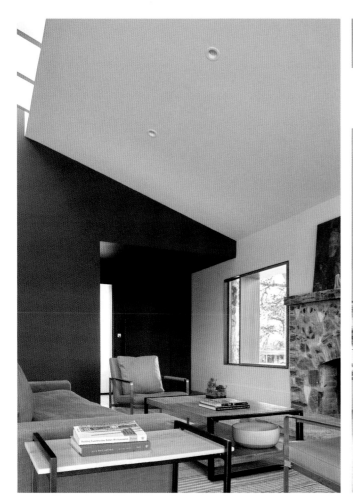
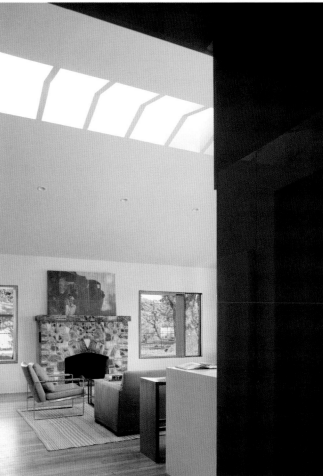

The original roof was reconstructed since it relied upon an interior wall for structure. The new larger living area is accentuated by a linear skylight running the length of the living room bordered by large windows foreshadowing the location of the future dining room addition.

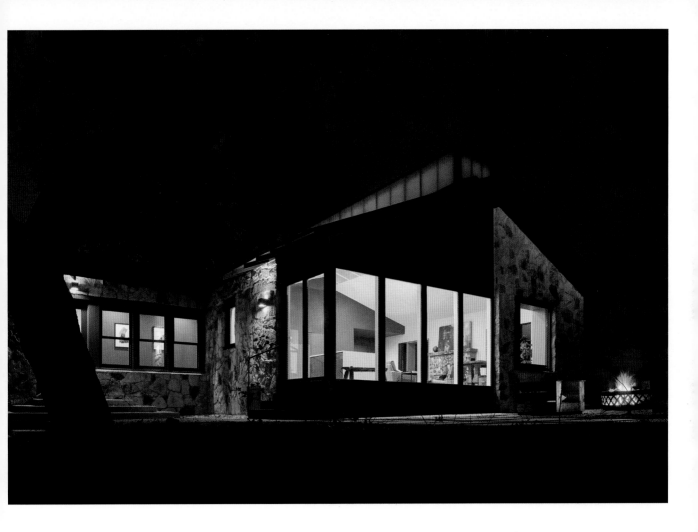

**Credits**

**Architect:** A.GRUPPO architects
www.agruppo.com

**Home owner and interior decorator:**
Cala Ferrand

**Structural engineer:**
Lawrence Calvetti

**Appliances and Materials**

**Appliances:** Bosch
**Cabinets:** DuPont Custom Cabinets
**Clerestory:** Poly-Gal
**Countertops and backsplash:**
Silestone, quartz
**Flooring:** Reclaimed longleaf pine
**Plumbing fixtures and sinks:** Kohler
and DXV
**Siding:** Standing seam metal
**Windows:** Custom and Pella

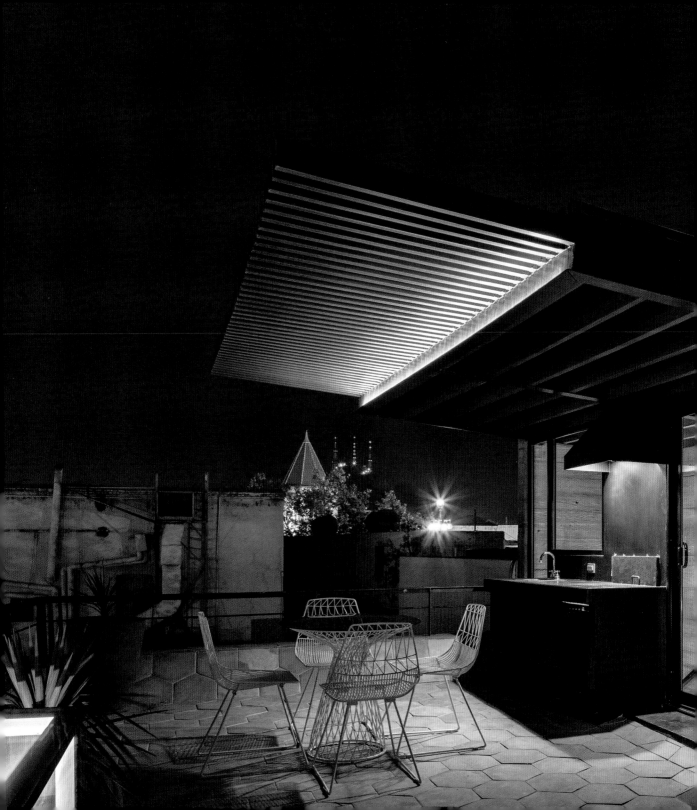

# C2A HOUSE

## 3,229 sq. ft.

Chihuahua City, Mexico

———

**LABORSTUDIO**

Photos © Rafael Gamo

Landscape
Architecture
Border
Paisaje
Arquitectura
Frontera
**LABor**

Project team: Víctor Mendoza,
Diana Ordoque, Pavel Rentería,
Marysol Enríquez, Fernanda Arriola,
Ilse Esparza

**www.laborstudio.com**

> MAXIMIZE THE FLOW OF CIRCULATION
THROUGH THE ENTIRE HOUSE BY MEANS OF
INTERLOCKED SPACES

> DEVISE A LAYOUT WHERE EXTERIOR SPACES
ARE JUST AS IMPORTANT AS INTERIOR ONES

## THE NEED FOR THE REFURBISHMENT OF AND EXTENSION TO AN OLD, NEGLECTED BUILDING ENCOURAGES A COMPELLING JUXTAPOSITION OF STRUCTURES.

"The project began with the restoration of an old building dating from the early twentieth century in a deteriorated urban environment. This led to a study on the refurbishment of derelict building structures and the exploration of the possibilities of urban regeneration.

The neighboring property was added as an extension to the existing old building. This extension was conceived as a series of articulated volumes and a staircase that not only connects the different floor levels of the extension, including a new roof terrace with fantastic views, but also acts as a link between the old and new constructions. All living spaces are interconnected to enhance visual continuity and opened to the outdoors wherever possible to maximize a sense of space."

Existing ground floor plan

Existing second floor plan

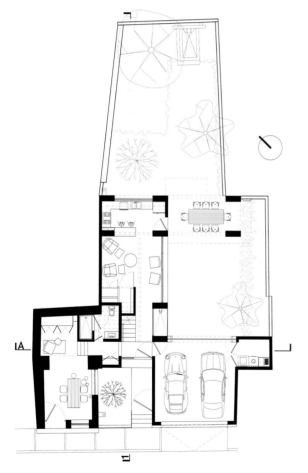

New ground floor plan

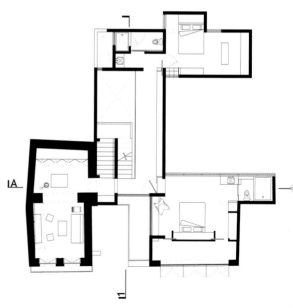

New second floor plan

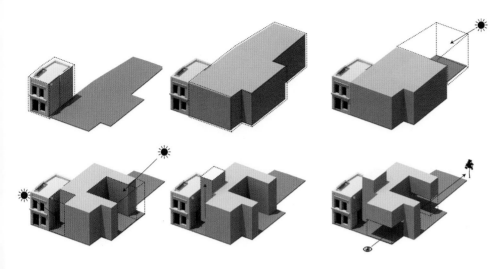

Addition's schematic diagram

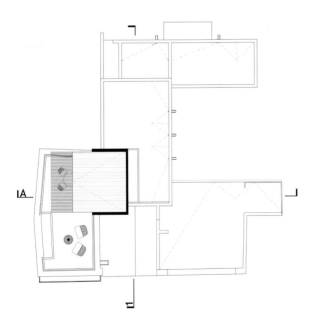

New roof plan

The staircase is a key element of the design on two levels: formally, it connects the existing building with the addition; conceptually, it makes a clear separation between two different architecture styles: the old, massive brick building and the modern, almost-transparent addition.

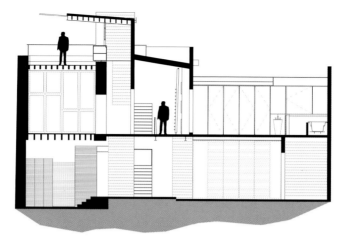

Section A

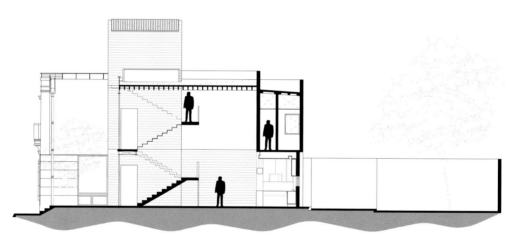

Section 1

The design of the house is a complex composition of interlocking volumes that display a balance of solid and void spaces. The distinction is better appreciated at night, when lights inside the house are turned on, revealing a mosaic of opaque and see-through surfaces.

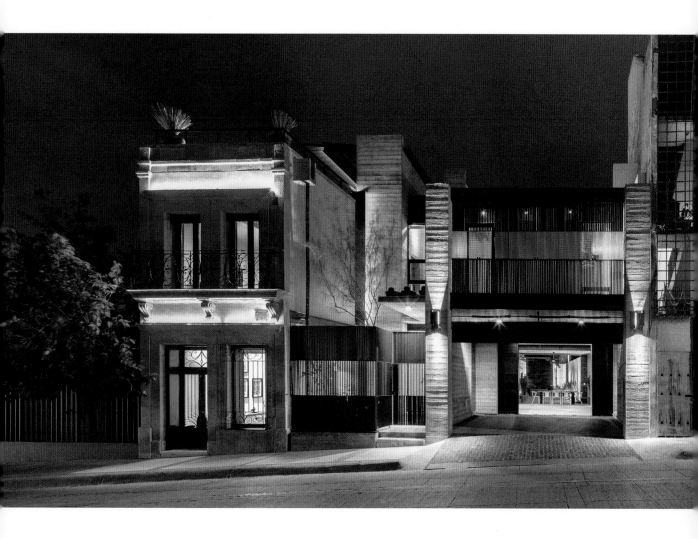

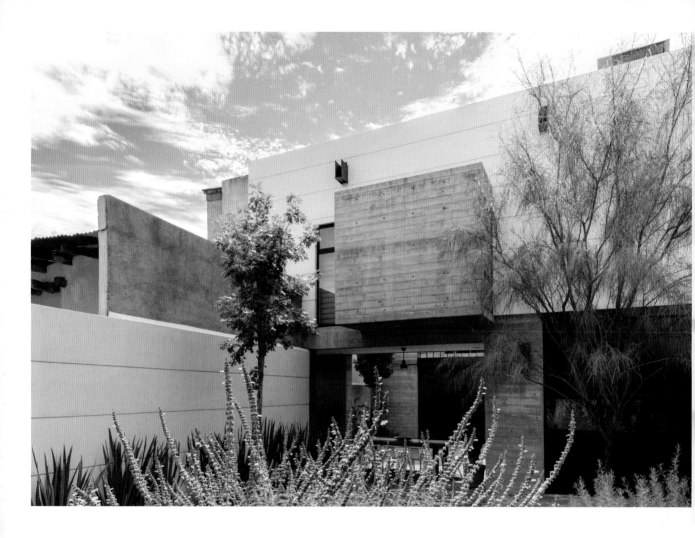

The solid volumes enclose interior
spaces, protected from the outside.
In contrast, voids make room for
passageways and staircases, which
act as intermediary spaces that link
the interior with the exterior, or for
courtyards, as spaces in their own right.

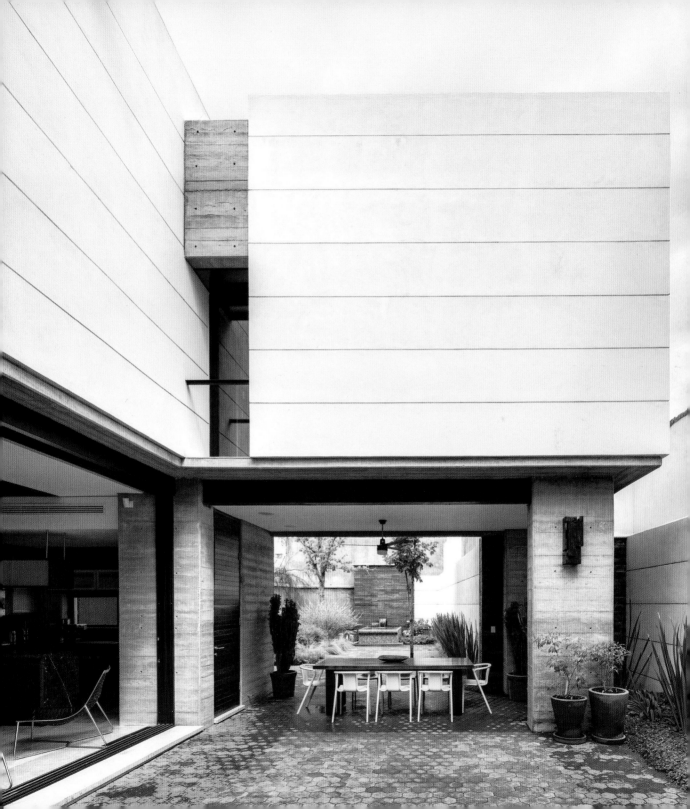

Parts of the house are generously glassed in. The goal was not as much to let light in as to display the interior. By doing so, the interior is as much a part of the exterior as the interior is of the exterior.

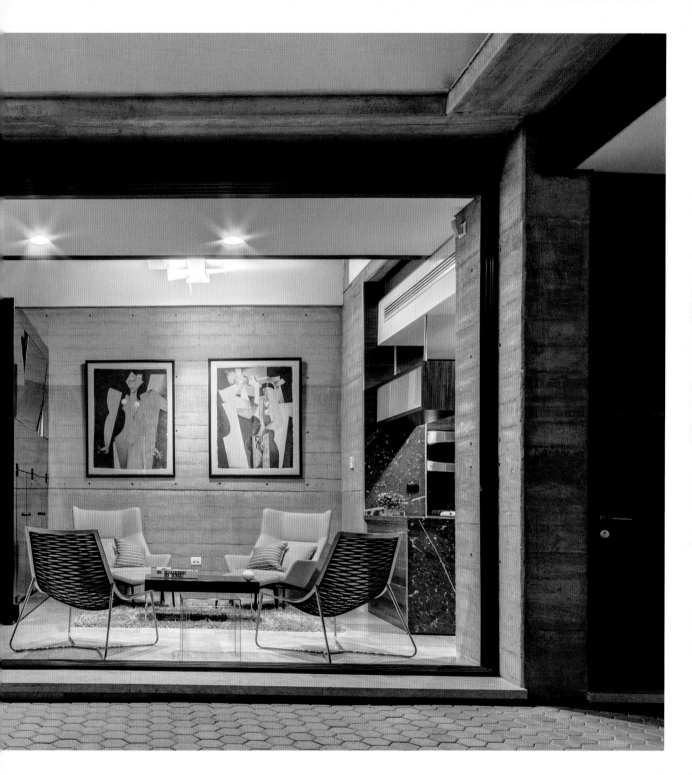

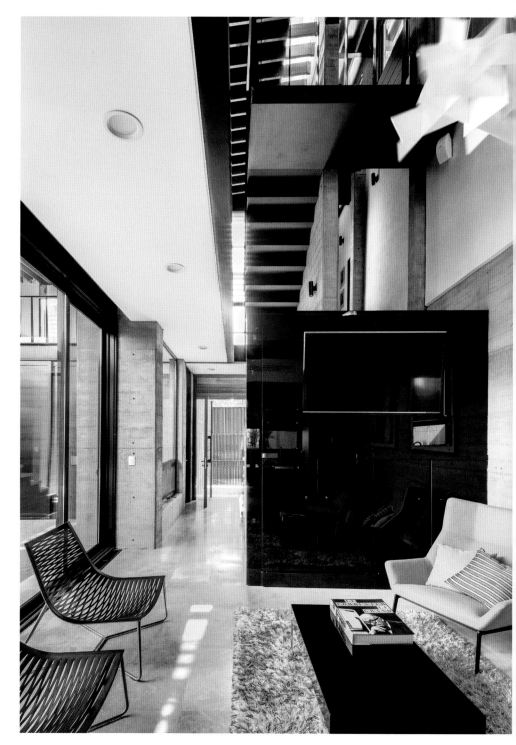

The metal staircase is devised as an inserted object into a void in the interior of the house. This concept is made all the more clear with a slender design detached from the building structure.

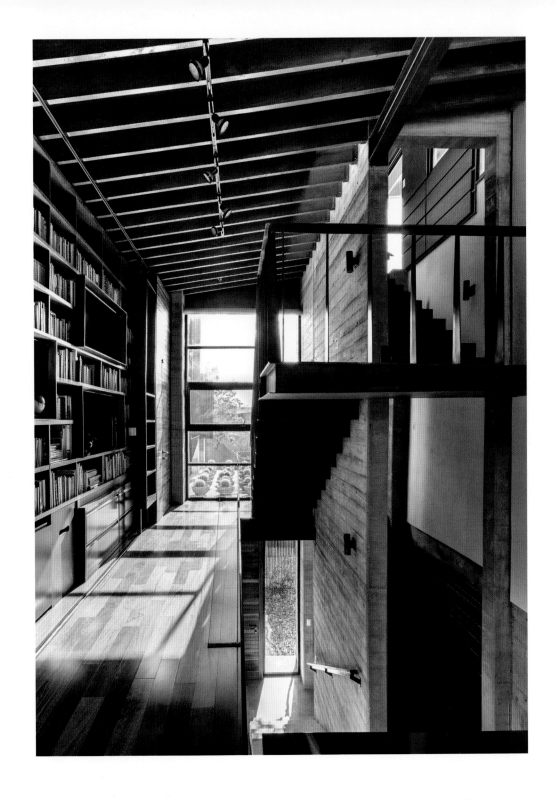

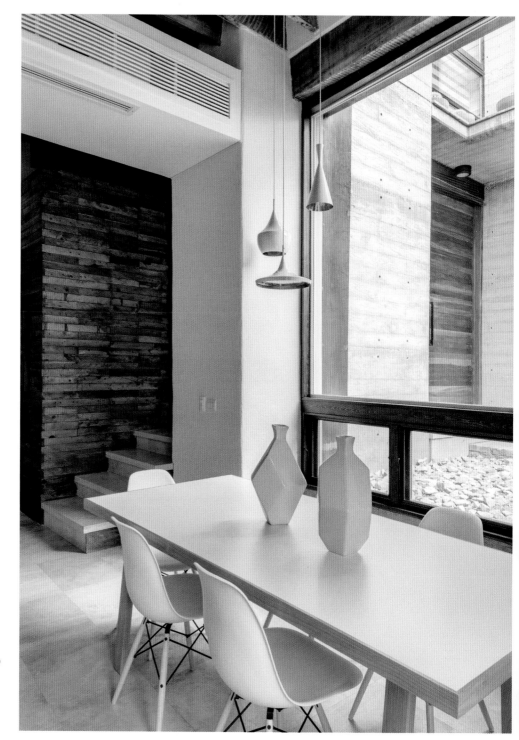

The fenestration is an integral part of the house design, contributing to its strong geometric configuration. Windows, doors, and skylights are parts of the building envelope that accentuate the openness of the house interior toward the exterior.

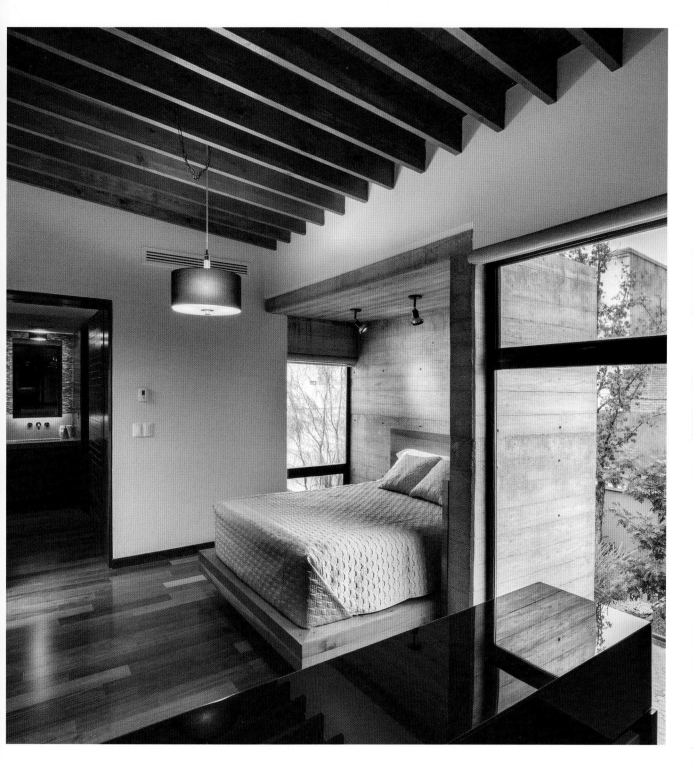

The boundaries between interior and
exterior dissolve, while sight lines
hint at other spaces beyond, further
dramatized by a captivating play on
light and shadow.

## Credits

Architect: LABor Studio
www.laborstudio.com

General contractor:
Mario Reyes / LABor Studio

Interior designer:
Claudia Garza / LABorstudio

Landscape designer: Evergreen

Structural engineer: David Olivas

Windows: Eliud Chávez